*The Classical
Tradition
in Art*

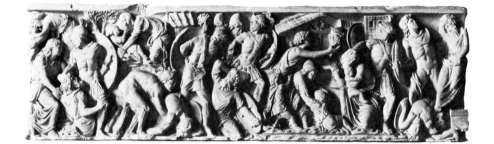

THE CLASSICAL
TRADITION
IN ART

Michael Greenhalgh

DUCKWORTH

© 1978 by Michael Greenhalgh

First published in 1978 by
Gerald Duckworth & Co., Ltd,
The Old Piano Factory, London NW1

Distributed in USA by
Southwest Book Services, Inc
4951 Top Line Drive
Dallas, Texas, 75247

Book design by
Alphabet and Image, Sherborne, Dorset

*The picture on page 2 shows a Roman battle
sarcophagus. Mantua, Palazzo Ducale. The
picture on page 8 shows a figure from the fountain from the
main square of Perugia, by Arnolfo di Cambio,
1381, now in the National Gallery of Umbria, Perugia.*

ISBN 0 7156 12778 Cloth
 0 7156 13006 Paper

Filmset and printed by BAS Printers Limited, Over Wallop, Hampshire

Contents

Acknowledgements

I gratefully acknowledge my debt to the following friends and colleagues:

Philip Conisbee and Rosalys Coope, who read all the text, and made frank and helpful suggestions; Susan Conisbee, who clarified the confusion surrounding Ingres's style; Luke Herrmann, who supported the project from the beginning; Hamish Miles, who first introduced me to the problems of the subject, and is the real originator of the book; and Alastair Smart, who was also sympathetic from an early stage, and made useful comments on the draft of the Renaissance section.

The Research Board of the University of Leicester was generous with grants; one of these helped me to stay at the British School at Rome where the Director, David Whitehouse, and the staff of the marvellous library made me welcome. I also made extensive use of the Library and the Photographic Collection of the Warburg Institute. Finally, I should like to pay tribute to the British Library Lending Division at Boston Spa, which, through the kindness of the staff of the Inter-Library Loans Department at Leicester University Library supplied me with large quantities of material.

Permission to quote from the following sources is gratefully acknowledged:

Librerie Droz, for parts of the English translation of Raphael's *Letter to Leo X*, from C. Pedretti's *A chronology of Leonardo da Vinci's architectural studies after 1500*, Geneva, 1962, within 162–71.

Christopher Lloyd, for a part of his translation of Algarotti in his exhibition catalogue of *Art and its images*, Oxford, 1975, 7.

Harper and Row, for a translation from Bellori in E. Panofsky's *Idea*, New York, 1968, within 155–7.

Pennsylvania State University Press, for a passage from H. Saalman (ed.), *The Life of Brunelleschi by Antonio di Tuccio Manetti*, University Park and London, 1970, within 50–2.

M.G.

Foreword

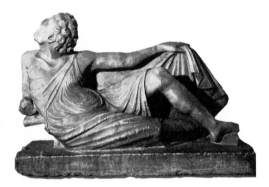

This book is a survey of the development of the classical tradition in art and architecture from the fall of the Roman Empire to the time of Ingres. The classical tradition is more than the revival of antique motifs and their re-use from generation to generation, for that is a feature of all stages of post-antique European art. What I have attempted to describe is the history of an intellectual attitude toward Antiquity which led certain artists to re-interpret antique ideas and antique models not slavishly but creatively, so that a fresh stylistic tradition was formed and developed. That tradition, the classical tradition, was decisively formulated by Nicola Pisano and Giotto, and was a cornerstone of Renaissance art. Its later history is coterminous with the influence of Renaissance attitudes in art and architecture.

Because of limitations of space, I have concentrated on the work of a restricted number of artists and architects from Italy and France, and have shown classicism as just one of the stylistic and intellectual modes available to them. I do not wish to suggest that classicism was the only tradition in European art, but to demonstrate its importance within the rich tradition of classicism in other disciplines, be it literature or law, epigraphy or political science. I hope that the brevity of the treatment will not lead the reader to think of one artist as 'classical' from birth, and another as inexorably 'gothic' or 'romantic'.

The richness of the classical tradition is due to the variety of antique sources available and to the interpretations and re-interpretations of them from age to age. The attitude of the men of the Middle Ages, for example, and the extent of their knowledge of the past, was very different from that of the Renaissance artists

who nevertheless sometimes built on and re-interpreted medieval versions of the antique as well as looking directly to Antiquity for their models. W. S. Heckscher has explained the process by a three-tiered fountain which he calls 'The Fountain of Classical Influence'. The current of Greek art wells up into the upper-most and smallest bowl which, when it over-flows, fills the one below it. The top bowl represents Hellenistic and Roman art, the next bowl the art of the Middle Ages. The largest bowl, Renaissance art, is at the bottom and receives water from both bowls above it, as well as pure jets of the waters of Greek art which have not passed *via* the interpretations of the Middle Ages.

Superscript numbers in the text refer to the Bibliography which is divided into sections corresponding to those within each chapter of the text. The problems of providing a bibliog-raphy for such a huge project as the classical tradition are almost insuperable. My solution, where possible, has been to preface each section of the Bibliography with general books which are not referred to in the text. The superscript numbers then either give specific references or indicate to the reader further reading on aspects of the subject omitted because of the necessary brevity of my survey. In the latter case the references explicate the text rather than support it. Because the biblio-graphy of an artist is often more available than that of a subject such as 'survival *versus* revival', or the 'idea of Rome', I have concen-trated on the latter at the expense of the former. References to primary sources have been omit-ted; these are collected in J. von Schlosser-Magnino, *La Letteratura Artistica* (rev. edn,

O. Kurz (ed.), Florence, 1956). Large biblio-graphies on artists and subjects are available in *The McGraw-Hill Encyclopaedia of World Art* (15 vols, New York and London, 1957–68).

Asterisks within the text refer to notes at the foot of the page. These have deliberately been kept to a minimum and in consequence the bibliographical entries are sometimes followed by brief comments about content or general approach. Asterisks within the Bibliography are placed against books which I recommend as basic reading within each subject division.

ABOVE *Mantua, Palazzo Ducale. Roman sarcophagus with the story of Phaedra.*

BELOW *Ingres: Virgil reading the Aeneid to Augustus, c. 1812. Toulouse, Musée des Augustins.*

Introduction

What is Classicism?

In ancient Rome, the citizens of the first rank were called *classici*. When Aulus Gellius (19.8.15) contrasted a *scriptor classicus* with a *scriptor proletarius*, the description carried an implication of quality which is still current: we speak of a work being a 'classic' in the sense that it is a model which deserves to be followed. The French were using *classique* in this manner in the sixteenth century but it was not until the eighteenth century in England and France that the term 'the classics' came to mean precisely the masterpieces of Greek and Latin literature. Since at that time a classical education was acknowledged as the only correct training for civilized life, such an extension of meaning is not surprising. In the history of art as in the history of literature, classicism is an approach to the medium founded on the imitation of Antiquity, and on the assumption of a set of values attributed to the ancients. The continuing importance of ancient culture in many disciplines, such as law and administration or epigraphy and poetry, is shown in the fusing of the two senses of the word 'classic' in the term *classical tradition*, which denotes the retention of and elaboration upon classical values in the art of succeeding generations. This is not a notion invented in the twentieth century to explain the history of art; there is an observable propensity in some artists and at certain times to work in a classical manner: their antecedents are proclaimed by the very characteristics of their work.

Classicism has certain basic features in art as in literature. Its concern is always with the ideal, in form as well as in content. Such is the case, it is true, with virtually all artists before Romanticism, but classical artists looked back to the ideal of Antiquity as well as to its varied styles. They were sure that art is governed by rules which are determined by reason. Beauty, which is one form of truth, must depend on some system of measurement and proportion, as Plato explained in the *Timaeus*; artists working from classical models made it their business to rediscover such a system in the works of art and buildings of Antiquity. Such an emphasis on measurement, allied to reason, is summarized in the Vitruvian figure of a man within a circle and a square, which expresses the concurrence between beauty, mathematics and Man. For the Renaissance artist, Man, within the circle of God, is the measure of all things, and he rules himself and his affairs by the application of reason. Antique art, centred on the depiction of a noble human mind in an ideal body, provides convincing models for imitation.

The depiction of the ideal entails certain formal as well as intellectual qualities. Clarity of subject-matter must be reinforced by clarity of style, for extraneous detail and secondary incident would detract from the precision and hence from the impact of the meaning. Simplicity is joined by understatement, 'expressing the most by saying the least', in portraying Man as he ought to be, 'raised above all that is local and accidental, purged of all that is abnormal and eccentric, so as to be in the highest sense representative', as Babbit writes in his *New Laokoon* of 1910.

Considered thus, art has a moral aim, like literature, and so surely deserves that place among the Liberal Arts which the ancients had denied it.[5] Indeed, Renaissance theorists, basing their ideas upon Horace's famous aphorism (*Ars Poetica*, 361) *ut pictura poesis*, 'as is painting, so is poetry', created a long-lived theory of

the ideal which drew parallels between the two disciplines and also justified artistic practice.[4] Visual art, they affirmed, is an intellectual pursuit, for the artist must know the stories both sacred and profane and appreciate their implications in order to be able to translate them convincingly into paint, stone or metal. The artist must therefore be intelligent enough to choose and plan a subject, to articulate his 'actors' in an expressive manner, and to point the moral of the story. Such conformity to the idea of painting as silent poetry implied conformity also to poetry's descending scale of genres in only slightly amended form: at the top of the scale, epic could be translated into historical painting, and then on down the scale to burlesque and bucolic at the bottom. The inherent worth of a painting therefore depended to some extent on the type of subject-matter treated, for theorists were quite clear that the mark of a fine painter (or sculptor) was his ability to portray the significant actions of men in climacteric situations. Taken together with Horace's affirmation that poetry should instruct as well as delight, the highest type of art therefore approximates almost to moral philosophy.* It is pointless for us to protest that painting is by nature totally different from poetry, and should not borrow its aesthetics, for Renaissance humanistic theory confounded the two.

Antique art holds an important place in such a formulation. Renaissance artists, anxious to imitate human nature not as it was but as it should be, were forced to select features of the everyday world and elevate them to the ideal, just as the antique Zeuxis had selected elements from five maidens for his portrayal of Helen. Thus good artists, as G. P. Bellori wrote in 1672,

imitating that first Maker, also form in their minds an example of superior beauty, and

in beholding it they amend nature with faultless colour or line. This Idea, or truly the Goddess of Painting or Sculpture, when the sacred curtains of the lofty genius of a Daedalus or an Apelles are parted, is revealed to us and enters the marble and the canvases. Born from nature, it overcomes its origin and becomes the model of art; measured with the compass of the intellect it becomes the measure of the hand; and animated by fantasy it gives life to the image.

As Bellori implies, the great works of Antiquity contain that Idea of which he writes.[6] Renaissance artists therefore regarded the study of the antique as a way of looking afresh at human nature, conveniently clothed as it was in imitable artistic forms.[1,2] The imitation of the antique is therefore crucial to the classical tradition. A good artist would aim to build upon work of acknowledged quality, and thereby to rival Antiquity itself; such, indeed, was the highest praise a Renaissance critic could bestow upon a modern production. Today we find it difficult to accept that art might progress by looking backward, for we automatically believe that most things fifty years old are out of date and irrelevant to us. Imitation seems to be a polite word for 'copying'. However, it is our perspective which is at fault. The richness of the classical tradition derives in part from the richness and variety of its antique sources, which are transformed, not copied, by artists as original as their forebears. Furthermore, when Vasari implied that art was progressing, he meant *away* from modern, namely Gothic, art and *toward* the standards and outlook of Antiquity. About two hundred years later, Winckelmann was to proclaim that the only way for an artist to become great was through the imitation of the ancients.

It is important to set the tenets of classicism—namely a concern with Antiquity, with the ideal, with the typical, and with morality in its widest sense—in the context of the civilization which gave it birth. From the fall of the Roman Empire, during the Middle Ages, Europe was permeated by the influence

*'... it is not the eye, it is the mind, which the painter of genius desires to address; nor will he waste a moment upon those smaller objects, which only serve to catch the sense, to divide the attention, and to counteract his great design of speaking to the heart ...' Sir Joshua Reynolds, *Third Discourse*, in which he defines the grand manner of classicism.

of the antique, as the first chapter of this book shows. From at least the fourteenth century, respect for the achievement of Graeco-Roman Antiquity was universal, and its example was seen as a means whereby civilization itself might be reborn after the night of the 'Dark Ages'. Not only art, but literature, law, philosophy, rhetoric, and other disciplines were to be transformed. For a Renaissance prince who collected antique coins and cameos, who dressed in armour modelled after the antique and led his troops under 'Roman' triumphal arches, who listened at his court to antique plays and collected manuscripts of the ancient authors, what more natural than that his artists should celebrate antique virtue in their work? Why not depict the Christian holy figures as versions of right-thinking ancients? For the Renaissance, indeed, there was no unbridgeable gap between antique and Christian, for they regarded the one as a variation of the other, another stage which (at least in those texts that the Renaissance scholars chose not to ignore) had nothing but good to say about the intellectual and moral attainments of paganism.[7]

The stylistic implications of classicism's involvement with the art of Antiquity were extensive. Qualities of clarity, simplicity, harmony and understatement allied to imitation of the ancients produced a monumental grandeur more convincing than the other-worldly austerity of the Gothic or Byzantine manners. The example of the antique induced Renaissance artists with understanding of geometry to attempt in their art a reproduction of reality itself; in this they were encouraged by theorists like Alberti, who based himself upon Pliny. The view that art was 'the ape of nature' was to have a long life,[3] but the aims of classicism were rather to elevate reality to a higher plane, while making full use of those advances in perspective and the portrayal of emotion which helped to render works more convincing and effective.

Classicism has a bad reputation in a century which favours a more emotional and personal approach to art. Many would agree with Mark Twain that 'a classic is something that everybody wants to have read and nobody wants to read'. Raphael is respected rather than loved, and Delacroix is more popular than David, but it is our century which is at fault when it construes classicism (in the words of one critic) as 'unexciting, formal and frigid'. The sensual exoticism of the Romantics and the bravura of the Baroque appear more acceptable than the intellectual control which classicism imposes. Why, indeed, did the classical tradition survive so long, and why did it end? One reason is evidently the tenor of the culture on which it fed, but a general cause is to be found in its very nature. Because it eschewed the individual for the sake of the typical, and the intricate for the sake of the simple, its products could be universal in character and message, rather than tied to any particular period or country. Given the continuing involvement with Antiquity, Raphael's Stanza della Segnatura meant much the same to the eighteenth century as it had to the sixteenth. It was more readily comprehensible than the convolutions of Mannerism or the ecstasy of Baroque, because it was founded on reason. The tradition began to decay with the political, social and artistic upheavals of the nineteenth century, when Antiquity, the imitation of which had hitherto been considered the life-blood of culture, began to look like a heap of outworn platitudes, preserved in artistic mortuaries (academies), and incapable of adaptation to the modern world. Well before Courbet the ideal lost ground in favour of the real—of the world as it was and Man in it—and the rationality and optimism of classicism ceded to a moral neutrality or pessimism, and to a desire that art involve itself with the particular and with everyday activity. Thus disregarded, classicism left the centre of the artistic stage.

In effect, the classical tradition survived as long as admiration for Graeco-Roman civilization grew naturally out of the concepts of society. The horizons of the nineteenth century, both geographical and conceptual, were much wider than those of any previous age; artists were faced with a greater variety of different civilizations which all made claims upon their attention; Romanticism and then Realism assured the near destruction of the classical tradition founded upon what was

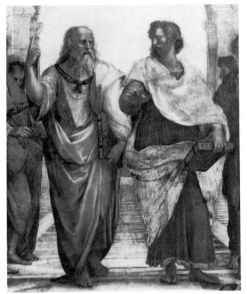

Raphael: School of Athens, detail, 1509–10.
BELOW *Plan of the Stanza della Segnatura.*

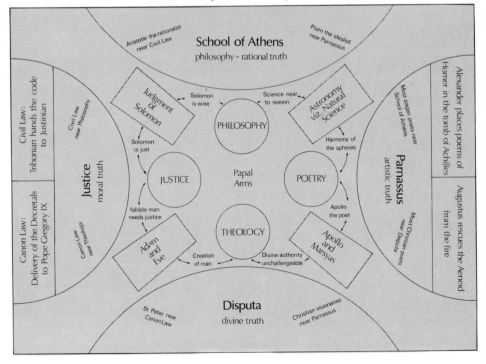

Aristotle the rationalist
near Civil Law

Plato the idealist
near Parnassus

School of Athens
philosophy - rational truth

Civil Law:
Tribonian hands the code
to Justinian

Civil Law
near Philosophy

Judgement
of
Solomon

Solomon
is wise

Science near
to reason

Astronomy
viz. Natural
Science

Alexander places poems of
Homer in the tomb of Achilles

Most pagan poets near
School of Athens

PHILOSOPHY

Harmony of
the spheres

Solomon
is just

Justice
moral truth

Canon Law
near Theology

JUSTICE

Papal
Arms

POETRY

Parnassus
artistic truth

Most Christian poets
near Disputa

Augustus rescues the Aeneid
from the fire

Canon Law:
Delivery of the Decretals
to Pope Gregory IX

fallible man
needs justice

THEOLOGY

Apollo
the poet

Adam
and
Eve

Creation
of man

Divine authority
unchallengeable

Apollo
and
Marsyas

Disputa
divine truth

St Peter near
Canon Law

Christian visionaries
near Parnassus

by this time but one civilization out of many.

This book surveys the birth and growth of the classical tradition and its collapse in the nineteenth century, and attempts to discuss art as but one manifestation of the antique in a renaissance of many aspects of Antiquity. It would have been equally possible to have taken classicism as the opposite of romanticism, and both these as two concepts between which the human spirit continuously oscillates: order versus disorder, reason versus emotion, health versus sickness, generalization versus particularity, ideal versus reality. Such a thesis should be borne in mind; it is too general to be of practical value, but it does avoid the danger of seeing the history of art as a series of revolutions and counter-revolutions. Interest in Antiquity from the Renaissance to the nineteenth century was, after all, not the sole prerogative of artists working within the classical tradition, but a feature of nearly all art and architecture of those centuries. This survey takes as its point of reference the attitudes of the classicizing artists themselves towards the tradition of which they were a part, and it is therefore concerned with but one important aspect of the influence of Antiquity upon European culture.

Classicism in practice: the Stanza della Segnatura

What I have written so far makes it clear that classicism focuses on the Ideal Man who, as Aristotle has it, by his 'heroic and divine virtue' raises himself above the level of common beings and is an example to them. Such a concept, current from the Renaissance, derives from a mixture of ancient doctrines together with the attitudes of the hero as observed in antique literature. [8,9] The Stoics, for example, taught that only a man in full command of his senses can achieve an ordered life, and not be buffeted by Fortune; they averred that the means to that end was the power of reason. Neo-Platonism emphasized the dignity of Man and his superiority to common nature, and proclaimed a synoptic view of religion which led toward pantheism. A comparison of its ideas with those of Christianity demonstrated many points of agreement.

The Stanza della Segnatura, frescoed by Raphael between 1508/9 and 1512 in the Vatican, has been considered by successive generations as the acme of classicism, as much for its iconography as for its style. The stylistic characteristics, which will be examined in the section on Raphael, display that noble simplicity and calm grandeur which Winckelmann finds in the Segnatura as in the best works of the ancients. The iconography of some of Michelangelo's schemes is as complicated as the subject-matter is extensive; the Julius Monument and the Medici Chapel express a Neo-Platonist view of life and death, a view which also pervades the story of Man's Creation, Fall and Redemption in the Sistine Chapel. Yet Raphael, in the Stanza della Segnatura, attempts much more: no less than an encapsulation on vault and walls of all aspects of Man's life on earth.

The life of Man is pictured as a search for truth, and the walls of the room symbolize the four main ways of attaining it, namely through Theology (*Disputa*), Beauty and Art (*Parnassus*), Reason (*The School of Athens*), and Law both canon and civil. On the vault, directly above the apex of each lunette, are personifications of these ideals and, in between each of these, and hence each adjacent to two lunettes, are scenes of *The Judgement of Solomon, Adam and Eve, Apollo and Marsyas* and *Astronomy* which point out some of the ways in which the subjects of the large lunettes are related to one another. For example, between the *Parnassus* and the *Disputa* is the *Apollo and Marsyas*, to underline the dangers of challenging divine authority through art; again, between the two scenes of civil and canon law and *The School of Athens* is *The Judgement of Solomon*, indicating that a wise king must act as both philosopher and judge. The Stanza della Segnatura, therefore, by the very juxtaposition of its scenes, displays a scheme for living. Rational Truth does not confront Divine Truth in the sense of wishing to oppose it, nor is Artistic Truth opposed to Moral Truth as divined by Justice. Rather, all four elements echo each other, and indeed are shown to be

related by the placing of particular figures within each fresco. The main figures of *The School of Athens*, Plato and Aristotle, the one representing a mystical, the other a rational approach to philosophy, are placed one either side of the central axis. Beneath either figure are like-minded spirits. The left side of the scene, with Plato, is adjacent to the *Parnassus*, which itself shows most of the ancient poets on the side nearest *The School of Athens*. On the other side Aristotle, representing Reason, is adjacent to Justice, where Moral Truth is arrived at through the application of reason, and specifically to civil law; the other side of that fresco, with canon law, is adjacent to the *Disputa*.

That such a highly concentrated arrangement was possible within a private papal apartment has much to tell us about early sixteenth-century views of Man. First, the scheme can explode erroneous myths about the Renaissance's being pagan and not Christian, for it clearly equates and balances Rational Truth with Divine Truth and does not oppose 'old pagan' to 'new Christian' Truth. For the iconographer of the Stanza, who might have been Pietro Bembo, or Raphael himself, what was an educated man? Presumably one whose knowledge and interests were balanced between the fields of art, theology, philosophy and law, with none taking precedence over the others. Truly, that man who could gain broad knowledge in the different spheres of intellectual, social and spiritual existence would attain an ideal of human conduct. We are reminded of Freedberg's characterization of the room as having 'an atmosphere of high clear thought pervaded by the energies of a powerful intelligence'.

Furthermore, the example of the Segnatura has much to tell us about the nature of classicism in architecture. For just as the Renaissance epic, or Renaissance Latin, imitate their antique prototypes not simply because of the aesthetic 'beauties' of their style but because they wish to create a similar system of life and values, so it is with architecture, which can display the spirit of Antiquity more obviously than any other medium. In *The School of Athens*, Freedberg's 'high clear thought' is considerably heightened by the architecture, which provides a dignity and monumentality to equal that of the figures. Indeed, architecture can convey *meaning* both through its abstract formal qualities, in this case the style of an ancient Roman basilica, and, more important, through that flood of associations which an architectural form such as a Roman barrel vault might conjure up in the mind of an educated man. At the same time a building, like a painting or sculpture, can proclaim the intellectual and social posture of the patron; Alberti wrote in his treatise on architecture, 'let us erect grand buildings, so that we may appear magnanimous and powerful to posterity'. And Lorenzo de' Medici wrote of the 'pomp and other honours, and public magnificence such as piazzas, temples and other public buildings which denote ambitious men, and those who with great care seek honour'.[8]

The poetic associations encountered in the doctrine of *ut pictura poesis* are evidently not applicable to architecture because, strictly speaking, it has no subject-matter. Viewed more widely, as we shall see, architecture in the classical tradition takes on the significance of that Roman Antiquity from which its forms derive. These forms can be described using the same general epithets of simplicity, harmony, clarity, regularity and so forth that are applied to painting and sculpture. In addition, we shall see that architectural theory was well served by the treatise of Vitruvius, a survival from Antiquity, which codified rules for constructing various types of building in the classical manner. As in the sister arts, the example of Antiquity was to prove a stimulus towards the production of creative works of architecture at once indisputably original and yet given added authority by the classical tradition in which they stood. As Sir Joshua Reynolds remarked in his *Thirteenth Discourse*, 'Architecture does not . . . acquire the name of a polite and liberal art, from its usefulness . . . but from some higher principle; we are sure that in the hands of a man of genius it is capable of inspiring sentiment, and of filling the mind with great and sublime ideas.'

Let us conclude with Sir Joshua Reynolds's summary, in his *Third Discourse*, of the essen-

tials of the classical style. He emphasizes the importance of the Idea, and of an intimate knowledge of Antiquity through which the student might apprehend that 'Ideal Beauty', and continues:

. . . if we now should suppose that the artist has formed the true idea of beauty, which enables him to give to his works a correct and perfect design; if we should suppose also, that he has acquired a knowledge of the unadulterated habits of nature, which gives him simplicity. . . . It must not, indeed, be forgotten, that there is a nobleness of conception, which goes beyond any thing in the mere exhibition even of perfect form; there is an art of animating and dignifying the figures with intellectual grandeur, of impressing the appearance of philosophick wisdom, or heroick virtue. This can only be acquired by him that enlarges the sphere of his understanding by a variety of knowledge, and warms his imagination with the best productions of antient and modern poetry.

1

Classicism from the Fall of Rome to Nicola Pisano: Survival and Revival

Surveys of the Italian Renaissance usually begin with the year 1260, in which Nicola Pisano signed and dated his pulpit in the Baptistery of Pisa Cathedral. Because of the high-minded seriousness of this work, and its clear relationship to antique Roman sarcophagi, the Pisa Baptistery pulpit is the first convenient example of that interest in Antiquity which is the governing factor in the Renaissance.

Yet to state baldly that Nicola Pisano is a classical artist is an inadequate beginning to a book on the classical tradition. The word 'renaissance' means 're-birth' or 'revival', and accords with contemporaries' conviction that culture had died with the fall of the Roman Empire, and that they were responsible for its resurrection. However, to take the Renaissance strictly at its own evaluation is to beg the question of the status of antique art in the preceding centuries, and to gloss over the crucial question of whether interest in Roman civilization ever died throughout the 'Dark Ages' and the 'Middle Ages', which were in fact two terms invented by the Renaissance frame of mind. Were the Pisa Pulpit and other monuments of romanizing art revivals or survivals? To answer that question, a survey of the classical tradition must begin with the later years of the Western Roman Empire, when elements of Roman iconography and style were assimilated quite naturally into the art of the

Early Christian Church, and therefore sanctified as part of a new and Christian tradition.

Pagan into Christian

In AD 313, with the conversion of Constantine to Christianity and the Peace of the Church, the Christian religion could come out into the open. No longer was it necessary for Christians to hide the meaning of Christ behind the form of Orpheus. Not surprisingly, Christian artists brought up in the Roman milieu took inspiration from Roman art, not necessarily contemporary art, but often the more classical forms of earlier years. It is therefore no coincidence that the most frequently illustrated aspects of Christian belief are those for which parallels exist in pagan Roman art.[15] Thus *The Emperor on his Throne* becomes *Christ in Majesty,*[18,19] *The Emperor Triumphing over his Enemies* becomes *The Triumph of Christ.*[12,16] In general, themes of glorification and power are those most frequently adapted, because the Roman Empire had no language for the humbler Christian virtues; the same is true in the art of Byzantium.

Certain motifs, therefore, have an antique Roman or Jewish origin together with a long christianized tradition.[21] Motifs such as the triumph[23] and the triumphal arch have a continuous history in Christian as well as in secular ceremonial and monuments.[20] The idea of borrowing a set of forms and changing their original meaning (often much more drastically than by the small shift from Emperor to Christ) is one which is crucial to an understanding of the classical tradition. It is largely through the christianization of Roman forms that those forms survive the Middle Ages.[24,25] Yet a

Entrance door of Castel del Monte, built by Frederick II. Hohenstaufen. Early thirteenth century. The architect has surrounded the doorway with an imitation of an antique Corinthian Order. He has included an attic storey, possibly suggested by triumphal arches.

distinction is to be made between the slow assimilation of ideas and forms during the Middle Ages, and the self-conscious revival of paganism in the Italian Renaissance, when there are examples of Christian ritual depicted in the manner of antique pagan custom.[22] There is, then, no doubt that the Italian Renaissance showed a *revival* of interest in Antiquity much more far-reaching than any previous period had manifested. However, revival is impossible without survival, because it is respect for antiquities which alone preserves them so that such a revival is possible. During the centuries between the fall of the Roman Empire and the time of Nicola Pisano, much was certainly destroyed and neglected; and yet enough survived to fuel a series of classical revivals great and small. Why should interest in an ancient civilization survive for a millennium and then become the backbone of European culture again from the Renaissance until the nineteenth century?

The strength of the classical tradition derives from its relevance to both secular and ecclesiastical power and pretensions. If, as Grabar has remarked, Christian art 'was born old, and saddled with the burden of an age-old Mediterranean tradition',[14] it was nevertheless a tradition that the papacy and the princes of the Church gladly accepted. Stories of Christian mistrust of things pagan are rare,[11] and can be more than balanced by examples of the re-use of pagan statues,[10] medals and gems, and buildings.[13,17] Indeed, the popes adopted Roman imperial imagery with little change;[34] in the later Middle Ages at least, their pretensions to temporal power, as seen particularly in their struggle with the Holy Roman Empire, made them to all effects secular as well as religious rulers. As Hobbes wrote in *Leviathan* (iv. 47), 'the Papacy is not other than the Ghost of the deceased Roman Empire, sitting crowned upon the grave thereof'.

Survival and revival

Survival and revival are complementary forms of the same respect for classical Antiquity, but were the classical tradition merely about the survival and revival of motifs, it would be a sorry thing, incapable of long life. Rather this tradition is an idea, an intellectual position, and a desire to imitate and learn from aspects of Roman civilization. Evidently the survival of Roman law and administrative practice was impossible after the break-up of the Empire and the move of the power-base north and west to France and Germany, for the social system gradually changed to feudalism based on agriculture, away from commerce based on towns and founded in slavery. Such aspects of Roman civilization would require deliberate revival; they had to await the growing importance of the towns in the later Middle Ages, and of a system with which feudalism could

Lecce, S. Croce. Detail of façade. The figures and architectural details of this seventeenth-century church are inspired by local Romanesque survivals.

not cope. Literature was a different matter. Certain texts were well known during the Middle Ages and, had it not been for assiduous copying of ancient manuscripts during the Carolingian period, little would have survived to excite the book-hunters of the Renaissance, who were sometimes misled in their dating of a manuscript because the Carolingian scribe had quite deliberately imitated an antique style of illustration as well as copying the text.

Survival depended on many factors, and certain classes of art fared better than others. Perhaps certain building forms survived best of all, because they were so easily converted to modern use: the Roman basilica becomes the Christian church,[30] the Roman tomb becomes the Christian martyrium.[31] The Roman villa sees long occupation and rebuilding and survives into the Renaissance (see pp. 62ff., below). Mosaics lasted well unless attacked by damp, but frescoes were easily painted or plastered over. Reliquaries of precious metals and stones usually suffered the obvious fate, as did statues of bronze.[28] Sculpture in the round was not a popular Christian art form in the Middle Ages, but relief work survived well, whether on sarcophagi, on church capitals or façades, or on coins, medals, ivories or gems. Differing chances of survival impede the historian and forcibly turn his eyes in one direction rather than another: ivories survive in profusion from Carolingian and earlier times, so that a coherent study can be made of influence and imitation, but to attempt a similar study on frescoes would be difficult indeed.

Revival, like survival, can often be a continuous process, and a very confusing one. It can, for example, be hard to determine whether a twelfth-century artist is imitating antique Roman work, or Carolingian or indeed Ottonian work, and equally hard to say whether the artist could himself tell the difference, or was simply imitating a good 'old' style.[26,27] The Church of S. Maria Antiqua, Rome, has a sixth-century *Maria Regina* fresco overlaid in the seventh century by an *Annunciation* the style of which imitates first-century work, and near by an eighth-century row of standing saints in the contemporary Byzantine tradition. In S. Maria Maggiore, Rome, mosaics

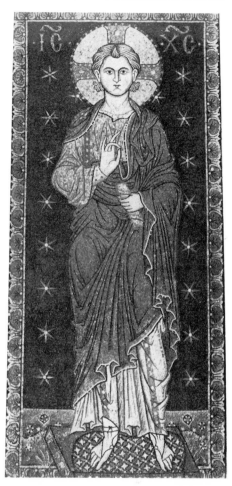

Venice, St Mark's Basilica. Christ. Revival and survival: this fourteenth-century mosaic, like much of the decoration of St Mark's, owes its style to a mixture of Byzantine and Romanesque manners, as well as to Early Christian work in Ravenna.

of the first half of the fifth century depicting scenes of the lives of the Virgin and Christ tell their stories in a manner similar to that in the contemporary *Codex Vaticanus*, and to that on Roman triumphal arches. Indeed, the divisions between the scenes effected by architectural elements, the episodes broken into horizontal ranks, and even the winged angel and winged bull at the apex of the arch recall a Roman triumphal arch with its winged victories and

21

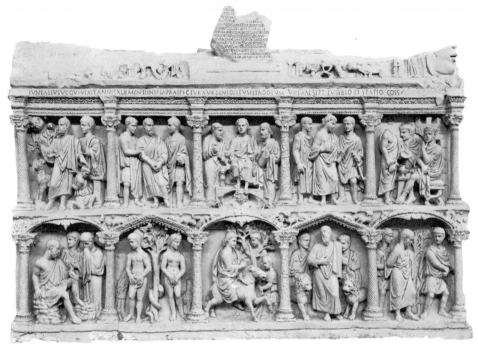

Sarcophagus of Junius Bassus. Cast, Museo Laterano Cristiano, Vatican.

scenes of conquest. Nor is the idea of triumph absent from the church decoration: it has simply been transferred into a Christian context.

The revival/survival problem is perhaps best seen in Early Christian sarcophagi. It is often difficult to date them, because they imitate Roman forms so conscientiously. Sarcophagi, whether pagan or Christian, are by nature almost indestructible. They were mass-produced in large numbers, shipped all over the Empire, and were also made according to

Lucca, S. Frediano. Detail of twelfth-century font. The influence of Early Christian columnar sarcophagi is clear in both drapery and architectural style. The shape of the font is perhaps derived from that of an Early Christian pyx.

Antique sarcophagus with a bust of the deceased. Cathedral atrium, Salerno.

more localized traditions. The better ones were so finely decorated that they were used over and over again (*sarcophagus* means 'flesh-eater'!) or converted into baths.[32,110a] They formed the largest single source of motifs up to and throughout the Renaissance.[36] The scenes on Christian ones might be vague adaptations of pagan subjects, such as a bucolic scene into *The Good Shepherd*, a *Sleeping Ariadne* into *Jonah*, or an *Emperor Receiving Tribute* into *The Adoration of the Magi*;[29] or pagan motifs which also carried Christian connotations might be shown, such as *putti* harvesting grapes, or scenes of sacrifice, or winged genii. One of the few dated examples is the *Sarcophagus of Junius Bassus* (AD 359, Rome, Grotte Vaticane),

which shows Old and New Testament scenes separated by ornately decorated columns which form a colonnade the length of the front. The figures are grave and noble, and wear togas. The central scenes, as is usual on Christian sarcophagi of this period, show Christ Triumphant, seated with feet resting on the cosmos in the upper range and making a triumphal entry in the lower. Like many of its fellows, and like the Arch of Constantine (of half a century earlier), the Junius Bassus sarcophagus, while retaining aspects of an earlier and more classical style, tends to change the proportions of the figures, to give to each of them a childish and expressionless face, and to abbreviate anatomical description. In other

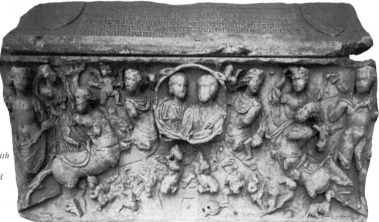

Antique sarcophagus with medieval lid. The end view, clumsily reworked in a pseudo-classical manner, is shown LEFT. Cathedral atrium, Salerno.

words, some Christian art, like contemporary pagan art, begins to display that disregard for classical elegance which is a feature even of much romanizing painting and sculpture of the early Middle Ages. Such an example illustrates one way in which forms change through time while retaining earlier characteristics—one way, indeed, in which a tradition changes and develops. Yet is a later artist who makes use of classicizing sources necessarily a revivalist? Surely the distinction between survival and revival must depend on an element of conscious choice, of selecting *this* rather than *that* sarcophagus or ivory. This is what the artists of the Renaissance did: they tended to ignore late sarcophagi in favour of earlier and better-proportioned examples.

To make use of classical antique objects and even to imitate them does not constitute a revival, a renaissance. When, for example, the Council of Macon, in 550, complained of corpses being unceremoniously thrown out so that sarcophagi might be re-used, the protest was against the indecent haste, not against a revival of pagan practice.[13] Indeed, it was not unusual for clerics, and nobles too, to be buried in pagan sarcophagi. Charlemagne, for example, was buried in one decorated with a representation of the *Rape of Proserpine*, and as well as serving as baths or fonts, sarcophagi were sometimes used as altars, or their relief sculpture was incorporated into architectural schemes. We must therefore expect to find the useful impedimenta of the ancient world being re-used during the Middle Ages. Only when the ideals of Roman civilization join a selective interest in Roman style are we entitled to call the product a revival.[33,35]

The Carolingian Renaissance

The invasions of Europe by barbarian hordes during late Antiquity and the early Middle Ages temporarily changed the romanizing tradition of Christian art but did not obliterate antique culture completely.[63] The Ostrogoths, the Burgundians and the Lombards (to name but three peoples) introduced a tradition of art which was not centred on the beauty of the human body, like classical art, but on elaborate

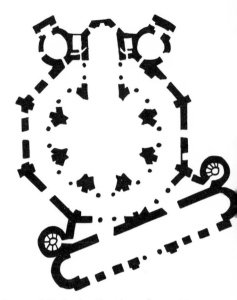

Ravenna, S. Vitale: plan. The atrium no longer exists.

decoration which can distort representations of people, changing them into ciphers and therefore de-humanizing them, as in *The Book of Kells* or *The Book of Durrow*. During the seventh and eighth centuries, in fact, it was the Eastern Roman Empire, established at Constantinople in AD 330 both as a refuge from barbarians and as a more convenient centre for campaigning in the East, that was the centre for the protection and study of things Greek and Roman. The city of Rome itself, subjected to waves of invasion and looting, was no longer a suitably tranquil place for the arts of peace. Byzantine art, popular in parts of Italy, including Rome, throughout the Middle Ages, contained within its style reminiscences of the style and formulae of Roman art.[41]

However, on Christmas Day in the year AD 800, the somnolent Byzantine Empire was challenged by the coronation in St Peter's, Rome, of the Frankish king Charles, called Charlemagne, as Holy Roman Emperor.[46] He entered Rome on horseback in pompous procession, as an emperor of old. The *Lorsch Annals* tell of the deliberations that went on before the coronation, and of the reasoning that the imperial throne was in effect vacant

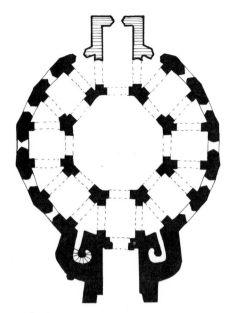

Aix-la-Chapelle. Plan of Charlemagne's palace chapel.

pire, when power over the city of Rome was often a feasible hope if never an actual fact, the Holy Roman Emperors had emotional ties with the city and its civilization which are explored in the next chapter. Frederick Barbarossa, for example, could proclaim (as the annalist Rahwein records): 'By the will of God I am called, and I verily am, the Roman Emperor; and I should therefore only possess the semblance of dominion, I should only bear a worthless title, a name without substance, if power over the city of Rome were to fall from my grasp.' Such beliefs were strengthened by the classicizing reflections in contemporary art.[43] Charlemagne's revival of things Roman, to bolster his imperial heritage, has great consequences for the history of the classical tradition.

The Carolingian period witnessed not only an awakening of scholarly study of the books of Antiquity (an activity which entailed their imitation and survival through re-copying), but also a conscious attempt to rival elements of Roman civilization by imitation of its material remains. Charlemagne's artists naturally looked to the Christian period of the Roman Empire for their models,[47,64] and the usual comparison for Charlemagne was to Constantine, a Christian Emperor, and not to his predecessors (who only began to receive attention in the Italian Renaissance). Charlemagne's empire covered much of what is now France and Germany, and he set up his imperial capital at Aix-la-Chapelle (Aachen), where he built a palace with a centrally planned chapel which partly imitated that jewel of Byzantium in the west, S. Vitale at Ravenna (consecrated AD 547),[37] and which itself fathered a long line of imitations.[53,73] And if there are similarities between the Chapel at Aix-la-Chapelle and the Golden Triclinium of Justinian at Constantinople,[56] so there are parallels between the Lateran Palace in Rome and Charlemagne's palace, also named the Lateran.[45] Charlemagne's Chapel is in part actually antique, for he received permission from the Pope to take marble and columns from the Ravenna churches to beautify his building. We know that his adviser and biographer, Einhard, had read Vitruvius and, like the widely-travelled

because a woman occupied it in Constantinople, and a usurper at that. After the ceremony, Charlemagne was acclaimed by the congregation as 'Charles Augustus, crowned by God, great and powerful Emperor of the Romans'. The crowd probably included Senate and army, hence adding to the *acclamatio* the sanctity of ancient Roman tradition.

The reinstitution of the Western Empire encouraged a belief in the continuity of Roman power. As Otto of Freising wrote in the prologue to his *Livre des deux cités* (mid-twelfth century), 'I have dealt with the line of Roman Emperors . . . continuing up to the present day'. As uncle of Frederick Barbarossa, a Hohenstaufen emperor, Otto's concern was clear, but his words underline the belief of Charlemagne and later emperors that they were the direct successors of Julius Caesar himself.* The Holy Roman Empire as temporal power and idea in fact survived until 1806, but declined rapidly in power and geographical extent.[50] In the earlier centuries of that Em-

*The most famous printed book on the subject of the emperors was perhaps H. Golzius's *Icones Imperatorum Romanorum* (Antwerp, 1645), where the images of the emperors are show in medallic form, with short accounts of their reigns underneath.[42,48]

Emperor, would have been aware of the associations of baptistery, imperial mausoleum and seat of imperial power which the central plan suggested.[49] Indeed, Charlemagne had a throne in the gallery of the Chapel Royal, an earthly equivalent to the *Christ Enthroned* (or possibly *Paschal Lamb*) depicted in the mosaic of the dome. Outside on the entrance façade, there is a large niche, probably imitated from that on the façade of the Palace of the Exarchs at Ravenna (of the sixth century). To emphasize still further his imperial *numen*, Charlemagne had an equestrian statue transported from Ravenna, supposedly representing Theodoric, to be placed in front of the palace.[51] He had his bronze-workers cast a pine-cone, which imitates the fourth-century AD pine-cone from the fountain which stood in the atrium of old St Peter's, and which is now in the Cortile del Belvedere.

The statue of 'Theodoric' which he placed before his palace was reminiscent of the *Marcus Aurelius*, then thought to represent Constantine. The prominence given to it by Charlemagne is the first example of a veritable cult of Constantine, the Emperor who introduced Christianity as the state religion into Rome, which lasted for the whole of the Middle Ages. If the story of Charlemagne himself is told in medieval epic, Constantine's fame is visible today in the numerous equestrian statues displayed in niches on French Romanesque churches.[57,79]

To match and illuminate these architectural pretensions to making Aix-la-Chapelle a new Rome (or a new Athens, as contemporaries also called it), Charlemagne gathered round him a body of scholars of whom the most famous was Alcuin. 'It was no more unusual then', writes Jean Hubert, 'to study works four or five centuries old than it is now for a French child to learn a fable by La Fontaine.'[52] Perhaps Charlemagne tried to learn to write; Einhard tells that 'although he tried very hard, he had begun too late in life and he made little progress'. According to Einhard, this failure must be set against his other accomplishments: he spoke Latin as fluently as if it were his mother tongue, he understood Greek, and he paid great attention to the liberal arts. All this

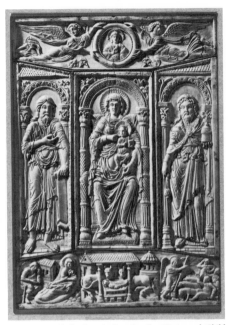

Ivory cover of the Lorsch Gospels: the Virgin and Child Enthroned, c. 810. London, Victoria and Albert Museum.

is, of course, highly unlikely: the explanation is that Einhard, classical scholar that he was, took inspiration for most of the material in his biography from Suetonius' *Lives*!

The main survivals from the Carolingian period, apart from architecture, are in the form of manuscript illumination[61] and ivories.[74] If, in the illuminated manuscripts of the Court School, the imitation of Roman precedents[44] is often limited to the majestic stance of the figures, the type of lettering, and the narrative technique, including the use of perspective, then Carolingian ivory plaques sometimes copy models directly.[67,76] Such models may be contemporary or antique Roman work. Unlike miniatures, where 'elements drawn directly from Classical models are more than rare',[65] Carolingian ivories imitate a whole range of styles, drawing from the 'vast, heterogeneous repertory of forms and content . . . left by all the preceding centuries, both in the West and in the East'.[70] The ivory covers of the *Lorsch Gospels*, for example (Vatican, Museo Sacro; and London, Victoria and Albert Museum), of

THE CAROLINGIAN RENAISSANCE

about AD 810, are closely based on sixth-century work, itself in the tradition of the consular diptych.[60] Furthermore, antique ivories were sometimes recut by Carolingian craftsmen. Also indicating complicated sources are the two ivory covers of the *Psalter of Charles the Bald* (mid-ninth century), which reproduce two illustrations from the *Utrecht Psalter*, itself produced under Charlemagne's son, Louis the Pious, at Rheims *c.* 830 (now at Utrecht). The *Utrecht Psalter* itself is, in its turn, an imitation of work of the first century AD, in the Hellenistic tradition.[40] This important manuscript was surely intended to look antique, for it certainly deceived many nineteenth-century scholars into dating it much too early. Its prestige can be judged by the copies and imitations of it in various media.[78] Nor is there any need to suppose that Rome was the exclusive source of Carolingian artistic affectations: certain styles have been discerned in manuscripts from the Aix Court School which make it likely that Byzantine artists, or artists trained in the East or accustomed to copying Byzantine models, were productive there. In other words, the classicism of some of the Carolingian output must have come from Constantinople.[38]

From the wide range of styles used by the Carolingians, it is clear that their love-affair was with the past and not exclusively with the classical. For example, the small ninth-century equestrian statue of a Carolingian emperor (Paris, Louvre) is evidently inspired by the *Marcus Aurelius*, particularly the horse. The rider, however, is particularized firmly in his own century by dress and crown, and is in no way antique. Nor was Charlemagne so entranced by book-learning that he wished to perpetuate his fame through the endowment of a library: he stipulated in his will that his books 'shall be bought at a reasonable price by anyone who wants to have them'. Such attitudes are balanced by the overt antiquarianism of Einhard himself, who probably provided drawings or instructions for the reliquary or base of a cross in the form of a triumphal arch which he commissioned *c.* 828 for one of his abbeys.[59] In a letter, he described this as 'made after the example of ancient works'; and, indeed, it is convincingly antique in its shape,

in the arrangement of the figures (which are Christian), in the pedestal for the quadriga on top, and in the inscription which Einhard composed for the attic storey, set in a tablet. Yet the work does not accept Roman forms or iconography on their own terms, but transmutes them into a Christian analogy of triumph.[39]

Perhaps the importance of the Carolingian Renaissance for the history of the classical tradition is only incidental in art and architecture, and more important in the appreciation of ancient literature, the copying of manuscripts and the imitation of ancient hands and good Latin which this entailed.[54] Without such copying, few of the famous books of Antiquity would have reached the Italian Renaissance and hence come down to us. Without the development of the elegant Carolingian uncial, the Renaissance printing types from which modern types are descended would probably not have existed.[72] And as well as preserving manuscripts,[62] the Carolingian concern with Antiquity aided the preservation particularly of the decorative arts, such as the pagan ivory plaques set into the ambo of Henry II at Aix-la-Chapelle (*c.* 1002). Such re-use can be paralleled during all periods of the Middle Ages, for precious stones and gems, coins and medals were prized for their decorative and their curiosity value; for instance, the famous cameo set into the *Cross of Lothair III* (*c.* 1000, Aix-la-Chapelle, Cathedral Treasury). Gem-cutting, an antique skill, was much practised in Carolingian times, and the craftsmen naturally used antique specimens as models for their own creations.[49,68,69]

Did the death of Charlemagne in 814 and the progressive dismemberment of his empire in the later ninth century entail the extinction of the advances in scholarship wrought under his rule? Although the death of Charles the Bald in 877 announced almost a century of artistic stagnation, when Otto I was crowned king at Aix-la-Chapelle in 936 a deliberate historical link was forged with Charlemagne. Otto (who was not even a Frank, but a Saxon, and had no other connections with Aix), crowned on Charlemagne's throne in his chapel, began a tradition to be followed by thirty-two kings

and Holy Roman Emperors. When he was anointed Emperor in Rome in 962, his seal bore the legend OTTO IMPERATOR AUGUSTUS RENOVATIO IMPERII ROMANORUM. The culture of the Ottonians can be described as another renaissance because of the connections between their art and that of Antiquity.[71] Just as the Carolingians had copied earlier works of art, so the Ottonians sometimes rehearsed not only Byzantine but also Carolingian precedents, as in the *Book of Pericopes* (Reichenau, 969/76), a close imitation of the *Lorsch Gospels* of the early ninth century. Surely there is a direct connection with the antiquities of Rome in the commissions of that latter-day Einhard, Bishop Bernward of Hildesheim.[77] His beautification of his cathedral between 992 and 1022 included a set of bronze doors for which there might well have been some direct antique source closer than the wooden doors of S. Ambrogio, Milan (fourth century) or S. Sabina, Rome (fifth century). He also commissioned a bronze triumphal column (in fact a paschal candlestick with scenes from *The Mission of Christ*) which, in the arrangement of the scenes, in the narrative technique, and in certain iconographical details, is directly based on Trajan's Column. What is more, the base of the Hildesheim Column has mouldings which show a true concern for the niceties of the classical Orders of architecture. Certain Ottonian manuscripts, such as the *Gospels of Otto III* (c. 1000, Munich, Bayerische Staatsmuseum), show a direct use of late antique precedents, and not a later Byzantine reinterpretation thereof.[75]

In an empire where the regent had to travel widely from centre to centre if he wished to retain power, it would be foolish to expect one single attitude toward Antiquity. The very size of the empire ensured fragmentation of styles. Thus in Metz were produced in the mid-ninth century a group of ivories based on late antique models—some of the same models, in fact, as those used by the earlier Court School at Aix. Another centre was Milan, better placed for antique models, as the magnificent *Golden Altar* (c. 850, Milan, S. Ambrogio) testifies: this has been described as standing 'in the closest proximity to the kind of north

Italian traditions and Late Antique sources fundamental to the whole creation of Carolingian art'.[55] Furthermore, Rome itself took part, during the ninth century, in the revival of its Early Christian and pagan past.[58]

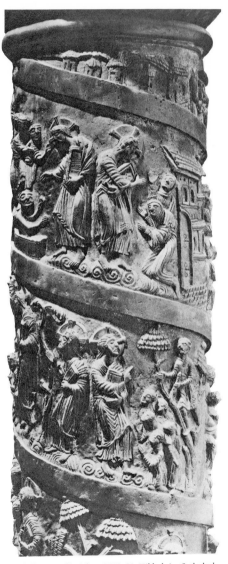

Hildesheim candlestick, c. 1015–22. Hildesheim Cathedral.

of many more universities, where not only Roman law, but ancient literature and philosophy as well, might be studied.

In several ways, therefore, the achievements of the twelfth century foreshadow the interests of the Italian Renaissance which, we should remember, is as much a revival of Roman civics and literature as it is of Roman art. To find imitation of classical originals in the twelfth and thirteenth centuries we move from the traditional centres of Carolingian and Ottonian culture southwards, to southern France[85,95] and Italy.[83,88] Earlier revivals had concentrated their efforts mainly on small-scale objects such as manuscripts, ivories, gems and, occasionally, coins; even their architecture was modest in scale, and sought little of that monumentality through sheer size which was to be found in Roman remains. However, southern France, particularly Provence[89] and the Rhone valley, and Italy were much richer than northern lands in antique remains.[94] Statues, bas-reliefs, sarcophagi and architecture were available for first-hand imitation, and their presence provoked a characteristic which clearly distinguishes the twelfth-century revival from earlier ones, namely the new prominence of sculpture in the round, usually in an architectural context, but never flat or lifeless even though connected to some backing support.[84] If earlier revivals were often, unknowingly perhaps, imitating models at second or even third hand, twelfth-century imitations can have a more authentic touch because they display direct contact with actual antiquities.[82] They tend therefore to look more antique, to breathe a classical spirit as well as to bear a classical form. The unity of spirit is best seen in architecture, for the façades of St-Trophîme at Arles,[80] or the nearby St-Gilles-du-Gard,[87] (both c. 1150) are variations on the theme of the triumphal arch; and one of the Roman gates at Autun (second century AD) inspired the fluted pilasters and arches of the nave of Autun Cathedral (begun 1090). Indeed, it is in southern lands that this, the Romanesque style, has most to do with that Roman architecture from which it takes its name; similarly, it was in those parts least affected by actual Roman remains that the new

The Renaissance of the Twelfth Century

We have seen that the Carolingian and Ottonian 'renaissances' were both small (in the numbers of scholars or artists they affected) and ephemeral in their consequences. The Twelfth-Century Renaissance is of infinitely greater importance because it touched a wider range of human activity. We might think of it as a reform of social and intellectual life supported by an expanding and more urbanized population. From the late eleventh century, Europe saw an increase in prosperity dependent not, as before, on agricultural estates, but on a renewed emphasis on industry and commerce, and a renewed focus on towns as centres of commercial and intellectual advancement. A firm administrative structure—a civil service—grew up, beginning in the Norman Kingdom of Sicily, where ancient Roman administrative systems had never quite died out. To support such a system, scholars studied and partly resurrected Roman law, which was seen as adding support to the legitimacy of the Holy Roman Empire and its emperors, and underpinning their political authority. Indeed, much of the struggle between Popes and Hohenstaufen in the twelfth and thirteenth centuries was rooted in *legal* issues, particularly the famous *Donation of Constantine* which gave the Popes authority over Rome and much of Italy. That this was an eighth-century forgery was not discovered until the fifteenth century; although previous writers had cast doubts upon it, Lorenzo Valla could apply a much fuller understanding of Roman legal practice and philology to bring about its demolition. Furthermore, commercial prosperity, a monetary system founded once again on coinage, and easier travel throughout Europe encouraged the foundation and spread

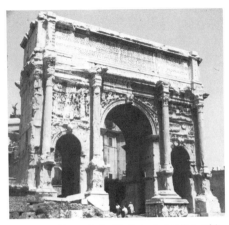

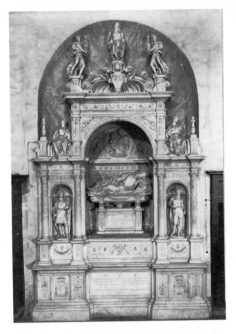

ABOVE *Rome, Forum. Arch of Septimius Severus (S.E. side).*

RIGHT *Andrea Sansovino: tomb of Cardinal Girolamo Basso della Rovere, 1507. Rome, S. Maria del Popolo. The triumphal arch motif is much used during the Renaissance.*

BELOW *Arles, St-Trophime. Portal, c. 1150.*

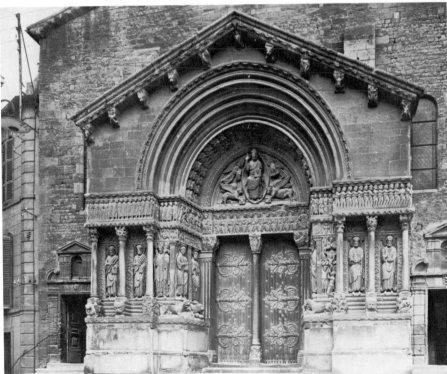

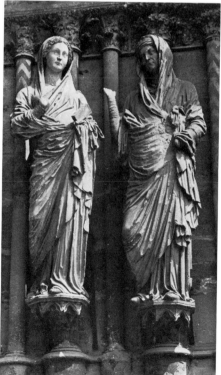

presses a classical poise and serenity, but the actual source remains as much a mystery as the evident (to some people at least) sixth to fifth century BC analogies for the figures on the west front of Chartres Cathedral of the mid-eleventh century. Even more remarkable is the work of the so-called Antique Master at Rheims, particularly the *Visitation Group* (c. 1240). The figures at Chartres (by the Master of the Archaic Smile, c. 1150) are elongated to emphasize their architectonic function, and do indeed have smiles analogous to Greek archaic work. There, surely, any parallel must stop, for the style of dress and coiffure is too different from the suggested sources, and compatible with contemporary practice. The work of the Antique Master, however, is very different; his figures are not dependent on the architecture against which they are seen. Their pose, dress, and whole personality are antique,

Liège, St-Barthélémy. Detail of Baptism of Christ from the font of Rainer of Huy, 1107–18.

RIGHT *Rheims Cathedral. W. façade, main portal. The Annunciation by the Antique Master.*

architecture of Europe, Gothic architecture, heedless of Roman structural techniques, ground plans, columns and façades, grew up. Evidently the location in Italy of the architectural revival during the fifteenth century is no mere chance; almost unaffected by Gothic, the Italian Romanesque style harboured reminiscences of Early Christian and Roman techniques and forms, and thereby facilitated a direct return to Antiquity.[90,91]

The relative simplicity of the revival in architecture is vitiated by the utter confusion in sculpture. There are, from Liège to Toulouse, sculptures which depend from classical originals, but the sources are lost to us. In about 1117, Rainer of Huy made a bronze font (now in Liège, St-Barthélémy), with majestically impassive toga-clad figures which suggest some contact with Greek painted vases. His whole treatment of the human body ex-

hardly of their own century at all. Their sources are Augustan, and it can be assumed that their author knew something of the Ara Pacis, as well as having studied antiques we know to have existed in Rheims. The importance of this one man's work for the Gothic style at Rheims (from c. 1260) and hence the fundamental importance of the antique for the Gothic sculptural style derives from the ease and gracefulness that he introduced into art, in comparison with the still and geometrical, the hieratic and remote Romanesque manner of his contemporaries. Without the example of the antique at one or two removes, perhaps the Gothic style would not have developed such a lilting and smiling type of humanity, but there is nevertheless a gulf separating Gothic art from the work of the Antique Master and his spiritual (not, of course, actual) heir, Nicola Pisano.

Not long after the Antique Master was working in Rheims, Nicola began work on the pulpit for the Baptistery of Pisa Cathedral (c. 1255–60). Why should this work, rather than that in Rheims, or work performed under the Ottonians in Milan, be judged the true starting point of the Italian Renaissance? Partly, of course, because Vasari gives a key place to Nicola in the *Lives*, but mostly because of his 'powerful imagination and unwavering seriousness',[93] which enabled him to find in Roman relief sculpture not only a monumental style but also a narrative technique which, after the gap of a generation, would be transferred to painting by Giotto. The Antique Master at Rheims had no coherent following, whereas Nicola, after a long gap, certainly did. That gap saw the introduction into Italy, via ivories and perhaps manuscripts, of a Gothic manner to be adapted by his son, Giovanni.

One illustration will suggest that classicism in art depended for its support, even in the twelfth and thirteenth centuries, on a strong ideological basis. The great Roman cemetery of Les Aliscamps at Arles had harboured many sarcophagi during the Middle Ages. It has been shown[87] that one of these provided one of the sculptors of the façade of St-Gilles-du-Gard (c. 1130–50) not far away with both a drapery style and a narrative technique, while a com-

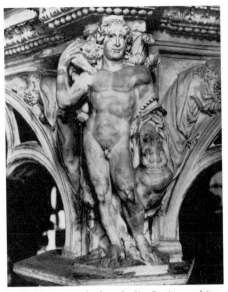

Nicola Pisano: Hercules from the Pisa Baptistery pulpit, c. 1255–60.

panion worker dressed his figures differently and worked in a totally dissimilar style. Yet Provence did not witness a sustained renaissance of interest in Antiquity: under the rule of Frederick II of Hohenstaufen, Holy Roman Emperor and King of Sicily (crowned Emperor in 1220), his southern possessions certainly did. Frederick, bolstered by the traditions of Roman administration and Roman law,[81] acted like the Roman Emperor he was: he erected a triumphal arch for himself at Capua and placed upon it a statue of himself dressed not in contemporary clothes but in a chlamys. From 1231 he struck golden coins at Brindisi and Messina, which were called *Augustales*. Roman antiquities were more readily available for imitation than they had been to Charlemagne, and Frederick's artists produced some of the most antique-looking art seen since the fall of the Roman Empire.[86] The very scale of the figures on the arch at Capua (1234–9) must have been immense. Little of the work survives, but the head of the tutelary deity, *Capua fidelis*, is nearly three feet in height, calling to mind the colossal bronze statue of an emperor (perhaps Theodosius) at Barletta,

which is over sixteen feet high. Nicola Pisano, whom we know for his work in Tuscany, was in fact a native of Apulia, and therefore grew up amidst Frederick's revival of Antiquity, although no work in the south can be identified as from his hand.

The revival in the Kingdom of Sicily (which included much of southern Italy as well) is different in nature from previous affairs with the antique, which had adopted a rather 'matter-of-fact' approach of using motifs where convenient. Frederick's culture involved a new attitude to Antiquity of which art was but one part of a grand design. His craftsmen tried to resurrect ancient models as they actually were, rather than adopting the standard medieval procedure of separating meaning from content, changing pagan to Christian and thereby producing figures with only one half of a split personality. As Panofsky wrote, 'the Middle Ages had left antiquity unburied and alternately galvanised and exorcised its corpse. The Renaissance stood weeping at its grave and tried to resurrect its soul.'[92] In the incarnation of the latter, first brought about by Frederick in the Kingdom of Sicily, Antiquity could become an ideal, a vision of the past dependent on those techniques of historical enquiry which its study stimulated. The study of history, a consciousness of the past and a desire to resurrect it, is the unifying theme of the Italian Renaissance, and the driving force of the classical tradition in European art.

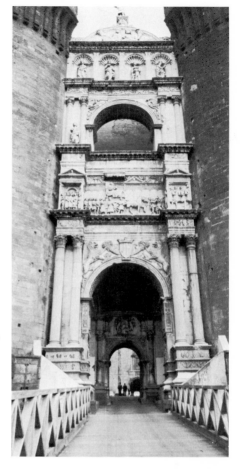

Castel Nuovo, Naples. Triumphal arch, built by Alfonso V, who conquered Naples in 1442. The antique remains in the area, and perhaps the legacy of the Hohenstaufen, dictated the idea and its classical form. LEFT *Detail of one of the pedestals.*

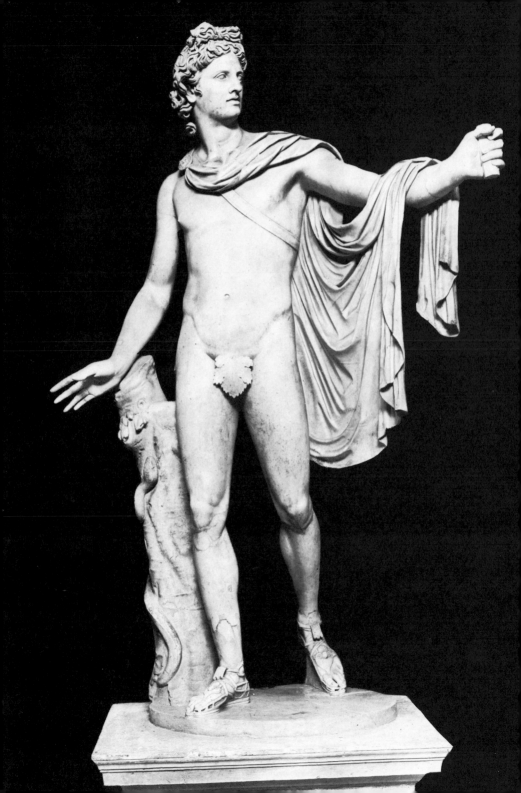

2

Antique Art and the Renaissance: a Gallery of Types

This chapter is a selection of photographs with running commentary which demonstrates the range of antique art that inspired Renaissance artists, and remained a feature of academic art training throughout the period covered by this book.

The following important points should be borne in mind. First it is not surprising to find artists (or lawyers or writers) looking to the antique past for models, particularly when the rich variety and great time-span of Graeco-Roman Antiquity is appreciated. Artists can therefore find sufficient antique examples to suit their own stylistic tendencies. This is as true of men like Botticelli and Ghirlandaio (neither of whom could be called classical) as it is of Masaccio or Raphael. In other words, the influence of the antique is all-pervasive, but only some antique works are used in a classicizing manner.[116] At the lowest level, Antiquity was a store-house of motifs and ready-made objects which, suitably adapted, might be used in modern art, and quoted in Christian art where need be.[110a]

Second, in spite of censuses, we often experience great difficulty in knowing exactly which particular work had been seen by a Renaissance artist.[100,108] The dilemma is only apparent, for antique statues and reliefs, like their modern equivalents, can be grouped into types, as sculptors from one shop, or town, or even country, took up ideas which might stretch back hundreds of years. Thus we have groups of a *type* of Meleager sarcophagus, or a *type* of Venus Pudica, of which all the members would have features in common. Even when we cannot pin down exact sources, we can therefore still study relationships between Renaissance art and Antiquity.[99,113]

Third, we must not underestimate the speed with which antique motifs could be passed from hand to hand and from town to town. As well as plaster casts and bronze reductions, sketch-books were probably constant reference tools in most Renaissance workshops, to be supplemented by the sixteenth century by prints which were sometimes accompanied by text. It was not strictly necessary for an artist to have had direct contact with an antique original in order for him to come under its influence.

Lastly, until the chapter on Neoclassicism I make no distinction in this book between Greek and Roman art. The ancient Romans were great admirers of Greek art and avid collectors and copiers of Greek work, and the Renaissance was therefore confronted with a mixture of styles from various periods of art. Artists, as I have said, gravitated to that antique style which pleased them most, and no one until the time of Winckelmann was sufficiently versed (or interested?) in stylistics to be able to classify antiquities chronologically. As far as we know, there was little contact with pre-Hellenistic Greek art before the later eighteenth century,[106] and the same applies to architecture. It is, indeed, one of the ironies of art history that the Elgin Marbles arrived on the European scene too late to affect radically the course of the classical tradition.

The Apollo Belvedere[120]

Discovered near Grottaferrata on land owned by Giuliano della Rovere. When he became Pope in 1503, as Julius II, the work was placed in the Vatican Belvedere, hence its name.

The Apollo Belvedere is shown LEFT. *Rome, Vatican.*

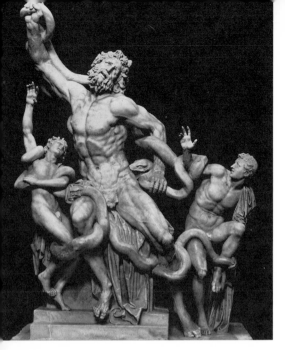

The juxtaposition of these, the two most famous antiques of the Renaissance, is a convincing demonstration of the range of styles available. The supple imperiousness of the god contrasts with the strong torsion of the dying priest, and with the echoing gestures of terror from his two sons. The former will remain the epitome of bodily grace, the latter of physical power and of strong emotion.[98,107,115]

The Laocoön[96,121] ABOVE

Discovered in the Baths of Titus, Rome, in January 1506. Now in the Vatican, Rome.

The Torso Belvedere[117] BELOW LEFT

Known throughout the fifteenth century and, like the *Apollo* and the *Laocoön*, housed in the Vatican Belvedere. It presents, as it were, the Laocoön in contraction, rather than in extension.

The River Nile BELOW

A less extravagant anatomical form than the *Laocoön*, this work has been on the Capitol since the Renaissance. The pose is one of Michelangelo's sources for *The Creation of Adam* on the Sistine Ceiling.

The Death of Meleager (sarcophagus RIGHT)

Reliefs of this kind were perhaps the most useful group of antiques for the classicizing artist, for their arrangement of sculptured figures in a frieze, together with their mixture of both dignified and calm and more emotional figures,[97] presented a series of solutions to problems of formal arrangement and of interpretation. The story of Meleager provided

Statue of the River Nile in front of the Palazzo dei Senatori. Rome, Capitol.

LEFT *The atrium of the Museo Pio Clementino, in the Vatican, showing the Belvedere Torso. From P. Letarouilly, Le Vatican, Paris, vol IV, 1882.*

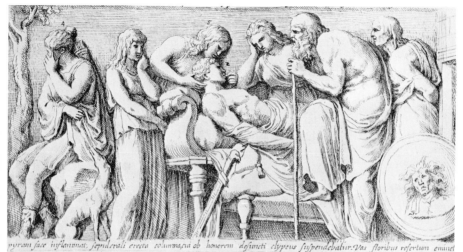

Death of Meleager, detail, from an antique sarcophagus. Engraving by François Perrier, from his Icones . . ., Rome, 1645.

two useful scenes of the youth's limp body carried home by mourning companions (cf. Raphael's *Deposition* in the Borghese Gallery, Rome) and of the sober death-bed scene, with mourners arranged round the bed, called the *conclamatio*. The latter episode has a parti- cularly long life, from Giotto's *Lamentation* in the Arena Chapel in Padua to J.-L. David's *Andromache mourning Hector* in the Louvre, and beyond. As the following examples show, both type of subject-matter and emotional content could be varied.

Giotto: The Lamentation, c. 1306. Padua, Arena Chapel.

Riccio: Conclamatio, c. 1515. Paris, Louvre.

37

The Death of the Children of Niobe
(sarcophagus relief) ABOVE

Niobe, the *beau-ideal* of grief (as Dr Brewer has
it), stands at the right side of this sarcophagus
protecting two of her children (cf. the group at
the right of David's *Brutus* in the Louvre). The
scene of destruction, with a mêlée of human
beings and horses, was a veritable academy of
drama for the Renaissance. Leonardo's *Battle of
Anghiari* was drawn from this, while for the
central scene of *The Fight for the Standard*,
Leonardo must have studied battle scenes of
Romans fighting barbarians on sarcophagi or
on reliefs like those on Trajan's Column.

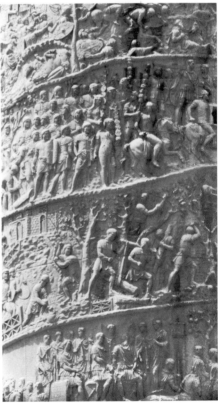

Trajan's Column (detail) RIGHT

Columns such as this provided a strip-cartoon
of narrative scenes. The detail illustrated
shows, from top to bottom: a sacrifice and
battle scene; a military parade; tree-felling for
siege warfare; and leaders in council. For
obvious reasons, the lower scenes on such
columns were studied much more than the
upper ones!

38

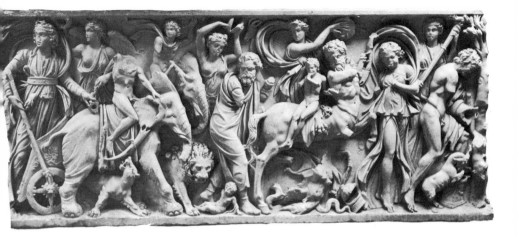

The Indian Triumph of Bacchus
(sarcophagus relief) ABOVE

The idea of triumph is frequently encountered in Renaissance art. Scenes such as this, with richly flowing movements, would have influenced Annibale Carracci's representation of the theme on the ceiling of the Farnese Gallery. A watery equivalent to it is that of the *Sea Thiasos*, as in the *Nereid Sarcophagus* illustrated below (from Perrier's *Icones . . .*), which provided a series of studies of the naked human form.

The Triumphal Arch of Constantine, Rome OVERLEAF

Arches were a rich source for the Renaissance artist and architect. The Arch of Constantine lacks the richly coffered barrel vaults found elsewhere, but displays a noble inscription, single standing figures in various attitudes (including captives at attic level), and scenes of many kinds in both roundels and rectangular frames. The architecture of such monuments was crucial not only for one type of church façade (cf. the works of Alberti), and for

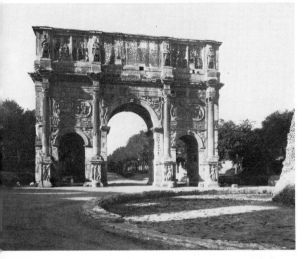

The Arch of Constantine, Rome. The Meta Sudans, demolished in 1935, is just visible on the right.

'Lisimachus, King of Thrace'. Naples, National Museum.

château façades in France, but also for the design of the Renaissance tomb, such as Andrea Sansovino's *Tomb of Cardinal Girolamo Basso della Rovere* in S. Maria del Popolo, Rome.

Christian sarcophagus of the Traditio Legis type BELOW

The Christians took over the forms and much of the iconography of Roman art, and adapted them. This scene of the Foundation of the Church, and another group called *City Gate* sarcophagi, as well as the *conclamatio* scenes, are rich sources for architectural motifs as well as for figures in noble togas.[111,112]

Roman portrait bust[110]

Not all Romans looked like the Apollo Belvedere. Many of their portraits, which usually served commemorative or funerary purposes, were intensely realistic, as this one shows. Donatello's prophets for Florence Cathedral must owe much of their powerfully conceived psychology to study of such work.

Fresco: The Aldobrandini Wedding

This famous example was found only in the early seventeenth century, and is illustrated here to evoke those examples of antique art

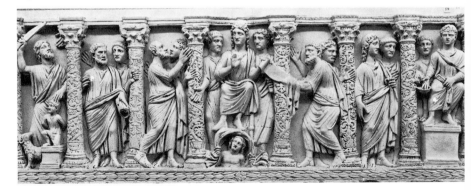

The Aldobrandini wedding. Rome, Vatican.

which must have been known to Renaissance artists and which have subsequently vanished. As well as the Domus Aurea,[103] from which some of the decoration survives, many Roman tombs as well as villas like that of Hadrian near Tivoli must have been painted or stuccoed.

Statuettes, coins, medals and gems

Few large bronzes survived from Antiquity, for the metal was valuable. Smaller objects, more easily hidden or mislaid, did survive. Avidly collected, such items were quickly recognized as of vital importance to historical research, apart from their intrinsic worth or

'La Volta Dorata' Rome, Domus Aurea. Engraving.

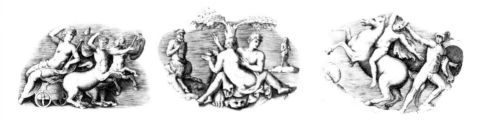

Sixteenth-century studies after classical cameos. Antonio Lafreri after G. B. Franco.

41

Lid of an Etruscan funerary urn. Volterra, Museo Guarnacci. Part of a collection originating in 1732, and extended in 1744 – an early example of Tuscan 'nationalism'.

Michelangelo: Bacchus. Florence, Bargello. Detail showing the Etruscan cup.

their use to artists. Sometimes, minute images were reminiscences of full-size works of art, long since lost. Because of their lightness and compactness, such miniature antiquities were easily transported and just as easily cast in plaster. They were also popular subjects for the forgers, who stepped in to bridge the gap between demand and supply. Padua, for example, was well known in the fifteenth and sixteenth centuries for such antiquarianism. Sometimes, Renaissance medals are made after the manner of the antique, without intent to deceive.

Greek and Etruscan antiquities

No gallery of types would be complete without an indication of the range of Renaissance knowledge of the antique. What did Florentine artists know of Etruscan art?[105,109] Do their reclining funerary figures derive from Etruscan sources?[114] Michelangelo's *Bacchus* shown above holds an Etruscan bowl in his hand: are other Etruscan motifs apparent in his work and that of his predecessors?[101,118] It is quite possible. Although early Greek sculpture made no impact on Europe until the importation of the Elgin Marbles, we known that Greek marbles were on display in Venice during the Renaissance. One scholar has seen the friezes of the Palazzo Spada, Rome (*c.* 1540) as inspired

ABOVE *Monument to Heges. Athens, National Museum. Could stelai such as this have been known to Donatello and Michelangelo?*

directly by the Monument of Lysicrates in Athens.[106] Certainly, scholars and merchants did visit Greece, and drawings were taken back to Italy.

A page from a Renaissance sketch-book by Amico Aspertini

Artists who could afford it collected real antiques; those who could not would rely on the collections of patrons, and particularly on sketch-books, which might themselves be made up of works copied from other sketch-books.[102,104] The idea of a complete census of antique architecture in Rome was projected by Raphael, but it was only in the early seventeenth century that Cassiano dal Pozzo made a 'paper museum' of the antiquities of the City, a scheme on which Poussin worked while new to Rome, gaining therefrom his vast and scholarly knowledge of ancient art.[119] There is no adequate history of museums, nor of collecting; both were vital to the training of artists in the academic and classical tradition (see pp. 53–5).

Amico Aspertini. Opening from a sketchbook of 1535. British Museum.

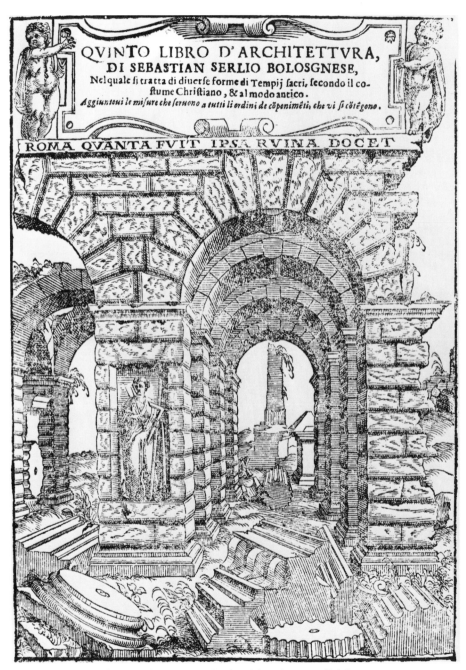

QVINTO LIBRO D'ARCHITETTVRA,
DI SEBASTIAN SERLIO BOLOSGNESE,
Nel quale si tratta di diuerse forme di Tempij sacri, secondo il costume Christiano, & al modo antico.
Aggiuntoui le misure che seruono a tutti li ordini de cōponimēti, che vi si cōtēgono.

ROMA QVANTA FVIT IPSA RVINA DOCET

Sebastiano Serlio. Frontispiece of Book V of the Architettura, published 1547.

44

3

Roma Quanta Fuit, Ipsa Ruina Docet*

The most important foundation of classicism is a passionate involvement with the idea of Rome, city and civilization, as well as with that culture's physical remains. Long before the Renaissance, artists had imitated ancient Roman styles and writers had worked in Roman modes. Throughout the Middle Ages Rome was also a political vision for Kings and Emperor, people and Papacy, and the city itself had become the focus of imperial and ecclesiastical power—*caput fidei et caput orbis*—at least by the time of Charlemagne. This meant that antique art was imitated for much more complex reasons than mere aesthetic appreciation, during both the Middle Ages and the Renaissance.

This chapter studies the importance of the idea of Rome during the Middle Ages and the Renaissance, and the way in which her remains were used during the same periods. An outline is given of the great outburst of scholarly activity in the fifteenth and sixteenth centuries, and the chapter ends with an account of the differing ways in which the antiquities were of use to three sometimes conflicting groups: artists, residents and architects.

The idea of Rome in the Middle Ages[128]

Although Rome had lost her power with the move of the capital of the Empire to Constantinople in AD 330, and the subsequent shift of European power to Gaul, the city continued to enshrine within its monuments and traditions a guarantee of influence and renovation to Emperor, Pope and Roman people.[124,140] Throughout late Antiquity and the Middle Ages, rulers maintained an attachment to Rome that was mainly political: their connections with the city helped to legitimize their own power. Its physical decline did not prevent the idea of the city and all it stood for remaining alive.[137] The epithet 'new Rome' or 'second Rome' was applied to other centres which, because of their political power or cultural development, merited such a comparison. The most important of these was Constantinople, followed in the West by Aix-la-Chapelle, Trier (Trèves) and Milan.[130,141]

Even cities with a more tenuous connection with Rome nevertheless built the prestige of Rome into the mythology of their past. Florence, according to a thirteenth-century chronicle, was built after the model of Rome; one of several other theories states that it was founded by Julius Caesar himself.[146] The Cathedral Baptistery, similar in shape to a Roman temple, transformed Florence in the eyes of her proud inhabitants into an important Roman settlement;[138,139] while in thirteenth-century Venice, artists imitated Early Christian art in order to perpetuate a supposed continuity between Roman Empire and Venetian Dogate.[127] The Renaissance period did not, therefore, create anew an interest in ancient Rome, but rather extended and enriched old traditions by the application of historical techniques which we shall presently review.[144]

Long before the supposed visit of Brunelleschi and Donatello to Rome, which Vasari places (perhaps symbolically) in 1401, the

*'*Roma quanta fuit, ipsa ruina docet*'. A medieval invention, perhaps. Compare the poem of Hildebert of Lavardin, Bishop of Le Mans 1097–1125:

> Par tibi, Roma, nihil, cum sis prope tota ruina;
> Quam magni fueris integra fracta doces.
> Longa tuos fastus aetas destruxit, et arces
> Caesaris et superum templa palude jacent.

ruins of Rome exercised a fascination over Europe.[163] The Barbarian Emperors preserved and sometimes restored the monuments: Theodoric, for example, rebuilt the walls and forbade the destruction of temples and statues.[129,135] Charlemagne aimed to make Aix-la-Chapelle a second Rome, and Otto III dreamed of reigning from the city, and raising his own palace on the Palatine, like the Emperors of old.[124] In southern Italy and Sicily, Frederick II of Hohenstaufen[131,142] surrounded himself with buildings and artefacts which underlined his connections with ancient Rome, including not only the triumphal arch at Capua, but also golden *augustales* in imitation of Roman coins,[145] and a seal bearing the proud legend *Roma Caput Mundi.*[125,132]

After Frederick's death in 1250, and the demise of Manfred and Conradin in quick succession, any stability the city of Rome might reasonably have expected through the competing and roughly equal forces of Emperor, Pope and Roman people came to an end. The Popes fled to Avignon in 1308, leaving the city without spiritual rule, just as the Emperors denied it temporal rule. One of Dante's constant visions,[123,126,134] which was later Petrarch's,[122,136,143] was to see Rome as *caput orbis* once more. In *Purgatorio* (VI. 112–14) he pleads with Albert I to come to Rome and rule:

'Vieni a veder la tua Roma che piagne,
vedova e sola, e dì e notte chiama:
"Cesare mio, perchè non m'accompagne?" '

Always in Dante's mind is the glory of the past compared with the poverty of the present. The re-establishment of the Empire in its original seat would ensure a new age. Partly as a result of Dante's letters to him, Henry VII of Luxembourg attempted to take control of the city by force, but his plans failed. In 1328, Ludwig of Bavaria, tradition relates, was not crowned Emperor in St Peter's, but on the Capitol itself, to shouts of 'Long Live Caesar!' The short-lived regime of Cola di Rienzo, and Charles VII's coronation in Rome in 1355 (he stayed for one day and then fled the country) are indications of the political anarchy of Italy and the consequent desolation of the city in the fourteenth century.

The gold bulla of Ludwig of Bavaria, 1328—the year he entered Rome to be crowned on the Capitol (here shown symbolically at the centre of the city).

Attitudes to the monuments during the Middle Ages[156]

Unlike the Emperors, the Popes did make Rome their permanent seat until the flight to Avignon. They converted pagan buildings to Christian use, and raised new buildings at the inevitable expense of the ancient monuments. And they were just as interested as their secular rivals in the implications for their glory of *Roma Caput Mundi.*[160] At least two popes were buried in pagan sarcophagi of porphyry: Innocent II (1130–43) in the sarcophagus from Hadrian's Mausoleum, and Anastasius IV (1153–4) in another from the Mausoleum of S. Helena on Via Labicana. Later rulers were to follow suit, because porphyry was considered redolent of imperial might.[152] Thus when Emperor Otto II died at Rome, in 983, his antique sarcophagus had a Roman lid. Frederick II was interred at Palermo in a porphyry sarcophagus. Even the Virgin Mary, as shown in the *Psalter of Henry of Blois* (London, BM), is to be placed in a porphyry sarcophagus! That popes should adopt a secular practice demonstrates the political implications of their claim to temporal power,[164] for porphyry (in the shape of marble roundels in cosmatesque

pavements) had a distinct place in both liturgy and the imperial coronation ceremony. [154,155]

Similar dreams of ancient glory were entertained by the Roman people when, in 1143, they installed a Senate on the Capitol—the most sacred of Roman hills[133,157]—and minted coins with the inscription *Senatus Populusque Romanus*. The Capitol was always *their* hill, to be vigorously defended when necessary; it is no coincidence that, to this day, it houses municipal offices, as well as municipal art collections.[219] The prestige of the Capitol continued throughout the Renaissance.[165,171] In 1538, for example, the statue of *Marcus Aurelius* (believed to be a *Constantine*), for long a symbol of imperial power and Roman justice, was brought thither from the Lateran, and was to form the centrepiece of Michelangelo's great scheme, which incorporated further antique references.[147,148]

But for most of the Middle Ages, the idea of Rome was more potent an inspiration than the beauty of its monuments. Petrarch's interest in them, for example, is in their power to evoke for him (and, as he hoped, the recalcitrant Emperors) the glory of the antique past, and thereby to restore that civilization which his own writings did so much to evoke.[160,169] His attitude is, in other words, an idealistic literary one, which uses the ruins merely as a spur to the imagination. Boccaccio can be more precise.[151] Until we reach the more complex sentiments of the Romantic Movement, we might say that there are two ways of looking at ruins, and that Petrarch indulges in them both. One might be termed 'constructive', the other 'destructive'. The first, evinced by the idea *Roma quanta fuit . . .*, sees ruins as a token of former grandeur. The second has as its watchword *sic transit gloria mundi*, and reflects on the ruins of those very monuments which supposedly proclaimed the immortality of the mortals who built them. Both ideas are staples of European interest in its past from the Middle Ages onward, the one a reflection of pagan glory, the other closely linked with the Christian conviction that only the City of God is eternal. It is essential to note that neither attitude is necessarily aesthetic, that neither presupposes anything other than a political or moralistic

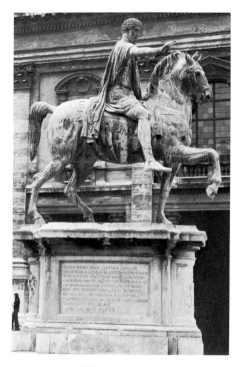

Equestrian statue of Marcus Aurelius. Rome, Capitol.

parti pris. Pleasure in ruins, as a romantic index of decay, begins in the eighteenth century, and it would be anachronistic to assume that either Middle Ages or Renaissance took any interest in ruins as such.[173] The former usually saw them as a quarry for building materials. The latter sometimes sought to reconstruct them, on paper at least, to their former glory. Were a monument too far decayed to be transformed into something useful, it seemed logical to make use of its materials just as previous ages had done.[149,158]

Because, for the Middle Ages, the monuments and even statues were mainly a convenient source of building supplies, there is little evidence[159] of aesthetic appreciation, unless it be for basically political ends.[153] Rome was, for most people, the centre of Christianity, and the guidebooks which catered for pilgrims usually omitted the ancient monuments, or used them as landmarks.[170] Certain guidebooks, such as the *Mirabilia Romae*,

ABOVE *Columns of the antique Temple of Hope, incorporated into S. Nicola in Carcere, Rome.*

The Roman Forum, as seen in the plan in the Anonymous Einsidlensis—the oldest guide-book to the City of Rome. The original is possibly late eighth century.

which deal with the 'Marvels of the City of Rome', do include the antiquities, but display a typical medieval propensity to deal in fantasy rather than in fact. They imbue the statues on the Capitol with magical faculties,[167] change Virgil from a poet into a necromancer,[150,172] and relate that the ashes of Julius Caesar are contained in the ball atop the Vatican Obelisk. The longevity of such ideas, given the supposedly different interests of the Renaissance, is startling: Virgil is still depicted as a magician in the sixteenth century,[162] and guidebooks in the *Mirabilia* tradition continue well into the eighteenth century, virtually unchanged in text or illustrations for more than two hundred years. But, for the more educated traveller, Italy was predominantly the land of classical antiquity, an image of greatness created by the new historical techniques of the Renaissance.

There is a gulf between superstitious medieval attitudes towards the monuments, which perhaps saw statues as devilish because they were so lifelike, and Renaissance attitudes which owe their balance to a historical framework developed during the fourteenth century. For a man like Petrarch, the 'middle' ages

were a barren period separating him from those ancient authors whose texts had not survived, and from the full glory of those monuments crumbled to dust. This realization of a *sense of difference* (no matter how we might hedge it round with qualifications) between past and present is an important step in the development of historical perspective.[166] Haphazard survival of the antique is now joined by a very deliberate revival, achieved through the exercise of techniques which seek to categorize and understand the past.[189] Petrarch, in his letters to classical authors, imitates a classical style. Lorenzo Valla, in the next century, will use his sense of classical style, and a knowledge of ancient history and custom, and of handwriting and philology, to overturn forged 'antique' documents, and forge a few himself as well. The Middle Ages had assumed that all ages are similar in character, which is why their stories of Alexander the Great are *romans de chevalerie*. The Renaissance borrowed from the ancients the

notions of difference, causation and change, and thereby learned to study the past as a sequence of actions with causes and consequences. The knowledge of why things happened, and the consciousness of time as the progenitor of difference and change, were important factors in the Renaissance scholars' resurrection of the past. For the Middle Ages, time had, as it were, stood still. For the Renaissance, the consciousness of difference impelled classicizing artists and architects to imitate sources much more closely than had hitherto been the case, and the ruins of Rome provided a rich quarry for study.

It is surely for this reason that documented instances of an aesthetic appreciation of antique remains are rare during the Middle Ages.[175] There are two conspicuous instances, from the thirteenth and fourteenth centuries. About the beginning of the thirteenth century, an Englishman called Magister Gregorius visited Rome and produced an account emphatically not in the *Mirabilia* tradition, for it

The Palatine, with a reconstruction of the Palazzo Maggiore. From Le Cose Maravigliose di Roma, Rome 1642.

concentrates not on the churches but on the ancient monuments, by the beauty of some of which, he says, he was deeply moved.[168] And in about 1375 a follower of Petrarch, Giovanni Dondi, visited the city and, as well as taking measurements and copying inscriptions, left a famous account which tells of contemporary interest in ancient sculpture:

> Those which have survived somewhere are eagerly looked for and inspected by sensitive persons and command high prices. And if you compare them with what is produced nowadays, it will be evident that their authors were superior in natural genius . . . when carefully observing ancient buildings, statues, reliefs and the like, the artists of our time are amazed . . .[174]

This passage is important because it implies not only an aesthetic interest in the past, but also the realization that study of ancient remains could perhaps improve deficient modern styles. This is surely the spirit in which we can imagine Nicola Pisano, Giotto or Ghiberti visiting the City; and we might wonder whether the progressive artists described by Dondi were not, like himself, Florentines, for whom Rome played an essential part in the developing civic humanism of their native city.

Rome after the return of the Popes from Avignon

No concerted move could be made toward the physical or political restoration of the city of Rome while the Popes remained at Avignon (1305–78). Their exile meant the further dereliction of secular and religious monuments, and when they finally returned in 1420 after the Schism of 1378–1417, it was to a city ravaged by years of anarchy, with a population of perhaps 20,000.

The return of the Popes was to be the spur to a thoroughgoing introduction of a classical style into Renaissance art.[180] Slowly at first,[184] then in earnest following the Jubilee of 1450,[183] they put in hand the building of a modern city with and on top of the remains of

The Capitol, Rome, prior to Michelangelo's remodelling. Anonymous engraving, c. 1538.

the old. Their projects for building and decoration not only provided work for artists and architects, but also uncovered antiquities which could then be studied and imitated.[177,181] Florentines fulfilled most commissions: Ghiberti went to Rome in 1425/30 and tells us in his *Commentaries* that he was present at the uncovering of the statue of a hermaphrodite; Donatello made the *Tabernacle of the Sacrament* for St Peter's (1432/3); Gentile da Fabriano worked at the Lateran (1427); Pisanello (1431/2) and Masolino (1428/31) also found work. Scholarly activity in the Papal Curia made it a centre of antiquarian learning,[182] and perhaps prompted the Popes to restore the Capitol.[185,186]

If Rome, in the early decades of the fifteenth century, might almost be called a Florentine colony,[178] then why did the revival of classicism occur first in Florence, rather than in Rome, apparently its natural habitat? Perhaps because interest in ancient Rome was an intellectual phenomenon for which close contact with the city was not at first essential. We have seen how Petrarch's preoccupation is primarily literary. Similarly, the scholarly career of Coluccio Salutati, Chancellor of the Florentine Republic, antiquarian and book-collector, is concerned largely with the written reminders of Rome, and not with her monuments (which were, of course, scarce in Tuscany).[187] The construction of the Porta della Mandorla of the Cathedral, probably under his

prompting, is important as a 'divide' between medieval and Renaissance attitudes toward Antiquity. Here, for the first time, Antiquity is used on its own terms, and not merely as a handy motif: classical meaning is reintegrated with classical form. Hercules can stand as Hercules, not transmuted into *Fortitudo* as on the Pisa Baptistery Pulpit. The figure can be appreciated without the need for a screen of Christian overtones, for his antique associations and for the beauty of his nude form. One of the artists of whom Dondi writes may well have found the model for such a *Hercules* in his studies in Rome, for there is a third-century AD pilaster relief now in the Grotte Vaticane which is extremely close to it. Thus Florentine artists of *c.* 1400 must have had contacts with Rome and its remains. But much more significant at this period is that leap of the historical imagination which makes possible the expression of such a classical style.

Despite artists' visits to Rome in the first decades of the fifteenth century, a broad renaissance of interest in the antiquities of the city could not begin until the Popes started to build in earnest. The wanderings and financial hardships of the Popes during the Great Schism (1378–1417) and the uncertainties of the Councils of Constance (1414–18) and Basle (1431–49) had precluded any great attention to the beautification of the papal city. It was only with the election of Nicholas V in 1447,[176] the establishment of the Vatican Library, and finally the election of Enea Silvio Piccolomini as Pius II (1458–64), that any thorough renovation began. Nicholas began to refurbish the city after centuries of neglect, to attend to the water-supply, and even to pave a few streets. He restored churches and the Vatican Palace, and tried to repopulate neglected areas of the city. Alberti,[179] a member of the Curia, helped him with his plans, and may have put into his mind the notion of rebuilding the Early Christian and very dilapidated basilica of St Peter's.* Nor was he the only scholar in papal service, for, as Vespasiano da Bisticci writes in his memoirs, 'all the scholars in the world came to Rome in the time of Pope

Nicholas, partly of their own accord, and partly at his request, because he desired to have them there'. He wished, in other words, to make Rome a centre of learning, as she had been in Antiquity. He collected Greek and Latin classics, as well as the writings of the early Church Fathers. Just as his manuscript-hunting was an attraction to scholars, so his building projects attracted like-minded artists.

Scholarly study of the antiquities of Rome

It is, therefore, from the mid-fifteenth century, and not earlier, that serious and prolonged study is made of the antiquities of Rome.[175] In earlier centuries, Roman marble had been enthusiastically exported as far as Ravenna, Pisa and even Westminster Abbey. The Romans of the fifteenth century had no scruples about continuing such an effortless practice, which provided great difficulties for the scholar. From Antiquity onward, new buildings had been built with old materials or on old foundations, and pagan buildings converted to Christian use. Problems of dating were therefore great, and Renaissance scholars tended to treat all Early Christian monuments as pagan Roman structures, and to urge their imitation along with that of the ruins themselves. Again, many of the ruins lay partially buried under several feet of earth and debris,

The Arch of Septimius Severus and the Temple of Saturn, from Etienne Dupérac, I Vestigi dell' Antichità di Roma, 1575. The buildings are partially buried by fourteen feet of debris, and the one on the right is not the Temple, but the Curia Iulia.

*For Alberti and architecture, see pp. 128–33.

so that close examination of lower parts required digging. Furthermore, the *renovatio* of Rome which the intellectuals so dearly desired could only occur at the expense of the monuments themselves.

Inspired by the example of Petrarch, fifteenth-century scholars tried to study the past in an ordered manner, arranging antiquities by classifying them into categories, and trying to understand the past as a sequence of events rather than as unrelated happenings.[189,196] The study which illustrates best the preoccupations of many scholars is that of topography.[200] Scholars realized that every new building and every new road entailed the destruction of clues to a fuller understanding of the past (even if further remains were revealed in the process). It became obvious that the only lasting way of evoking the glory of ancient Rome, short of preserving what remained and rebuilding what did not, was through some kind of census of the monuments, best achieved in a plan of the city. There are, of course, stylized medieval views of Rome,[174,199] but Alberti may have been the first to propose a scientific plan. No finished product survives, but, in any case, his project was probably for a plan of the city as it looked in his own day, and not a reconstruction of some antique period. Not until Raphael's famous letter of 1514 do we find a scholar trying to reconstruct the actual shape of a great number of ruined buildings, which his appointment as Superintendent of Antiquities in 1515 placed under his care. Raphael's evident expertise prompted the formation of a Commission in 1519 to prepare an ideal view of ancient Rome, which would include only monuments prior to the end of the Empire. He was helped by Andrea Fulvio,[202] who had produced a poem on the ancient remains in 1513, dedicated to Leo X—the *Antiquaria Urbis*. The appearance of Raphael's plan, and just how far it had progressed before he died, are a matter for conjecture.[190,194] The whole scheme, however, is the heir to an antiquarian tradition of exact scholarship begun in the time of Alberti, when a colleague in the Curia, Flavio Biondo, sought to offer 'a vision of ancient Rome' in a series of books, of which the *Roma Instaurata*

(1444–6) is the most important.[204] This seeks to relate evidence in the ancient authors to the remains on the ground—not always successfully.[197] Flavio's books are not illustrated, for his 'vision' was the total view of Roman civilization, not simply of its monuments. His work provides the *schema* for Andrea Fulvio's own contribution of 1527, the *Antiquitates Urbis*; it is, indeed, the first of a long series of antiquarian topographical handbooks.[191]

An invaluable aid in the reconstruction of the past were coins and medals.[206] In the study of numismatics (and, by extension, of epigraphy)[195,201] the interests of artists, scholars and collectors converged. Often available in many copies, coins and medals were small, portable and relatively cheap. They provided a wealth of documentation about ancient chronology, titles and mottoes, and satisfied the

Andrea Fulvio, Illustrium Imagines, Rome, 1517. Vespasian, showing the use of antique looking grotesques.

Aenea Vico. Page of medals from his Imagines ex antiquis numismatis desumptae, 2nd edition, Parma, 1554.

thirst for knowing what men of old actually looked like. The scenes or figures on their reverse sides were a mine of ideas for artists, for these sometimes included reminiscences of ancient works of art or architecture.[193] The roundel, derived from the antique medal, became a popular Renaissance motif, as on the façade of the Colleoni Chapel at Bergamo, or at Hampton Court. Coins and medals were often produced in the antique manner,[192,198] and the example of the antique provided the inventors of emblems and devices (very popular from the fifteenth century to the seventeenth) with much of their material.[188] Andrea Fulvio, in 1517, was the first scholar to publish a collection of images taken from coins: his *Illustrium Imagines* sought to include all well-known figures from the antique past.[203] A book such as this, which was to have many imitators, underlines not only a constant desire for true likenesses, but the extent to which scholars relied upon coins for the establishment of series of dates upon which to build the sequence of history. Petrarch, for example, had probably used coins to help him with the iconography of the Sala Virorum Illustrium at Padua.[161,169]

But the *Illustrium Imagines* also introduces another important aspect of the Renaissance interest in Antiquity. When Andrea had no image of a particular subject, he invented one. In other words, in this and other fields of study, the premium placed on authenticity was sometimes small; or, rather, the Renaissance view of fact was different from our own.[205] As in Andrea's frequently inaccurate copying of inscriptions, what counts is the spirit and not the letter. Artists and architects tried to recreate Antiquity in a modern guise, to rival the past in their work but not to copy it. Thus Bramante's *Tempietto* and Raphael's *School of Athens* have recognizable connections with the antique past, and display considerable scholarly research, but neither is a copy in any sense: they are modern works, just as Palladio's villas or the Villa Madama are modern houses conceived in an antique manner. Thoroughgoing antiquarians like Andrea Mantegna were rare. While, therefore, it is instructive to compare Renaissance works with their antique counterparts, to admire the progress of scholarship and to realize the use made of scholarship by artists, it is destructive to assess works of art for 'correctness' or 'fidelity of reproduction'. Renaissance classicism is in many respects a new style, and not an aping of the past.

The collecting of antiquities

Throughout the Middle Ages, and the earlier Renaissance, antiquities were sometimes preserved, or found by chance [208,226] and re-used, but it is not until the fifteenth century that we discover not much information about the formation of collections,[211] or evidence of deliberate excavation.[216] Collecting was pursued not simply for aesthetic motives, for the imitation of Antiquity formed part of the very fabric of Renaissance civic and court life.[209] Artists were commissioned to decorate rooms with antique motifs,[221,223] to organize pageants and triumphs with antique trappings, and sometimes even to work in an Egyptian manner, for Egypt was believed to be the source of ancient Roman religion and institutions.[210] As adjuncts to works of art, scholars produced inscriptions and genealogies, and writers imitated the antique in plays and poems.[224] The outward expression of a prince's interest in the antique, and often a convenient hunting-ground for his artists, was his collection of

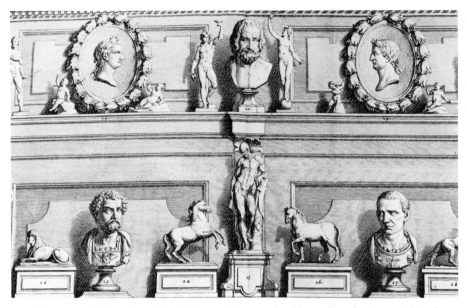

Some of the antiquities which an academically-minded seventeenth-century sculptor like Girardon might re-interpret in his work. Few artists' collections are known in such detail as that of Girardon. From R. Charpentier, Le Cabinet de Girardon, Paris, 1710.

antiquities; these became fashionable from the fifteenth century onwards, and were occasionally acquired with a manic zeal which ignored mere legality.[214,215] We have little information about early collections; we know Ghiberti possessed many examples of antique art, and, according to Vasari, it was Donatello who inspired Cosimo de' Medici the Elder to start collecting. This the later Medici did with a vengeance, so that by the time of his son Piero, the number of coins in the collection had doubled and, by that of Lorenzo, increased another four times. Again according to Vasari, it was in the Medici 'sculpture-garden' that Michelangelo received his early training.

Quattrocento collectors were not restricted to what was available in the immediate neighbourhood, for enterprising scholars and princes sometimes obtained material from as far afield as Rhodes or Cyprus.[217] Because of the frequent wanderings of the papal retinue, scholars in the Curia (who perhaps introduced into Rome the Florentine mania for collecting) were in a good position to hunt for antiquities, including manuscripts of ancient authors.[222]

One such official was Poggio Bracciolini, a protégé of Coluccio Salutati, whose letters provide us with a fascinating and exciting picture of his activities.[212] Although his main task in life was the hunting and copying of manuscripts, his letters also show his feeling for ancient art and life, and chronicle his attempts to build up a collection of his own. He writes enthusiastically to Niccolò de' Niccolis in 1427 that he has 'a room full of antique heads', and in 1433 he describes to his friend the procession into Rome and coronation of Sigismund as Holy Roman Emperor. In the letter, he emphasizes the antique elements in the procession and dress, discourses on the wearing of laurel wreaths, on the origins of the imperial *acclamatio*, and on the origins of certain ceremonies current in the age of Charlemagne.

No one, apart from families like the Medici,[220] could compete with papal purchasing power or with the intricacies of papal 'persuasion'. The Popes sought antiquities which would reflect their taste, and it is to the efforts of a select number of pontiffs that we

owe the richness of the Vatican collections. Pietro Barbo, a Venetian who ascended the throne in 1464 as Paul II (died 1471), was the first pope to collect seriously.[225] And if his collections were dispersed at his death by his successor (some pieces finding their way to the Medici), that successor, Sixtus IV, presented a notable group of antiquities to the Roman people, with the aim of assembling 'some tangible witnesses of Roman magnificence in the very seat of the city's municipal government . . . a museum of former Roman splendour'.[144] That museum is, appropriately, housed on the Capitol.[213,218,219] The next important foundation was the Statue Court of the Vatican Belvedere, instituted by Julius II in 1503 and used to house all important works found on papal property or bought by the papacy.[207] The bringing together of such works as the *Laocoön*, the *Apollo Belvedere*, the *Belvedere Torso* and the *Cleopatra*, all works which were both models and acknowledged standards of excellence for Renaissance artists, is in itself an act of inspiration from the antique. The Pope wished to make of his Belvedere villa the simulacrum of an antique villa, and to fill it with appropriate statues, after the fashion of the remains of antique villas which were plentiful in the Roman Campagna (see pp. 63–4).

The use of antiquities by artists

Thanks to public and private collections,[215] the student of antique art was not short of sculptural examples,[214] which he would copy in sketch-books for his own use and the use of his pupils and shop.[232,233] There is evidence that fifteenth-century sketch-books were carefully preserved, and even passed on from father to son. The Census of Antiques Known to the Renaissance,[229] maintained by the Warburg Institute and the Institute of Fine Arts at New York University, shows an increase in such sketch-books as paper became cheaper. We may be sure that they were maintained as books of reference sometimes put together over a long period; there are examples of sketch-books copied *in toto*, showing just how widely designs could spread through Italy, and later throughout Europe.

The ruins of Polyandrion from F. Colonna, Hypnerotomachia Polifili, Venice, 1499.

Printed books could also help in disseminating information. One very individual guidebook is the *Antiquarie Prospetische Romane*, written *c.* 1500, dedicated to Leonardo, and recently suggested to be by Bramante (see p. 134, below). Although the book is not illustrated except for a frontispiece, the author describes in 434 verses the monuments and works of art in Rome, and tries to woo the dedicatee to the city by the relation of such delights.[234] Even more individual is the *Hypnerotomachia Polifili*, a historical romance first published at Venice in 1499, which was famous throughout the Renaissance, as much for its profuse architectural illustrations as for its curious text. This describes, sometimes in detail, the buildings encountered by Polifilo on his travels, and the illustrations provide fanciful yet very imaginative reconstructions of ancient architecture. More serious, and ultimately more useful, are the architectural text- and pattern-books.[228]

Almost as important as artists' drawings are the prints of antique and contemporary works of art and architecture, which spread the

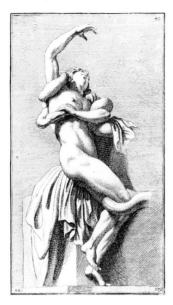

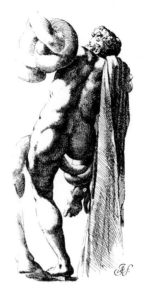

FAR LEFT *One of Laocoön's sons. E. Bouchardon: Statuas hasce antiquas ab E. Bouchardon . . . delineatas n.p. 1732.* LEFT *Rear view of one of the sons of Laocoön. Jan de Bisschop: Icones et Paradigmata, 1668, 1669. Compare these two engravings with the front view of the group on p. 36.*

standards and achievements of the Italian Renaissance throughout Europe.[230] From about the time of Mantegna, artists became aware of the publicity which the new technique could provide. Mantegna surely encouraged the making of prints after his work, and Raphael himself probably instigated the diffusion of his own works through the work of Marcantonio Raimondi.[240]

Study direct from the originals sometimes presented difficulties. Access to private collections might be hard to obtain. Figured columns required some kind of scaffolding if successful copies were to be made of the upper parts. To draw freehand something as large as the Sistine Ceiling would be, to say the least, exacting. Reproductions were therefore a welcome alternative, and were produced in huge quantities, of very varied quality, from about 1540 onwards.[227] Before this date, prints were certainly fewer in number and much more expensive.* The mid-sixteenth century was a time when foreign artists began to flock to Rome, and when paper had become relatively cheap.

*'Artistic' prints were no doubt collected earlier.[241]

We must, however, be careful to treat prints as a category of art which need not be at all faithful to the work it attempts to reproduce. Because of the limitations of the techniques of etching and engraving, or of the skill of the print-maker, the works of painting or sculpture copied were often presented in a more or less schematic manner. Sometimes composite works like the *Laocoön* or the *Wrestlers* would have their individual elements printed as separate plates, from several angles. Friezes or sarcophagi might be presented in the same manner, as an aid to study. An artist's sketch could, of course, abbreviate the subject-matter in a similar manner. It might be argued that a medium which reduces objects of light, texture, colour and atmosphere to a set of lines and semi-abstract shapes produces, in many cases, a treatment which is *per se* classical, since it concentrates perforce on formal and intellectual qualities in the work reproduced. Francesco Algarotti, writing in 1760, makes the position clear:

Prints can show the deportment and shape of the figures, the carriage of the head, the composition and general appearance of the

painting, but they do not give any of the delicacy of the effects of light, or the freshness and harmony of the colour tones. Tints, which alone provide the magic and charm of a painting, evaporate and disappear in prints. They resemble in these shortcomings those faithful translations which the French have made of the *Iliad* and *Aeneid* to which those who want to form a true opinion of Greek and Latin poetry never refer, because they contain so little of the purity of the original . . .[238]

An example to suit Algarotti's case would be Gaspard Dughet's frescoes in S. Martino ai Monti in Rome, full of silvery light, which appear totally different when engraved for the first time by Pietro Parboni in 1810. Compositions full of a baroque fugue become neoclassical ones in the manner of Domenichino. This example clarifies another procedure connected with the reproduction of pictures, namely that each generation sees the work of earlier ages after its own image. Such a process, to the possessor of photographic documentation, might seem purblind naïvety, but it is by such restatement and recapitulation that the strength of a tradition can be assessed. The idea that the *Laocoön* could mean different things to different artists (at the same moment as well as at different periods in time) is a simple yet crucial one for understanding the complex possibilities for imitation offered by a relatively restricted number of antiquities.[237]

The supply of antiquities was closely related to the rate of urban development, as more and more of the area within the walls was no longer used for agriculture but for housing and other building. From this gradual process came certain consequences which affect our assessment of the development of a classicizing style in painting and sculpture. The constant destruction meant, first of all, that we are unable to judge the relationship of a particular work to the antique because the probable sources do not survive. This is the case with many Early Christian frescoes and mosaics, and with richly decorated pagan sources such as the Domus Aurea, which is now dilapidated. Early Christian work surely had a great influence on

A detail of a pilaster framing Pinturicchio's fresco of Piccolomini at the Court of Scotland. The grotesques are influenced by the artist's study of the Golden House of Nero.

the manner of Masaccio; and it would be interesting to have seen the Domus Aurea while its decorations were unaffected by constant tracing and rubbing, in order to compare them with the schemes of Raphael and his contemporaries. Even if decorative frescoes and stuccoes sometimes survived into the Renaissance, antique painting could usually only be imitated through literary descriptions culled from the ancient authors,[235] perhaps aided by the example of sculptural remains, or by theory.[236]

57

Relief sculpture, on the other hand, was readily available throughout the Renaissance. It was relatively difficult to damage accidentally, and more awkward to carry to the lime kilns than sculpture in the round. Classicizing painters of the Early Renaissance (to say nothing of sculptors like Nicola Pisano) imitate low-relief sculpture, such as friezes on sarcophagi, much more than sculpture in the round: presumably their choice was predetermined by the sources available. As the rebuilding of Rome began and examples of sculpture were dug from the earth, and as lime-burners realized that more money was to be made from selling sculptures than from burning them, a wider range of antiquities became available to artists. Indeed, curbs were gradually placed on the activities of lime-burners and builders' merchants in order to preserve the remaining monuments. Because of the larger selection of sculpture in the round, High Renaissance works of art (mostly, after all, produced in Rome) differ from their earlier counterparts: due weight can now be given to each individual figure in a composition, rather than to the interlacing of a set of figures in imitation of antique friezes. From the anonymity of figures in a crowd, the Renaissance moves towards a powerful expression of idealized personality.

For sculptors, the availability of models had equally drastic effects on their art. Florentine sculpture of the fifteenth century is more antique-orientated than painting of the same date precisely because of the availability of models in the same medium. And here again, the frieze or bas-relief precedes the free-standing sculpture; works of the latter type were sometimes given the admiring appellation of *statua*, which had overtones of grandeur.[239] Alberti, indeed, judged that the statue was the best of all types of monument, and surely did so because he realized the public function of much of the sculpture of the Roman world, for it was often erected to enhance the *fora* and other monuments which were a necessary part of military triumphs, and an index of the commissioner's thirst for fame to outlast his lifetime. In the *De re aedificatoria*, Alberti urges patrons to decorate religious and civil buildings with large statues, because they 'marvellously preserve the memory of men and deeds'. Clearly Renaissance patrons, well versed in antique literature, and persuaded by the prestigious remains of ancient sculpture visible in Rome, were well aware of the overtones of power, virtue and glory that could accrue from a judicious use of works of art. Large and expensive works like Donatello's *Judith and Holofernes*, or his *Gattamelata*, or Michelangelo's *David* or *Julius Monument* project, were commissioned not because of a love of pure art, but for a purpose. The great artist is he who, drawing on the tradition of which he forms a part, can create an image which is endlessly suggestive. Thus the *David* of Michelangelo carries outside its biblical reference clear connotations of ancient Roman heroism and grandeur, just as the *Julius Monument* was planned as a modern version of an Imperial Roman funeral monument to be set within the largest mausoleum ever built, the new St Peter's. The commemorative monument, unknown to Christianity, makes its reappearance in the fifteenth century, and has clear links with those antique monuments from which its ideology and imagery derive.[231]

What is a forgery?[243]

Much of this book is concerned with the ways in which artists made use of antiquities, but one aspect deserves special mention in this chapter. From the fifteenth century onwards, there were always more collectors to be satisfied than genuine pieces to satisfy them. In addition, imitation of the antique was the aim of mature artists, and not simply part of their training; it forms part, for example, of Vasari's criteria of excellence. Little wonder, therefore, that forgery, or the completion of fragments, was a thriving industry in Rome, and continues to this day. The most commonly forged of all articles were small bronzes, coins and medals, some of which are so deceptive that there must be Renaissance works masquerading as antique,[242,244] and *vice versa*.[246,247] After all, a work is not really a forgery until the fact that it is a forgery is discovered! Those which we can now recognize as deceptive copies of

RIGHT *An anonymous relief, in an 'antique' style, and with reminiscences of Michelangelo. Vienna, Kunsthistorisches Museum.*

BELOW *Agostino di Duccio (attrib): Tomb of Giovanni Arberini (died c. 1490), the relief probably antique. Rome, S. Maria Sopra Minerva.*

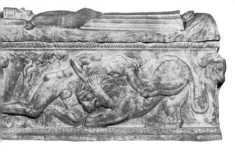

antique work provide us with an important insight into the Renaissance conception of the past. Details of whom they deceived, and for how long, can be a measure of antiquarian skill, and of the development of a rational and informed view of the past.[245] Imitation is certainly the sincerest form of flattery, and there is a very thin dividing line between the desire to pay tribute to the past and the desire to deceive one's contemporaries, a line which, at this distance in time, we have insufficient evidence to draw.

The use of antiquities by builders

The earlier sixteenth century saw a boom in construction unparalleled in the fifteenth century. Because of the activities of the Popes and the rich Roman families, Rome during the High Renaissance must have resembled a large building site.[248,251] The taunt of the following century, *quello che non hanno fatto i Barbari, facevano i Barberini,*[250] was certainly valid for the age of Raphael, and prompted him to write the famous letter to Pope Leo X protesting against the depredations:

... those famous works which today more than ever would be magnificent and beautiful, thus by the wicked rage and cruel impetus of evil men [i.e. the Barbarians]

were injured, burned, and destroyed, yet not to such a degree that there has not been left to us almost the entire structure, but without ornament, so to speak the bones of the body without the flesh ... How many Pontiffs, Holy Father ... have attempted to ruin ancient temples, statues, arches and other glorious constructions! ... How much lime has been made from statues, and from other ancient ornaments! ... all this new Rome, which we now see, however great she is, however beautiful ... is made entirely with lime from ancient marbles ... It should not therefore, Holy Father, be among the last thoughts of Your Holiness to have concern that the little which remains of this ancient mother of glory, and of Italian greatness ... be not extirpated and devastated by the malicious and the ignorant ...

Raphael—if he was in fact the author of the letter—goes on to give a brief history of architecture, and then to sketch out the method he will use to draw on paper a plan of ancient Rome so that the city's buildings, 'through true argument ... can infallibly be brought back to the very state in which they were, reconstituting those parts which are entirely ruined'.[252]

View of the Palatine from the Forum. Etienne Dupérac, I Vestigi dell'Antichità di Roma. Rome, 1575.

But in spite of Raphael's protests, the magnificence of the new St Peter's came from the inevitable sources. Indeed, the attitude of the Papacy to the monuments was as wanton as that of its secular rivals.[253] The Holy See, by custom, controlled debris on the ground and under it, while the Roman people had rights over the monuments. For authorization to excavate, the Holy See sometimes took a cut of the profits. No one showed any desire to preserve the past for the past's sake. Monuments which could not be re-used or in some way converted were dismantled, unless they were of supreme importance as examples of Roman grandeur—what Raphael calls 'noble and harmonious'. His contemporary Albertini, for example, writing in 1509, reported having seen at least five triumphal arches turned into lime within his own lifetime. And not only were the marbles destroyed for Roman purposes: their export continued to thrive.[249]

The use of antiquities by landowners

An account of the building activity on one Roman hill, the Palatine, through several cen-turies, will demonstrate varying attitudes to the ancient remains, ranging from total insouciance to fully controlled archaeological investigation. Such an account will also show what architects could infer from the ruins they saw on the ground.

The Palatine, with its fine view and gentle breezes, had been the preferred site for the palaces of the Emperors. (The name of the hill, indeed, gives us the very word 'palace'.) Because of this popularity, the Palatine is rich in large and sumptuous ruins, and must have been a choice area for excavations during the Renaissance. In the Middle Ages, however, its function was rather different.[257] It contained at least one monastery and one church, both of which were enclosed within the fortifications of the Frangipani family, whose rather draughty palace was the Colosseum itself.

As in the case of the Forum[256] below it, much of the prime building material was stripped from the site during the fifteenth and early sixteenth centuries. In 1539, the Farnese began buying up parcels of land, and built a sump-tuous *vigna* on part of the hill (begun 1542). This was a vineyard and pleasure-garden, with no house but with casinos, an underground

author was the antiquary Pirro Ligorio, and we shall return to his activities shortly when dealing with his designs for another *vigna* in the antique manner, the Villa d'Este at Tivoli.

In 1690 the Horti Farnesiorum were chosen as the site for the foundation of a literary equivalent of Poussin's *Arcadian Shepherds* (Chatsworth): the academy called the Arcadia[255,258] is the culmination of Renaissance beliefs in a golden age of Mankind.[263] An amphitheatre in pastoral mode was built for it in the Horti in 1693, and, as a jaundiced English visitor described this still thriving institution in 1823: 'Every member, on admission, becomes a shepherd, and takes some pastoral name, and receives a grant of some fanciful pastoral estate in the happy regions of Arcadia, where he is supposed to feed his harmless sheep . . . rills of nonsense meander from every mouth . . .'[259] The *genius loci* which

Rome, Villa Giulia: frescoes of the semicircular portico, with grotesques, c. 1553.

nymphaeum decorated with frescoes, and a cryptoporticus. Nymphaeum and cryptoporticus derive from the example of the nearby palace of Nero, the Domus Aurea, so called because of its sybaritic splendour; filled in by rubble and buried by the Baths of Trajan which used its walls as foundations, the palace was discovered during the later years of the fifteenth century, and provided the Renaissance with a wealth of decorative motifs which were known as *grotteschi* because they were discovered underground. No doubt the new gardens, the 'Horti Farnesiorum', were filled with antique statues found on the hill, but in no other way do they respect the site, for the creators of the formal gardens swept away any ruins which impeded them.[260,262,265] Etienne Dupérac's view of 1575 shows the Circus Maximus divided into allotments, and the Septizonium still intact—as it remained until 1588, when Domenico Fontana demolished it on the orders of Sixtus V in order to use its fabric for St Peter's.[261] In 1552, for the first time, a map of the city was produced which attempted to reconstruct the 'Palace of the Caesars' on the Palatine, rather than to show the ruins or the original ground plan. Its

ABOVE *Pirro Ligorio: Map of Ancient Rome, 1561. Detail of reconstruction of city, showing 'Palace of the Caesars'.* BELOW *Francesco Bianchini: Del Palazzo de' Cesari, Verona, 1738.*

Vatican, Cortile del Belvedere. Engraving by Ambrogio Brambilla, c. 1579.

surely inspired such pseudo-antique pre-occupations was not enough to satisfy the Duke of Parma, who purchased the Horti in 1720, for he immediately undertook a series of excavations, which were published in 1738 together with reconstructions of their former glory.[254] In the full spate of the neoclassical revival, Rancoureil excavated part of the atrium of the Domus Augustana (*c.* 1775). He worked in strict secrecy to guard against theft (which was also a great problem in the extensive excavations at Pompeii and Herculaneum). His plan of the atrium was published in 1785 in a periodical publication entitled *Monumenti antichi inediti ovvero Notizie sulle Antichità e belle Arti di Roma*, which appeared between 1784 and 1809. In purpose, the journal underlined the growing interest of that period in archaeological documentation although the quality of the contributions to this new science was often low. Then, with the quickening pace of excavation of the 1840s, most of the Horti were destroyed. Fuller excavations took place when they passed to the State in 1870.[264]

The use of antiquities by architects: the Renaissance villa

Given the large numbers of remains in Rome and in the Roman Campagna, it is natural that, of all the arts, Renaissance architecture should be the most clearly antiquarian. The chapter on Italian architecture will give a chronological account of developments; here I shall explore the importance of the villa and its setting during the sixteenth century, in order to clarify the extent of antique inspiration.[272,277,286]

Princes of the fifteenth century usually built villas which were airy versions of medieval castles, and knew of antique prototypes only through accounts in ancient authors.[268] However, the survival/revival dilemma occurs in the study of villa history just as it does in other disciplines. How much, in fact, could the fifteenth century have known of antique villa design through surviving antique types?[284] At least one villa, the Villa Colonna at Palestrina (portico dated 1493, the rest probably earlier), is actually erected on the ruins of a classical structure, and there may of course have been other examples.[289] A debate continues about whether Palladio's villas were based on surviving types to be found in the Veneto.

Certainly, the High Renaissance knew and used the most famous villa sites (particularly that of Hadrian's Villa at Tivoli) for fixing the plan and sometimes the elevation of their own constructions, as well as being influenced by modern types of building. Thus Bramante was to follow the lead of the Belvedere Villa of Innocent VIII in the Vatican (1484–7, by Pinturicchio) in making his own addition to the Vatican, the Court of the Belvedere, rigorously symmetrical.[267] Pinturicchio had made explicit

the links between the humanism of the papacy and its architectural environment by introducing into his design illusionistic decorative schemes both directly derived and freely interpreted from the Domus Aurea.[281,302,303] He probably studied other ancient sites about which we know nothing. The intricate rooms and grand spaces of Nero's palace were recreated by Raphael and his associates at the Villa Farnesina and the Villa Madama,[286] and it is likely that Raphael also sought inspiration at Tivoli.[300]

Bramante's scheme for the Cortile del Belvedere in the Vatican makes use of remains of ancient villas and of descriptions of villas given by authors like Pliny.[266] Bramante intended to produce an ensemble whose architecture would form a permanent theatre set, with the best viewing position being the windows of Raphael's *stanze*.[275,301] The Cortile's main features of exedra, nymphaeum, elaborate waterworks, and changes of level by means of grand staircases are all based on antique precept, as is its architectural detail.[287] The parallels with Pliny's very full description

J. M. Suaresius: Praenestes Antiquae Libri Duo, Rome, 1655. Detail of his reconstruction of the hill and temple.

of his Tuscan villa—full enough to prompt many reconstructions from the words alone—are very close.[296,304] Ackerman, citing Serlio's estimation of Bramante as the restorer of antique architecture, buried until his time, argues that the Cortile, with its axial and scenic arrangement, is in fact the parent of the monumental piazza format, and of the outward-looking, garden-orientated villas of later years.[267,271]

Perhaps the most impressive feature of the Cortile as designed by Bramante (it was subsequently altered) is the variety of ways in which he deals with changes of level. He learned some techniques not from an ancient villa, but from the splendid temple site at Praeneste, where the Temple of Fortuna is approached by a series of ramps, stairs and colonnades.[290] Built on top of a hill, the Temple of Fortuna and its approaches were clearly visible during the Renaissance (bombing during World War II cleared more of the site). We may imagine the author of the *Hypnerotomachia Polifili* visiting Praeneste, investigating the caverns and passages and staircases, and transposing them into the make-believe of his architectural fairy-tale.[293] But the fame of Praeneste was no greater than that of the Cortile which derives from it, so that when Palladio drew the Temple of Fortuna in plan and elevation in 1546/7, and reconstructed missing sections,[306] his ideas were greatly influenced by Bramante's own work in

The Cortile del Belvedere, with Bramante's original staircase to the exedra. From Amico Aspertini's sketchbook, c. 1540. British Museum.

the Vatican.[283] He supplies, that is, his recon-
struction of Praeneste with just such a
concave–convex semi-circular staircase[307] as
Bramante used for the approach to *his* exedra
at the highest level of his scheme, a design
which Serlio had popularized in a woodcut.
There seems, then, to have been influence both
ways between reconstructions of Praeneste
and the Belvedere project. Indeed, we might
add to the equation the elaborate complex of
the Temple of Hercules Victor at Tivoli, which
Bramante must have known well, and which
Palladio reconstructed to look much like the
Temple of Fortune at Praeneste.[308,309] Modern
buildings now cover much of the site.

Such an example illustrates the complicated
relationship between antique and Renaissance
architecture. If the above supposition is cor-
rect, Palladio looked at some antique architec-
ture through eyes trained and conditioned by
the achievement of his High Renaissance fore-
bears. The view of the past changes from
generation to generation, and depends largely
on previous interpretations of the tradition.
Indeed, we have not yet reached the end of the
story of the Cortile del Belvedere. Bramante
had designed a calm and logical courtyard, airy
and spacious, with an exedra at one end. In the
early 1560s Pirro Ligorio, as Papal Architect,
added another storey and a capping to the
great niche, to reinforce visually the powerful
staircase designed by Michelangelo, which
had replaced Bramante's semi-circular
concave–convex one. Pirro Ligorio thus over-
powered Bramante's clarity and understate-
ment by introducing the grand scale of Roman
baths into a place to which they were not
suited. Pirro cannot be dubbed a Mannerist
architect, since he inveighed heartily against
the architectural style of his contemporaries:
he writes of their 'stupidities' and continually
harks back to the achievements of the High
Renaissance.[278] Yet his addition of a storey to
the niche, which makes the Cortile look much
more like the Temple of Fortuna at Praeneste,
and indeed like Palladio's reconstruction there-
of, shows clearly the distinction between a
classical and a proto-baroque interpretation of
Antiquity.

In other words, in the same way as its statues

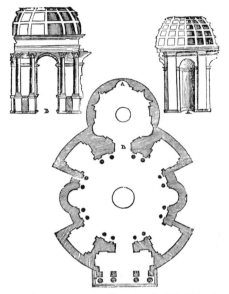

Temple plan and elevation of bays, from Book III of Sebastiano Serlio's Architettura, 1540.

had done, so the ancient remains of Rome and
its environs influenced different periods in
differing ways. All architects from the Re-
naissance onward grounded their work on the
example of Antiquity, but so vast was the
range of forms and styles in antique architec-
ture that almost any taste could be suited.
Nowhere in the sober, classicizing work of
Bramante, for example, is there any interest in
the drama and surprise that certain juxtapo-
sitions of rooms and passages in the Domus
Aurea could provide; nowhere does he in-
dulge in the cunningly concealed lighting
system which he had opportunity to study
there. Nor, again, in his researches at Hadrian's
Villa, did Bramante take any notice of the
swinging re-entrant curves which are a feature
of the so-called 'Piazza d'Oro'.[292] For such
elements of the 'Ancient Roman Baroque' only
began to exert their fascination in the seven-
teenth century, and to form the foundation of a
style whose exuberance and freedom of detail
had little connection, even in basic voc-
abulary, with the High Renaissance tradition
and its codification of Vitruvius. It is not that
architects like Borromini did not respect and

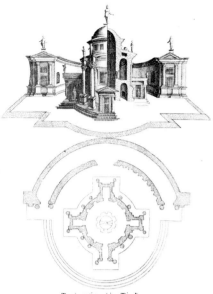

Tempio antico uicino Tiuoli

One of Montano's temple plans from G. B. Soria: Scelta di varii tempietti antichi, Libro Secondo, Rome, n.d.

use Antiquity, but rather that it was a *different* Antiquity which appealed to them.[270] Blunt has surmised that 'if the ancient sources used by Borromini were collected, I believe they would make a list almost as consistent as the corresponding series of models used by Poussin'.[274] The whole question of Borromini's sources might be symbolized by the engravings published after drawings by G. B. Montanus (died 1621). Montanus says that his plans and elevations, some of them reconstructions, are taken from antique remains.[305] But the question is a vexed one, for most of Montanus' designs look so Baroque that the truth of his assertion is doubted. On the one hand, there must have been a very rich selection of antique mausolea available, judging by survivals in Campania.[285,298] On the other, some of Montanus' designs are similar to those of Serlio, and since the latter's knowledge of antique architecture is not thought to extend much further than Flavian and Hadrianic styles, probably Montanus' designs *are* mostly make-believe.[273] However, they are no more make-believe and no less antique than, for example, the grand basilica which forms the setting for

Raphael's *School of Athens*. In other words, the antique is an inspiration to architects, and not a vice which cramps their style.

Bramante, who died in 1514, left few drawings and no notebooks, so we can only guess at his involvement with the antique. Pirro Ligorio, of the next generation (c. 1520–80) left plenty of both, and we can follow the importance of his antiquarian activities in his work as a popular architect. Like both Raphael and Bramante, Pirro was also a scholar. So industrious was he that in the decade 1543–53 he compiled forty volumes of accounts of Roman antiquities, very few of which were published.[297] He made a map of ancient Rome in 1552, which was republished in amended form in 1553 and again in 1561. The success of these maps was surely due to the reconstructions they provided of the monuments, for they did not merely provide a plan, as Leonardo Bufalini's work of 1551 did.[282] Somewhat later Pirro Ligorio also made a plan of Hadrian's Villa at Tivoli. His work must have been recognized as of high quality, for eight manuscript copies of the plan are extant, and when a large-scale plan of the site was published in 1751, Pirro's name was incorporated in the title.[280]

During the very years when Pirro Ligorio was making plans of Rome and Hadrian's Villa, he was also engaged on the design of villa and gardens at the Villa d'Este at Tivoli (begun 1549).[279] His antiquarian activities were essential for his own architecture, as a walk round both ancient and modern sites makes clear. The sixteenth-century vogue for villas and their settings and for the country life they conjure up was largely inspired by ancient literature; the same might be said about the rustic genre scenes of the Bassano family. In the seventeenth and eighteenth centuries the vogue continued.[291] A comparison between Hadrian's Villa and the Villa d'Este certainly shows so many points of similarity that the latter may be considered an imitation of the former: Pirro had many statues brought from Hadrian's Villa to his own site,[269] and introduced nymphaea, cryptoportici and unusually shaped pools into the design of his garden. As for the Villa d'Este itself, it stands

65

on a steeply sloping site, and the corridor that gives access to all the rooms (which are frescoed with *trompe l'oeil* scenes and grotesques) is itself a cryptoporticus, tall, long, lit diagonally from above, and derived from prototypes at Hadrian's Villa.

Pirro was, of course, also complying with the desires of his client, Cardinal d'Este, who had been prevented by the Pope from building magnificently in Rome itself. He is reported to have vowed that, 'if he could not have a house in Rome, he would have Rome in his house'.[295] Pirro therefore built in the gardens a *Fountain of Rome* (begun 1567), which is a version of the reconstructions on his own map of Rome, for several famous Roman landmarks are easily recognizable. Now dilapidated, the full splendour of this miniature Rome can still be captured in contemporary engravings. Coffin's comparison of this backdrop to the actual fountain with Serlio's *scena tragica* (Book II, 1545)[288] and Palladio's *Teatro Olimpico* at Vicenza (*c.* 1584) is apt if, as seems likely, the *Fountain of Rome* was also the setting for theatrical performances. Mantegna's *Triumphs*, it will be remembered, served the same function. Such insubstantial reconstructions, like magnificent designs on paper, were a

Fountains in the Villa d'Este gardens from G. F. Venturini: Le Fontane del Giardino estense in Tivoli. RIGHT, *a modern view.* BELOW *The scena tragica, from Sebastiano Serlio's Architettura, Book II, 1545.*

substitute in miniature for grand and impossibly expensive real buildings.[276]

The fountains and pools of the Villa d'Este were to set the standard for seventeenth-century designs; in the eighteenth century, the whole dilapidated site enchanted an age preoccupied with ruins. Of course, similar fantastic creations at Hadrian's Villa had dried up long before the sixteenth century, but it is

interesting to reflect on how the ancient Roman love of water, expressed through the fountain,[294] the nymphaeum[299] or the great public bath, introduced a whole series of designs into Renaissance architecture. We might add the small mausoleum to the list. This great arsenal of motifs could be drawn on in the design of structures as diverse as garden temples and fountains, loggias and enclosed rooms, public monuments, funeral monuments and churches. The architecture of the Italian Renaissance is a new and original architecture, but it could not have existed without the example of ancient Rome.

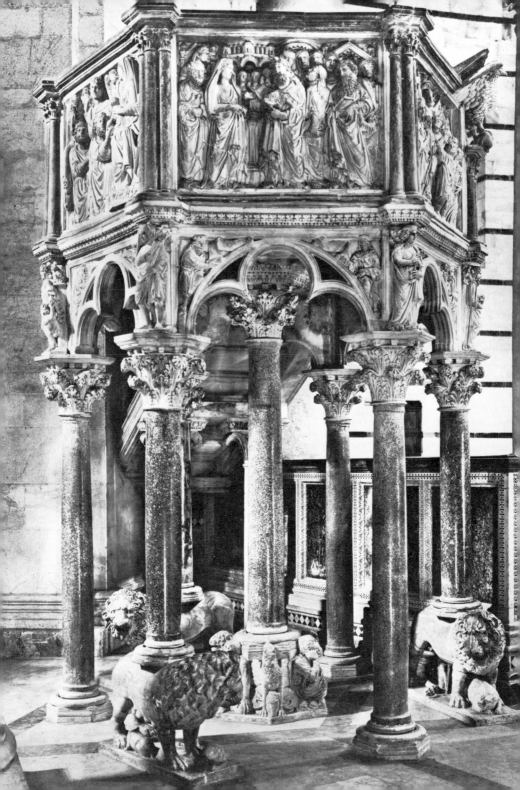

1

Nicola Pisano and Giotto: Founders of Renaissance Classicism

Nicola Pisano

The first classical work of the Renaissance period is Nicola Pisano's pulpit for the Baptistery of Pisa Cathedral, which he signed and dated in 1260. Both its general form and the modelling and pose of some of the figures show the influence of antique sculpture, which Nicola could have studied in Apulia, where he lived as a young man. The Kingdom of the Two Sicilies, under the rule of Frederick II, the Holy Roman Emperor, produced a secular style of classicizing sculpture which also affected Nicola's training.[310,311] Vasari relates that Nicola visited Rome, although we have no evidence for this. In any case, there were in Pisa antique sarcophagi imported from further south by the Pisan navy as booty or ballast; one of these, says Vasari, representing *Meleager hunting the Calydonian Boar*, was fixed onto the façade of the Cathedral 'on account of its beauty'. We know that a sarcophagus relief of the second century AD on the portal of the transept of S. Paolo a Ripa d'Arno, Pisa, was used as a model by both Nicola Pisano and his pupil Arnolfo di Cambio.[315] Vasari states that Nicola constantly studied Roman remains, and we can see this by studying his pulpit of 1260, and comparing it with the antique sarcophagi which still grace the nearby Camposanto.

Of great importance is the actual fabric of the pulpit which, like much of the Cathedral, is made with marble and columns from the remains at Ostia and Porto. It might be that the sculptor went to choose his own second-hand stone, and saw in Rome triumphal arches which gave him the inspiration for his pulpit,

which differs markedly from contemporary work. The columns of the pulpit have rich Corinthian capitals and, although the arched openings they support are cusped in the Gothic manner, the spandrels contain figures just as they do on the Arch of Constantine in Rome. Again, that antique arch has figures standing atop columns, and an attic storey with sculpted scenes on it: so does the Pisa Baptistery pulpit. These scenes, which are of course religious in content, reflect a thorough study of antique work.[316] With the exception of *The Last Judgement*, which must derive from some Byzantine ivory, and *The Crucifixion*, which exudes an elegance similar to contemporary French Gothic, all the scenes are antique in the spirit of antique sarcophagi. The *Phaedra Sarcophagus*, in the adjacent Camposanto, is one such source. In Nicola's *Adoration of the Magi*, Phaedra becomes the Virgin, while the nude standing before Phaedra becomes

Sarcophagus with the story of Phaedra. (It has been re-used for Christian burial.) Pisa, Camposanto.

Nicola Pisano: The birth of Christ and associated episodes. Pisa Baptistery. Panel of the pulpit, 1260.

Giovanni Pisano: The birth of Christ. Pisa Cathedral. Panel of the pulpit, 1302–10.

Fortitudo, one of the figures at arch level, beneath the scenes.

Nicola is a true imitator, and not a wayward pasticheur who has found an easy source to copy. Very few of the figures on the pulpit have any traceable source, for they are original creations made through a close understanding of antique and Romanesque prototypes.[317] The panel of *The Nativity* (and associated episodes) serves to show that clarity of thought which informs both composition and figure style. In Roman fashion, the figures are few, and are scaled to the full height of their simple, flat, rectangular frame. Their dress is Roman: the *tunica* with its ample folds is gathered at the waist and covered by the *pallium* or *toga*, which the Virgin wears drawn over her head, in the manner of a Roman matron sacrificing. She wears a comb in her under-drilled wavy hair which, with the sober expression and the blank eyes, completes the picture of an Imperial Roman funerary portrait. In some of these, and in their Etruscan prototypes, the figure similarly reclines on a couch. The very gestures with which the human beings created by Nicola control the large and simple folds of their heavy garments add to the noble seriousness of the theme: all movements are slow and considered, all emotions restrained. Nicola has discovered how to tell the Christian story in an antique language.

His son, Giovanni Pisano, did not appreciate this Roman manner.[313] And, indeed, perhaps Nicola himself found the contemporary vogue for Gothic[312,318] too prevalent to ignore, for in 1265–8, helped by his son and by Arnolfo di Cambio, he made a pulpit for Siena Cathedral which has many Gothic features. Nicola died about 1284, and his son completed pulpits for the Cathedral at Pisa (1302–10) and S. Andrea at Pistoia (1301).[314] Giovanni's Pisa Cathedral pulpit is the most elaborate of all his works. Basically circular in plan, highly decorated and with the panels of the attic curved and heavily undercut, this pulpit rejects sober and simple forms, and bulky monumental garments, in favour of a more linear style. In *The Birth of Christ* (incorporating *The Annunciation to the Shepherds* and *The Washing of the Child*), he aims at a pleasing sweetness instead of imperial *gravitas*: the Virgin still reclines, but she now smiles as she rocks the baby's cradle, which is a true cradle and no longer the Roman sarcophagus of Nicola's interpretation. Heavy folds have given way to figure-hugging garments which flow like rippling water round her body and even over her feet, adding an air of excitement to the scene which flows throughout the composition in swinging curves. These run down through the Virgin's cloak, into the body of the right-hand midwife, up again via the crinkly cave in which the birth, according to medieval lore, took place; then over to the excited and gesticulating angel, and to the shepherds, surrounded by their flocks and dogs, clinging to the sheer mountainside. Such a style, with its soft, sweet curves, its

Traditional pulpit by Guido da Como, 1250, detail. Pistoia, S. Bartolommeo. Contrast with N. Pisano's antiquarian innovations.

high emotion and its meticulous detailing of the outside world, is in strong contrast to his father's manner. Perhaps Giovanni even visited France, and learned from the Gothic cathedrals how to work large and powerful figures, as he did for the façade of Siena Cathedral; perhaps he simply saw imported French ivories, of the type which were to influence the maker of the first pair of doors to the Baptistery of Florence Cathedral, Andrea Pisano (no relation; doors finished 1336), and his son Nino.

I have described Giovanni Pisano's work because its obvious popularity shows that the classicism of his father was by no means the only available thirteenth-century style.[325] It is as well to remember that, although the classical style might well triumph in the short period of the High Renaissance, it usually exists alongside other styles which are often as popular. Thus in spite of the way Vasari tells the story of the Renaissance in his *Lives*, classicism was not necessarily the most popular style in every generation of that period; it probably appealed to a restricted number even of cognoscenti and, in the fifteenth century for example, was surely outdone in quantity of production by the International Gothic and variations thereof.

Perhaps for this reason, classicism in sculpture plays little part in fourteenth-century art. Nicola's pupil, and the inheritor of his classical style, was Arnolfo da Cambio (c. 1250–1302), whose early death left the field clear for the style of Giovanni Pisano. Arnolfo had worked on the pulpit at Siena Cathedral, under Nicola, and on the Shrine of St Dominic at Bologna (1264–7), before going to Rome in 1277 where he competed with the dynasty of marble workers known as the Cosmati and imitated their use of coloured *tesserae*, a practice which derives directly from antique work visible among the ruins of Rome. Arnolfo's style is best seen in his *Tomb of the Cardinal de Braye* (Orvieto, begun 1282), where he crystallized a type of tomb monument which was to remain popular throughout the early Renaissance: the dead man lies on a bier above the tomb chest within an architectural framework animated by sculptured figures, the most important of whom is the enthroned Virgin Mary. Perhaps Arnolfo's main claim to our attention is the work that he did for the Cathedral of Florence, the façade of which he was commissioned to design in 1296. The scheme, which got as far as the tympanum, is known through a sixteenth-century drawing. Judging by the fragments which survive—a Reclining Virgin from *The Nativity*, or a seated *Virgin and Child* (both in Florence, Museo dell'Opera del Duomo)—the effect of his façade on the artists of Renaissance Florence must have been that of Nicola Pisano's Pisa Baptistery pulpit writ large. The reclining Virgin is imitated directly from that pulpit, while the seated group, placed in the lunette above the central doorway, must have seemed heroic in its sober frontality and stern monumentality in comparison with the elegant puppets on Andrea Pisano's doors for the

Baptistery, set up in 1336. Nevertheless, it was Andrea's doors which, as we shall see, were to provide the model for that competition in 1401 which is often held to be the starting-point of the Florentine Renaissance. Yet if we are to equate the Renaissance with a truly classical style, rather than with merely a flood of antique references within a Gothic style, we must return to the very beginning of the fourteenth century, to the frescoes of a man who can justly be called the father of modern painting.

Giotto

Giotto (c. 1266–1337) was a Florentine whose art was once well represented in Florence, for he frescoed four chapels in S. Croce, of which the work in two, the Bardi and Peruzzi Chapels, partly survives. His greatest work, however, is in Padua, in the Arena Chapel (completed c. 1306).[326] So bare and simple is the interior of this chapel, with six windows symmetrically spaced along the south wall of the nave, and none along the north wall, that it may well be that Giotto designed it himself (as, late in life, he designed the campanile of Florence Cathedral). Certainly, the lack of architectural clutter ensures that his story-telling, so clearly articulated within each individual scene, gains in meaning because of the clarity of the general arrangement and hence the possibilities for parallelism and contrast between subject-matter which result.[319] In the top band, above the window level, is told the story of Joachim and Anna, and that of the early life of their daughter Mary; the main bulk of the nave displays the story of the Life and Passion of Christ, read from left to right. Examples from the two main bands will demonstrate how Giotto can point a moral:[321] on the north wall, The Baptism of Christ is directly above The Crucifixion, and the water of the one contrasts with the blood of the other, just as the angels in the upper scene hold Christ's garments, while below the soldiers draw lots for them; on the south wall, The Adoration of the Magi is placed over The Washing of the Feet, and these scenes echo each other structurally, but whereas the act of kneeling in the first

signifies the rich and powerful falling before a weaker but greater King, in the second that same King is shown in the service of sinful humanity.

Giotto's preoccupation with clarity of meaning is evident in each individual fresco because of a totally new concern with psychology, which he can 'explain' not only through gesture and expression, but also through the very way in which he composes his scenes. The first episode in the chapel, The Expulsion of Joachim from the Temple, demonstrates his technique. The feelings of Joachim, whose temple offering has been rejected because he and his wife are childless (in the scene below, The Nativity, his miraculously conceived daughter and her Son have also been rejected), are shown by a priest pushing him out of the temple into nothingness. The temple is portrayed as a Christian church, with its three main functions of communion, absolution and preaching represented by an altar, a priest and penitent, and a pulpit.[330] By juxtaposing in credible perspective the essentials of the religion which rejects him, the 'hole' into which Joachim is being pushed presents us with an instantly recognizable metaphor of his feelings of distress, heightened by his mournful backward glance and the protective cuddling of his offering. The large and simply clothed figures are described by the light, which gives to them a statuesque bulk. They move in a setting stripped of all incidental detail, and every element of that setting helps to explain the story, just as, in the scene described, the very lines of the architecture help the High Priest to push Joachim into the void. In none of the scenes is the landscape or the architecture merely incidental: they serve to explain the action, to point the moral, and to form a convincing spatial setting for the figures. The walls of the Arena Chapel convey a sense of spiritual significance heightened by that restraint which is the backbone of Giotto's art. Underlined by the geometricality of the compositions and the powerful yet simple draughtsmanship, the physical appearance of Giotto's figures is a weighty reflection of their morality. To the Christian, the story told is that of the salvation of humanity, but it is Giotto's

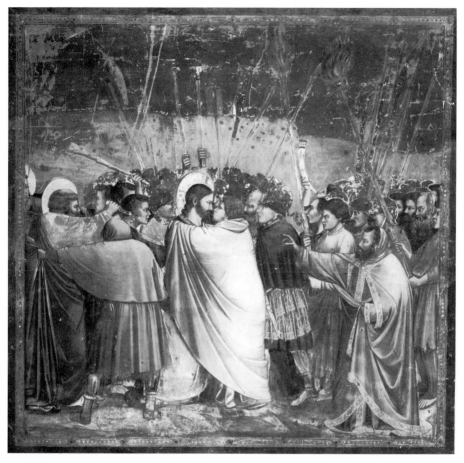

Giotto: The Kiss of Judas. Padua, Arena Chapel, c. 1306.

concern with 'establishing the dignity of human fate through the material significance of the human figure'[322] which makes the Arena Chapel the first monument in paint of the revived classical tradition.

Where did Giotto learn to paint in this manner? Did he take inspiration, like Nicola Pisano, from Imperial Roman sculpture? There are several cases of direct borrowings from antiquities, such as the grief-stricken figure of St John in the *Pietà* in the Arena Chapel: he comes from that same *Meleager Sarcophagus* in the Camposanto at Pisa that Nicola Pisano had studied for a figure in his *Massacre of the*

Innocents (Pulpit, Siena Cathedral, 1265/8). Similarly, the figures of Virtues and Vices which punctuate the dado of the Arena Chapel, and which are intended to resemble statues standing in real niches, may be imitations of statues: *Fortitudo* is a female figure assuming the dress of some antique Hercules, or *Juno Sospita*; *Caritas* and *Hope*, furthermore, both wear the antique chiton. The *Winged Victory* held by the enthroned *Justitia* also proclaims an imperial prototype. The random indecisiveness of the above suggestions should indicate that Giotto's references to Antiquity are not straight copies; he does not treat the past as a

storehouse of motifs, but as a corpus of ideas and attitudes on which he can build. The St John from the *Pietà* is the only direct borrowing in that scene from the *Meleager Sarcophagus*, but we can be certain that it was Giotto's scrutiny of such antiquities which inspired the general profile pose of the dead Christ, the emotional relationships between the figures, and that shallow relief-like staging used in the majority of the scenes. Throughout the Chapel, figures do not walk, but rather process with a slow and majestic cadence—an antique *gravitas*—which is a function of their heavy drapery and their considered gestures. Examine any representation of an Imperial Roman procession, or of an Emperor sacrificing*: it is from such works that Giotto learned the syntax of his style.[324,327]

We can also assume that Giotto had direct knowledge of antique frescoes and mosaics.[320] He visited Rome probably in about 1298, but all that remains of his work there is the much

*e.g. *allocutio* of Hadrian from the Arco di Portogallo, Rome, now in the Capitoline Museum; illustrated Nash, *A Pictorial Dictionary of Ancient Rome*, rev. edn, I, plate 87

reworked *Navicella* mosaic in St Peter's.[323] However, he came into contact with the work of his greatest contemporary in the Roman school, Pietro Cavallini, whose major achievement was a series of frescoes in the nave of S. Paolo fuori le Mura, known to us only through prints and watercolour copies, the latter made for Cardinal Francesco Barberini in 1634.[329] These copies and Cavallini's mosaics in S. Maria in Trastevere show a figure style not dissimilar to that of Giotto, and an interest in drama and naturalism that Giotto also shared. Were more Early Christian fresco and mosaic cycles available to us, the extent to which he and Cavallini studied and used them could be more clearly determined.[328]

Giotto had followers during the fourteenth century (including Bernardo Daddi and Taddeo Gaddi), but, like the art of Nicola Pisano, his style found great popularity only in the early fifteenth century in Florence. Perhaps the work of Giotto and Nicola was too severe and too far from accepted norms to find an appreciative audience until the time of Donatello and Masaccio.

Giotto: *Flight into Egypt, c. 1306.*
Padua, Arena Chapel.

5

The Early Renaissance

Florence was the setting for important developments in art during the early fifteenth century which were to affect the very nature of the Italian Renaissance and the crucial part played in it by the classical tradition. The term 'renaissance' is not synonymous with the term 'classicism', because it is evidently possible to depict antique subject-matter in a non-antique and completely unclassical style; this is what Ghiberti does at the beginning of the century, and what Botticelli, the great inheritor of the Gothic manner, does towards its end. If, therefore, the study of Antiquity is the *sine qua non* of the Italian Renaissance, that study manifests itself in various styles not all of which are classical. Of course, Antiquity itself embraced figure styles which are much more 'Gothic' than classical, and some of these were certainly imitated by artists like Botticelli, whose work we can therefore describe as antiquarian but not classical, even anti-classical. The same problem of the great range of authentically antique styles will occur throughout the centuries influenced by the classical tradition.

Sculpture and civic pride

Because of her civic prosperity, the appetite of her intellectuals for antique literature and jurisprudence, and the belief of her citizens that she was the true successor to ancient Rome (see p. 45 above), Florence nurtured classicism long before any other Italian city.[332]

Coluccio Salutati, Chancellor of the Florentine Republic from 1375 to 1406, and a noted humanist, probably encouraged the commissioning of sculpture as a vehicle of civic pride.[337,339] From the viewpoint of the classical tradition, painting was less advanced than sculpture in the fifteenth century;[336] it has been suggested that, apart from the obvious shortage of antique examples in that medium, most painting was religious, intended to encourage other-worldly contemplation and therefore quite suitably couched in traditional styles. Sculpture, on the other hand, was frequently a public and hence a civic art which, as was well known from survivals and from antique literary descriptions, had served similar patriotic purposes in Antiquity. The same argument would attempt to draw contemporary political inferences from the 'advanced' antiquarian style of Masaccio,[335] as well as from some of the work of Michelangelo[334] and the High Renaissance. The use of a classical style during the Renaissance would imply not simply an aesthetic response to antique beauty, but rather the making of social, moral and political parallels with an antique ideal. One scholar has surmised that 'the grandiosity of the High Renaissance in both Florence and Rome may well have represented a symbolic response, on the plane of

ABOVE *Lorenzo Ghiberti: The Sacrifice of Isaac. Relief for the competition of 1401 for a set of Baptistery doors. Florence, Bargello.*

75

fantasy, to crises that despite the most desperate efforts, neither the Florentine Republic nor the Papacy was powerful enough to solve in reality.'[335] During the Middle Ages, as we have seen, attachment to the idea of Rome had been much more than stylistic; for the Florentines, during a period of increasing antiquarian scholarship and therefore awareness of the past, it could not but be likewise.

The first monument to sculpture as a vehicle of civic pride was the Porta della Mandorla (1391–1422) of Florence Cathedral, to which both Donatello and Nanni di Banco were to contribute. Mainly a tribute to the Virgin, the iconography also includes a Hercules as *Fortitudo* and, possibly, the other Cardinal Virtues of Prudence, Temperance and Justice as well. Of great interest is a jamb relief of a naked Hercules set amidst acanthus-leaf decoration, which is totally different from contemporary Florentine work, and very similar to a relief in the Grotte Vaticane. Whether its maker, perhaps Pietro di Niccolo Lamberti,[333,338] had visited Rome is not known, but the work makes Nicola Pisano's *Fortitudo* on the Pisa Baptistery Pulpit, which might be a source, look vague and wooden.

Ghiberti

It is against the background of the encouragement of classical scholarship among the culture-hungry nobility of Florence that the references to antique sculpture in the famous competition reliefs of Brunelleschi and Ghiberti can be understood. The rules of the competition of 1401 for a new set of doors for the Baptistery might have stipulated such references, or perhaps they were simply known to be acceptable. Hence the kneeling barbarian prisoner (Isaac) and the Spinario (left-hand attendant) in Brunelleschi's relief, and the kneeling son of Niobe (Isaac) and groups from a Pelops sarcophagus (the two attendants) in Ghiberti's panel. Neither panel displays a truly classical manner. Ghiberti (who probably won because his work was easier to cast) uses an elegant International Gothic manner. Brunelleschi is all brutality and dash (as befits his antique sources), and

presents a scene more violently realistic than Ghiberti's graceful diagonals, with swinging drapery and angel in cunning foreshortening. The doors as built (after a change to New Testament subjects, the Four Doctors of the Church and the Four Evangelists) show few references to the antique, and little in the way of classical style, except certain heads decorating the frame. Indeed, Ghiberti does not seem to have really interested himself in Antiquity until he came under the twin spurs of Donatello and Rome.[340]

Thus the decorative and linear style of the North Doors is echoed in Ghiberti's contemporary sculpture in the round, such as the *St John Baptist* of 1412 or the *St Stephen*, for that showpiece of fifteenth-century sculpture, the niches on the four façades of Orsanmichele. It is the swinging draperies, cascading under their own momentum, which construct these figures, not the anatomy underneath. The dizzy sway rubs away any sense of personality, and the blank mindlessness contrasts strongly with the forcefulness of Donatello's *St Mark* of 1411 for the same guild church; in the latter work the drapery actually enhances the *contrapposto* of the stance, and helps the gestures and expression to render the impression of a living, thinking consciousness. Faced with a work like this, or with groups like Nanni di Banco's *Four Saints* (Orsanmichele, 1413), we can see Ghiberti's *St Matthew* (1419–21) for the same church as a highly uncharacteristic classical response to Donatello's spirit and Nanni's overt antiquarianism. The folds of drapery, still conspicuously lilting, are now controlled by the weight-bearing left leg and the graceful trail of the right leg, although the usual elegance in the folds over the torso and the right arm is undiminished.

The appearance of this toga-clad philosopher type in Ghiberti's work may also have been the result of his visits to Rome, one of which was probably undertaken before 1416, when he was working on the frame for the North Doors of the Baptistery. Krautheimer has listed motifs by Ghiberti from antique sculpture on view in Rome and Pisa, of widely differing styles.[339] He must have noted his observations in large sketch-books, and

Lorenzo Ghiberti: St Matthew. Florence, Orsanmichele, 1419–21. *Lorenzo Ghiberti: St Stephen. Florence, Orsanmichele, c. 1426.* *Donatello: St Mark. Florence, Orsanmichele, 1411.*

borrowed from them poses, gestures and compositions, particularly for the ten panels and the frame of the Baptistery *Gates of Paradise* (so called by Michelangelo, according to Vasari). These were commissioned from him in 1425 without competition and finished only in 1452, although the panels themselves were cast by 1436. As Ghiberti tells us in his *Commentari* (c. 1447), he visited Rome again during the 440th Olympiad, between 1425 and 1430 (most probably in 1429), a slack period in his work. Between 1420 and 1430, his collection of antiques seems to have increased greatly, fed perhaps by a conjunction of money and inclination. On the *Gates of Paradise*, in spite of the extensive use of antique quotations, and of the new mathematical system of perspective, there is little of that sobriety and nobility of moral purpose which we have seen in Giotto. The long-legged, high-waisted, slender bodies are suffused with elegance, not moral energy; Ghiberti, who modelled his *Commentari* on Pliny and Vitruvius, and probably based his *Gates of Paradise* on ideas about Antiquity in Alberti's *Treatise on Painting* (c. 1435), remained an International Gothic artist from first to last, except in his treatment of the *St Matthew*. In his work is is obvious that classicism is not synonymous with the use of antique motifs.

Donatello

In contrast to Ghiberti, Donatello's versatility in style and medium is astonishing. In reliefs and statues large and small, in both bronze and marble, Donatello ranges from the Ghibertian elegance of the bronze *David* (Florence, Bargello, c. 1430) and the vivid theatricality of the *Habbakuk* (one of a series of prophets for the Cathedral campanile, 1427/35, now in the Museo dell'Opera del Duomo), to the meticulous horror of the *Judith and Holofernes* (c. 1457–60, Florence, Piazza della Signoria)[344] and the emotional confusion of the two pulpits for S. Lorenzo, Florence (begun c. 1461). His great contribution to the classical tradition is his demonstration of how to embody in marble or bronze the thoughts and mental attitudes of Man, the 'motions of the soul', as Leonardo was to call them. Such qualities had not really been attempted before Giotto or Nicola Pisano. In Antiquity the concern had largely been with bodily beauty, or physical power or pain; subtlety of emotion, or will-power, or the overt expression of moral attitudes, were less in evidence. The favourite antique statues of the Renaissance, the *Laocoön* and the *Apollo Belvedere* (not known until the turn of the

Donatello: Judith and Holofernes. Florence, Piazza della Signoria. The anti-classical horror of Holofernes' dangling legs indicates the breadth of Donatello's styles.

Donatello: St George. Originally as shown, in niche on façade of Orsanmichele, Florence.

fifteenth century) demonstrate this point; sarcophagus and other reliefs, for all their vitality and complex compositional ideas, portrayed the gods, not the human predicament. This psychological emphasis was to be the innovation of the Renaissance, built, it is true, on the inspiration of antique Roman portrait sculpture. Just as there is no account of Man's indecision in ancient literature to compare with *Hamlet*, so nothing approaches the complexity of the mental stance of Donatello's *St George*.

Nanni di Banco's *Four Saints* on the north façade of Orsanmichele, although robed like Roman senators and dripping *gravitas* from their drilled hair and from every heavy fold of their togas, give no impression either of thought or of communicable emotion. The *St George*, however, in a neighbouring niche (c. 1415?; original now in the Bargello), stands in an equivocal legs-astride posture which hesitates between unease and defiance. This ambivalence is concentrated by the smallness of the figure within a tall but shallow niche, and by the outward-pointing sword or spear which the saint originally held. Donatello contrives to

convey spiritual as well as physical energies by gesture, expression, stance and drapery, all of which he adjusts according to the work's destined location. The expressiveness of two prophets for the Cathedral campanile, the *Jeremiah* (1423–6?) and the *Habbakuk* (1427–36?), the one fraught with holy terror, the other more starkly benign, supports Vasari's story of the sculptor pleading with the *Habbakuk* to speak. The mechanics of the way in which Donatello made his figures 'think' were to be studied with great attention throughout the Renaissance, for their involved psychological nature was recognized and imitated.[341,350]

Such considerations do not, of course, negate the strong antique inspiration of the majority of Donatello's work.[348,362] They underline, however, the innovatory aspect of the Italian Renaissance which, while building on foundations laid by Antiquity, produced works quite distinct from its models.[356] Antique traditions provided the strength of classicism: modern reinterpretation provided the vitality and renewal necessary for its lasting importance.

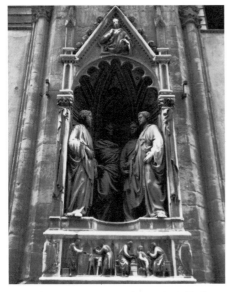

Nanni di Banco: Four saints, Florence, 1410–15. Orsanmichele.

It is to be expected of an artist as varied as Donatello that his interpretations of Antiquity should often be more personal than the tenets of classicism allow, for his response to antique art (and hence to the Middle Ages) was scarcely that of an antiquarian. Sometimes he takes classical art to pieces and reconstructs it differently, as in the *Cavalcanti Altar* (Florence, S. Croce, c. 1435), where the tabernacle is certainly antique in its separate elements; but these are put together with a supreme disregard for the syntax of classical architecture. A comparison between his *Singing Gallery* for Florence Cathedral (1433–9) and Luca della Robbia's *Singing Gallery*, also for the Cathedral (begun 1432; both works now in the Museo dell'Opera del Duomo) shows the contrast between Luca's naturalistic and controlled classicism and the demonic character Donatello gives to the rowdy *putti* who race across his Gallery. Luca's figures are elegant in proportion and in rhythmic movement, clearly spaced the length of the work; Donatello has borrowed his nearly naked *putti* from some bacchic sarcophagus: they shove, kick and crowd each other behind the architectural members which are again derived, if distantly, from antique models. Luca's work is a studious revival of antique forms, but it lacks the spirit of vitality which Donatello learned also from the antique and applied to his creations. Another comparison would be with work

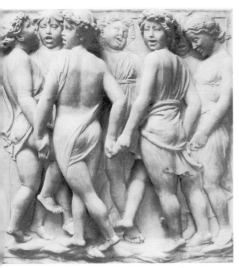

Luca della Robbia: Singing Gallery, detail. Florence, Museo dell'Opera del Duomo. c. 1432.

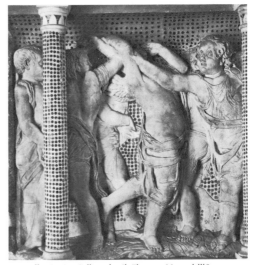

Donatello: Singing Gallery, detail. Florence, Museo dell'Opera del Duomo. 1433–9.

carried out by Michelozzo, his partner for about ten years from c. 1423.[353,354] Together they made two tombs: that of *Cardinal Brancacci* (1427; made in Pisa, shipped to S. Angelo a Nilo, Naples), where Michelozzo's pensive figures in double-tucked chiton who hold back the curtain of the bier contrast with the rustic-featured and dramatic plaque of *The Assumption of the Virgin* by Donatello.[355] In the other tomb, of the anti-pope *John XXIII* (Florence, Baptistery, finished c. 1426), the uncompromis-

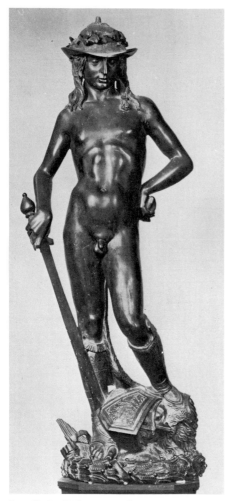

Donatello: David. Florence, Bargello.

ing realism of Donatello's effigy again offsets Michelozzo's blank-faced, toga-clad figures in their antique shell-adorned niches on the tomb chest, which is a direct imitation, we may be sure, of some antique prototype.

Donatello's highly coloured interpretation of Antiquity probably began with a visit to Rome, placed by Vasari in late 1401, but in fact probably c. 1410, for it is only with his *St Mark* (1411) on Orsanmichele that Donatello's work takes on any reminiscence of antique *contrapposto*, facial characteristics, or drapery effects. Donatello supposedly made the visit with Brunelleschi: 'They left no place unvisited, either in Rome or its neighbourhood, and took measurements of everything when they had the opportunity', writes Vasari. A later visit, perhaps in 1430–3, not only gave him work (the *Tabernacle of the Sacrament*, now in St Peter's, Rome, derived from a Meleager Sarcophagus) but may well have introduced him to Leon Battista Alberti. Alberti was the son of a family banished from Florence, and worked from 1428 to 1431 for Cardinal Albergati, a powerful figure in the Papal Curia; he then worked as secretary to the Chancellor B. Molin until 1434, when he went to Florence, probably for the first time in his life (see pp. 128ff.,). Evidence for a friendship with Donatello is a warm reference to him in the preface to *Della Pittura*, written in 1435: 'After I had returned from exile . . . I recognised in many, but foremost in you, Filippo [i.e. Brunelleschi], and in that very good friend of ours, Donato the sculptor, and in . . . Masaccio, a genius for all praiseworthy endeavours not inferior to that of the famous ancients . . .' It has also been shown that the proportions of Donatello's bronze *David*, and the later one in marble (now in Washington) adopt similar proportions to those suggested in Alberti's *De Statua*, written c. 1433.[361] Perhaps we may therefore imagine Donatello welcomed into the humanist circle in Rome, which included Poggio Bracciolini, Bartolomeo Aragazzi, and Cardinals Niccolò Albergati and Prospero Colonna, as well as Alberti, all men involved in the study of Antiquity in its various forms. He surely saw the sights with them, and shared their enthusiasm for those reminders of a time when Rome

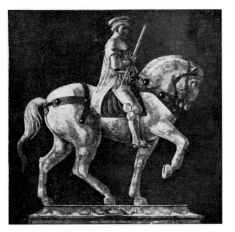

Uccello: detail of monument to Sir John Hawkwood, 1436. Florence Cathedral.

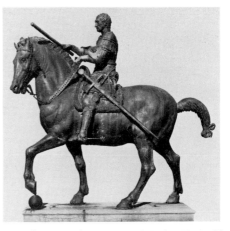

Donatello: Gattamelata, c. 1443–53. Padua, Piazza del Santo.

was great, *frena orbis rotundi.* We know from Alberti's works that a revival of the arts, following an antique pattern, was taxing his thoughts during the very years of Donatello's visit. Was one of the heroes of that revival, Donatello, able to talk of theory with the humanist, and help to mould his ideas? Was the bronze *David* (Florence, Bargello), of this period and derived from the antique Antinous type, influenced by Alberti's ideas, or did Donatello's work inspire Alberti?

In 1443 Donatello left Florence for Padua, leaving the field clear for a type of sculpture, the 'sweet style' of artists like Antonio and Bernardo Rossellini, and Desiderio da Settignano,[358,359] which drew inspiration from his own more approachable works, like the *Pazzi* Madonna (c. 1422, Berlin). At this date, furthermore, Ghiberti's *Gates of Paradise* were not in place, and Luca della Robbia was also working in a less demanding manner than, for example, Donatello on his prophets for the Cathedral campanile.

In Padua, Donatello produced two works which were to be of vital importance to the development of classicizing painting and sculpture: the *Equestrian Monument to Gattamelata* (c. 1443–53, Padua, Piazza del Santo) and the series of seven free-standing bronze statuettes under an architectural canopy, with twenty-one bronze plaques and one stone

plaque disposed around the base, for the *High Altar* of the Basilica of St Anthony (c. 1446–50) called the Santo Altar. The figures were of the Virgin and Child with saints—a *sacra conversazione*—the plaques depicting scenes from the Passion, and from the life of St Anthony.

The *Gattamelata* is the most impressive example of a growing tendency to exalt great men in sculpture, painting and architecture, in a re-creation of ancient Roman *virtus.* This is not the Christian virtue of saintliness, but rather an amalgam of wisdom balanced by heroism, or a rational equilibrium, with the qualities of courage, patriotism and steadfastness also suggested.[346,349] Antique equestrian parallels existed[360]: the *Marcus Aurelius*[347] in Rome, the great statue of *Justinian*[352] in Constantinople, the *Regisole*[342] in Pavia and a modern monument by Florentine sculptors to Niccolò III d'Este in Ferrara (1441–2) possibly derived from the *Regisole.* Near at hand were direct models for the horse: the antique quadriga, booty from Constantinople, on St Mark's, Venice. Other precedents included the Scaliger Tombs in Verona, and Uccello's fresco of *Sir John Hawkwood* in Florence Cathedral, of 1436. Uccello, working in Venice 1425–c. 1430, used the bronze quadriga as a model for his horse, but, whereas he painted his mercenary in contemporary dress, Donatello dressed Gattamelata in a curious amalgam of ancient and

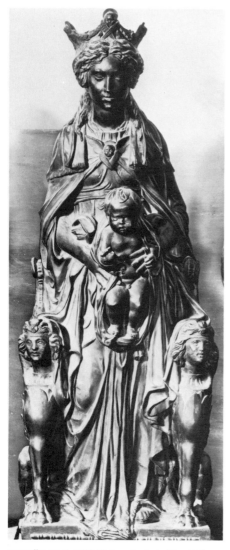

Donatello: Virgin and Child, from the Santo Altar, Padua.

does not explain the 'meaning', does give to the figure a structural backbone: horizontals and verticals augment the austere sense of unswerving purpose. As in the art of Giotto, composition may be said to clarify and support meaning: we shall find similar qualities of balance and restraint, moral as well as physical, in composition and subject-matter throughout the classical tradition.

The Santo Altar[363] raises wider questions about Donatello's involvement with the past. Is the group of *Virgin and Child* derived from Etruscan sources or, as seems more likely, from Romanesque groups of the *Madonna in Majesty*?[345] What did the architectural canopy look like, and is Mantegna's altar piece for S. Zeno in Verona a reflection of the arrangement? What contacts did Donatello have with the scholars of Padua, a well-known centre for the study and indeed forgery of antiquities? Certainly, the Altar is monumental in its heroic intention, in the grand seriousness of the figures and in its use of the antique.[343] Some reliefs, such as *The Miracle of the Mule*, enhance the glory of the Church by the grandeur of the architecture: that relief has great Roman barrel vaults, complete with trumpeting figures, which tower above and beyond the frieze arrangement of the figures watching the miracle. Others, such as the *Pietà*, attain a pathos which is truly antique. In the Altar, as in certain of the scenes on the pulpits for S. Lorenzo in Florence, on which he was working when he died, Donatello invests antique references with an imaginative power which, redolent of heightened emotion, sometimes departs from the norms of classicism into a more private world.[351] His art is, however, crucial for the classical tradition because he demonstrates how to make pieces of stone look and act like living, thinking beings, and how to impart to them a sense of high purpose. Raphael and Michelangelo, as we shall see, are greatly in his debt.

Masaccio

If Donatello's *St George* transformed sculpture, then the frescoes of his friend Masaccio recreated the manner of Giotto in painting. Yet

modern, and made his head a Roman portrait with a fair resemblance to Julius Caesar. The group is on a high pedestal, with one satisfactory view: seen from the left side, we can contemplate its silhouette and admire the control the man exercises over his horse and hence over himself. The whole composition is controlled by a rigorous geometry which, while it

Masaccio's example led to no immediate conversion to a classical manner in Florence, where Pisanello, Benozzo Gozzoli and Gentile da Fabriano, the counterparts to Lorenzo Ghiberti in sculpture, worked in the popular International Gothic style long after his death. Masaccio's two most important works are a *Holy Trinity with Donors* (c. 1426, Florence, S. Maria Novella), and part of a series of the *Life of St Peter* (1427, Florence, S. Maria del Carmine, Brancacci Chapel).

The *Holy Trinity*[364] must have amazed contemporaries in its demonstration of the new science of perspective, invented by Brunelleschi and first demonstrated in the bas-relief on the pedestal of Donatello's *St George* (perhaps c. 1417; some scholars place it in the 1430s). The eye looks up to the towering figures of the Virgin and St John, into the barrel-vaulted church nave in which is the Trinity. The pseudo-architecture[366] is close to the manner of Brunelleschi. Before the entrance to this painted nave is a painted tomb, bearing the skeleton of the First Adam, who did not die in vain, for we see the Second Adam, with Father and Holy Ghost, apparently moving in *our* space. Masaccio's settings are as tightly constructed, his figures as credible, even when he has no architecture to echo antique nobility. In *The Tribute Money* (Brancacci Chapel),[365] the holy figures are palpably of our world because he clothes them

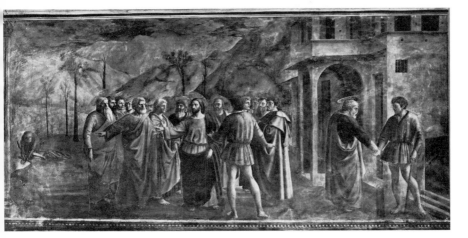

Masaccio: ABOVE *Trinity, fresco, detail, c. 1426. Florence, S. Maria Novella.* BELOW *The Tribute Money, fresco. Florence, S. Maria del Carmine, Brancacci Chapel.*

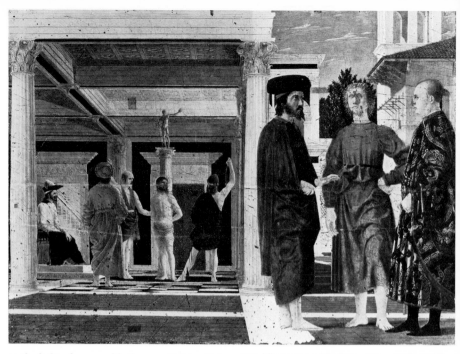

Piero della Francesca: Flagellation. Urbino, National Gallery, Palazzo Ducale. 'A painting is nothing else than the demonstration of bodies and surfaces which experience diminution or forshortening . . . I consider it necessary to have prospectiva, which proportionally distinguishes all the dimensions from one another as becomes a true science.' Piero, in De prospectiva pingendi.

in the light of our world, the same light which rakes through the window of the chapel and across the fresco. He also attempts aerial perspective: objects close to our eye are more distinct than distant ones. In this and the circular central motif with Christ as the pivot, the fresco parallels Donatello's contemporary relief of *The Ascension, with Christ giving the Keys to St Peter* (London, Victoria and Albert Museum).[357] Of all the figures in the fresco, only the tax collector appears in Florentine dress; all the others wear togas which, sturdy as tree-trunks, support the noble, pensive Roman portrait heads of the Apostles. Possibly the composition itself also owes much to antique or Early Christian prototypes.[367]

In 1428 Masaccio went to Rome (presumably not for the first time), where he died. Throughout the Renaissance, he was considered the artist who revived and embellished with greater naturalness and more illusionistic perspective the classicism of Giotto. Vasari named him as the one who 'first painted people's feet actually standing on the ground', and went on to list the great names who 'have become excellent and distinguished by studying in that chapel'.

Piero della Francesca

There was no Florentine artist who adopted wholeheartedly the style of Masaccio. Fra Filippo Lippi does, perhaps, reproduce some of his sense of volume described by light in works like the *Coronation of the Virgin* (1441–7, Florence, Uffizi). Masolino provides, both in the Brancacci Chapel and in the baptistery at Castiglione d'Olona, a compromise between Masaccio and International Gothic. Piero della Francesca, from Borgo San Sepolcro, near Arezzo, makes the most constructive use of Masaccio's classicism in the mid-century. He is recorded as working under Domenico Veneziano in Florence in 1439, and it is probable that he had been there some considerable time before he went to work in Arezzo and Ferrara during the 1440s, for Florence was the only place where he could have developed a lifelong interest in Masaccio and in mathematical

perspective. His first great work, the *Madonna della Misericordia* (Borgo San Sepolcro, Palazzo Communale, commissioned in 1445) has several parallels with Masaccio's *Pisa Polyptych* (for the Carmine church, Pisa, 1426): Piero would have travelled to Pisa to see it, and the pulpit of Nicola Pisano as well. In both works, furthermore, the inspiration of Donatello is evident, and it has been suggested that the manner of Andrea del Castagno, a follower of Donatello in painting, is also to be seen in Piero's figures.

But it is the Brancacci frescoes which are the main foundation of his art. He found in them a concern for bulky, idealized form in a strictly geometrical setting which aided monumentality. His own fresco cycle of *The Story of the True Cross* (Arezzo, S. Francesco, c. 1451–c. 1463) contains figures of almost abstract geometricality, carefully placed in a constructed space flooded with light which, as in the Brancacci Chapel, is logically disposed according to the actual light source from a window. Such simplified forms, always calm, sometimes pensive but without particularizing features, and simply if majestically clothed, achieve an impassive grandeur which, after close study by artists like Raphael, was only to be rediscovered by Seurat and Puvis de Chavannes, after four hundred years of neglect.

While in Florence Piero may well have spent much time in the circle of Brunelleschi and Alberti.[368,370] He was certainly the friend of the latter from 1450, when he began painting *Sigismondo Malatesta before his patron saint* in S. Francesco, Rimini; Alberti was transforming this church into a classical temple in a style more antique and much less spidery and elegant than anything Brunelleschi had executed in Florence. A better impression of Alberti's style *ab initio* than that unfinished conversion is given by his *Tempietto del S. Sepolcro* in the Rucellai Chapel in S. Pancrazio, Florence (c. 1650–60). Rich in marble inlay, this shrine illustrates Alberti's conception of the simple cubic beauty of ancient architecture; there are no frills, and the cool proportions are patently worked out mathematically. Piero's *Flagellation* (c. 1456?, Urbino, Palazzo Ducale), while mysterious in subject-matter, is crystal clear in its Albertian architecture,[369] and in its complicated but exact scheme of perspective.[371] The Arezzo frescoes also convey a strong sense of immobile figures fixed for all eternity within their antiquarian settings. Here again the architecture derives from Alberti (compare the building in *The Proof of the Cross* with Alberti's façade for S. Francesco, Rimini). It therefore comes as no surprise to learn that Piero spent his last years writing two works on perspective—*De prospectiva pingendi* and *De quinque corporibus*—which underlines his mathematical approach to beauty. Furthermore, it is likely that Piero maintained connections with Florence throughout his career: perhaps he went there again in the late 1450s, for the two Arezzo battle scenes, *The Victory of Heraclius over Chosroes* and *Constantine's Victory over Maxentius*, are dependent for perspective and for the occasional figure on Uccello's battles. He must also have known well the work of Andrea del Castagno, whose *Last Supper* and *Resurrection* (1449/50, Convent of S. Apollonia, Florence) and the *Famous Men and Women* from the Villa Legnaia are stylistically similar to Piero's work at Arezzo. Indeed, the whole idea of Piero's *Resurrection* comes from Andrea del Castagno's work, with the flag-carrying Christ stepping onto an almost identical tomb, with similar trees and lolling soldiers. Andrea del Castagno might be called the inheritor of both Masaccio and Donatello; for example, his *Pippo Spano* from the Villa Legnaia is a brash version of Donatello's *St George*, with all his doubts resolved.

Mantegna

A similar mixture of Florentine styles was crucial to the formation of Andrea del Mantegna, the most antiquarian of classical artists in any century. The adopted son of Squarcione, a Paduan antiquary and teacher,[395] the boy was made, according to Vasari, to 'study from plaster casts of antique statues from various places, but chiefly Tuscany and Rome'. Squarcione's own collections would have included statuettes and coins, and probably drawings as well.[376,393] Mantegna's first

Mantegna: St James led to Execution. Padua, Eremitani.

work, the saints in the spandrels of the Ovetari Chapel (c. 1449, Padua, Eremitani Church; destroyed in World War II) are in the manner of Castagno's frescoes in nearby Venice (1442, S. Zaccaria),[377] while his earliest scenes on the walls—lunettes of *The Calling of James and John* and *St James Expelling Demons*—strongly resemble the manner of Filippo Lippi, who had painted frescoes (now lost) in the Capella del Podestà in Padua (c. 1434?). At that stage in his career, Filippo was firmly wedded to the formal ideals of Masaccio, whose pupil he may have been. Uccello, too, had worked in Padua, summoned thither by Donatello, but the frescoes (in the Casa dei Vitaliani) are lost. We can only assume that they resembled works he was to paint in the Chiostro Verde of S. Maria Novella in Florence, c. 1450. These works are in

monochrome, as were those in Padua; it may be that knowledge of both these schemes, together with a study of mostly monochrome antique statues, impelled Mantegna himself to work in monochrome, which he did increasingly as he got older.

More decisive than the above influences is that of Donatello, in Padua from 1443, and therefore during the years of Mantegna's youth (Mantegna was probably born in 1431). Donatello's work there, writes Vasari, was 'considered as a miracle there and praised by every intelligent man'. From Donatello's example, Mantegna learned how to construct in paint figures which looked like antique statues, with draperies sharp, hard and detailed. Together with a tendency to eschew colour, this style makes for an unemotional dryness

(far removed from Donatello), which his overt antiquarianism intensifies.[392] His works often give the appearance of being archaeological reconstructions, so thorough was his knowledge of classical literature,[373] epigraphy and art; his interest in antique architecture,[375] furthermore, perhaps depends on a knowledge of Alberti's theory and practice.[372,388] Probably he also had connections with antiquaries of wider experience, such as Cyriacus of Ancona, whose knowledge of Greek sculpture from Samothrace is perhaps reflected in Mantegna's *Parnassus* (Paris, Louvre).[379,380] Unfortunately, the frescoes that he painted in Rome have not survived.[384,390]

The frescoes of *The Lives of SS. Christopher and James* on the walls of the Ovetari Chapel (1448–55?) develop Masaccio's concern for perspective and tactility to such an extent that the figures appear to be real human beings on a stage which begins about two feet above our heads. Monumental in scale, dressed in correct antique clothing, the figures make the Roman scenes come to life with an illusionism which was to be much studied by Correggio and then the Baroque. For Mantegna, Antiquity was full of splendour, as in *St James before Herod Agrippa*,[378] which has in the background a triumphal arch with bas-reliefs and roundels,[396] and lettering in a style no doubt culled on one of his antiquarian excursions with Felice Feliciano.[385,387] Throughout Mantegna's paintings, such attention is paid to epigraphy that he has been called the reviver of the Imperial Roman Majuscule.[386] The illusionism of the Ovetari Chapel is continued in the Camera degli Sposi in the Castello at Mantua (begun 1472), but is equally apparent in the altarpiece for S. Zeno (1456/9, Verona, S. Zeno), in which the architectural canopy which forms the frame, and the type and disposition of the figures, surely derive from Donatello's Santo Altar. Again, the transposition of sculpture into paint is typical of Mantegna and, what is more, this type of altarpiece was a recent Florentine development. Previously, elements of the *sacra conversazione* had been marooned in separate panels of a polyptych, but Filippo Lippi's *Barbadori Altar* (begun 1437, Paris, Louvre)

represented the new trend of unifying the picture space. In the *S. Zeno Pala*, the figures stand within a loggia of antique architecture, and possess a Roman solemnity and general aspect. The same airy illusionism, and the same concern with Antiquity, is evident in the Camera degli Sposi, which is painted as a perspective extension of our space on two sides, unified with the facing two walls by the painted leather curtains hung on them and continued by Mantegna's painted curtains, swept back to reveal the Gonzaga Court. If one ignores the sheer ordinariness of the two scenes, one on each wall (decorated with charming details), the very solemnity of those

Mantegna: a wall of the Eremitani, Padua (largely destroyed in World War II), c. 1448–55.

simple and grave figures acting out their lives amidst an exuberant Antiquity which infects even the landscape is touching; they are disposed around the wall at eye level like one of the antique friezes owned by Mantegna's patron. Balancing the actuality is the ideal of the background to *The Meeting of the Marquis with his Son, Cardinal Francesco Gonzaga*, which shows a landscape with antique temples, pyramids and statues, a fitting setting for such an antiquarian court.

That the Gonzaga court really was a humanist court steeped in the study of Antiquity[391] and surrounded by its remains (there was also a fine collection of antiques)[382,383] is fully reflected in the nine canvases of *The Triumph of Caesar* (perhaps begun 1485; originally Mantua, now Hampton Court). It may be that they were used as theatre scenery, presumably as back-drops to performances of plays by Plautus and Terence or by their contemporary imitators, antique drama being very popular there. It is known that the canvases were hung between pilasters, which would have framed them but also would have heightened the impression of a continuous procession passing behind the pillars of a loggia inside which the spectator appeared to stand. The inspiration for them is partly literary, and the procession copies no specific antique frieze, although it owes an obvious debt to Roman triumphal imagery. We should bear in mind that the enactment of triumphs was a serious part of Renaissance pageantry, accompanied by just those trappings of the genre (antique shields, statues, inscriptions) which Mantegna is known to have provided for a play in 1501. As well as theatre back-drops, perhaps the canvases were conceived as decorations in the manner of those in the Camera degli Sposi. Certainly they were hung in the new palace by the Porta Pusterla, the Palazzo Te, which one Seicento chronicler maintained was erected solely to house them! They remained there until 1626, and were sold three years later to the agent of Charles I of England, together with some antique statues, for no less than £10,500.[394] This immense sum (slightly less than the annual income of the wealthy Earls of Rutland, in an age when a skilled craftsman earned about £35 per annum) indicates the fame of the series, which important visitors to Mantua were always shown. That fame was extended not only by subsequent artists in Mantua, particularly Giulio Romano, Titian and Rubens, but also by the publication of sets of engravings, the sale of which had already begun in Mantegna's lifetime.[381,389] Knowledge of his work even reached Normandy via prints.[374]

The Triumph of Caesar is no piece of dry-as-dust antiquarianism. Its combination of what must have been bright colouring, strongly rhythmic movement and splendid ornaments contrived to make it the most impressive poetic, if not realistic, vision of the classical ideal. Mantegna recreates, through a frieze of rhetorical figures, a living and breathing past which must have found many echoes in contemporary Mantuan custom.

Such classicism was only one of several varieties current in the later Quattrocento, from the neo-Attic manner of Agostino di Duccio at Rimini (a Florentine sculptor and architect working on the Tempio Malatestiano under Alberti) to the even more neoclassical manner of Tullio Lombardo in early sixteenth-century Venice. Painting was less affected by classicism, as the production of Florentine workshops in the second half of the century clearly showed. Indeed, while Florence had spread her craftsmen and her styles all over Italy, soon the inevitable was to happen when Rome began her rise as a star to eclipse Florence permanently. When Sixtus IV began to decorate the Sistine Chapel in the Vatican (1481), the first artists to be employed were Florentines, but later the balance shifted to Umbrians, principally Perugino and his pupil Pinturicchio (the latter working in the Borgia Apartments in the Vatican).

The new focus on Rome encouraged a style more grandly classical than anything hitherto produced, in architecture, painting and sculpture. The artists reviewed in this chapter all contributed in important ways to the formation of that classicism which is the most significant feature of the period we call the High Renaissance.

6

The High Renaissance

A vigorous Papacy, keen to patronize art, made Rome the chief centre of classicism in the first two decades of the sixteenth century. The historic and even organic conjunction of Rome and classicism ensured that artists were attracted there from all over Italy. The ambitious schemes that were centred around the building of new St Peter's, the refurbishment and extension of the Vatican Palace, the increase in church building and renovation and particularly in commissions for the building and decorating of private palaces and villas made Rome the target of every artist who wished to learn and profit by the new monumentality. There never was, however, any one 'High Renaissance style', but a variety of manners which had certain qualities in common. All artists respected Antiquity, and wished to see the new Rome bear some relation to such an inspiring past. All adopted a simpler and clearer style than any of those current in late Quattrocento Florence, for example, while the pretensions to grandeur and to correct archaeological knowledge were greater in the setting of Rome and her ancient monuments. All these elements conspired to motivate artists to produce works of art and architecture of high idealism and intellectuality, and on a scale (not merely of a size) greater than anything hitherto attempted. Vasari, who breaks the Renaissance into three sections, from Nicola Pisano to *c.* 1400, then the Quattrocento, then the Cinquecento (which he almost, but not quite, marks as 'good', 'better' and 'best'), sees previous ages as preparing for what we call the High Renaissance, which then transformed earlier styles into something new. What he calls the 'dry, hard, trenchant manner' of the Quattrocento was, he claims, transformed by the innovations of Leonardo da Vinci, who inaugurated the 'third manner'.

Leonardo da Vinci

Leonardo, according to Vasari, could make figures 'with correctness, improved order, right measure, perfect drawing and a godlike grace'. These qualities and the contrast they make with the 'dry' (i.e. sculptural) manner can be seen in a very early work, the left-hand angel which Leonardo painted in Verrocchio's *Baptism of Christ* (*c.* 1475, Florence, Uffizi). His master's figures are flat and tough, with a nervosity derived from Castagno: they are a frieze, set against a landscape with no depth. Leonardo's figure, on the other hand, seems alive. The supple body, the tilt of the head, the formation and colouring of the flesh and drapery (not to mention the landscape) are more richly powerful than Verrocchio's forms. With such exuberant life, such bulky drapery (studied from clay figures covered in stiffened cloth, says Vasari), and such subtle colouring, Leonardo's angel exudes a new authority, a new ideal for the human body. The first great painting for which he was totally responsible, *The Adoration of the Magi* (commissioned 1481, never finished; Florence, Uffizi), introduces another great gift from which the High Renaissance could benefit: his ability to design a simple yet strongly constructed composition. Leonardo was a scientist as well as an artist, and it is possible that his concern with mechanical equilibrium of forces prompted similar experiments in art. Structural mechanics also exercised him in his architectural studies.

Two early composition drawings for *The Adoration of the Magi* show the composition

Leonardo da Vinci: Adoration of the Magi. Florence, Uffizi. 'It is one of the ironies of art history that the Adoration, the most revolutionary and anti-classical picture of the fifteenth century, should have helped to furnish that temple of academic orthodoxy, Raphael's Stanza della Segnatura.'[398]

built up on the traditional perspective grid, with steps in the foreground which, as it were, set the figures in a grander world than ours. In the painting, the figures articulate their own space because of the strength of the pyramid in which the main group is arranged. The Virgin and Child form its apex, the worshipping kings its base. The triangle affirms a psychological as well as a physical relationship, an electric flow of meaning induced by a glance, a gesture or a fall of drapery within its field of influence. Masaccio had used an open circle in *The Tribute Money*, but his figures lacked those attributes of characterization and human vitality which Leonardo's techniques permitted. Leonardo's figures are of every age and type, from the beauty of youth to the craggy decrepitude of old age, from the Masacciesque philosopher on the left to the Donatellian knight on the right. They are presented as types, as an ideal gallery of the human body and the human soul. 'A good painter', he wrote, 'has two chief objects to paint, man and the intention of his soul; the former is easy, the latter hard, for he has to represent it by the attitudes and movements of the limbs.'[404]

The Adoration of the Magi is the first document of the High Renaissance manner, but it is a painting with quite different qualities as well. Leonardo's discovery of how to model features in light, his *sfumato*, which regulates colouring in subtle stages,[405] can prompt the dreamy vagueness and twilight poetry of Giorgione, the sensuous elegance of Andrea del Sarto, as well as helping Raphael to a more immediate realization of three-dimensional form. As the work stands, with its main figures in underpainting only, the pyramidal armature is very clear; finished, would the work have looked something like Filippino Lippi's painting of the same subject (1496, Florence, Uffizi) which is based upon it? Why did Leonardo leave so much unfinished? Was he perhaps aware that no compromise was possible between the classical and romantic aspects of his personality, and that his works could not, as Lord Clark put it, 'survive the Florentine ideal of finish'?

Whatever the answer, his interest in structure continued. The two versions of *The Virgin of the Rocks* (one commissioned 1483 and still unfinished 1508; London, National Gallery; the other *c.* 1492, Paris, Louvre), for all their dark mystery, show a small number of figures in a pyramidal formation, linked by gesture and glance. The composition is unified by light, on which the colouring depends. Because the very forms are therefore controlled by the light (rather than by hard-edged patches of colour), Leonardo can impart a new majesty to his ideal types and make them assert their position in space, which breathes around them. He adopts a tonal, not a chromatic approach to colour; certain hints of this idea are to be seen in Masaccio, and were presumably recognized by Leonardo, but his main impulse would have come through reading Alberti's *Della Pittura*, with its theories based on antique practice.[410] Leonardo was also conversant with ancient literature on the subject.[403,404]

The majestic terror of *The Virgin of the Rocks* is dispelled in his *Last Supper* (*c.* 1495–8, Milan, refectory of S. Maria delle Grazie).[408] A comparison with Ghirlandaio's rendering of the subject (1480, Florence, refectory of the

Leonardo da Vinci: The Last Supper, c. 1495–8. Milan, Refectory of S. Maria delle Grazie.

Ognissanti), or with Castagno's (illustrated here), demonstrates the pithiness of Leonardo's new manner. Ghirlandaio's and Castagno's figures sit calmly, with glazed eyes in a sumptuous setting filled with beauty and incident. What is happening? Nothing of significance, reply the composition, the mood and the detailing of the picture. Leonardo, Vasari tells us, spent a lot of time just looking at his own fresco when, as the angry abbot claimed, he should have been 'working'. The artist protested that 'men of genius are really doing most when they work least, for they are thinking out ideas and perfecting the conceptions which they subsequently carry out with their hands'. Leonardo's *Last Supper* therefore

Castagno: The Last Supper. Florence, Convent of S. Apollonia. Similar in mood to Ghirlandaio's, but without the garden behind.

After Leonardo: The Battle of Anghiari, engraved by L. Zacchia, 1558.

shows not simply a ritual-to-be of the Church, but its climactic moment whose implications are central to the general experience of humanity, just as they are to the specific beliefs and morality of Christianity:

> And in the evening he cometh with the twelve. And as they sat and did eat, Jesus said, 'Verily I say unto you, One of you which eateth with me shall betray me.' And they began to be sorrowful, and to say unto him one by one, 'Is it I?'
>
> (Mark xiv)

It is this point, *before* the institution of the Eucharist, that Leonardo chooses as the moment of high drama and significance: its tension is expressed in every face except that of Christ, yet is controlled by the organization of the composition. Christ is seated in a triangle of passivity while around him a storm breaks; the Apostles, like rolling waves, retreat in a highly ordered confusion, by threes to give structural cohesion and emotional contrast. The table trestles (now invisible), 'point' quite clearly to the groupings, while the dark panels of the room, in their staccato rhythm, balance the smooth white horizontal of the tablecloth, which is as strong a unifying element as the perspective with its vanishing point in the head of Christ.

The *Last Supper* is not realistic, but the representation of an ideal. The table is too small to seat thirteen guests; the space is formed by the exertions of the figures and not by mathematical perspective; the background is stripped of all diverting incident. Most important, the figures are not portrait studies of ordinary men drawn at random, but types of men making types of reaction to Christ's statement. Because of the abstraction of this highly organized, even academic composition, and because of the potency of the figures, the significance of the painting is heightened. The work sets the tone for Raphael who, like Leonardo, considered painting an intellectual activity. Leonardo despised artists who were like mirrors, who drew 'by practice and judgement of the eye without reason'; rather, he thought of his art as 'a subtle invention which brings philosophy and subtle speculation to bear on the nature of all forms'.

In 1504 Leonardo was commissioned to paint a secular work, *The Battle of Anghiari*[401] (originally Florence, Palazzo Vecchio, Sala del Maggior Consiglio) which introduces us to the difficult problem of Leonardo's knowledge and use of antique art. Just as in *The Last Supper* Leonardo had experimented with oil as a fresco medium, here he tried the ancient technique of encaustic. Whatever painting survived his experiments was subsequently destroyed by copyists; the central section of *The Fight for the Standard* is known through poor copies and through prints, but his drawings show that the whole composition included massed cavalry action in an extensive landscape.[400] The centrepiece bears the same relation to Quattrocento battle scenes as does *The Last Supper* to earlier versions: Leonardo concentrates the action with a small number of figures on a grand scale within a vigorous composition which epitomizes the blood and fury of combat. No less than Michelangelo's *Battle of Cascina*, painted in the same room and in direct competition, Leonardo's work was a political statement of the glorious past of the Republic, now freed from the tyranny of the Medici. But whereas Michelangelo's cartoon consisted entirely of male nudes, not evidently related compositionally, the older man used his powers of characterization and compositional geometry to evoke intense energy. Compared with the confusion of Quattrocento battle scenes, *The Fight for the Standard* shows

again that selection and simplification by epitome which are the essence of High Renaissance classicism. There has been a tendency to deny that Leonardo had any interest in that source of classicism, namely Antiquity, but recent researches have uncovered much relevant material.[409] Lord Clark and others detect the influence of antique battle sarcophagi in his work after *c.* 1500, particularly from examples known to have been in the Aracoeli on the Capitol.[399] His drawings of ideal warriors[397] have been connected with colossal antique images,[402] and his two projects for equestrian statues, the *Sforza Monument* (begun *c.* 1483) and the *Trivulzio Monument* (perhaps begun 1506), clearly show the influence both of actual works like the *Marcus Aurelius* and of depictions of similar material on antique coins.[406,407] Leonardo must have been to Rome sometime between 1500 and 1505, because there are notes about Rome and the area in Codices *Madrid II* and *Atlanticus* which strongly suggest that they were made on the spot, and also because a long poem on the antiquities, dedicated to him and probably written by Bramante, would make no sense unless he had already been to the city (see p. 134, below). No work in sculpture by Leonardo (save the small bronze of a prancing horse in Budapest) has come down to us, otherwise the antique inspiration of his secular art might be clearer.

Raphael

Leonardo was entering an antique phase at just the time when Raphael arrived in Florence. Born in Urbino in 1483, his first allegiance was to the style of Piero della Francesca from nearby Borgo San Sepolcro, whose influence in the bulky figure types and noble space organization is evident in an early work by Raphael, *The Madonna of Mercy* (banner, late 1490s, Citta di Castello). The stern monumentality of Piero is modified in these early years by the graceful sentimentality of Pietro Perugino, who was Raphael's teacher from *c.* 1496, as in *The Mond Crucifixion* (1503?, London, National Gallery). Certain critics have seen in the galvanization of Peruginesque forms and in their greater vital-

ity a proof that Raphael was in contact with Florentine artists, particularly Leonardo, well before 1504. The greater organization of Raphael's art is shown in a comparison between his *Betrothal of the Virgin* (1504, Milan, Brera; cf. Perugino's painting on the same subject in Caen) and Perugino's *Christ giving the Keys to St Peter* (1481, Vatican, Sistine Chapel). The wide spaces and straggling figures of Perugino's composition invite our eyes to stray. Raphael reduces the number of figures and disposes them in two balanced groups about the priest. The round temple which closes both compositions is of greater compositional use in Raphael's: its curves, its open door and the podium on which it stands concentrate our attention by providing a dignified foil to the figures. Nor is it redundant in meaning, for it is a vision of the Church (centrally planned, of course) which will spring from the union of Joseph and Mary. All the elements of Raphael's composition are directed and emphasized by geometry; the

Raphael: Betrothal of the Virgin, 1504. Milan, Brera.

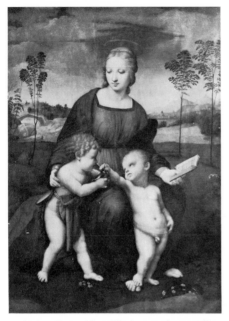

Raphael: Madonna of the Goldfinch, 1507. Florence, Uffizi.

square, the circle and the triangle control the picture, and pile moral certainty onto mathematical clarity.[417]

Autumn 1504 was an exciting time to arrive in Florence. Leonardo was working on the *Mona Lisa* (begun 1503), having returned from Milan in 1500, and also on the *St Anne* idea which was to result by about 1505 in the National Gallery Cartoon. Michelangelo might already have begun the *Doni Tondo* (Florence, Uffizi). The gigantic statue of *David* was set up before the Signoria on 8 September 1504, shortly after Michelangelo had been commissioned to fresco a battle-scene in the Council Chamber in the Palazzo Vecchio. He began to make studies for this, *The Battle of Cascina*, in October, and Leonardo was soon to begin his rival work in the same room.

Raphael's main concern would have been to learn from such masters.[426] Perugino, perhaps himself a pupil of Piero della Francesca in the late 1460s, and working in Florence in the 1470s, might have taught him something of Florentine ideas, but that was different from study of actual works. Two works of 1506, *The*

Madonna of the Goldfinch (Uffizi) and *The Madonna of the Meadow* (Vienna), pursue Leonardo's interest in a pyramidal arrangement, with two figures contained within the protective silhouette of the adult. Gone is Leonardo's dark mystery, replaced by the seemingly innocent play with a goldfinch in the one picture, and a friendly tussle over a cross in the other: yet the goldfinch is a symbol of the Passion, because it was thought to eat only thorns, while Christ's grasping of the Baptist's cross is another reference to the fate he will accept. The compositional scheme is refined in *La Belle Jardinière* (1507, Paris, Louvre). At the same time Raphael was experimenting with half-length portraits such as the *Angelo Doni* and the *Maddalena Doni* (c. 1506, Florence, Pitti), which both take up the firm pyramidal pose of the *Mona Lisa*, but simplify the background and banish the chiaroscuro. Mystery gives way to clarity and rigorous intellectualism, as we shall see with the most important example of the genre, Raphael's *Baldassare Castiglione* (c. 1515, Paris, Louvre). Raphael's other variations on the *Mona Lisa* theme include *La Muta* (c. 1505, Urbino), *A Cardinal* (c. 1511, Madrid), and *La Velata* (c. 1516, Pitti). Leonardo was to remain a potent influence on the whole of Raphael's career. Donatello was important for Raphael's Vatican frescoes,[421,454] but even in the early years his *Pazzi Madonna* type, partly responsible for the Florentine 'sweet style', is particularly fruitful for that tender gracefulness of Raphael's which, thanks to tourists' souvenir shops, has made of his art one of the most widely known and widely misunderstood of commodities.[431] Donatello, then Giovanni Bellini, had placed the heads of Virgin and Child in close proximity for pathos; Raphael did so to bring his Madonna down to earth, to make her relationship with the Child seem human. The marvel is that the images Raphael presents, such as the *Casa Tempi Madonna* (c. 1507, Munich, Alte Pinakothek), are not ordinary and pedestrian, because their structure, their restraint of detailing, colour and emotion idealizes them, not toward the untouchable supra-human goddesses of some of Leonardo's works, but as an ideal of human sweetness. Works like *The*

Madonna of the Chair (*c.* 1515, Pitti) and *The Sistine Madonna* (*c.* 1515, Dresden), much more monumental than the early Florentine examples, are based on the same motif.

Raphael also learned from Michelangelo, who, indeed, was to write in 1542 that 'all that Raphael knew in his art, he had from me'. He was particularly impressed by the circular *Taddei Madonna* (bas-relief, *c.* 1504, London, Royal Academy), which he sketched. The possibilities of the circular composition, and of the Child who flings himself bodily into his mother's protective grasp, while looking back at the bird (a goldfinch) held by his cousin, are worked out in *The Orleans Madonna* (1506? Chantilly, Musée Condé), a composition closed by the arms of Christ grasping the neck of His mother's dress, and her right hand holding His left foot. A work of greater power but equal stability is *The Bridgwater Madonna* (1507?, Edinburgh, National Gallery of Scotland, Sutherland Loan) where the Child turns His head over His shoulder toward the Virgin; the vigorous torsion of her head and the sweep of her draperies make a diagonal to balance that of Christ's body. From Perugino's flaccidity to such nervous strength was a great step, which was confirmed in *The Entombment* (1507, Rome, Borghese Gallery).[442] This takes up ideas from Michelangelo's *Battle of Cascina* and his *Doni Tondo* (as well as from his *Pietà* in St

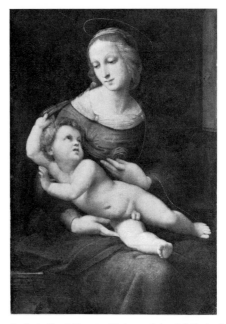

Raphael: The Bridgwater Madonna. Duke of Sutherland's collection, on loan to the National Gallery of Scotland.

Peter's, Rome, and from Mantegna's engraving of *The Entombment*). Preliminary drawings show that Raphael's first idea was for a *pietà*, but this was then changed to a subject where bodily power and strain might be studied: he paints a Meleager sarcophagus, as it were, but endowed with the greater nervosity of Michelangelo's art. The whole composition, a frieze with crossing diagonals, and figures of declamatory drama, bespeaks a new monumentality in Raphael's art, a physical power which projects emotional energy as well. We may speak of a new dimension, for from now on Raphael's figures do appear to require more space than previously: they become more dynamic and assertive, as Raphael learns how to weld figures together in grandiose compositions.[412]

It is the series of rooms in the Vatican, the *Stanze*, begun soon after he was called to Rome in mid-1508 at the instigation of Bramante, that shows this development clearly. However, the *St Catherine* (variously dated 1507 to 1509, London, National Gallery) provides a link

Raphael: The Entombment, 1507. Rome, Galleria Borghese.

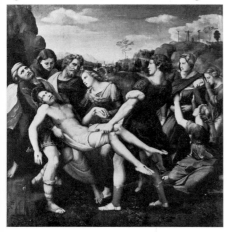

between Florence, Rome and the overwhelming interest of Raphael in the antique from now onwards. The dress might well be taken from some antique statue, and the powerful corkscrew posture is surely derived from Michelangelo's *St Matthew* (begun 1506 but unfinished, Florence, Accademia), and is therefore indirectly or even directly inspired by the *Laocoön*, discovered in Rome in January 1506. There is nothing unlikely about this new, mature Raphael using that most dynamic of all sculptural finds as a stepping-stone to a vigorous style[452] which was to crystallize in the Stanza della Segnatura. The meaning of the Stanza della Segnatura has already been explained :[423] its formal characteristics were to be equally influential.

We know of the enthusiasm with which Raphael studied the remains of ancient sculpture and even painting in Rome.[434] Fine collections were to be found in, for example, the Casa Sassi and the Palazzo della Valle. He recorded his impressions in drawings, which were then worked up into compositions. Thus the executioner in *The Judgement of Solomon* on

Raphael: St Catherine of Alexandria, c. 1508. London, National Gallery.

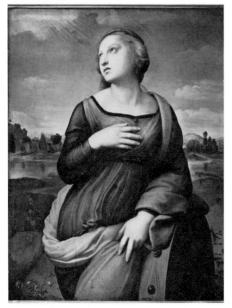

the ceiling of the Segnatura is taken from a torso in the Casa Sassi, while the scene of *Apollo and Marsyas* near by is taken from a statue in the della Valle collection.[428,432] (The same figure will reappear as the youth dropping from a wall in *The Fire in the Borgo*.) It is, however, often difficult to recognize prototypes in Raphael's work because his powers of assimilation, already seen in his treatment of ideas from Michelangelo and Leonardo, were applied to antiquities as well.

The first wall lunette in the Segnatura was the so-called *Disputa* (more accurately *The Triumph of Christian Religion*). This is a composition without architecture, but with figures sufficiently dynamic to provide a strong spatial structure, helped by abstract geometry. The airy space is shaped like the apse of a church,[448] and sweeping semi-circles of figures in three tiers—earth-bound, then thrones of cloud, then God the Father with a host of angels—echo the same circular form. The smallest circle of the monstrance with the wafer is the compositional and intellectual centre of the fresco, and the shape is repeated in the larger circle with the dove, and then in the Glory surrounding the enthroned Christ. Leonardo's lessons have been assimilated: Raphael can now articulate figures much more clearly than did the artist of *The Betrothal of the Virgin*. He has attained the spiritual excitement of Leonardo's *Adoration of the Magi* while avoiding any confusion; as in Leonardo's *Last Supper*, he groups his figures, which adds to their impact, and joins those groups together by gesture, which ensures the unity of the inherently stable semi-circular composition. We might even say that the truth of Christianity is proved for us by geometry, so clear and balanced is the composition, so ideal and noble with its rarified atmosphere and steps up to that human architecture. Indeed, its formal organization was to be highly influential.[424]

An important spur to some of the more powerful figure types (bottom left and right) was probably provided by a glimpse of Michelangelo's Sistine Ceiling. Raphael might have seen work in progress before half the vault (or, according to some, the whole) was unveiled in August 1510. Its prophets and

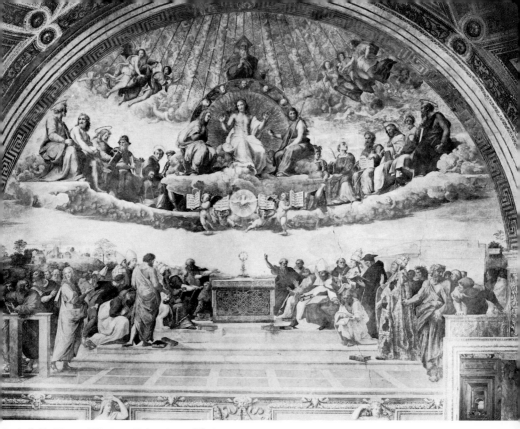

Raphael: The Disputa, 1509. Rome, Vatican, Stanza della Segnatura.

sibyls provided Raphael with some of the intensity evident in the most important fresco in the Segnatura, *The School of Athens* (1509–10), in which the atmosphere of 'high clear thought' (in Freedberg's phrase) is overwhelming. The scene is an idealized gathering of the thinkers of Antiquity, together with some moderns (including, for example, Bramante), within a domed hall which reflects the splendour of ancient Rome. The setting has reminiscences not only of the Baths of Caracalla, the Basilica of Constantine and the Arch of Janus Quadrifons,[429] but also of new St Peter's, so perhaps Raphael's mentor Bramante helped in its design. The treatment of the setting adds grandeur to the figures, and increases the profundity of their thoughts; it provides the geometrical elements which balance the fresco just as the meaning of the work is divided by Plato with his *Timaeus* and Aristotle with his *Ethics* symbolizing the two

ways of approaching knowledge. These two paths of empiricism and idealism are acted out, as it were, by groups of characters, each symbolic of a specialism, to left and right. Again, therefore, content is balanced and expressed by form. This fresco is the very keystone of Renaissance classicism: it will be used again and again as a reference point for artists learning how to design ideally rational forms in a grand setting.

Yet to write of the Segnatura as a keystone of classicism is to make certain assumptions about the nature and development of Raphael's style. The room was finished in 1511, and Raphael still had nine very productive years of life ahead in which he completed the frescoes of two more rooms the size of the Segnatura, several altarpieces and portraits, ten tapestry cartoons, the Vatican loggias and the Loggia of Psyche in the Villa Farnesina, these last mostly executed by assistants. Raphael was a very

97

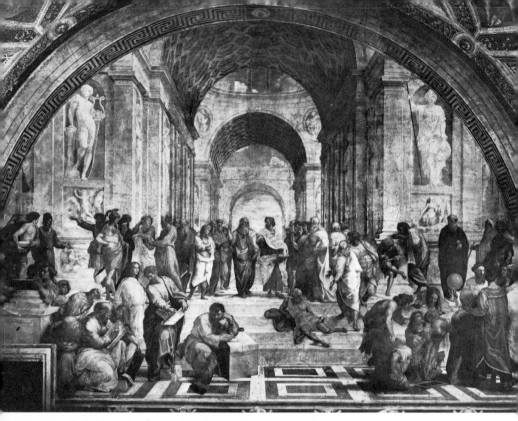

Raphael: The School of Athens, 1509–10. Rome, Vatican, Stanza della Segnatura.

inventive artist, and he was to continue developing solutions to particular stylistic problems for the rest of his life. We must therefore guard against applying partial hindsight to the problem, and seeing the rest of his *oeuvre* as either an extension of the classicism of the Segnatura, as a betrayal of it, or as a regrettable slide toward Mannerism. Nevertheless, it is true that the later *Stanze* were painted by the same artist, that there was no caesura between his finishing the Segnatura and beginning the Stanza d'Eliodoro, and that the later rooms were to provide artists like Giulio Romano with stylistic ideas which are such a distortion of the classical ideals of simplicity, balance and restraint that they are almost a contradiction of their evident origins.

In the later *Stanze*, Raphael had to find a style suitable for actions, not for abstract thoughts, and even incorporate references to contemporary events and contemporary portraits within the historical scenes. There could therefore be no unity of time. Thus the fresco which gives the room its name, *The Expulsion of Heliodorus from the Temple*, shows divine intervention in the form of angels, prayed for by the High Priest Onias (kneeling in the centre), who drive the looters from the Temple. Julius II, the commissioner of the frescoes, is seen at the left, both as a witness to the biblical event, and perhaps also as a symbol of the Lateran Council of 1512. The fresco would therefore mean that the doctrine of the Church, like the treasure of the Temple, is sacrosanct.[451] As well as this chronological disjunction, there are compositional and iconographic fractures in the work. The subject of the scene, Heliodorus, like some antique river-god, lies at the extreme bottom right, about to be trampled by the angel's rearing horse. The whole motif could be a reminiscence of Leonardo's *Trivulzio Monument*.[425] The physi-

98

al centre of *The School of Athens* had been the ocal point of meaning as well as composition; ere the centre is displaced. The figure style as changed as well. The kneeling woman who ooks across at the right-hand group but also wings her trunk and arms towards Julius, as if o alert him to the event, is a linking figure, like he *Diogenes* in *The School of Athens*. His movement, his drapery and his pose were imple yet graceful, unlike those of the woman n the later work, who appears frozen in her ose, as if a camera had caught her at the moment of turning. The same is true of the ngel with billowing drapery to the left of the orseman. In neither case is the pose or gesture response to the demands of the situation and tory; they both show a delight in vigorous nd difficult postures, and are really 'acad-mies' after the manner of Michelangelo's *Battle of Cascina* figures. (The word indicates heir use by students as suitable models for mitation, as well as their source in in-dividually posed figures.) In contrast with *The Mass at Bolsena*, the first fresco in the room early 1512), which takes its compositional rinciples from the Segnatura, *The Expulsion of Heliodorus* displays force and drama instead of grace and calm; an exploding composition has replaced a harmonious and balanced one.

Between the years 1514 and 1517, Raphael was so busy that only the general design of the Stanza dell'Incendio can be attributed to him. Assistants seized upon the more readily imit-able qualities of their master's work, and the esult is evident in the main fresco of the room, *The Fire in the Borgo* (1514).[413,437] The subject-matter of the frescoes in this room consists of events connected with popes called Leo, like he room's commissioner, Leo X; in *The Fire in he Borgo*, a medieval Pope Leo is seen quench-ng a fire in the Borgo by making the sign of the cross from the Vatican. Again, as in the pre-vious room, the logical arrangement of the Segnatura has given way to a composition in which incidentals dominate the picture space. The action of the Pope is relegated to a small section of the background, while the fore-ground is furnished with an elaborate journal-istic description of a fire and its effects. The figures perform actions which show off the

Raphael: The Expulsion of Heliodorus from the Temple, detail. Rome, Vatican, Stanza d'Eliodoro.

skill of the artist rather than clarifying the meaning of the composition. The theme is, as it were, a hook on which to hang a series of marvellous individual studies. Form has become detached from meaning, pose from purpose (and turned into posturing). Unity of perspective, meaning, balance and form are all lacking. The classical style, in the hands of assistants, has become a different manner, a nascent Mannerism, indeed (see pp. 121f., below).

The probable reason for Raphael's inability to give personal attention to the Stanza dell'Incendio was that he had been commis-sioned to make a series of ten designs for tapestries[456] depicting the Acts of Peter and Paul, destined for the dado of the Sistine Chapel and therefore below the frescoes of Botticelli, Perugino and others on the upper walls, and in direct competition both with them and with Michelangelo's Ceiling. The car-toons were made in 1515–16, and seven of them now hang in the Victoria and Albert Museum, London. We must reverse them in our minds as

99

Raphael: Fire in the Borgo, 1514. Rome, Vatican, Stanza dell'Incendio.

in a mirror to visualize their effect *in situ*, because the tapestry process involved reversal. Their order on the walls has been convincingly reconstructed, and it is evident that their placing, both in relation to each other and to the frescoes on the upper walls (which they roughly match in size), was as carefully worked out both formally and iconographically as was that of the designs for the Stanza della Segnatura.[447] To take but one parallel, the tapestry of *The Healing of the Lame Man*, the central scene on the wall devoted to Peter, is placed beneath Botticelli's *Healing of the Leper*. The fresco has a central temple with two main figures in the foreground, there are towering rocks to either side, and tall, straight trees divide the picture area. In the tapestry,

two central figures stand before the pedimented doorway to the Temple, and the rich columns echo the placing of the rocks and trees in Botticelli's composition. And iconographically *The Healing of the Leper* is a prefiguration of that Power of the Keys, the *potestas ordinis*, which Peter has just received in the tapestry immediately to the left, *The Donation of the Keys*, and is putting into action at the Beautiful Gate.

We can imagine the problems of figure style with which Raphael had to cope. He must compete with but not overwhelm the frescoes in the Chapel. He must produce designs which would stand out clearly in the bland colours of tapestry. His figures must possess sufficient power to survive translation by craftsmen into

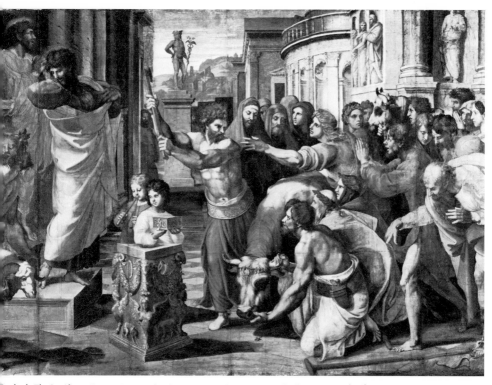

Raphael: The Sacrifice at Lystra. Cartoon, detail, 1515–16. London, Victoria and Albert Museum detail.

another medium. This conjunction of needs ensured simple and straightforward compositions with little detail (which would be obliterated in tapestry), and a much greater emphasis on the figures than had been the case even in the Segnatura. Because the figures bulk very large within the patterned borders of the tapestry, they form their own space. Since the Segnatura, there had been a marked increase in rhetoric in Raphael's figures; this is taken to the utmost in the Tapestry Cartoons where, contained within simplified silhouettes, and with sweeping articulated gestures and dramatic expressions, the actors give a powerful (rather than, as in the Segnatura, a graceful) version of ideal form and clear purpose within an ideal setting. The power of the figures is partly anatomical (and that derives from Michelangelo), but is intensified because they are in all cases pushed to the front plane of the pictorial stage and become like the relief sculpture of Michelangelo's Ceiling. The monumental simplicity of the forms on the original tapestries was helped by gold thread, which was added not for ornamentation, but to clarify the drawing. For it is draughtsmanship which is the key to the impact of the series: the Cartoons themselves and the many prints made from preparatory drawings presented Raphael's pupils and later imitators with an encyclopedia of human emotions, and of powerful and credible poses which magnify those emotions to the ideal. We might suggest that the Cartoons are the very limit to which an artist can project a style of restraint, balance and nobility without incurring that magnificent vacuity which can be sensed in the Stanza dell'Incendio.

In such a setting, and for such a learned audience, it was to be expected that the

Simon Gribelin, after Raphael: The Death of Ananias. Engraved 1707.

Tapestries would be suffused with the spirit of Antiquity. Raphael (appointed Keeper of Inscriptions and Remains of the City of Rome in August 1515) informs his scenes with a mixture of inferred fact and projected ideal, the result of much study of the biblical texts and of a wide range of ancient and contemporary references. *The Healing of the Lame Man* is inspired by Early Christian sarcophagi of the 'columnar' type, as well as by the depiction of the same subject on the *Ciborium of Sixtus IV*, made by various artists *c.* 1475/80 for the High Altar of old St Peter's (now in the Grotte Vaticane). This, in its turn, is decorated with scenes from the lives of Peter and Paul in a style much inspired by Roman imperial sculpture. Similarly, *The Death of Ananias* owes its arrangement to the *Oratio Augusti* relief on the Arch of Constantine, and *The Charge to Peter* to Early Christian sarcophagi of the 'city gate' variety.[450] Usually, the figure style on such sources is inadequate for Raphael's needs, and we can sense rather than demonstrate his debt to Giotto, Masaccio, Donatello and Michelangelo.

Most of a Renaissance artist's production was, of necessity, religious, but occasional secular commissions allowed him to manifest an even greater sympathy with the spirit of Antiquity. The Villa Farnesina was a countrified retreat which, in architecture and decoration, was intended to look like its antique counterpart.[443,444] Raphael's first work there was *The Triumph of Galatea* (perhaps *c.* 1512, Sala di Galatea). The convincingly antique central figure[455] extends the corkscrew twist of the London *St Catherine* (*c.* 1508) and projects its dynamism into a composition with other figures. Galatea must glance toward the adjacent fresco of Polyphemus (by Sebastiano del Piombo), but at the same time she controls her chariot, which moves out toward the spectator. Her pose is echoed by the other figures: the left-hand group near to the plane of the wall, and the right-hand group considerably behind it, are linked by a *putto* whose pose is that of Galatea herself. Flying *putti* aim their bows at the girl, and we now realize how tightly the composition is organized: they point to Galatea's head, which is the centre of a circle, with the twirling bodies of nymphs and tritons on the circumference. A wheel is formed, and the spokes are Galatea's limbs, her upward glance, the dolphin reins, and the arrows of the *putti*. The dynamism of the work is increased because the spectator views this and the other frescoes of land and sea as if from inside a loggia, marked by the wall pilasters, so that the tightly packed figures in *The Triumph of Galatea* explode towards him. Several years later, probably in 1517, Raphael designed and in part executed frescoes for the loggia of the Farnesina (they were completed in January 1518). The loggia, opening directly onto the garden with its rich population of antique statues, had as its theme Cupid's love for Psyche. Raphael constructed an architecture of frescoed greenery, an arbour resembling a garden structure, and stretched simulated 'tapestries' along the centre part of the flat vault to keep out the sun. These 'tapestries' have scenes of *The Council of the Gods* and *The Wedding Banquet of Cupid and Psyche* while the ten spandrels relating walls to ceiling show earlier episodes; intervening lunettes show how Cupid conquers all the gods through love. Perhaps the walls were to receive more 'tapestries' to complete the story,[427] or even real woven tapestries, which would have made the loggia's links with Mantegna's Camera degl Sposi even clearer. Certainly, the whole

Raphael: Galatea, c. 1512. Rome, Villa Farnesina.

Rome, Villa Farnesina, general view of the Sala di Psyche, designed by Raphael.

tua to Annibale Carracci, Pietro da Cortona and beyond.[416]

An antiquarian scheme for which the sources are more evident is the decoration of the Vatican Logge (1518–19) with scenes from the Old Testament set amid grotesques and stucco-work. Again, Raphael was too busy to do the actual painting, but the whole idea depends from his professional concern for archaeology. His post of Keeper of Inscriptions and Remains made him overseer of the excavations necessary to make a decayed city into a new one: he would have seen all discoveries, whether of statues or buildings, in order to decide which should be preserved. His passionate concern about the destruction of Rome is clear from the Letter to Leo X, quoted above (p. 59). The most important discovery for the designs for the Logge was the Palace of Nero near the Colosseum called the Golden House, or Domus Aurea, because of its luxury. Parts of this mostly buried structure had been known since at least 1480, and the style of room decorations had found popularity[418,439] at the hands of Perugino (1499/1500, Cambio, Perugia) and Pinturicchio (notably in the Borgia Apartments of the Vatican, 1492–4). Raphael uses structures inspired by the Golden House to decorate both the walls and the vaults and to frame the biblical scenes, which he treats as framed pictures. Of similar inspiration is the stucco-work which Giovanni da Udine, from Raphael's shop, modelled on the arches separating the bays, incorporating within that antique world some works by great moderns (including Donatello's David and the Jonah in S. Maria del Popolo, designed by Raphael) as if to place them on an equal footing with the famous antiques reproduced, such as the Apollo Belvedere. There were other schemes from the Raphael shop of the same nature as those for the Logge: for the Bathroom of Cardinal Bibbiena,[419,453] the Loggetta (both Vatican, 1519), and the great loggia of the Villa Madama, decorated by pupils after the master's death. All these decorations and the schemes they spawned[445,449] would have been pointless had their connections with ancient Rome gone unrecognized.

Thus far in this account of Raphael's career a

scheme is taken from some antique decoration now lost: it is the kind of conceit which appealed to the ancient Romans, and which Raphael might have studied in the buried ruins of their villas.[414] This type of room and subject-matter, its style,[446] its arrangement of scenes within fanciful architecture and its subtle connection with the garden, greatly influenced artists from Giulio Romano at Man-

Rome, Vatican, the Loggias of Raphael: a bay of the second floor gallery. P. Letarouilly: Le Vatican, Paris, 1882.

and Son are seen; this is echoed not only in the semi-circular top of the panel itself, and in the rainbow under the Virgin's feet, but also in the disposition of the figures on the earth. All forms are grand, all gestures unequivocal, and the tone is ideal. The majesty of Virgin and Child is balanced by their immediacy; this is contrived on the one hand by the geometrical control and by the splendid torsion of the two figures and, on the other, by the Virgin's pose. Her right leg forms a link with the right arm of St Francis, and, because the figures on the ground are so tangible, with us. The simplicity of the finished work is only apparent, for every element of the panel is exactly judged, right down to the placing of the saints and donor close up against the frame, which gives to the work the immediacy and impact that Raphael later achieved in the Tapestry Cartoons.

A development of the *Madonna of Foligno* is to be seen in his most influential altarpiece, *The Sistine Madonna* (1514?, Dresden).[411,433,441] Here, the sense of immediacy, of

greater weight has been given to his frescoes than to his panel pictures. This is deliberate and reasonable: *buon fresco* was the natural medium for the Renaissance artist, and a coherent outline of Renaissance classicism in painting could almost dispense with the less prestigious panels. Furthermore, Raphael's frescoes were often more public* and hence of a grandiloquent conception, and continuously available in their original setting. The same applies to the Tapestries which, like the frescoes, were well-known through prints.

Raphael's first important altarpiece of the Roman period, *The Madonna of Foligno* (1512?, Vatican), is based on the stable Leonardesque triangle with which he had experimented in Florence. Helping this construction to weld heaven to earth and saints to Virgin and Child is the circular aureole against which Mother

*The *Stanze* were difficult of access while they were the Pope's private apartments; under Sixtus V (from 1585) the situation changed, and his extensive building programme ensured that they became as public as the Sistine Chapel had always been.

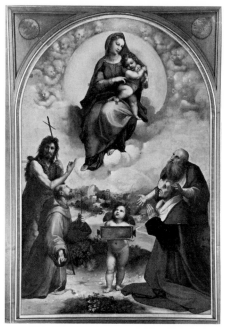

Raphael: Madonna of Foligno, c. 1512. Rome, Vatican.

105

Word made Flesh, is greater, and derives again from the composition. We are convinced that the Virgin is walking downwards and out of the picture towards us. The picture surface is treated like a window, with a ledge (on which rests Sixtus' crown, and the two wistful and slightly bored *putti*), and a curtain rail, the curtain on which is gathered back to reveal the heavenly vision against another cloud of angel faces. Here is Leonardo's triangle in movement: the forceful blue and red of the Virgin's robes is drawn out by the splendid gold of Sixtus' cope, and a twist that is a confirmation of the Virgin's descent is provided by the fine *contrapposto* of St Barbara. Raphael has very plausibly hidden the saints' feet in cloud, so that they intercede for us from a position intermediate between heaven and earth. The two *putti*, far from upsetting the tone of the vision, temper it, as they do the composition: for as well as providing links in the circular movement, and defining our earth, their expressions soften the monumental seriousness of the Virgin and Child. In composition if not

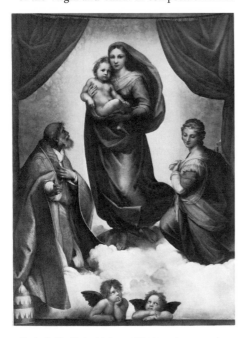

Raphael: The Sistine Madonna, 1514? Dresden.

in mood, *The Sistine Madonna* is very similar to the roughly contemporary *Triumph of Galatea*.

The Sistine Madonna is effortlessly clear in form, psychology and the illusion of movement. Nothing is forced or gratuitous, and the tightness and exactitude of the composition can be tested by using the mind's eye to alter a gesture here, or a curve of drapery there. The psychology partakes of the same balance between hieratic grandeur and the tender affection of the face-against-face of Virgin and Child. Their emotional identity is again underlined by the composition, not by grimaces or overt emotionalism: the gentle curves of the Child interlace with the Mother's arms and garments, encapsulated within the voluptuous sweep of her veil. The tactility of the painting is, of course, also a result of the oil technique and of the chiaroscuro which it allows. Even in fresco, a comparison between early and late *Stanze* shows that Raphael was moving toward a more forceful and atmospheric presentation of the human body. This can be seen in his *Madonna of the Chair* (1514?, Florence, Pitti) which is stylistically and compositionally close to *The Sistine Madonna*. Here, the emotional realism is made explicit by the circularity of the composition, which closely echoes the tondo shape, using the turned wood chairback to anchor it in the vertical. This light-reflecting piece of gilded wood, and the Virgin's headscarf, are so detailed that the forms seem as real as the emotions they express. Yet this acuity is balanced by the broadness of execution of the rest of the panel: the detail is all on the picture plane, and shadowy vagueness increases as the forms are canted into depth. Compare the similar devices of Sixtus' crown and equally intricate cope in *The Sistine Madonna*: in both works, a conjunction of fluidity and precision effects an overwhelming sense of presence, of palpitating life.

These same characteristics are present in Raphael's best portraits,[430] particularly the *Baldassare Castiglione* (c. 1514/15, Paris, Louvre), which might be called his critique of the *Mona Lisa*. Gone are the dreamy, misty background, the equivocation of the facial expression, and the intricacy of clothing and

Raphael: Madonna of the Chair, c. 1514. Florence, Pitti.

by the white of the cravat and the flesh tones of face and hands. In spite of the apparent simplicity, this portrait of a humanist is infinitely rich in psychology; the slight tilt of the head, the twist of the body, the clasping of the hands, the soulful eyes—all bespeak a nervous energy which is the result of those reticent yet abundant movements within the calm and stable triangle of body and head. In effect, the calm, level eyes in the spot-lit face reveal the man's soul, for the slight restlessness of the drapery is made to indicate personality. Raphael therefore presents us with two portraits in one: the outer man, a portrait of calm and restrained nobility, and that man's sensibility, which has impact precisely because it forms a counterpoint to the statuesque exterior. This alchemy can be better appreciated by comparing the work with *La Velata* (1515?, Pitti), similar in structure but empty of psychology.

landscape, in favour of a plain, light-filled ground and a more open face. The pose remains, as does some of the chiaroscuro. Leonardo's interest in textures has also been retained, and is exploited in a softly-lit description of grey fur against black cloth, set off

Just as Raphael's altarpieces, portraits and frescoes change from a simple stasis to a more vigorous type of composition during the second decade, so his smaller panels pursue a

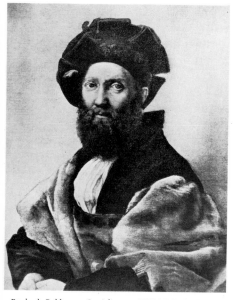

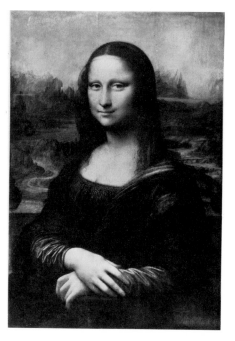

Raphael: Baldassare Castiglione, c. 1514–15. Paris, Louvre.
RIGHT *Leonardo da Vinci: Mona Lisa, 1503f. Paris, Louvre.*

similar development. The process begins in about 1510/11 with the *Alba Madonna* (Washington), which is startlingly different from even those Michelangelo-inspired works of his Florentine period. It is, rather like the London *St Catherine,* conceived in an altogether more heroic form. Whereas earlier exercises had looked back to the Leonardo of *The Virgin of the Rocks,* or to Michelangelo's *Taddei Madonna,* this work explores the formal problems inherent in Leonardo's theme of *The Virgin and Child with St Anne,* clothed in the heroic bodies of the Sistine Ceiling. Here, as in Leonardo's prototype, the resultant composition is a vigorous parallelogram of meaning, but it is evident that much further tension will dispel the classical balance.

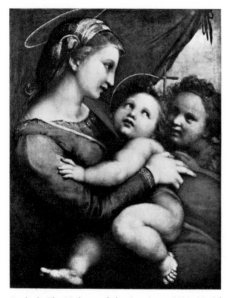

Raphael: *The Madonna of the Curtain, c. 1514.* Munich, Bayerische Staatsgemaldesammlungen.

That point is reached in *The Madonna of the Curtain* (*c.* 1514, Munich); this makes an interesting comparison with *The Madonna of the Chair,* which perhaps precedes it a little. The sense of presence so strong in that work is even more imposing in *The Madonna of the Curtain*: in the tondo, the arm of the chair defines the picture plane, the distinction be-

tween our space and painted space. No such conventional barrier exists in the other work, nor are the attitudes so restrained. If, in the tondo, the forms complement one another harmonically, then here similar poses have been adjusted to create an outward-straining tension centred on the pose of the Christ Child, whose left knee and foot protrude into our space. This arrangement, together with the fluidity of the chiaroscuro and the Michelangelesque heroism of form, point the way to a series of multi-figure altarpieces of the following years, not often autograph, and too sensuous and full of exciting incident to be called classical. Thus *The Canigiani Holy Family* (1508?, Munich), where a pyramid of five figures is tightly formed, develops into the *Madonna dell'Impannata* (*c.* 1514, Pitti), where the formal structure begins to lack cohesion. *La Perla* (*c.* 1518, Madrid, Prado) continues the trend toward elaboration of incident and weakening of classical structure.

The work which best demonstrates the incipient confusion of Raphael's late style is *The Transfiguration* (begun 1518?, Vatican), which was completed by Giulio Romano and Penni after Raphael's death. The design depicts two distinct events, namely the Transfiguration itself and the curing of a young boy of possession by the Devil which follows the Transfiguration in St Matthew's account. The composition makes the events synchronous, and uses the scene of healing to add drama to the Transfiguration, which hitherto had been depicted as a tranquil event. An added spur to drama was probably the commissioning by Giulio de' Medici of a companion altarpiece from Sebastiano del Piombo, a follower of Raphael (*The Resurrection of Lazarus,* London, National Gallery). On Raphael's death, the top section of *The Transfiguration* was nearly complete, the lower part in sketch form only. Little wonder, therefore, that the contributions of pupils somewhat overbalance the scene with Christ, who is above and behind the large foreground figures. In other words, the lower section seems a logical development of the inflated figure style visible in the later *Stanze,* but the figures lack that logical concordance between pose and intention which triumphs in

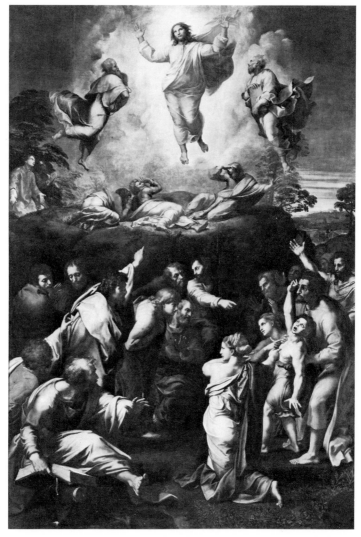

Raphael: Transfiguration, 1518. Rome, Vatican, Pinacoteca.

the Tapestry Cartoons. Perhaps this late work can be seen, as one commentator has it, as 'the explicit and far-reaching investigation of Leonardesque principles'.[440] Certainly, it over-reaches the bounds of classical decorum in its strong chiaroscuro and powerful yet some-times vacuous gesturing and posturing. If we judge the work by Raphael's intentions, as seen in a group of beautiful drawings,[438] we must nevertheless accept that the painting, had it been totally autograph, would have presented an interpretation of the human body much more vigorously alive and dramatically power-ful than anything in the Segnatura, something of a stature to inspire the classical revival of the seventeenth century, and perhaps the painted equivalent of the Tapestry Cartoons.

Throughout his life, Raphael's multifarious

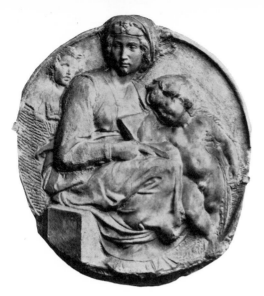

Michelangelo: Pitti Madonna, c. 1504–5. Florence, Bargello.

activities built up for him a formidable reputation among his contemporaries.[422] He was praised as a restorer of the beauties of ancient Rome and, in Baldassare Castiglione's characterization, as the man who breathed life into the corpse of the city of Rome, who endowed it with antique decorum, and whom, for this reason, the gods carried off. His death did not spell the end of his style, which was continued not only by his principal assistants (particularly Giulio Romano) and by prints made after his drawings and finished compositions (chiefly by Marcantonio Raimondi),[420] but also by the fame of his own paintings, which were much studied. Because of his ability to assimilate lessons from the styles of others, and to continue and develop solutions to artistic problems on his own account, and because of his achievement in so many media and genres, Raphael was to be quite simply the most influential of all European artists.[415,435,436] The solutions which he propounded were, in terms of style, composition and psychology so fruitful that they could be developed even further by succeeding generations. Far from being frozen in the ice of passionless perfection (as he is so often presented), Raphael's treatment of a sensuous yet ideal humanity gave to the classical tradition a vigour which would last to the age of Ingres.

Michelangelo

We have seen that Michelangelo played an important part in the development of Raphael's style. Indeed, in all but his late works, and in both painting and sculpture, Michelangelo took up and enriched the classical tradition as he saw it in the works of Giotto, Masaccio, Ghiberti, Donatello and Jacopo della Quercia. It was probably while he was in Ghirlandaio's shop (1488/9) that he made drawings after Giotto and Masaccio, obviously impressed by their statuesque monumentality; he sought, in those drawings, to increase even further the sensation of *gravitas*, of high seriousness, and of bulk transmitted to the garments by the body underneath, Vasari tells us that he next entered the 'sculpture garden' of Lorenzo de' Medici, where he could draw and model after specimens of antique and modern sculpture under the eye of Bertoldo, a pupil of Donatello and a sculptor of wide antiquarian interests.[478] None of his sculpture from this period survives, but we can be sure that he owed his lifelong interest in Neoplatonism and its ultimate identity with Christian philosophy to the circle around Lorenzo, to people like Landino, Ficino, Pico della Mirandola and Poliziano, the tutor to the Medici children. Neoplatonism, with its belief that the beautiful is but the outward sign of virtue, led Michelangelo to express his vision of Christianity (for he did little secular work) by figures that are as beautiful as antique statues, yet are sometimes imbued with a tormenting self-knowledge which distinguishes them from their models.[477] Throughout his career, the study of Antiquity provided the basis of his style,[458,471] helped by reference to Florentine traditions.[474,487]

Perhaps his earliest extant work is *The Madonna of the Stairs* (1489/92, Florence, Casa Buonarroti), which shows the Virgin, seated in pure profile and staring straight ahead. Its stern monumentality is inspired by the example of Donatello,[464] its form just possibly by Greek grave *stelae*. To these sources Michelangelo adds the powerful torsion of the Christ Child encased within the silhouette of His

mother: a token of things to come. No one in Florentine art except Donatello had ever made an image of the Virgin with so much of the prophetess about her: she is the ancestor of the great figures on the Sistine Ceiling.[482] Another early work, *The Battle of the Lapiths and Centaurs* (1492?, Casa Buonarroti), is clearly a reinterpretation of antique battle sarcophagi: its vigour derives partly from the torsion of individual figures, and partly from the symmetry of their arrangement in a circular movement around the central figures. Surely the work must have been one of the sources for Raphael's *Galatea*, which uses the same compositional idea.

In 1496 Michelangelo went to Rome, whither his fame had preceded him in the form of a *Sleeping Cupid* in imitation of the antique,[479] which he had sold to a Roman dealer.[476] This is lost, but his *Bacchus* (1496/7, Florence, Bargello), another imitation of an antique type, was bought by the connoisseur Jacopo Galli and placed in his garden of antiques, which it was evidently considered to rival. The company it kept there reminds us of one source, but another is the work of Jacopo della Quercia, particularly his figured portals for S. Petronio in Bologna (1425–38). Michelangelo worked in that church in 1494/5, and elements of Jacopo's sinuous classicism appear throughout his work, from the nervosity of his *Pietà* for St Peter's (1498/9) to the figures on the Sistine Ceiling. The St Peter's *Pietà* also profits from a study of Leonardo (especially *The Virgin of the Rocks*) in the pyramidal simplicity of the composition and the understatement of emotion. Leonardesque also is the elaboration of the drapery, to be replaced in *The Bruges Madonna* (begun 1501, Bruges, Notre Dame; sent to Flanders 1506) by a more monumental simplicity of form and an austerity of psychology which parallels that of the contemporary *David*. Just as Raphael develops Leonardo's pyramidal composition in the early 1500s, so too does Michelangelo.[461] Further variations on the form are provided by three *tondi* of this period. The marble *Pitti Tondo* (1503/5, Florence, Bargello), more massive and simple than the St Peter's *Pietà*, includes a Christ derived from the mourning genius type

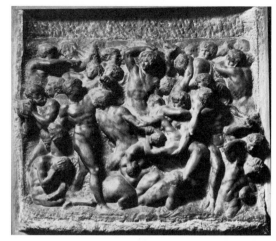

Michelangelo: *Battle of the Lapiths and Centaurs, 1492?* Florence, Casa Buonarroti.

on antique reliefs. The marble *Taddei Tondo* (c. 1505–6, London, Royal Academy), an even more vigorous triangle of meaning, is again heavily dependent on the antique for its motifs.[483] The painted *Doni Tondo* (1504?, Uffizi) takes the scheme even further: Michelangelo would have studied Leonardo's cartoon of *The Virgin and Child with St Anne* (London, National Gallery), which was on exhibition in Florence in 1501, and would have recognized it as a new departure for that artist both in the complexity of its structure and in a totally new monumentality of form.[486]

All four works—the *Bruges Madonna* and the three *tondi*—signal a new stylistic direction in their greater simplicity of form and their neglect of those qualities of delicacy, intricacy and prettiness most sought in contemporary Florentine art. They lead to the growth of Michelangelo's version of the High Renaissance manner. This is best seen in the marble *David*[481] (1501/4, Florence, Accademia), a subject of great political importance to the Florentines.[465] Michelangelo's figure looks back to the *Fortitudo* on Nicola Pisano's Pisa Baptistery Pulpit, and to the *Hercules* on the Porta della Mandorla of Florence Cathedral. Hercules appears on seals of the city of Florence, and Vasari underlines the significance of the *David* by the gloss that 'as David

Michelangelo: David, 1501–4. Florence, Accademia.

of his mind, is only partly a result of the colossal height of nearly seventeen feet; it also derives from the physical power which is latent in the body. The clarity of the pose and the hero's restrained anger are evident; David also carries a sling, but it is mostly hidden so that the statue is a generalized symbol of David and his accomplishments, rather than a specific reference to the fight with Goliath. In fact David has not yet met Goliath: he stands in a more confident version of the pose of Donatello's St George, outside the Palazzo della Signoria, looking defiantly toward the threat from the south.[473] The *David* is therefore both biblical and antique hero, and a political symbol of Florentine liberty; but why is it so huge? Michelangelo certainly looked on the commission as a challenge to make something of the block of marble, supposedly 'ruined' by an earlier artist; this is why the statue is so thin from front to back. More important are the antique traditions of colossal statues both of gods and as commemorative monuments (the Horse-Tamers of Monte Cavallo have been suggested as a source),[485] and the Florentine tradition as well.[480] Donatello made two 'giants' for the Cathedral, a *Joshua* of terracotta (a brave experiment in such a medium, 1410) and a *Hercules/David*, of which a model with metal plates over stone was made in 1415. Both are lost, but both were known to Michelangelo who was himself to make a gigantic statue of *Hercules* for Fontainebleau, which is also lost.[463]

Henceforth, Michelangelo concentrates on the heroic male nude, as in *The Battle of Cascina*, begun in 1504 for the Sala del Maggior Consiglio (cf. pp. 92–3, above) of the Palazzo Vecchio. Leonardo's scene designed for the same room had been of violent action in the heat of battle (*The Battle of Anghiari*). Michelangelo did not show a battle at all, but a call to arms while Florentine soldiers were bathing. His subject-matter is therefore the nude human body shown in various postures as the soldiers haul themselves from the water and get dressed; indeed, the work (known only through copies and prints, as is that of Leonardo) is popularly called *The Bathers*. This work perhaps reflects Michelangelo's preference for sculpture over painting: he tends

defended his people and governed with justice, so should this city be defended with courage and governed with justice'. And indeed, whereas former representations such as Donatello's and Verrocchio's had shown David as boyish and clothed, Michelangelo showed him in the guise of an antique hero, and nude.[470] The artist's conception of the splendour of his body, a counterpart to the nobility

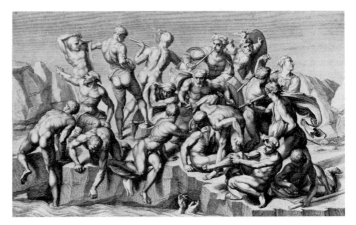

After Michelangelo: Engraving of a figure from The Battle of Cascina.

Luigi Schiavonetti, after Michelangelo: Bathers surprised at the Battle of Cascina. (Taken from Henry Howard's eighteenth-century copy of Sansovino's copy.)

to isolate the figures, and to treat them each as individual studies and not as parts of a coherent composition. The same is often true on the Sistine Chapel Ceiling where, excepting the antique bas-reliefs of the scenes, the greater part of the area is covered by painted statues in splendid isolation. Little wonder that *The Bathers* was a popular academy for students (who obliterated it from the wall by tracing; it never got further than the underdrawing), or that it was usually studied for individual figures or groups, and not as a complete composition.

Michelangelo's vision of Antiquity was radically enlarged by the discovery of the *Laocoön* in Rome in January 1506, the style of which accentuated tendencies of power and bodily tension in his own work. The *Laocoön* allowed him, as it were, to animate the *David*, and he drew on the Trojan priest's physical suffering as a metaphor for the spiritual inspiration of a long line of prophets, saints and sibyls both painted and sculpted. The *St Matthew* (1506, Florence, Accademia), for example, is inspired by the antique, but it might have been begun before the discovery of the *Laocoön*. No matter, for Michelangelo could have borrowed the *contrapposto* pose from either the *Pasquino* (one of the famous antique talking statues of Rome), or from Donatello's majestic group of *Abraham and Isaac* on the

Michelangelo: St Matthew 1503–5. Florence, Accademia.

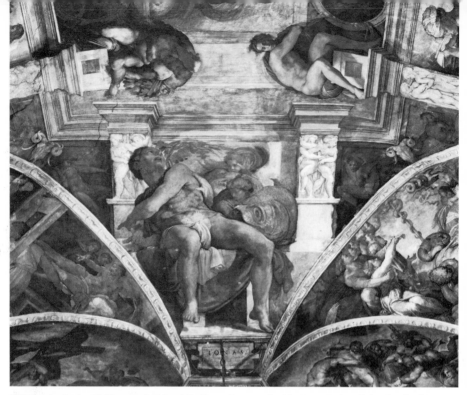

Michelangelo: Jonah, with Haman to the left and The Brazen Serpent to the right. Rome, Vatican, Sistine Chapel Ceiling.

Campanile of Florence Cathedral.* The *St Matthew* presents a vision of revelation, and is a harbinger of the *Julius Monument*, first projected in 1505 but never completed. The structure of this tomb, judging from Michelangelo's sketches, from the 'slaves' made for it, and from the various modern reconstructions of how it was intended to look, resembled that of antique monuments, particularly Roman imperial mausolea or temporary funeral pyres.[466] The latter he would have known from bas-reliefs and from literary descriptions.

Different projects for the *Julius Monument* were to occupy Michelangelo for much of his life, and it is a commonplace that he partly mitigated the 'Tragedy of the Tomb' on the Sistine Chapel Ceiling, which he painted, against his will, between 1508 and 1512. The *Julius Monument* was intended to grace the new St

*G. de Francovich has suggested that Donatello knew of the *Pasquino* from his visit to Rome at the beginning of the fifteenth century (see Bibliography, below, under Donatello).

Peter's, the very centre of the artistic revival of Rome (a much reduced version was eventually erected in S. Pietro in Vincoli). Despite all difficulties, how much easier was it to paint the enormous structure on the vault of the Sistine Chapel, where he could indulge his sculptor's preference for a large number of massive single figures within a painted architectural structure, which in its turn frames a series of figured scenes usually treated as bas-reliefs. The Ceiling complements the famous frescoes on the walls, which show Man *sub lege* and *sub gratia*, for it tells the first part of the story of Man, beginning with the Creation of the world, and Man *ante legem*, followed by the domination of Man, then of sin which will rule until Man is redeemed by Christ. The four pendentives in the four corners contain Old Testament scenes of temporal salvation which are types for Christ's salvation of the world through crucifixion, and eight of His ancestors are shown in triangular niches, four down either side of the Ceiling. In the spandrels between these figures

are twelve prophets and sibyls, the seers Jewish and pagan who foretold Christ's coming. They, in their inspiration, are contrasted with the *putti* who decorate their thrones, the bronze coloured figures chained to either side, and the *ignudi* above their heads, who show varying degrees of awareness of the scenes they witness.

The style of the Ceiling changes as Michelangelo progresses from above the entrance towards the altar wall. The first scene, *The Flood*, is the most painterly and complicated of all, a version of *The Bathers*, so to speak. Michelangelo then begins to limit his treatment to a few figures which bulk large in the frame, as in *The Sacrifice of Noah* and *The Drunkenness of Noah*. The contiguous *ignudi*, which are almost mirror images of each other (the result of reversing each cartoon and thereby using it twice) are in poses both elegant and simple, without strain. The five corresponding seers likewise adopt straightforward if powerful attitudes. The next stage, with *The Expulsion from Paradise* and *The Birth of Eve*, shows an increasing concern with

monumentality, perhaps coupled with the realization that the figures already painted were either too small or not sufficiently demonstrative to make an impression on the spectator at ground level. From this point on, Michelangelo therefore increases the size of the figures, gives more drama to poses and gestures, and thereby magnifies the impact of the story. Now the *ignudi*, far from being symmetrically opposed, are often strongly contrasted, with one facing in, the other facing out, the one in extension, the other in contraction, or the one tense, the other calm and relaxed. But it is in the seers that this enlargement of scale is most evident. Whereas one of the first, *The Delphic Sibyl*, is calm and relaxed, the later *Libyan Sibyl* is not only greater in size but also magnified in psychological power. This *numen* depends from the increased inventiveness and intensity of the pose. The Delphica holds her left arm across her torso, pointing right and looking left; the Libica intensifies this movement, helped by the heavy book of prophecies she is holding, and by the tall block on which she rests her left foot

Michelangelo: LEFT *The Delphic Sibyl* and RIGHT *The Libyan Sibyl. Rome, Vatican, Sistine Chapel Ceiling.*

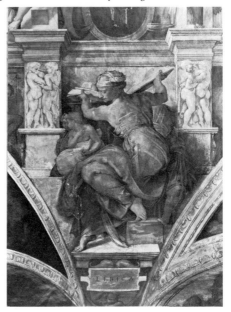

and which, as it were, electrifies the *contrapposto*. Of all the seers it is the last, *Jonah*, who is the most impressive: his pose mimics those of the *ignudi* (it shows Michelangelo's study of the *Laocoön* group), and reflects his excitement and wonder at seeing God, for his gaze is directed upward, toward the scene of *God separating Light from Darkness*. A similar development informs the four pendentives. The early pair, *David and Goliath* and *Judith and Holofernes*, have small figures within an illusionistic pictorial space. The pair adjacent to the altar wall, *Haman* and *The Brazen Serpent*, are as energetic as the *Jonah*, and the inspiration for both is the *Laocoön* group.

The Sistine Ceiling, in its structure, its sculptural figures and its histories, is mainly a reinterpretation of antique art[467] but it is also a reworking of Quattrocento elements, taken particularly from Ghiberti, Masaccio and Jacopo della Quercia. This substitute for the *Julius Monument* makes figures the form and colouring of which are sculptural, as is their location in niches for the seers and on pedestals for the *ignudi*. The use of medallions and histories in what is effectively bas-relief strengthens the reminiscence of a monument in marble; and it has been suggested that the whole Ceiling forms a 'Tree of Jesse' for Pope Julius II (and is therefore some substitute for the Tomb).[468] The main structural source of the Ceiling, and of some of its devices, is the antique Roman triumphal arch (and this is even more clearly the case with the designs for the Tomb). The triumphal arch showed Michelangelo how to articulate a blank wall with pilasters or columns, bas-reliefs and medallions, and even free-standing figures. The Arch of Constantine, in Rome, has all these features, with genii reclining in the angle formed by the arch and the architectural Order, and something approaching caryatids decorating the pedestals of the columns. All these elements Michelangelo borrows. The columns become square pilasters with caryatids, marking out the rhythm of the Ceiling and providing pedestals for the *ignudi*; the same pilasters are given strongly projecting cornices, which further define the history section and distinguish it from the line of seers

down either side, and which also provide the sides of the seers' thrones. The *ignudi* themselves, as well as some of the medallions they support, are taken from the antique. The bronze-coloured nudes, to either side of the seers, and confined in their triangular niches, are variations of the genii on triumphal arches. Some of the larger figures are also specifically antique, like God the Father in *The Creation of Adam*, taken from a Victory on the Arch of Titus, and one of Christ's ancestors, who is drawn from a seated river god on the Arch of Septimius Severus. For some of the histories, Michelangelo looks to fellow Florentines. *The Expulsion from Paradise* is a reworking both of Masaccio's treatment in the Brancacci Chapel and of Jacopo della Quercia's on the portal of S. Petronio, Bologna. *The Creation of Adam* and *The Creation of Eve* likewise depend on Jacopo, but the Gothic swirl of his light draperies has in all cases been monumentalized. The same process applies in his borrowings from Ghiberti, whose Gates of Paradise provide one of the ideas for Adam in *The Creation of Adam*, while his God the Father is reworked into the Creator in Michelangelo's *Creation of Eve*.

Michelangelo transforms his borrowings, and clothes them in a style more heroic and infused with greater energy and inspiration than anything hitherto seen. Like the Stanza della Segnatura, the Sistine Ceiling is a definitive statement of classicism; or, in Tolnay's phrase, 'a second reality superposed on our own and containing the essence of existence'. It is the expression of an ideal of religious revelation achieved through a union of the beauty of Antiquity and the inspiration of Christianity. Both elements are evident in what is justly the most famous scene on the Ceiling, *The Creation of Adam*, whose 'Greekness' has even provoked the suggestion that Michelangelo could have seen a drawing by Cyriacus of Ancona of the Parthenon *Theseus*.[484] Here, Man is indeed made in the image of God, but it is an image conditioned by the Renaissance vision of Antiquity. The scene epitomizes the sculptural clarity of the Ceiling particularly in the later parts where the intricacies of detailing and of small figures and complicated compositions have given way to a vigorous gran-

deur in which the basic unit is the individual human body. Such concentration on the individual body in movement made it easy for students to excerpt figures and put them to different uses. Thus one of the last scenes, *The Separation of Sky from Water*, presented Raphael with a pose which he developed into the wonderful gesture of the apostle in *The Sacrifice at Lystra*. The seers and the *ignudi* were particularly popular, from Fontainebleau (where they were re-created as stucco sculptures) to Annibale Carracci's Farnese Gallery and beyond.

Despite the interval between the Ceiling and Michelangelo's two other fresco commissions, the frescoes are remarkably homogeneous in style, given that no architectural structure was possible in either case. *The Last Judgement* (1536–41) on the altar wall of the Sistine Chapel may be regarded as an affirmation of the classical principles of the Ceiling at a time when the Mannerist styles were popular in Rome. The two frescoes in the Pauline Chapel of the Vatican, *The Crucifixion of Peter* and *The Conversion of Saul* (1542–50), are as athletic and inspired in their figure style as the Ceiling itself, except for what can only be called a mystification of emotion which is an element in the increasing *terribilità* of the ageing Michelangelo.

After the completion of the Sistine Ceiling, Michelangelo's sculpture went through a phase which, in its exploration of tendencies present in the *Laocoön* group, can be called Mannerist. The two works nearest to the Ceiling in date, *The Dying Slave* and *The Rebellious Slave* (finished 1513?, Paris, Louvre), both intended for the 1513 version of the *Julius Monument*, owe their manner to the *ignudi* and the bronze captives between the prophets and sibyls on the Ceiling, and their origin to one of Laocoön's sons and to the priest himself respectively. The statue of *Moses* (1515/16) for the same version of the Tomb is also reminiscent of the Ceiling, for his pose is a combination of those of *Joel* and *Isaiah*. What explanation might be offered for the slaves is difficult to determine, for their place on the Tomb and their meaning are matters for conjecture. The *Moses* certainly

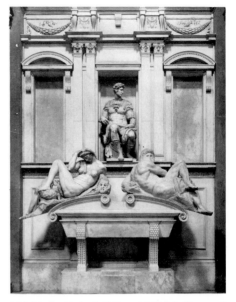

Michelangelo: Tomb of Giuliano de' Medici. Florence, S. Lorenzo, New Sacristy, 1524–33.

possesses greater emotional stability, but the whole conception of the work is inflated beyond any classical norm, and might be said to make a mannerism of the style of the prophets on the Ceiling.

From the 1520s, Michelangelo increasingly sought satisfaction in architecture and therefore gave less and less time to sculpture. In the *Medici Chapel* (1524–33, Florence, S. Lorenzo), as in the near-by Library (discussed below, pp. 140ff.), he broke the bounds of classicism in sculpture as in architecture.[472] The chapel contains the statues of *Giuliano de' Medici* and *Lorenzo de' Medici*, seated one to either side, looking toward a group of the Virgin and Child on the altar wall. The clarity of these figures (descendants, again, of the seers on the Ceiling) contrasts with the stronger torsion and much less precise emotional complexion of the figures which rest on the tomb chests underneath the seated heroes: *Dusk* and *Dawn* beneath Lorenzo, and *Day* and *Night* beneath Giuliano. Classicism demands stasis, or rationally induced movement. These figures, however, represent eternal change as, under the influence of restless emotion, their bodies appear

117

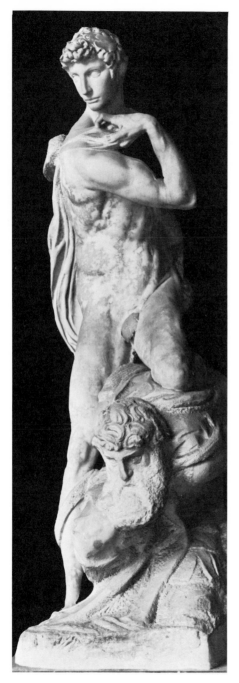

to slip down the sloping tops of the sarcophagi. They are palpable reminders not of Man's perfectibility and glory, but of instability and approaching death and destruction, as would have been the mouse which, Condivi assures us, Michelangelo thought of introducing to symbolize the frailty of Man and his environment. Elegance, an extravagant *contrapposto*, and a delight in compositional intricacy, made these four figures examples for later Mannerists: imitations of them and of the general design of the tombs stretch into the seventeenth century. A similar finesse and comparable pose inform Michelangelo's *Victory Group* (1527/8?, Florence, Palazzo Vecchio), which it is instructive to compare with the *David* or the *St Matthew*. Both these works had a simple grandeur occasioned by the meaning they embodied in their poses. The *Victory*, on the other hand, assumes an elaborate posture of 'easy strain', his lissom knee between the shoulder blades of a much heavier opponent; he twists his own arm across his body, but for no apparent reason other than to impart a satisfying twist to the composition. The gesture is there for effect, and is without sufficient cause; it is artificial—a mannerism. That this is but a phase in Michelangelo's sculpture is seen by his return to a classical vein in the two statues for the c. 1542 version of the Tomb: *The Active Life* ('Leah') and *The Passive Life* ('Rachel'). They show us a sculptural version of the Pauline Chapel frescoes, on which he was working during these years: heavy figures with broadly treated drapery and stern, almost Hellenistic-looking faces. His final sculptures, like the last works of Donatello, are part of a private world. In the *Florence Pietà* (Florence, Cathedral, by 1555) and the *Rondanini Pietà* (Milan, Castello Sforzesco, 1552, reworked 1563/4) the physical beauty of the human body dissolves away as Michelangelo searches for a new mode by which to convey the religious emotion of his old age; the radiant classicism of his earlier work is replaced by an expressionism which is almost Gothic.

Michelangelo's art is scarcely as important for the development of the classical tradition as

LEFT *Michelangelo: Victory. Florence, Palazzo Vecchio.*

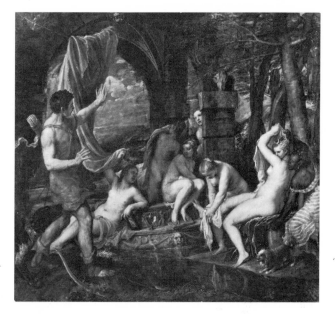

Titian: Diana surprised by Actaeon, 1556–9. The Duke of Sutherland's collection, on loan to the National Gallery of Scotland.

that of Raphael who, we might say, reduced some of Michelangelo's creations from the awe-inspiring to the safely grand. Often, the greater power of Michelangelo's art led imitators to copy the form of his individual figures, but to miss the spirit completely. Raphael, on the other hand, provided a selection of figures and compositional structures covering a much wider range of human activity and emotion.[460] For this reason, Michelangelo's influence in Italy, France[462,469] and England[475] is broader in the Mannerist,[457] Baroque and Romantic periods than in the seventeenth-century classical revival or under Neoclassicism, when his manner was thought of as too powerful.[459]

Titian and Roman classicism

It is tendentious to introduce Venetian art into a survey of classicism for, in spite of the abundant interest of Venetian artists in the antique,[489–91,495] their work is founded in light, colour, atmosphere and the exploration of the senses rather than in the formal and intellectual qualities which generate Roman art of the High Renaissance. Thus, in spite of the evident geometry of Giorgione's *Castel-franco Madonna* (1504, Castelfranco), it is the pervasive light and gentle reverie which govern the painting, which is so different from contemporary creations by Raphael or Michelangelo. However, something must be said of Titian, because his achievement was to be seen by future centuries as a very successful mixture of the colour of Venice and the form of Rome (just as Correggio was thought a conflation of Raphael and Michelangelo).[493] It was reasonably believed that such a unification represented a manner almost as worthy of imitation as that of Raphael, even by artists more interested in classicism than in Titian's proto-Baroque bravura and compositions.

Titian, like Raphael, left an *oeuvre* of bewildering range, and his much longer life ensured a greater variety of style. Throughout his working life, from *c.* 1505 to his death in 1576, his interest in the antique waxed and waned, as did his attachment to developments in Rome. Vasari stated that Titian did not study the Ancients; in fact he did, but for reasons different from those common to students of classicism. Titian was an intensely sensual artist whose interest in the subtleties of the mind was small. He produced nothing like the

School of Athens, for he saw Antiquity not as a collection of ideas but as an arsenal of forms and poses which he could plunder in his search for ways of expressing physical vigour, emotional intensity and vibrant movement.[488] Like Michelangelo, he was fascinated by the *Laocoön* (of which he had a cast by *c.* 1520). He studied the priest and his sons from every possible angle, and made use of the group in many more of his pictures than is usually realized. (Rubens did likewise.[492]) There are numerous examples of the re-use of antique art in his work, but no evidence of the exacting scholarship of the antique shown by Raphael.[496,497] For Titian, Antiquity seems to have evoked not the splendour of Rome, but the voluptuousness of splendid bodies in an idyllic setting.[494] In this respect, his early mythologies are no different from those that he painted late in his life for Philip II of Spain. Sometimes he increases the nostalgia by the addition of semi-ruins, as in *Diana and Actaeon* (Duke of Sutherland), where the huntsman happens on a scene which might have come from the *Hypnerotomachia Polifili* of 1499. That amazing book, printed in Venice, a mixture of love-story and architectural fantasy, set the tone for the whole Venetian attitude toward the past. For in spite of his close and scholarly interest in the monuments of ancient Rome, the unknown illustrator of the *Hypnerotomachia* transformed everything he saw into fantasy; Titian, with the ruined arch, the washing line, and the semi-sunken sarcophagus of the *Diana and Actaeon,* does much the same.

Such make-believe, presented with brilliant technique and luscious colouring, was to entrance later artists. Equally important to posterity were the compositional innovations of Titian's great altarpieces, which might almost have been produced in competition with those of the Roman High Renaissance. His *Assumption of the Virgin* of 1516–18 in the Frari Church, Venice, is of the same date and basic construction as Raphael's *Sistine Madonna,* but employs a double zig-zag to add vigour to the composition. The same structure appears in the *Pesaro Altar* of eight years later in the same church, but cleverly canted to one side. The

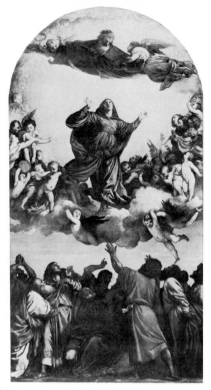

Titian: ABOVE *Assumption of the Virgin, 1516–18, and* RIGHT *Pesaro Madonna, 1526. Venice, S. Maria Gloriosa dei Frari.*

ideas in these two works were to be the staff of life to Baroque artists.

Was Titian at all interested in contemporary art in Rome? Several of his works clearly owe a debt to Michelangelo and, in one case, the *Danaë* of 1545/6 (Museo Nazionale, Naples), he even painted a figure in a Michelangelesque manner. He was on a visit to Rome at the time, and the work might have been by way of a demonstration that he could match the Romans when he so wished. And from about 1560 reminiscences of Raphael and Michelangelo are particularly strong, as in the *Transfiguration* in S. Salvatore, Venice (*c.* 1560), which indicates a study of Raphael's version and of his *Sistine Madonna.*

Such comparisons, the more they are pursued, serve only to separate Titian and the whole of Venetian art from the classical tradition. We need only to observe, as it were, the historical company the Venetians were to

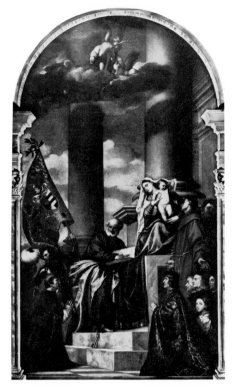

by the grandeur of their own classical style, inflated classicism into something totally different. The modern term for the result is 'Mannerism', from the Italian word *maniera*, meaning 'style'. It is a term even more vague than 'Baroque' or 'Gothic', and scholars have found difficulty in establishing its relationship not only to Renaissance classicism, but also to the traumatic Sack of Rome and to the Counter-Reformation with its religious revival.[505]

There are three basic theses concerning the way in which classicism and mannerism are related.[507] The first, and the least tenable, is that mannerism is a violent reaction against everything represented by classicism: disorder replaces order, vagueness replaces precision, and profusion replaces restraint.[508] The characterization is correct, but the idea of reaction is difficult to maintain, as a reading of the Third Part of Vasari's *Lives* demonstrates; that perceptive commentator on style, himself an artist, found no decisive break between the early and the mid-Cinquecento. The second thesis sees mannerism as a constant current in the arts, co-existing with the impulse to classicism and called now Gothic, now Baroque;[499] how to give chapter and verse for such a broad notion? The third thesis is less likely than the other two to introduce the element of religious reform, or the 'shock' of the Sack of Rome, for its proponents see sufficient seeds of mannerism in work by Michelangelo and Raphael before 1520 to explain mannerism as an obvious development of tendencies inherent in the classical style.[506] The enormous prestige of the High Renaissance achievement 'stood between the Maniera painter and the world of nature like a screen', states Freedberg, and he goes on to detect in the refined idealism and abstraction of mannerist art the 'characteristics of a *fin de race*'.[500]

Indeed, the respect of the later sixteenth century for the High Renaissance is amply demonstrated by the growth of a new type of institution which helped to underpin the classical tradition well into the twentieth century—the academy of art.[504] The Middle Ages had viewed accomplishment in art as the result of long apprenticeship and painstaking application. The High Renaissance attitude (as

keep: Rubens and the Baroque, Watteau, Delacroix, Courbet—the family of flesh-painters, as Zola was to remark. Nevertheless, Titian's achievement impressed the Carracci and Poussin almost as much as it impressed Rubens. His lack of Mannerism, in the Roman sense, made him, like Correggio, a reinvigorating force in seventeenth-century art.

Classicism and Mannerism: the growth of academies

What was the inheritance of classicism for the sixteenth century? We have seen the answer in embryo in some of the works of Michelangelo[498] and Raphael, when reason and understatement are abandoned, when meaning loses its clarity, and when there is no logical connection between the meaning of a work and the forms within it. We might say that sometimes High Renaissance artists, invigorated

exemplified in the remarks of Leonardo), was that the art of painter or sculptor was worthy to rank with the liberal arts, being related more to the intellect than to the hands. The work of men like Titian and Raphael made it clear that art was a career as worthy as philosophy or letters, partly because it drew on such intellectual disciplines. There were no formal academies during the fifteenth century; artists were trained in the shops of their masters, where they might try their hand at all manner of artistic tasks, but this was not what we would call an academic education. The first academy with a fixed regime for the education of artists was Giorgio Vasari's Accademia del Disegno in Florence,[502] founded about 1560, and referred to by the Grand Duke in 1563 as *una sapienza*—a university. From the emphasis on drawing (*disegno*), and the stipulated lectures on anatomy and geometry, together with the attention given by teachers to correcting 'faults' in pupils' work, it is evident that Vasari saw his brainchild as a practical extension of the ideas promoted in his *Lives*. The mannerist academies—and this is a demonstration that there was no break with classicism in contemporary eyes—all looked *back* to the High Renaissance rather than *forward* in an earnest attempt to continue and build upon that tradition.[501,503]

Such, indeed, was the main intent of all academies of art until well into the nineteenth century: they were teaching institutions, and they saw in the classical tradition an approach to art which was teachable because it was rationalistic. Classicism, with its interest in antique literature as well as antique art, in geometry and mathematics, in the things of the intellect rather than of the senses, is eminently

teachable. So austere were mannerist pretensions for the education of students that Federico Zuccari, in about 1575/8, wished to stiffen the programme of Vasari's Academy with more theory, which he claimed had been neglected. He suggested mathematics and physics, and the establishment of a class in life-drawing. In 1582, Ammanati proposed lectures on perspective and composition. Apparently no such reforms were carried out until 1593, when Zuccari founded the Accademia di San Luca in Rome, and with it the structure which has lasted to this day. *Disegno* was its mainstay, concentrating on the parts of the body studied first in casts after the antique, and then in life; finally, the whole body was studied as a unit. As with Vasari's brainchild, more seems to have been promised than was carried through, but it was from the example of the Accademia di San Luca that a really strong organization, the French Académie de Peinture, was founded in 1654. We shall see (pp. 173ff., below) that this Academy, and its sister foundations, exercised a strong hold over French artistic life, and provided the State with conventional and hence predictable artists working in a highly codified manner which, taught as it were by the State, usually satisfied the authorities by its approved orthodoxy.

Academies, in other words, flourished because the productions of their subsidized artists were predictable; to work in an approved manner alone spelt success in the form of lucrative State commissions. Their foundation in the various countries of Europe, and in America as well, often represented the moment when a country's art came of age, expressing a desire to revive national art at the well-head of the classical tradition, the art of Italy.

7

Classicism in Italian Architecture

A medal of Sigismondo Malatesta by Matteo de'Pasti, showing the dome with which Alberti wished the crossing of the Tempio Malatestiano at Rimini to be crowned.

Brunelleschi

At first sight a clear distinction can be made between Romanesque, Gothic and classical Renaissance buildings; correct use of the classical language of architecture in the last category should make it easy to distinguish from the rest.

Unfortunately, the position is much more complicated than this. We are not only badly informed about what the Trecento or indeed the Quattrocento knew or believed about ancient architecture, but are equally vague about the stylistic intentions of the architects of those times. The matter is further complicated, as always, by the revival/survival problem; Tuscan Romanesque, for example, can be shown to contain elements from the antique which were to be re-employed during the Renaissance.[511] Occasionally it is apparent that architects were unclear about the exact period in which their models had been built; this is the case with Brunelleschi's imitation of elements of the Florence Baptistery in his work on the dome of the Cathedral precisely because he believed the Baptistery to be a Roman building and therefore worthy of imitation. Alberti used the same source, surely for the same reason, in his *Holy Sepulchre* for S. Pancrazio, Florence (c. 1455–60). Although it is self-evident that the classical style in architecture implies an interest in the remains of Antiquity and in the details of the Orders and their

decoration, it may well be that Brunelleschi's architecture, *pace* his own best intentions, is only pseudo-antique. A scholar has recently asserted that 'there is not a single major work of Brunelleschi for which a plausible and specific post-antique source (or sources) cannot be suggested'.[511] He illustrates his point by comparing the very similar ground-plan and elevation of the Old Sacristy in S. Lorenzo, Florence, and those of the much earlier baptistery of Padua Cathedral. Other scholars have demonstrated how much the details of Brunelleschi's architecture depart from the example of the antique *as we now know it to have been*.[513,517]

We must therefore make a distinction between the basic principles of classical architecture, which control its rationalism and emotional temperature, and the motifs, which can only be assimilated by the study of antique remains. Brunelleschi, as we shall see, could work in a classical manner without access to a full range of antique motifs.[512,533] Then again, our knowledge of Quattrocento opinion about what made a building *look* antique is slight. Obviously a work which, to us, looks respectably antique can be both antique and Romanesque in inspiration, like the lantern of Florence Cathedral, which resembles the lantern of the Baptistery. The same is true of Brunelleschi's unfinished centrally planned

Brunelleschi: portico of the Pazzi Chapel, Florence.

to Ghiberti. His biographer Manetti reports, perhaps fancifully, that 'he decided to rediscover the fine and highly skilled method of building and the harmonious proportions of the ancients . . . Together [i.e. with Donatello] they made rough drawings of almost all the buildings in Rome and in many places beyond the walls . . . In many places they had excavations made in order to see the junctures of the membering of the buildings, and their type . . .'[518] But even if some of his ideas can be easily related to the Romanesque, and even if he tends to conceive of architecture in two dimensions, as a pattern on a wall, rather than as the forming of space (except, perhaps, in S. Maria degli Angeli), his example nevertheless laid the foundations of the Renaissance style. The basis of his buildings was geometry, for he believed in the power of geometry to represent and evoke beauty. Sphere and cube, and exact proportional relationships based on mathematics, made his architecture clean and uncluttered. Decoration was kept to a minimum so that the vocabulary of antique architecture—columns, pilasters, entablatures —might speak for itself. To such a work as the Old Sacristy of S. Lorenzo, Florence, one can apply the same terms as for Masaccio's great frescoes in the Brancacci Chapel: reason, balance, proportion and harmony. Although architecture cannot 'speak' in the same way as painting because it lacks narrative subject, nevertheless Brunelleschi's forms, because they evoked the past, evoked also that flood of associations which were wedded to the antique during the Renaissance.[509]

Indeed, his understanding of the antique enabled Brunelleschi to adapt antique forms to the needs of the Christian religion, as well as to the technical problems raised by the construction of the enormous dome of Florence Cathedral. But while it is correct to maintain that his knowledge of Roman masonry led him to adopt a strong herring-bone formation for the masonry of the dome which did away with the need for centring,[516] it is equally true that the skeleton of the dome, formed by the great ribs which require the weight of the marble lantern to keep them from buckling, is Gothic in inspiration.[515] Brunelleschi must of course

church of S. Maria degli Angeli, Florence, commonly believed to have been inspired by the antique Temple of Minerva Medica at Rome; a much more likely source is the doubling of the transept of Florence Cathedral. Certainly, Michelozzo's circular chapel at the east end of SS. Annunziata (begun 1444), which really is a copy of the Temple of Minerva Medica, met with much opposition from the critical Florentines.[527]

Brunelleschi is important to the classical tradition because he understood the basic principles of classical architecture;[514] the dome of Florence Cathedral, together with its absidal chapels, forms in reality a centrally planned church. He may have taken the idea from the Baptistery or, as Vasari asserts, he may have studied antique remains in Rome in 1401, after losing the competition for the Baptistery Doors

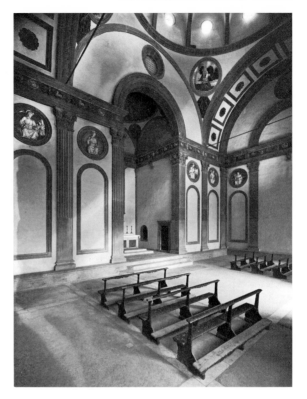

Brunelleschi: Pazzi Chapel, interior.

have known this, but it is pleasant to imagine him thinking his work the equal of that most influential of all antique edifices, the Pantheon. It seems likely, from the little knowledge we have, that the form of the Pantheon dome conditioned that of S. Maria degli Angeli (1434–7), which he began immediately after another postulated visit to Rome, no doubt with Donatello (1432/3).[510,519]

The centrally planned church: a Renaissance ideal

In Rome, Brunelleschi surely met L. B. Alberti, who may well have inspired him to build a truly antique structure. S. Maria degli Angeli, however, is not a totally new departure in Brunelleschi's work, for it makes explicit a type of plan already broached in the Old Sacristy of S. Lorenzo (designed 1419, built 1421–8) and in the Pazzi Chapel adjacent to S. Croce (1430 or later). This type is the centrally planned church, able to fulfil better than any other form the Renaissance interest in geometry. Because of its 'perfect' shape—always some variant on the square or the circle—and patent descent from antique prototypes, it was to become the preferred shape of the ideal Renaissance church. But in practice this form was highly inconvenient. It was very difficult indeed to span such a great area without intermediate supports, and the placing of altar and congregation, as well as the planning of suitable routes for ceremonial processions, posed almost insuperable problems.[523] Brunelleschi's S. Lorenzo (begun 1419) and S. Spirito (designed 1434 or later), with their basilican form and flat wooden ceilings, were much more practical and still allowed the architect to exercise his interest in geometry.

125

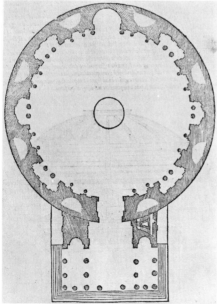

Rome, the Pantheon. ABOVE *A nineteenth-century photograph taken before the removal of the two bell towers.* LEFT *Sebastiano Serlio's plan. From the Architettura, Book III, Venice, 1584.*

The prototypes both formal and iconographical of the centralized plan of the Renaissance church were various.[522,524] A clear Christian source was the tradition which connected the circular church with the Virgin who was frequently referred to in litanies as the 'Temple of the Lord';[521] hence the appellation of the Pantheon as S. Maria Rotunda. The Virgin is often depicted in paintings with the Temple of Jerusalem, popularly believed to have been a centrally planned building, as in Raphael's *Betrothal of the Virgin* (and its source, Perugino's version in Caen, 1503/4). In Perugino's *Donation of the Keys* in the Sistine Chapel, the building is indicated as an IMENSV(M) TEMPLUM, and again the Temple of Jerusalem is clearly intended. In some respects, therefore, the Virgin *was* the Church. Equally, antique pagan tradition connected centrally planned buildings with certain gods,

ABOVE *Brunelleschi's design for the east end of S. Maria del Fiore, Florence, approximates to a central plan.* RIGHT *Plan of S. Maria degli Angeli, Florence, by Michelozzo.*

particularly Diana, a virgin, who was on occasions compared to the Virgin Mary. During the Renaissance, antique circular temples (many of them, of course, tombs) were often called 'temples of Diana'.[520]

Again, the Church of the Holy Sepulchre in Jerusalem was centrally planned; and its frequent imitation in Italy during the Renaissance[525] usually corresponds in form with the Early Christian *martyrium*, a monument commemorating the death of a martyr,[31] and based on the pagan Roman forms of the mausoleum, These buildings are imitated in several Renaissance churches. The best-known example of the church as memorial is Bramante's Tempietto beside S. Pietro in Montorio; the above considerations make it obvious that its shape is not determined merely by mathematical aesthetics or by a desire to imitate the antique closely, for the work was intended to mark the spot where St Peter was martyred. Other examples would be Michelozzo's rotunda[527] for SS. Annunziata, commissioned as a memorial to the Marquis of Mantua, and S. Maria della Pace in Rome (by 1483), a memorial church by an unknown architect. Of course, the greatest of them all is the new St Peter's, conceived (but not completed) as a centrally planned building, and planned by Julius II as a

mausoleum for himself, as well as to shelter the relics of St Peter.

In the question of centrally planned churches, the revival/survival problem is again much in evidence. As with Brunelleschi and the Baptistery of Florence Cathedral, so Bramante had no way of distinguishing Early Christian (or later) from Roman work, because most of the serviceable structures had been converted into churches. For Bramante, the circular mausoleum of the daughter of Constantine, S. Costanza, must have been as important as the pagan mausolea of the Appian Way, the circular Temple of Vesta by the Tiber, or the Temple of the Sibyl at Tivoli. The circular churches of the Renaissance are a mixture of pagan and Christian: Raphael's centrally planned Chigi Chapel in S. Maria del Popolo is Christian, yet its position near the Porta del Popolo, and its shape, as well as the presence of Elijah-cum-Jove in the cupola, inevitably link it with the form and siting of pagan memorials, which had to be erected outside the City.

The final link between mausoleum and church, pagan and Christian, is that baptisteries are, by long tradition, often centrally planned. They are places of death and resurrection: the death of the old life and the birth of the new. A mausoleum, for both pagans and Christians, has similar overtones. With such a wealth of associations behind the

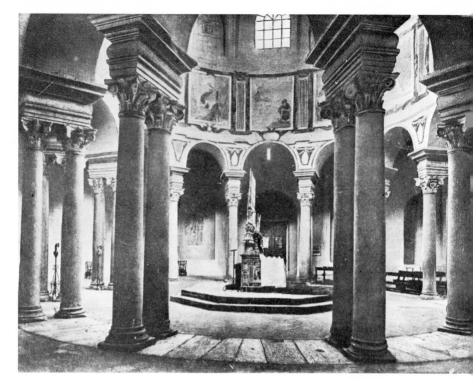

ABOVE *Interior of S. Constanza, Rome. Until 1791 it held the porphyry sarcophagus of Constantia, Constantine's daughter.*

LEFT *The Temple of Vesta (or of the Sibyl), Tivoli.*

central plan its popularity in Renaissance architectural theory is understandable. We shall meet it again when considering the work of Alberti and Bramante.

Alberti, architect and scholar

Brunelleschi's S. Maria degli Angeli is the first separate centrally planned church of the Renaissance, although both the Pazzi Chapel and the Old Sacristy of S. Lorenzo are in effect separately designed buildings as well. They were the foundations on which Alberti, who dedicated his *Della Pittura* to Brunelleschi, built his theories, aided by the only architectural treatise to survive from Antiquity, Vitruvius' *De architectura*, and by his own observation of antique remains.[534,537]

When Brunelleschi died in 1446, many of his projects were incomplete, and were to be completed in accordance with others' designs. Alberti's schemes were often to suffer a similar fate, but we know his intentions better than those of Brunelleschi because his theories are clearly stated in his imitation of Vitruvius, the *De re aedificatoria*, which was completed by 1452.[535] The first printed edition appeared in 1485. These theories were of great importance, for they influenced not only Bramante and Raphael, but also the architectural textbooks of Serlio and Palladio and, of course, the latter's architectural style. Often dismissed as a mere theorist, Alberti's example is in fact crucial for the classical tradition because he demonstrated how to apply the vocabulary of antique architecture to contemporary needs.[529,530]

Alberti's scholarly knowledge of antique architecture was, we may be certain, much greater than that of Brunelleschi; the older man was a consummate construction engineer, for example, whereas Alberti was a scholar and apparently never a practical architect in that sense. His position in the Papal Curia entailed not only advising the Pope on the rebuilding of St Peter's (an idea broached long before the time of Bramante) but also supervising restoration work on Early Christian churches such as S. Stefano Rotondo and S. Prassede.[541] It was in Rome, amidst that repository of antique solutions to the problem of how to rebuild the city in a grand manner,[546] that he composed his book on architecture.[538]

In the Seventh Book of *De re aedificatoria* he lays down his requirements for the ideal church. Unlike Vitruvius (who has little to say about centrally planned buildings), Alberti ignores the basilican form in favour of the central plan. He wishes churches to be 'of great Use for stirring up Men to Piety, by filling their Minds with Delight, and Entertaining them with Admiration of their Beauty', and therefore recommends the central plan: the church is to be placed on a podium which will elevate it above the everyday world, and embellished by a portico such as the Ancients had used. The whole should be rich yet simple, in colouring as in form. High-placed windows

Leon Battista Alberti's self-portrait on a medal, c. 1430.

would concentrate the mind on devotions, for 'That Horror with which a solemn Gloom is apt to fill the Mind naturally raises our venerations, and there is always something of an Austerity in Majesty . . .' The building should be completed by a dome, and even the 'Composition of the Lines of the Pavement full of musicall and geometrical Proportions' will echo the perfect harmony of the whole structure (translation by J. Leoni, London, 1755). Beauty is conceived as being the result of a mathematical formula based on reason, in which nothing can be added or taken away without spoiling the whole. One scholar, denying that Alberti was a mere antiquarian, maintains that his passionate concern with the revival of antique forms arises 'from a conviction that the beauties and harmonies of the plastic arts correspond to a moral and spiritual equilibrium of human existence'.[531]

As we have seen, Alberti's ideas on architecture derive partly from his close study of Vitruvius. Although Vitruvius' text had been

129

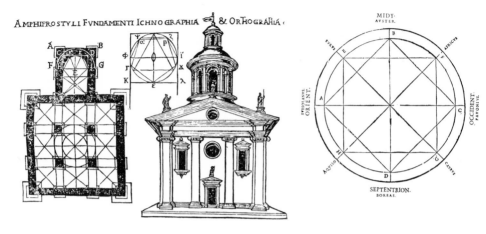

Amphiprostyle Temple, from Caesariano's edition of Vitruvius, Como, 1521. Renaissance editions of Vitruvius contain more central plan buildings than the text warrants. RIGHT Diagram of the winds. Philibert de l'Orme: Architecture,

Rouen 1648. This figure is similar to that in Vitruvius for ideal city plans, and to the well-known Renaissance scheme of the man within the circle as a measure of all things. It is another example of an obsession with the centralized plan.

known and quoted since Carolingian times,[528] Alberti's examination is important because he was the first scholar with a good knowledge of antique remains to compare written word with surviving ruins, and to form a system of architecture from that comparison. His interpretation and misinterpretation of the text can stand as an example of the kind of difficulty faced by any scholar who looked to ancient texts for authority.

The problem with Vitruvius' text was the obscurity of its language. Alberti admitted (De re aedificatoria, VI. i) that, in the field of architecture, Vitruvius was 'the only writer, and without doubt very instructive, to have survived that great shipwreck [of Antiquity], but much ravaged by time so that in many places much is missing and, in others, you would wish for a fuller explanation'. His style was so bad, Alberti complained, that 'the Latins thought he wrote Greek and the Greeks believed he spoke Latin . . .' Such obscurity meant, of course, that the commentator could read almost what sense he liked into the Vitruvian text and still, as it were, receive the blessing of Antiquity. The text must have been illustrated once upon a time, but no manuscript with illustrations survived. The scholar's

task was therefore to try to make sense of Vitruvius by comparing his words with the visible remains of Antiquity. (Fra Giocondo, who edited Vitruvius in 1511, may have similarly clarified Vitruvius' account of town planning by referring to what he could see on the ground.)[532]

It is no surprise to find that Alberti sometimes made mistakes, as with Vitruvius' account of the Etruscan Temple.[536] Vitruvius describes a temple type with three cellae at the rear of the site and a portico taking up half its area. Actual examples of that form have now been uncovered, but Alberti knew nothing so strange. And so, in the De re aedificatoria, he describes the nearest thing he knows that will fit Vitruvius' description—a miniature version of the Basilica of Maxentius, which, indeed, was believed throughout the Renaissance to be the remains of a temple.

Unconstrained by Vitruvius' neglect of centrally planned temples, Alberti makes his own specification for the form: such structures must, he writes, have a portico leading to a room which must be vaulted, and should usually be circular or some elaboration on that shape. He obviously studied buildings like the Pantheon and the Temple of Vesta at Tivoli,

but for the more complicated apse and chapel shapes that he prescribes Alberti must have closely examined the mausolea in and around the City of Rome. Krautheimer forges another link between temple and mausoleum by suggesting that the widespread Renaissance belief that antique gods were great men made immortal (euhemerism) may have made it clear to Alberti that such small buildings, precisely *because* they contained tombs, were in fact temples as well, raised to the glory of the newly created god. The same duality would, in Alberti's eyes, apply to Early Christian centrally planned buildings such as the Mausoleum of Theodoric at Ravenna, or S. Costanza in Rome.

Whatever the quibbles, Alberti it was who resurrected and interpreted Vitruvius for the Renaissance. He was also the first modern architect to pay thorough attention to the Orders of classical architecture,[526,540] although he was never sufficiently interested in architecture as structure to conceive of the Orders as anything other than decorative motifs. In his work, they are not essential load-bearing elements. Nevertheless, it was his interest in the Orders, combined with his study of antique remains, which led him to propose two solutions, both of which have been extensively used, to the problem of how to make a Christian building look suitably antique. His church designs are therefore of crucial importance in the history of architecture.

He began with the remodelling of the old church of S. Francesco at Rimini (begun 1450), where he hit on the idea of using a triumphal arch on a high podium for the façade: the one large opening and two small openings could then correspond with the entries to the nave and aisles. Sometimes, however, the aisles of a church are very much lower than the nave; at S. Maria Novella, Florence (begun 1458) he solved the awkward connection between nave–façade and aisle–façade by joining them with elegant scrolls, another feature which established a tradition in church architecture. S. Francesco at Rimini is more commonly called the 'Tempio Malatestiano',[541] because it was designed for the tyrant of Rimini, Sigismondo

Malatesta, as a memorial to himself and his humanist court. It is indeed a temple—almost a temple of fame.[542] The imagery of the complex scheme, quite possibly worked out by Alberti himself, is replete with classical references, being a Neoplatonic monument to Sigismondo's 'own apotheosis as a sun-god'.[539,543] This pantheon has sarcophagi (containing members of his court) in the outside walls under arched openings which, in their articulation, derive from Roman aqueduct design, or a simplified Colosseum. The crossing was to have been completed by a dome, which would probably have resembled that of the Pantheon in Rome. The implications of the whole scheme must have shocked the Church: Pius II publicly excommunicated Sigismondo for his presumptuous vainglory. Yet the idea of the building bore fruit in future centuries, as in the Pantheon in Paris or the Walhalla at Regensburg.

An alternative to the triumphal arch, conveniently used to express Christian beliefs of resurrection, is the temple front, which Alberti was also the first to use in church design, in his much altered S. Sebastiano, Mantua (begun 1460). Alberti's own design, as reconstructed by Wittkower, shows a high podium bearing a Greek-cross church, whose façade has its austerity modified by a broken pediment from

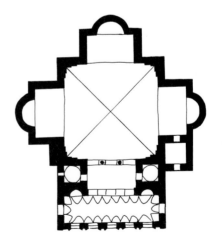

Ground plan of S. Sebastiano, Mantua, by Alberti.

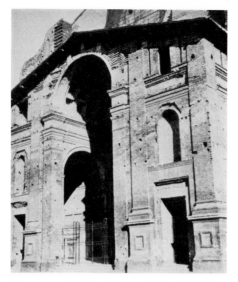

West transept of S. Andrea, Mantua, by Alberti, 1470ff.

which is suspended a window. A precedent for this arrangement was the triumphal arch at Orange, in Provence.* Neither S. Sebastiano nor the façades of S. Andrea at Mantua (begun 1470), which give a better idea of Alberti's intentions, make any use of full columns; both use a wall architecture of pilasters. At S. Andrea, the façade motif of a massive wall pierced by a barrel vault is increased in majesty by the giant pilasters which, rising apparently through three storeys, frame the exact square of the façade, and divide it into four exact and smaller squares. Inside the church, the same façade motif is continued down the aisle-less nave in the chapels to left and right, and unified by the barrel vault of the nave itself. Never before, in form or decoration, had the grandeur of ancient Rome been so potently evoked. It was works such as S. Andrea that were strongly to affect Bramante's conception of ancient Rome, which was, for him, as much the Rome of the great

*The matter is contentious. Heydenreich and Lotz reject Wittkower's reconstruction, call the work 'a bizarre revival of late antiquity', and speculate on the connections of Alberti's design with Early Christian works, pointing out its two-storeyed similarity to the Mausoleum of Theodoric at Ravenna. From either position, the church is clearly in an antique spirit.

baths as the Rome of the little temples and mausolea. Unlike Brunelleschi, Alberti throws over delicacy in favour of strength, and sacrifices Brunelleschi's light arcading for the massiveness of barrel vault and pillars. It is essentially in a structure like S. Andrea that the Plato and Aristotle of Raphael's *School of Athens* hold sway, when their philosophy is magnified by the very scale of the architecture. In *De re aedificatoria* (VII. ii), Alberti prescribed the vault as an essential element of the temple: the dome, as in S. Sebastiano and as projected for the Tempio Malatestiano, is a variation on the vault.

Alberti was an expatriate Florentine, and left examples of his architecture in Rome as well as in Rimini and Mantua. Elements of his style took root in Florence,[544] where he founded a type of palace façade with his Palazzo Rucellai (begun 1446), a building which applies the Orders, as pilasters, to its façade, and divides the three storeys horizontally and mathematically by bold entablatures. Later palaces owe much to this example: the Palazzo Pitti (begun 1485), unusual in its monumental scale, might even be by Alberti himself, while the Palazzo Gondi (Giuliano da Sangallo, begun c. 1490) and the Palazzo Strozzi (begun 1489) take the easier course of no Orders, deriving their manner from Michelozzo's Palazzo Medici (begun 1444). The great breadth of Alberti's ideas on architecture and town-planning[545] bears fruit in the work of Bernardo Rossellino, whose ideal city of Pienza, the birthplace of Pius II (Enea Silvio Piccolomini), was actually in part built (1460–2). The Palazzo Piccolomini there is a variation on the Palazzo Rucellai, which Rossellino had in fact helped to build. The various buildings of Pienza are arranged almost as a stage-set, but unfortunately Pius II died before the grand design could be completed. Then again, Alberti also provided the first barrel vault in Florence, in the Chapel of the Holy Sepulchre within the church of S. Pancrazio (c. 1455–60).

Alberti was not what we would call today a 'professional' architect, and presumably he did not take students. But the career of Giuliano da Sangallo (1443–1516), a Florentine architect, demonstrates the spread of Alberti's

deas. Giuliano was apparently the first Floren-tine architect to receive a thorough training in Rome; he arrived there in 1465, and worked until at least 1472. Some of his earlier designs—for example, La Madonna delle Car-ceri, Prato (begun 1484)—are an extension of the manner of Brunelleschi, but his mature work benefits from his study of antique Roman architecture. Such is the case with his villa for Lorenzo de' Medici at Poggio a Caiano, near Florence (begun c. 1482), and with his Palazzo della Rovere at Savona, of the next decade. If we examine these works together with the grandiose designs in his sketch-books (includ-ing one for an immense palace for the King of Naples), Giuliano's confident use of antique Roman forms becomes even clearer. Poggio, for example, is probably the first villa where a Roman temple portico is introduced, albeit

recessed; the *salone* displays a coffered barrel vault designed and constructed after the man-ner of the antique. The Naples project has a portico standing proud of the block, and is completely unlike any Florentine scheme; its whole organization is Roman, and shows a concern for balance and mathematical division which Palladio, drawing on similar sources, used in the next century. On the Palazzo della Rovere, furthermore, Giuliano takes up the classical Orders, and applies them, as Alberti did, as pilasters to the austere façade. In the Palazzo Scala, in Rome (1472/80), Giuliano attempted to recreate an antique palace, com-plete with reliefs in a totally antique manner. He might therefore be called a link between the delicate Florentine manner of Brunelleschi and, through the antiquarianism of Alberti, the grand manner of the High Renaissance in Rome.

Various ground plans for houses, using centrally-planned courtyards. Francesco di Giorgio: Codex Magliabechiano, fol. 20r. Florence, Biblioteca Nazionale, MS II.I.141.

Studies of round temples. Francesco di Giorgio: Codex Saluzzo, fol. 84r. Turin, Biblioteca Reale, MS Saluzzo 148. Francesco provides a link between Alberti and Leonardo.

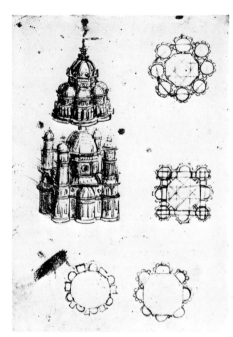

Leonardo da Vinci, drawings of central-plan churches. Paris, Institut de France.

Leonardo and Bramante: the High Renaissance in architecture

Another link between Alberti and the High Renaissance is forged by the extraordinary treatise of Antonio Filarete (1461/4). This not only copies parts of Alberti's *De re aedificatoria* (which was not printed until 1485, in Florence), but also adds an immense disquisition on an ideal city called Sforzinda, named after his Milanese patron Francesco Sforza (he had arrived there from Rome by 1456). The book is important because Filarete's enthusiasm for classical antiquity and his dismissal of the 'modern' style no doubt affected the outlook of both Leonardo and Bramante, both of whom lived for a time in Milan, the former from 1482 to 1499, the latter from 1481 to 1499.

Leonardo is certainly a crucial figure in the development of Bramante's art, but the extent of his actual involvement with real buildings is unclear.[551,553] Leonardo drew centrally planned churches in his notebooks; these

derive from the Florentine tradition of Brunelleschi, particularly the cathedral dome and the S. Maria degli Angeli project, and Giuliano da Sangallo's sacristy for S. Spirito. Furthermore, we know that Leonardo took an interest in ancient ruins: he describes an antique temple in the *Codex Atlanticus* (fol. 285) and from the anonymous *Codex Bramantinianus* it is certain that he possessed a book containing drawings of ancient buildings (which he might have drawn himself). Several links have been suggested between Leonardo and Bramante. They were, of course, working in Milan near each other, the one on the *Last Supper*, the other on the fabric of the same church and convent of S. Maria delle Grazie. Pedretti has recently shown that among Leonardo's drawings are details of the Grazie, and he has concluded that Leonardo took an active part in the actual process of design.[555] Leonardo's proven interest in engineering problems makes the suggestion convincing, for he could have offered his friend much help in an area where subsequent events showed Bramante to be woefully inadequate (particularly the cracking of the piers of the new St Peter's). The same scholar has even suggested that, because of his centrally planned church designs, Leonardo might well have had a hand in the design of the Tempietto in Rome, which is now dated as post-1510.[554] The supposition is supported by the close friendship of the two men, revealed by the *Antiquarie Prospetiche Romane*, dedicated to Leonardo, of which Bramante seems to have been the author.[547] But it is possible to argue the matter the other way, as Heydenreich does, stating that Leonardo 'derived the values of ancient monumentality through the classic style of Bramante'.[548]

Bramante's architectural education must have begun in his home town of Urbino, where he would have seen the marvellous and sober buildings in the frescoes and panels of Piero della Francesca. We can assume that, on his way to Milan, he would have passed through Mantua, and admired the works of Alberti. Once in Milan, his manner shows connections with the spirit of Alberti's work.

Bramante's only centrally planned building in Milan was the little chapel of S. Satiro next to the church of S. Maria presso S. Satiro (where he also worked). His inspiration here was the original foundation of S. Satiro, a ninth-century structure based on Early Christian examples, which it was his task to remodel. The ground-plan of the medieval church appealed to him, and he adapted it for his sacristy to the same church (1470–c.1482). As for the exterior elevation of S. Satiro, the clarity with which he indicates the cross-within-the-circle is completely Florentine, whilst the pilaster-and-niche motif probably derives from Brunelleschi's S. Maria degli Angeli. He was to use it again when he went to Rome.

Equally significant in Bramante's search for an antique style is his interior modelling of S. Maria presso S. Satiro. The trick perspective of the apse (he lacked the space for anything other than an illusion) is less important than the massive barrel vault which weighs down upon it and echoes the vaulting of the nave. The articulation of S. Maria, with its use of

Rome, Cloister of S. Maria della Pace, by Bramante, 1504.

The sacristy to S. Maria presso S. Satiro, Milan, 1470–c. 1482, remodelled by Bramante.

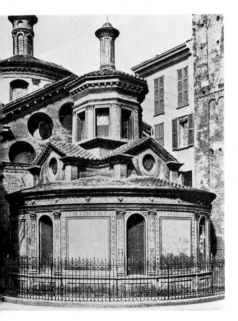

pilasters and great pillars, is in the tradition of Alberti's S. Andrea at Mantua. And the architectural detailing of this beautiful church reveals a close study by Bramante of the Early Christian architecture in which Milan then abounded. But the greatest similarity with Alberti's style is shown in the tribune of S. Maria delle Grazie, which is very close in style to S. Sebastiano at Mantua. Not only is the Milanese work in effect a centrally planned design; a comparison may also be made with the Tempio Malatestiano at Rimini, since the tribune was intended as a mausoleum, in this case for the Sforza family. This links the building not only with Alberti and with antique prototypes, but also with Leonardo's projects for a Sforza mausoleum.[549]

In 1499 Milan fell to the French, and Bramante moved to Rome where, after making the cloister of S. Maria della Pace (finished 1504), he designed the Tempietto[550,556] at S. Pietro in Montorio, the original design of which is preserved in Serlio's woodcut. This shows the temple as the centrepiece of a courtyard

135

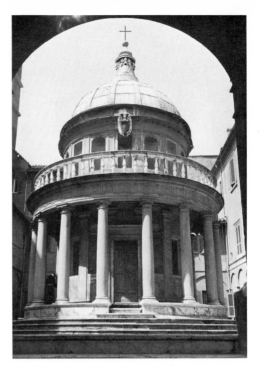

LEFT *Colosseum, Rome. A general and essential source for Bramante's elements of architecture, and in particular for his cloister at S. Maria della Pace.*

which, also with columns and niches, echoes the structure itself, and provides a clear demonstration of Bramante's concern with geometry. The scheme is similar in plan to the Early Christian church of S. Lorenzo, Milan, which Bramante would have known well. The columns of the Tempietto actually are antique; Bramante combines them with detailing and forms of his own invention to make a building inspired by antique temples and, in its proportions, by a basically Greek notion of geometry. Yet in spite of these derivations it remains wholly original. The Tempietto as we see it today is not as Bramante designed it : the dome has been heightened from the original halfsphere, and the air of blank-eyed austerity would perhaps have been mitigated by statues in the niches. This small temple was to assume great significance during the Renaissance, for it was considered the equal of anything erected during Antiquity. Palladio, for example, in his *Quattro Libri dell'Architettura* (1570) refers to Bramante as the man who was the first 'to bring back into the light of day the good and beautiful architecture that had been hidden since the time of the ancients'. He, like Serlio before him, therefore includes the Tempietto among his accounts and illustrations of antique buildings. His ground plan is different from Serlio's; he makes the temple look more like the mausolea or Christian martyria from which it is derived. Palladio himself was a great sketcher of ancient ruins, so perhaps this is an example of wishful thinking.

The Tempietto had presented a relatively simple problem which could be solved by recourse to the readily available formal sources, ranging from Early Christian martyria to the rooms of Roman palaces like the Domus Aurea or Hadrian's Villa, and the numerous tombs and *nymphaea* scattered around the Campagna. But when, in 1503, Bramante was asked to design a new church of St Peter to replace the Early Christian basilica, problems abounded.[552] Old St Peter's had consisted of a centrally planned martyrium with a long nave, which made Bramante's choice of a central

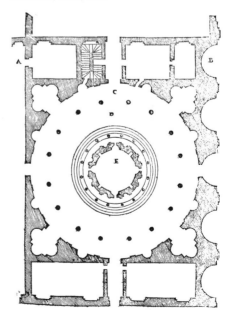

Bramante's Tempietto of S. Pietro in Montorio, Rome (after 1510), and BELOW *in plan, as drawn by Sebastiano Serlio in the* Architettura, *Venice, 1584.*

Bramante's project for St Peter's, Rome, redrawn from Caradosso's medal of 1506.

The design for St Peter's by Antonio da Sangallo the Elder (redrawn).

plan all the more likely. His idea, known from a drawing in the Uffizi, was to incorporate a Greek cross within a square, and to divide the interior symmetrically into a series of smaller, centrally planned areas. The entrances were to be through columned porticoes on each of the four sides of the square, and, as the foundation medal by Caradosso of 1506 shows, a tower at each corner would have set off the semicircular dome. It was the dome which was to cause the trouble. Bramante intended to support it on a drum decorated by columns, to build it up in 'steps' like the Pantheon dome, and then to crown it with a lantern. But Bramante's inexperience of work on such a huge scale necessitated his considerably enlarging and strengthening the supporting piers at the crossing. After his death in 1514, when Raphael took over, it was suggested that the central plan should be abandoned, and a whole series of nave designs based on the Latin cross were put forward, all of which had to incorporate the great piers for the crossing, which had already been built.

Had Bramante's first project been completed, how antique would it have looked?* The answer must lie in the relation of the dome

to the four façades, and the only evidence we have for this is the foundation medal mentioned above. This, like some of the designs by Leonardo which surely influenced Bramante's conception, shows a set of four porticoes reaching to drum level, with the transition to the lower entrance porticoes being made by four smaller domes, each on its own drum, all providing an echo of the much larger central dome. Also, of course, the antique intention of the structure would have been made clear by its purpose: to shelter the tomb of St Peter (let alone that of Julius II!)—in other words, to act as a gigantic martyrium.

It is impossible to tell whether Bramante's façades would have been quite as austere as the medal implies: blank walls predominate, and nothing fights for attention with the dome. This was to have been a single-shell dome, like the Pantheon; a double-shell in the Brunelleschi manner would have been much lighter. But whereas the Pantheon was supported to ground level by its thick walls, Bramante tried to maintain his dome on four piers, and misjudged his calculations. Some idea of how Bramante's St Peter's might have looked, but with a double-shell, not a saucer dome, can be

*Perhaps we should ask the question with one eye on Bramante's part in the destruction of the old basilica: this was too rickety to survive, but what happened to most of the fittings and monuments?

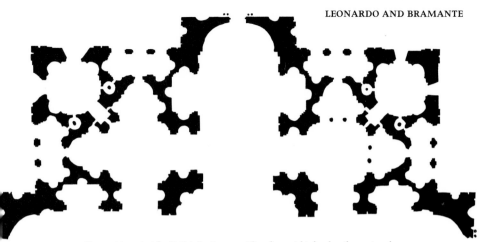

Bramante's project for St Peter's, Rome, from a drawing in the Uffizi, Florence.

The plan might be for the east end, or, equally, half of a central design.

gained from the two churches obviously modelled upon it. S. Maria della Consolazione at Todi, by Cola da Caprarola (and others, begun 1508), has similar giant pilasters on the piers supporting the dome, and looks even more like one of Leonardo's sketches. La Madonna di S. Biagio, at Montepulciano, by Antonio da Sangallo the Elder (begun 1518), is more impressive because in it a much bolder use is made of the classical Orders and therefore the work achieves an impression of antique weight

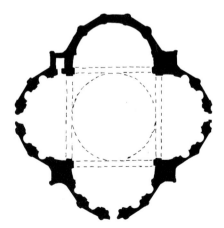

Plan of S. Maria della Consolazione, Todi, by Cola da Caprarola.

and seriousness lacking in the church at Todi, which is elegant rather than strong. La Madonna di S. Biagio, although built to a Greek cross plan, is directional: two towers, only one of which was completed, were to flank the main entrance. They are similar in design to those on the Caradosso medal, fully articulated by the Orders, and welded into the façade storey by storey, which presumably would have happened at St Peter's too.

In fact, La Madonna di S. Biagio might represent a slightly later stage of work on St Peter's, namely the period when Raphael was in charge and produced a model (now lost), plans and elevations. It is interesting to note that Antonio's son worked on the fabric from 1516 to 1520, under Raphael. Basically, Raphael's design changed St Peter's permanently from a Greek-cross martyrium into a nave church adapted for processions. A drawing by Raphael shows that the façade was intended to have a two-storeyed portico, the storeys linked by a giant Order (to echo the piers of the crossing?) and supporting a triangular pediment. This would have been the exact height of the barrel-vaulted nave, itself graced by giant pilasters. To such elements, evidently inspired by Alberti's S. Andrea at Mantua, Raphael added flanking towers of a festive nature, articulated by the Orders and decorated by niches and swags.

Mannerism

The scale of St Peter's is indicative of the tendency toward much larger buildings both civil and religious during the sixteenth century. A different architectural vocabulary from that perfected by Bramante in the Tempietto was required in order to cope with the increased scale of construction. This alone, however, cannot begin to account for the development of 'Mannerism' in architecture, which can best be understood as a reaction to the elements of classicism as erected in the High Renaissance canon. Basing themselves on the example of Antiquity, architects like Al-

berti and Bramante had evolved a structural system which was rational, calm and dignified: columns supported entablatures, the design of window openings was consistent with antique practice, and the whole system of architectural detail found its justification in Antiquity. Architecture, for such men, was a pleasure for the mind, which could delight in both the calm perfection of its mathematics and the associations it evoked.

By contrast the Mannerist architects, particularly Giulio Romano and Michelangelo, looked to Antiquity not as the seat of all

authority but rather as a vast mine of examples which could be drawn upon to satisfy an approach to art which is emotional, not rational. Nevertheless, it is obvious that Mannerism is a development of High Renaissance classicism, and in order to appreciate the effects at which the Mannerists aim, a knowledge of the syntax of classicism is essential. Giulio Romano's buildings create an impression of emotional instability and capriciousness only because of this underlying contrast with classicism, and we can therefore say that they play on the notion of classical order and reason for their effect.

All Giulio's important architectural works—he was also Raphael's chief assistant in painting—are in Mantua, where he ruled as architect, designer and painter from 1524 until his death in 1546. He built himself a strange house (c. 1540) which, like the Cortile della Cavallerizza of the Palazzo Ducale (c. 1539) breaks all the rules of classicism. But the most amazing achievement was the Palazzo del Tè, a villa on the outskirts of Mantua for which Giulio was almost totally responsible: it is filled with his frescoes, some of which are pseudo-antique, others shockingly illusionistic. As with all Mannerist creations, at the

In Giulio Romano's mannerist façade for the courtyard of the Palazzo del Te at Mantua, all is restless confusion. Note the dropped 'keystones' breaking the architrave.

Palazzo del Te the total effect is one of unease and confusion. The eye is frequently made to doubt what it is in fact seeing, and nowhere more so than in the courtyard where the deviations from the classical canon are quite deliberate. For a start, none of the four sides match, nor do they appear to be completely finished, thanks to Giulio's startling use of heavy, rusticated blocks in contrast with expanses of smooth blocks. Occasionally, stones of the architrave have slipped and left gaps in the frieze, where the triglyphs have slipped as well. Strangest of all is the section where a pedestal supports both the high Order

Michelangelo's mannerism: LEFT *The vestibule of the Laurentian Library, Florence, begun in 1525, and* RIGHT *a corner of the Medici Chapel (begun 1519) in S. Lorenzo, Florence, where complicated motifs jostle one another for breathing space.*

141

bearing the entablature, and a lower Order bearing the pediment over the central opening: the point of the pediment struggles for room and the supporting columns teeter in the midst of their more robust fellows.

Michelangelo's desire for emotional force is as great as Giulio's, but his greater inventiveness assures his work of a larger impact. The work of both men was extensively imitated: Mantua, that antiquarian paradise, was much visited until the fall of the House of Gonzaga, but Michelangelo's buildings were easily accessible in Florence and Rome. The New Sacristy of S. Lorenzo, Florence (the Medici Chapel, begun 1519) and the vestibule of the Laurentian Library attached to the same church (begun 1525) present the epitome of Michelangelo's maltreatment of classicism for expressive ends. Instead of making the library vestibule a light and airy room he presents the visitor with a combination of antique elements, all altered, which are almost threatening because of the way in which they are combined. The staircase (by Ammanati after a design by Michelangelo) threatens to flood the room with steps. But it is the wall architecture which is so strange, principally because the exact level of the wall surface and the relation of the columns set within it to that surface cannot be worked out by logic or by eye alone.* If the columns support the entablature, why are they recessed into the wall and themselves supported only on gigantic volutes, which never knew this task in Antiquity? If they do not, why does the thick wall between them support nothing other than the evidently paper-thin area of the window-openings? This system of solid above void and void above solid is contrary to reason, particularly when everything described, except those volutes, is far above the head of the spectator, who can find nothing of human scale with which to relate. Essentially the same effect is created in the Medici Chapel: architectural elements lead a wilful life of their own, pushing and squeezing. A comparison with the

Old Sacristy, by Brunelleschi, demonstrates the wilful misuse of the vocabulary of classical architecture.

Michelangelo cannot, however, be cast as the villain of the piece. Certainly, the attitude to the 'correct' use of classical elements was never the same again, but it is equally true to say that Michelangelo broadened the emotional vocabulary and thereby extended the life-span of the classical language of architecture. One device he invented was widely used in succeeding generations: the giant pilaster. In his redesigning of the Capitoline Hill (perhaps begun 1539), Michelangelo wished to give a unity to the piazza, and attained this by endowing the facing Palazzo del Senatore and Palazzo dei Conservatori with identical façades. Crowned by a balustrade, and including a loggia at ground level, the two-storeyed buildings are articulated by the Corinthian Order, but, unlike any secular building hitherto erected, these palaces have their storeys united by a giant Order which supports the imposing entablature. The ground storey has its own scaled Order as well. Although some triumphal arches use a similar scheme, nothing quite like this had been built in Antiquity; however, Alberti's S. Andrea at Mantua, with its giant triumphal arch, provides a similar solution. In other words, Michelangelo solved the problem of linking two or more storeys without recourse to the usual 'Colosseum' solution of using one Order per storey, each with its own apparatus. The solution provides a new way of balancing horizontals and verticals, but represents a totally new departure in scale and monumentality. This can best be seen by comparing Bramante's plan for the new St Peter's with the design of Michelangelo (1546); while adhering to Bramante's general scheme, Michelangelo greatly increased the size of the supports for the dome, and added a portico with giant columns, and a giant Order of Corinthian pilasters both inside and outside.

It is at this point that problems of nomenclature intervene to demonstrate that 'Mannerism', while possibly a suitable concept in

*The fact that Michelangelo had to work within an awkwardly thin set of foundations cannot affect our reactions to the design, although that design depends partly from such considerations.

RIGHT *Palazzo del Museo Capitolino, Rome 1539ff., designed by Michelangelo.*

Mantua Cathedral, rebuilt in 1545 by Giulio Romano, and inspired by the classicism of Early Christian basilicas. Compare this with his more fractured Palazzo del Te, p. 141.

painting, has little to recommend it in architecture, unless we understand it as simply a *different* approach to Antiquity. Perhaps the work of Michelangelo, Vignola and Pirro Ligorio founds a new orthodoxy in architectural design. Thus Vignola (1507–73) is not only the architect of the Palazzo Farnese at Caprarola (begun 1559), the Villa di Papa Giulio (begun 1551) and the church of the Gesù (begun 1568), but also the author of the *Regola delle Cinque Ordini* (1562) which, as he says in the preface to this collection of illustrations, is derived from his examination of antique architecture. Pirro Ligorio, builder of the Villa d'Este (c. 1565–72) and the Casino di Pio IV in the Vatican (begun 1559), would also have been outraged had anyone told him that he was mangling the very spirit of antique architecture. He would have pointed to his painstaking study of Antiquity, and shown how his own work depended on it. Nomenclature is also difficult for seventeenth-century Italian architecture: in painting, it is easy to make a precise distinction between Mannerist and Baroque, but such is not the

case with, for example, the standard comparison between the façade of Vignola's Gesù and Carlo Maderno's S. Susanna (1597), both in Rome. Any differences are only of degree, not of type. The Gesù façade, in the ordering of its constituent parts, begins a tradition at least as important as Alberti's Tempio Malatestiano, which we shall meet again not only in seventeenth-century Rome, but also in Paris, particularly in François Mansart's Val de Grâce (begun 1645). Or, to be more accurate, the Gesù restates a theme initiated by Alberti's S. Andrea at Mantua, both in its façade and in the arrangement of the interior.

Palladio

Perhaps the best way of underlining the fact that the classical tradition in architecture is both more continuous and, indeed, more long-lived than it is in either painting or sculpture is to study the career of Andrea Palladio. The façade of the Redentore, Venice (begun 1576),[558] a mature work, is clearly an extension of the temple-front idea of Alberti, but, equally clearly, the multiplication of pediments one behind the other produces an excitement and

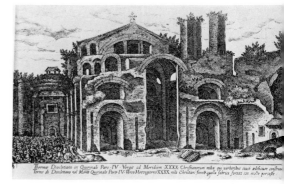

LEFT *Section west-east of the Redentore, Venice, by Andrea Palladio. From Bertotti-Scamozzi, Le fabbriche . . . di Andrea Palladio, IV, 1783.*

Baths of Diocletian, Rome. Etching by Alo Giavonnoli, early seventeenth century.

effects of light and shade which the sober Alberti did not seek. Inside, Palladio moulds the space of his white vaults by techniques derived from his study of the great Roman baths; the screen of columns in the chancel, half-revealing a room beyond, are from the same source. Palladio uses walls as the Romans of the Empire used them, as elements to be gouged out by arches and niches, and decorated by columns and pilasters. Undeniably, therefore, ancient Rome is the very foundation of his architectural vocabulary, enhanced by a good knowledge of his Renaissance forebears.[560]

Balancing the splendour of Palladio's forms is another quality which is the main reason for his great popularity, and for the ease and frequency with which he was imitated: mathematical clarity in both plan and elevation, stemming from the Renaissance belief that beauty could be attained through the use of geometry and measurement. His fame was spread by his textbooks. *Le Antichità di Roma* (1554) was to become the most popular of all guides to the antiquities of the city. His illustrations to Daniele Barbaro's edition with commentary of Vitruvius (1556) underlined

his involvement with the antique. Above all, his own *I Quattro Libri dell' Architettura* (1570), the most popular of all architectural treatises except Vitruvius', constantly reminds the reader that the author's own buildings were largely intended as reconstructions of antique architecture, based on his reading of the Vitruvian text. Such an avowal was obviously good publicity, perhaps not to be taken too seriously; but Palladio does find authority for his multi-pedimented façade to the Redentore in Vitruvius' description of his own basilica design at Fano, which refers to the 'double arrangement of gables'. His villas, the most influential part of his work, also use the temple front, because Palladio believed that this was also a feature of antique domestic architecture. As well as worshipping in antique temples, the classically minded intelligentsia of Europe could henceforth live in them as well, choosing the variation which pleased them most from the great range of alternatives illustrated in *I Quattro Libri*.

How far Palladio based his villas on actual classical remains is not clear, but he did produce a practical form of country house, well fitted to be the centre of a farm, and

145

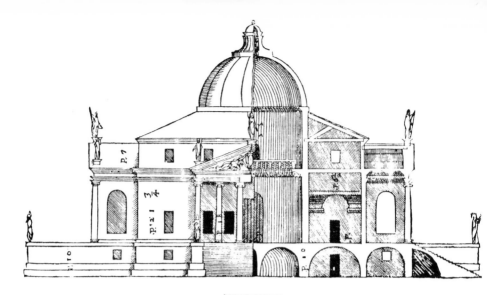

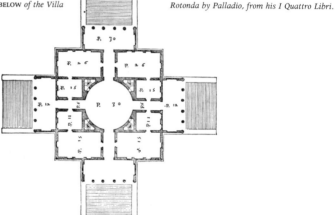

Elevation and section, and plan BELOW *of the Villa Rotonda by Palladio, from his I Quattro Libri.*

capable of adaptation by the landed gentry of northern Europe, particularly those of eighteenth-century England, after the emotionalism of his typically Venetian effects of light and shade had been chastened.

Much of Palladio's early manner depends on the achievements of the High Renaissance in Rome. The palace type represented by Bramante's House of Raphael (after 1510) is manifestly the source for Palladio's Palazzo Porta Colleoni in Vicenza (*c*. 1550). His church façades are in the same tradition, partly because they go back to Vitruvius and to the Pantheon (which also has intersecting pedi-

ments). True, he sometimes does violence to correct classical usage (the eighteenth-century critic Francesco Milizia wrote of his work as 'bizarre' and of 'impure taste'),[557] but the exuberance of some of his motifs is less important than his general feeling for symmetry and clarity. He conceived of architecture as something rational, which obeyed rules: if a work is created according to rules, it can be imitated and taught, assuming that the same basic precepts are imparted. This *I Quattro Libri* did for classicizing Europe. Palladio's feeling for clarity is boldly in evidence in some of his earlier buildings, like the Villa Godi, where he

dispenses completely with antique details, and cannot therefore rely on their cosmetic qualities. With most of his structures, we can strip away the Orders and their accessories in the mind's eye, and produce an armature very similar to some of the buildings of the Neoclassical period. That such a process is possible demonstrates the classicism of Palladio's style.

His later work, following his visit to Rome in 1554 when he would surely have learned of Michelangelo's project for the Capitol, becomes much more monumental. the giant half-column or pilaster is now used, following Michelangelo's example, as at Vicenza in the Palazzo Valmarana (1566) or the Loggia del Capitanio (1571). In the Loggia, the festive decoration with which Palladio covers the whole design is deliberately reminiscent of a triumphal arch, for the building was intended as a symbol of victory against the Turk. Even more powerful is the Palazzo Thiene in Vicenza (façade 1556–8) where he used the favourite motif of Giulio Romano (whose work he must greatly have admired), namely the rusticated base pierced by plain windows. On the *piano nobile*, the windows are articulated by great projecting blocks of semi-hewn stone which almost mask the architectural frame of colonettes and pediment. The whole composition, held down by a powerful cornice, has much greater power than, for example, his casing of the Basilica in Vicenza (1546/9) which, with its succession of 'palladian' windows (actually invented by Bramante and popularized by Sansovino in Venice, and by Serlio's book), is much lighter and less imposing. We might say that the Palazzo Thiene is more personal and hence less imitable, at least as far as palaces are concerned, because the forms which Palladio borrows from Rome ancient and modern are specifically urban in intention; they have to be surrounded by other buildings to give them scale. A hundred years later, we find Bernini proposing a design for the rebuilding of the Louvre (the 'First Design') which clearly has close connections with the Loggia del Capitanio, just as his piazza for St Peter's has touches of Palladio in its light and movement.[559]

With the coming of the seventeenth century and architects like Maderno, Borromini, Bernini and Rainaldi, this chapter of Italian classicism draws to a close. Classicism—simple, measured, intellectual—gives way in the seventeenth century to the Baroque, a style which is exuberant, expansive and sensuous. As I have already emphasized, it is not, for all that, estranged from the example of Antiquity. Antiquity is modelled by each age after its own image, and to follow the classical tradition in architecture we must pass to France (pp. 177ff., below), whose artists and architects, at the end of the sixteenth century and the beginning of the seventeenth, look to the style of the High Renaissance in Italy, and adopt and develop it into a national style of their own.

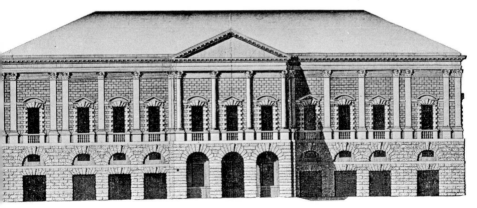

Main façade of the Palazzo Thiene, Vicenza, by Palladio. From Bertotti-Scamozzi, Le fabbriche . . ., I, 1776.

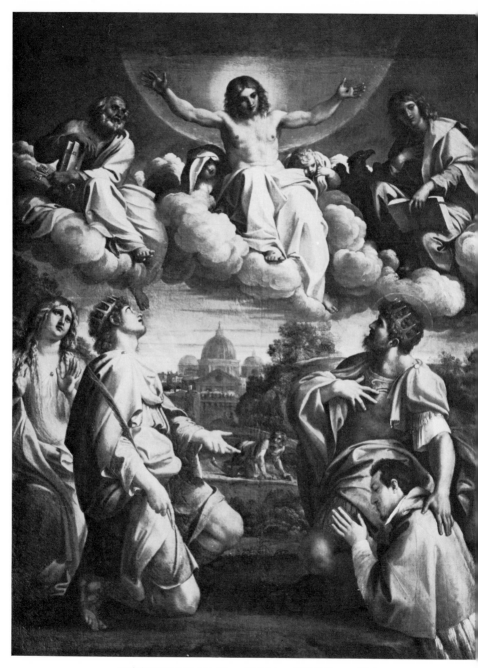

Annibale Carracci: Christ in Glory with Saints, c. 1595–7. Florence, Pitti.

8

The Classical Revival in Seventeenth-Century Italy

The Carracci

Although Mannerism may have begun as an extension of elements of the High Renaissance style, it atrophied during the later sixteenth century into a repetition of formulae. Complex in composition, colour and meaning, strange in lighting and extreme in bodily contortion, in expression and psychological tenor, Mannerism was a style for courtiers and sophisticates, blatantly clever, and far removed from the naturalistic simplicity and clear-headed idealism of the Stanza della Segnatura. At the end of the sixteenth century Annibale Carracci of Bologna, aided by his brother Agostino and their cousin Lodovico, began to develop a style based on the High Renaissance achievement, and not on contemporary trends. From his own lifetime, Annibale was considered to be the man who placed painting back on the true path of the classical tradition. His works, and those of his followers, particularly Domenichino, Guido Reni and Guercino, were avidly collected.

The Carracci spread their net wider than the Roman High Renaissance, and their style was consequently a new one. Annibale visited Parma and Venice in about 1585/6, and in Parma discovered in Correggio a master of forceful yet graceful compositions, of poses and expressions touched not by *maniera* but by a sweetness which made their idealism more human and hence approachable. Above all, Correggio's forms were simple and natural, executed with an attractive *sfumato* derived from Leonardo, and his subject-matter was clear and inviting. Annibale had in fact been experimenting with and extracting from Correggio's work as early as *c.* 1583, at a time when other Bolognese artists were still looking to Roman Mannerism. Annibale's visit to Venice introduced him to nobler counterparts of Correggio, for there he studied Titian and Veronese, and saw in them a coloristic and more naturalistic alternative to the art of Raphael, all the more impressive because it was 'alive, vigorous and varied', His brother Agostino had already visited Venice in 1582, and made prints after Tintoretto and Veronese; indeed, he championed Venetian art against the attacks of Vasari, who gave it slighting treatment.[561,568,572] During these years, Annibale was studying under his cousin Lodovico, from whom he probably took his interest in Correggio—an interest which Lodovico's *Madonna dei Bargellini* (Bologna, 1588) or his *Virgin and Child with St Joseph and St Francis* (Cento, 1591) show. But Annibale's own visit to Venice taught him how to paint textures with a shimmering brilliance derived from the technique of Veronese and Titian of dragging a loaded brush across canvas. He learned how to adapt Veronese's compositions and figure types, as in his *Madonna of St Matthew* in Dresden (1588) which is inspired by Veronese's *Marriage of St Catherine* in the Accademia in Venice (late 1570s). He could also paint mythologies in the manner of Titian, for example his *Venus and a Satyr* in the Uffizi (*c.* 1588).

After the manner of the age, the Carracci founded a school of art in Bologna in about 1582. This, the Accademia degli Incamminati (that is, of those who had set out on the road, i.e. to good art), largely avoided theory and the usual academic programme of instruction. Its students drew from the living model in a variety of formal and informal poses, not from casts. Teachers and students therefore never lost sight of how a body really looks and

Lodovico Carracci: Virgin and Child with St Francis, 1591. Cento.

Correggio: Virgin and Child with Saints, 1525–6 Dresden.

moves, and such knowledge was to be of great importance in tempering their encounters with High Renaissance examples.

In 1595, Annibale Carracci was called to Rome to work for Cardinal Odoardo Farnese, who had recently inherited the collection of antiquities formed by his uncle, Cardinal Alessandro Farnese, who had died in 1589. He desired painted decorations for the Palazzo Farnese which would harmonize with its population of antique statues. The first room Annibale frescoed, the Camerino Farnese,[566] was given an oil painting in the centre of the vault, *The Choice of Hercules* (now in Naples; copy substituted), with frescoes of Ulysses, Perseus, Hercules and the Catanian Brothers, all of which illustrated the theme of virtue. These were arranged in the jigsaw-like gold and white coffering, the interstices of which were filled with grisailles in imitation of stucco. The source for these is Mantegna's Camera degli Sposi, and Correggio's Camera di S. Paolo in Parma. The canvas of *Hercules at the Cross-roads* shows the hero, his pose derived from an antique coin, choosing between Virtue and Voluptas, the one facing out of, the other into

the composition. Their poses echo each other, but whereas Virtue, dressed in deep red over blue, the garments falling in solemn folds aided by the figure's noble *contrapposto*, stands firmly on the ground, Voluptas is as unsteady as her nature. Her imbalance is accentuated by the insubstantial fluttering veils which partly cover her body. The concepts which these allegories embody are clearly stated in attributes to left and right of the foreground, and echoed in the stony path against the luscious vinous grove of the background.

A similar clarity of presentation is to be seen in earlier works by Annibale, but the noble monumentality and easy geometry of the oil painting in the Camerino are the result of his first-hand knowledge of Raphael. The same qualities are particularly noticeable in altarpieces painted between 1595 and 1605, when illness forced him to stop painting. Thus his *Christ in Glory with Saints* (c. 1595/7, Florence, Pitti) takes up the arrangement of Raphael's *Madonna di Foligno*, which is also an ex-voto. However, it is a later Raphael, the maker of the Tapestry Cartoons, who provides him with a model for those eagerly gesticulating figures,

their heavy drapes given greater weight by the strong lighting. Later works by Annibale develop this tendency, as a comparison between earlier works and the *Domine Quo Vadis?* of 1602 (London, National Gallery), or the *Assumption of the Virgin* (1600–1, Cerasi Chapel, S. Maria del Popolo), clearly demonstrates. The forms, reduced in number compared with earlier productions, bulk large in the picture space, and press toward the front plane for added effect. They are noticeably more sculptural and more rhetorical.

Annibale's most important works are the frescoes in the Gallery[562,565] of the Palazzo Farnese (*c.* 1597–1604). This room, which is about 66 ft by 22 ft by 32 ft in height, had antique statues in the niches on the entrance and window walls. Annibale painted figures on the same scale in the main frescoed decoration above the heavy cornice. Here are flesh-coloured youths, kneeling on the cornice itself, or so it appears, and holding garlands of flowers. Behind them are bronze-coloured medallions guarded by friendly-looking 'stone' herms. Interspersed between the medallions are scenes carefully treated to look like actual canvases in gilded frames, as are the scenes on the crown of the vault. The impression of being in a picture-gallery is strengthened by the large 'paintings' at either end of the room, of which the lower edge rests, it seems, on the cornice, the upper part being tipped forward to afford the spectator a better view. We are convinced by the almost breathing nudes, so lifelike against the bronze and stone figures; and we now realize that we are apparently not in an enclosed room but in a loggia which is open to the blue sky, glimpsed behind the balustrade against which the pictures are lodged. The logicality of the whole illusion is enhanced by the strong lighting, shining from below and casting shadows.

The ancestry of the design of the Gallery is complex, but there are three main sources, corresponding to the three main features: architectonic frame, *quadri riportati* ('framed pictures'), and simple friezes. The structural idea of painted architecture is borrowed from the Sistine Ceiling, together with the population of *ignudi*, herms and medallions. In his

Annibale Carracci: Assumption of the Virgin, 1600–1. Rome, S. Maria del Popolo.

native Bologna, in the Palazzo Magnani, Annibale had already dealt with a highly coved vault by employing a continuous frieze, and he repeats the device here. The framed pictures in a 'loggia' come from Raphael's *Logge* in the Vatican (*c.* 1517–19). The clean lines and restrained illusionism of the decoration can be called a correction of earlier Mannerist work, such as Jacopo Zucchi's in the Palazzo di Firenze, Rome, of 1574/5, and Annibale's figures are also quite distinct in style from those of Michelangelo; they are more yielding and human, and the theme of the decoration is not the long story of Man's redemption, but rather the loves of the gods. The mood of the Farnese Gallery is correspondingly more humorous.

The main inspiration for the drawing style and the composition of the Gallery was Raphael,[567] not Michelangelo. The Villa Farnesina had come into the possession of the Farnese in 1580, and it is plausible that Annibale should have been both inspired by and urged to compete with Raphael's *Story of Psyche* in the Loggia of that villa (*c.* 1517). That series had 'framed picture' elements in the imitation tapestries stretched across the top of the

Annibale Carracci: the Farnese Gallery,

c. 1597–1604. Rome, Palazzo Farnese.

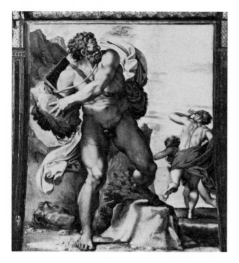

Annibale Carracci: Polyphemus throwing a rock at Acis, fresco. End of the Farnese Gallery, Palazzo Farnese, Rome.

'arbour'. In the next room was *The Triumph of Galatea*; Annibale used the dynamic *contrapposto* of Galatea herself as the basis for his own *Glaucus and Scylla*, but its indirect influence was also very pervasive: the same idea appeared in *Polyphemus and Galatea* and *Polyphemus and Acis* at either end of the Gallery, while similar exploding forces were harnessed in the noisy frieze which is the centrepiece of the vault, *The Triumph of Bacchus and Ariadne*. No single work can teach us more about the regenerative powers of the classical tradition. Its ultimate source is the iconography and arrangement of Bacchic sarcophagi, which it follows closely. It is partly inspired by Titian's *Bacchus and Ariadne*, which had been in the Aldobrandini Collection in Rome since 1598, but the immediate model was a drawing by Perino del Vaga, owned by the Farnese family, which Annibale tidied up and simplified, whilst retaining some motifs. And yet, in its fleshy vigour, sensuality and bright colouring *The Triumph of Bacchus and Ariadne* is new and modern, 'a dazzling demonstration', in J. R. Martin's happy phrase, 'of the fact that it was possible for an artist of vision and intellect, through diligent study of the antique and of the High Renaissance, to shake off the fetters of

Mannerist artificiality and bring into being a new and original style which ... could ... take its place in the monumental tradition'.

In essence, Annibale revitalized the tradition of Antiquity and the High Renaissance style at one and the same time. As for the Camerino, the programme for the Farnese Gallery was probably worked out by the Farnese librarian, Fulvio Orsini, a specialist in ancient coins and gems. We may imagine Annibale working under his guidance both in the immense Farnese collections and on Fulvio's own possessions. The Farnese sculptures at eye level in the niches of the Gallery surely suggested to Annibale, trained as he was in a naturalistic and monumental style, that he should make his painted figures look like sculptures brought to life. Thus the Polyphemus seems now an invigorated Laocoön (in the *Polyphemus and Galatea*), now the Farnese Hercules in violent motion (in *Polyphemus and Acis*).

Such features ensured that the Farnese Gallery was studied not only as an example of the work of the classical school, but as a scheme containing a wide range of stylistic possibilities.[563] Rubens, one of the most scholarly of artists interested in Antiquity,[570] studied here.[564,569] Van Dyck, who found the style of the High Renaissance too stiff for his taste, did likewise.[571] Pietro da Cortona and Bernini, as well as Nicolas Poussin, partly founded their styles on Annibale's achievement.* In brief, seventeenth-century classicism is a style not completely distinct from the Baroque, as we shall see in a discussion of the work of Domenichino.

Classicism and Baroque

Aspects of Annibale's style were developed by pupils of the Accademia degli Incamminati, particularly Domenichino, Guido Reni and Guercino, in whose work we can see something of the varying stylistic pressures in the years when the Baroque style was developing. Even the general framework of the Farnese Gallery was adapted by Baroque artists: Lanfranco

*For Annibale's interest in landscape painting, see the section on Claude (pp. 170–2, below).

reworked it for his 'Benediction Loggia' for the Vatican (1619–20; never executed) and for the ceiling of the Casino Borghese in Rome (c. 1616), while Pietro da Cortona transformed it for his frescoes in the Villa Sacchetti at Castelfusano (1626/9). But it was Domenichino, who had worked in the Gallery from 1602, who was Annibale's chief successor. He adopted a cooler, less rhetorical style in the two main monumental fresco commissions which he accepted from 1608, namely frescoes of *The Life of St Nilus* in the Abbey at Grottaferrata, near Rome (1608/10), and of *The Life of St Cecilia* in S. Luigi dei Francesi in Rome (1611/14). Domenichino restrains his scenes within a well-defined border, and it is the verticals and horizontals which control the emotional tenor of his figures. This feeling, in its turn, is reflected in the architecture of his scenes, the antique inspiration of which ennobles the monumentality of the sparse figures on their delicately lit stage. *The Flagellation of St Andrew* in S. Gregorio, Rome (1608–10), demonstrates these points. Gesture and expression, even figure types and poses, derive partly from Raphael's *stanze*: we might see the *St Cecilia Giving Alms* as a classicizing restate-

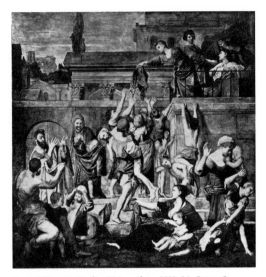

Domenichino: St Cecilia Giving Alms, 1611–14. Rome, S. Luigi dei Francesi.

ment of *The Fire in the Borgo*, with fewer figures, all exhibiting more self-control, in a spatially exact setting, rather like the stern characters of the Tapestry Cartoons.

The rhetoric inherent in Raphael's Tapestry Cartoons makes a bold appearance in the figures of the *Four Evangelists* which Domenichino painted in the pendentives of S. Andrea della Valle in Rome between 1622 and 1628. Their explosive vigour and exuberantly expressive drapery may have been a reaction to the style of Lanfranco's contemporary frescoes in the dome of the same church, in the Correggiesque illusionistic manner. In that Domenichino's figures differ but little from the mood of Bernini's *St Longinus* for St Peter's (begun 1629), they might be called Baroque.[577] They obtrude upon the rigorous classicism of his scenes from *The Life of St Andrew* in the apse of the same church. Work on such a large scale, of course, presented problems which Domenichino could solve only by extending the rhetoric of the Tapestry Cartoons to make figures even larger, simpler and more theatrically grand. His unease in such commissions is confirmed by his unhappy frescoes in S. Gennaro, Naples, begun in 1631 and still unfinished at his death in 1641. These are on the

Domenichino: The Intercession of the Virgin, 1631–41. Naples, S. Gennaro Chapel.

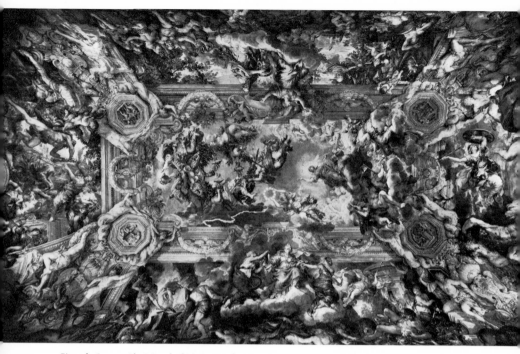

Pietro da Cortona: The Triumph of Divine Providence, 1633–9. Rome, Palazzo Barberini.

scale of Baroque and have its outward forms, but they lack any warmth of sentiment, beauty of colouring or excitement of vision.

Nor is Domenichino's toying with the nascent Baroque an isolated phenomenon, for Poussin did likewise in 1624–30. Lanfranco, fabled as Domenichino's mortal enemy, at least began as his stylistic ally, as witness his training in the Carracci shop in Bologna and his decorations in the Casino Borghese in Rome (*c*. 1616). He may also have worked on the Farnese Gallery commission. However, his stay in his birthplace of Parma between 1610 and 1612 prompted him towards the introduction into his work not only of the Correggio of the altarpieces, but also of Correggio the grand illusionist. I have explained the part played by Correggio's works in the stylistic development of the Carracci; his importance for Baroque art as well confirms the existence of similarities between the roots of seventeenth-century classicism and the Baroque. The difference

between the styles is often one of degree. The painting career of Pietro da Cortona offers examples to prove this point, as well as a testimony to the wide influence of Annibale's Farnese Gallery. Pietro's frescoes of *The Life of St Bibiana* of 1624/6 in the church of that name in Rome are similar in setting to Domenichino's works in S. Luigi. However, Pietro's scenes present us with a larger, more sculpturally conceived collection of figures which, instead of remaining calm within a sober architecture, press forward with powerful gestures into the very space in which we stand. Canvases of the same decade, such as *The Sacrifice of Polyxena* and *The Rape of the Sabine Women* (by 1625 and *c*. 1629, respectively; both Rome, Capitoline Museum) show his move from a Domenichinesque figure style set in strong *chiaroscuro* to a brighter and more dynamic conception of the human body. In his later works the figures are, indeed, reminiscent of Bernini's sculpture. These canvases derive from the paintings of

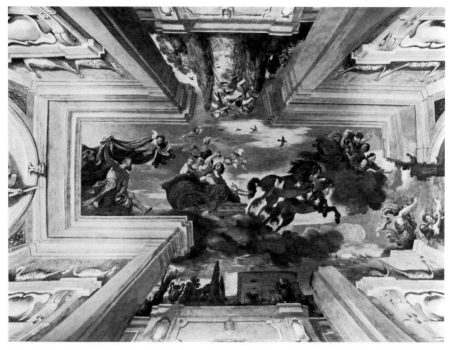

Guercino's flamboyant Aurora ABOVE, *in the Casino Ludovisi, Rome, and in which all the architecture is painted, not real, can* *be compared with Guido Reni's more classical Aurora* BELOW. *Rome, Casino Rospigliosi.*

the Farnese Gallery, and so does Pietro's frescoed ceiling in the Great Hall of the Palazzo Barberini (1633–9). He retains the architectonic framework,[574] the medallions and the slaves, and the scenes have to be viewed as *quadri riportati*. What makes the Barberini Ceiling the epitome of early Baroque is its heightened illusionism and feeling of space.

During the second and third decades of the century, therefore, the classical style fought against the rising Baroque. The struggle is captured in a comparison between Guido Reni's *Aurora* in the Casino Rospigliosi (1613–14) and Guercino's *Aurora* in the Casino

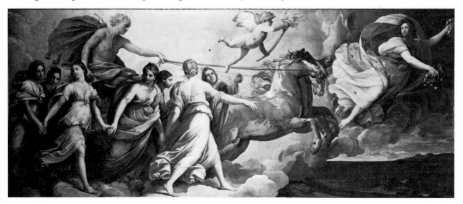

157

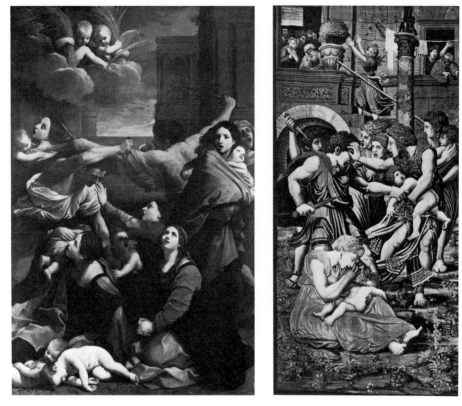

Guido Reni: Massacre of the Innocents, 1611–12. Bologna, Pinacoteca.

After Raphael: Tapestry of the Massacre of the Innocents, for which the Cartoon is lost. Rome, Vatican.

Ludovisi (1621–3). Reni's painting makes no attempt at illusionism; his bright and simple frieze derives from an antique sarcophagus, and is designed to look like a framed canvas.[576] Guercino, on the other hand, produces a romantic vision partly contrived by the illusionistic architectural perspective of Agostino Tassi, and partly by the *sotto in su* view of the groups. The stylization so noticeable in the exquisite elaboration and rhythms in the drapes of his *Aurora* is equally evident in Reni's justly celebrated *Massacre of the Innocents* in the gallery at Bologna (1611–12). The precise symmetry of this composition, which is in effect a *contrapposto* turning around the central vertical dagger, echoes a geometry in the faces which is perhaps inspired by antique masks. Nothing is closer to the elegant monumentality

and poignant understatement of this painting than Giotto's rendering of the same scene in the Arena Chapel.[573]

Eclecticism

In the rest of Guido Reni's work, we can truly say that *disegno* is matched by *colore*. In its sobriety of composition and monumentality of conception and figure type, his work is an extension of the Bolognese tradition; but there is added a new coolness of colour and a freedom of brushwork. Except for occasional glimpses of Caravaggio's style,[575] which also affected Guercino, Guido's paintings are in the High Renaissance manner, heightened and enriched by his training in Bologna. That school, averred Horace Walpole in 1747,

to the dignity of the Antique, join'd all the beauty of living nature. There was no perfection in the others, which was not assembled here. In Annibal Carracci one sees the ancient strength of drawing. In his Farnese Gallery, the naked figures supporting the ceiling are equal to the exerted skill of Michael Angelo, superiorly coloured. In short, in my opinion, all the qualities of a perfect painter [are] never met but in Raphael, Guido and Annibal Carracci . . .

Modern taste has veered away from appreciation of such qualities. What seventeenth- and eighteenth-century connoisseurs saw as restrained and delicate beauty might appear to a modern critic as 'distressing insipidity'. Such connoisseurs believed that the Bolognese were conspicuously eclectic in their choice of sources, and that their success derived from this aspect of their art. Some modern critics deny that the Carracci were any more eclectic than Poussin or Raphael;[579–81] others present the contrary view.[578] Looking at the question in the naïvest manner, it must be the case that the later an artist or school works within a tradition, in this case the classical tradition, the greater the variety of manners from which he can form his own style. It was certainly in the later years of the seventeenth century that classicism was fully codified in G. P. Bellori's *The Idea of the Painter . . . superior to nature by selection from natural beauties* (1672) and in the lectures of Charles Lebrun in France. Perhaps critics like Bellori recognized artists such as the Carracci as eclectic because they were themselves eclectic in gathering the portmanteau theories of art. In Panofsky's definition, such critics and the art they generate are not classical but classicistic, manifesting 'classicism that has become conscious of its own nature after a past no longer classical and within an environment no longer classical'.[582]

Caravaggio

Critics like Bellori saw the Carracci as the rescuers of true art from the slough of Mannerism, and also from the destructive naturalism of Caravaggio, whose art was believed

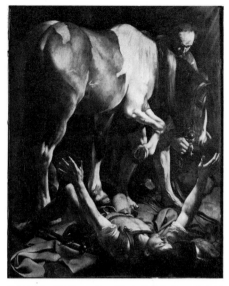

Caravaggio: The Conversion of Saul, 1600–1. Rome, S. Luigi dei Francesi.

to be without invention or selection, intellect or decorum. The task of the classical artists was to steer a median path between Mannerism and Caravaggism. As Bellori complained,

The antique lost all authority, as did Raphael, and because it was so easy to obtain models and paint heads from nature, these painters abandoned the use of histories which are proper to painters . . . some artists began to look enthusiastically for filth and deformity. If they have to paint armour, they choose the rustiest . . .

Recent examination of Caravaggio's sources, of the iconography[584,585] and style of his work, have shown him as 'less of an anti-traditionalist . . . than was believed for almost three hundred years'.[587] Indeed, a comparison of his *Conversion of Saul* with Annibale Carracci's *Assumption of the Virgin*, both in the Cerasi Chapel of S. Maria del Popolo, shows a marked compatibility of styles. The magnified rhetoric of Annibale's forms harmonizes with Caravaggio's simple and calm composition, sparse and dignified figures, and emotional reticence. Because of his familiarity with antique sources, his use of the works of Raphael[583]

and Michelangelo,[586] and the sublime understatement of his religious compositions, a case for the inclusion of Caravaggio in the classical tradition might be formulated. His so-called 'popular' art was in fact created for an audience that was anything but populist. Two factors prevent his receiving more than a passing mention here. First, the illogical quality of his *chiaroscuro*, which has connections with Mannerism, picks out details such as Bellori's 'wrinkles . . . defects of skin . . . knotted fingers . . .', which a classical artist would judge a disturbance of any depiction of the ideal. Second, the outward features of his style, imitated by artists who could not approach the intellectual and spiritual rigour of the master, led to hollow mannerisms which the classicists rightly abhorred.

Carlo Maratta

In the eyes of Bellori, the art of his friend and contemporary Maratta, like that of the much older Poussin, whom he also befriended, was the answer to the crudities of realism as it was to the fantasies of the Baroque. Maratta's long life (1625–1713) gives him as it were a bridging place in the history of classicism between the achievement of Sacchi (whose pupil he was and in whose shop he worked until 1661) and the consequent classical revival of the early seventeenth century, and the codification of the grand manner by theorists like Bellori.[582] Maratta's fame was extended by Bellori's biography, begun in 1689 but unfinished, and not published until 1732—in time, one might say, to be read by the young Anton Rafael Mengs. Bellori's championship of Maratta must be seen in the context of his view of the history of art, at which I have already hinted: art declined after Raphael, to be reborn with the Carracci and succoured by Domenichino. Bellori saw Maratta's style as part of the same grand manner, a beacon of clarity against the confusion of works such as Baciccia's ceiling of the church of the Gesù in Rome which (on the analogy of Bellori's condemnation of contemporary architecture) adopts '. . . frantic angles, fragmented and distorted lines . . .'. *The Clemency of Clement X*, Maratta's ceiling

fresco (begun 1676) in the Palazzo Altieri near the church of the Gesù, proclaims the formal and intellectual qualities of classicism. Except for the bright colouring, which is a feature of the age, it might be compared with Sacchi's fresco of *The Divine Wisdom* in the Palazzo Barberini (1629/33), to the greater credit of Maratta, the later artist. As we have seen, classical artists had difficulties with ceiling decoration when they did not treat their scenes as framed pictures; Maratta, like Domenichino before him, made certain concessions to the Baroque manner of artists like Pietro da Cortona and still retained simplicity and narrative control.

This short account cannot do justice to Maratta's commanding position in the last decades of the century as a painter of small devotional works, mythologies and portraits as well as great altarpieces. His importance extends well into the eighteenth century, partly through the work of pupils, and makes Rome the natural centre of Neoclassicism. His importance as a symbol is in association with Bellori, with whom he forms just the same kind of pair that Mengs later made with Winckelmann. For all four men, it is admiration for Raphael which provides their ultimate artistic standard. Bellori's *Descrizione delle Stanze di Raffaello* (1695) is only the last of a series of publications on Raphael in the second half of the century. Mengs was probably a great help in matters both of theory and of practice to Winckelmann: likewise Maratta, who restored the Stanze and the Farnesina, surely shared his own enthusiasm with the antiquarian rather than copied it from him. Bellori's archaeological text to the engravings of P. and F. S. Bartoli in their *Admiranda . . . veteris sculpturae vestigia* (1693) becomes one more example of cooperation between antiquarian and classical artist to place beside Dal Pozzo and Poussin, Winckelmann and Mengs, and Quatremère de Quincy and Canova. That same stream of classical theory which had fed the Carracci and Poussin found only its *summa* in Bellori; it was already part of French academic theory. In the eighteenth century, Reynolds no less than Winckelmann was to codify it into even stricter doctrine.

Art in Seventeenth-
Century France

Since the Italian Wars at the end of the fifteenth century, the achievements of the Italian Renaissance had fascinated the French (see pp. 177ff., below). Motifs from Italy found favour in sixteenth-century French architecture, and Italian artists and craftsmen were imported for such important projects as the decoration of the Château of Fontainebleau. French-born painters could not at first compete with the Italian immigrants, and even in the later sixteenth century their styles were but versions of the Mannerism of the paintings of Rosso and Primaticcio at Fontainebleau, or of the northern Mannerism of the Antwerp School. Little is known of the aptly named Second School of Fontainebleau, for few of their decorations have survived. Like the court artist Antoine Caron, they are far removed from the classical tradition, although one adherent, Martin Fréminet, painted in a more Renaissance-like style. He was in Italy from c. 1586 to 1602, and his ceiling in the Chapelle de la Trinité at Fontainebleau is a tribute to Michelangelo and the first sign of the importation of a High Renaissance as opposed to a Mannerist style into France.

In short, there was no painter in sixteenth-century France who, like Philibert de l'Orme in architecture, might be considered the originator of a French classicism. The dearth of painterly talent was such that in 1622 Marie de' Medici employed Peter Paul Rubens, a Fleming, to decorate the new Luxembourg Palace. This had been designed by a Frenchman, Salomon de Brosse—but the patron had sent the drawings to Italy to be checked, as it were, for quality! Rubens's canvases were regarded with indifference until nearly the end of the century, demonstrating a French lack

of sympathy for the full-blooded Baroque.

Soon, however, French painters were to be available for large commissions, for a French style was being developed in Rome by a group of young students. They had gone there to study both the products of the Renaissance and the equally impressive recapitulations of Caravaggio and of the Bolognese School. Claude Vignon was there from c. 1616 to 1624, and imported into France a mixture of Caravaggesque tricks, impasto technique and some Venetian ideas, all laid over his original Mannerist training. Valentin de Boulogne went to Rome in 1612, and died there in 1632. Sandrart says he was a pupil of Vouet, and certainly Caravaggism is strong in both men's works in the 1610s and 1620s; Valentin is remembered today chiefly for painting the *Martyrdom of SS. Processus and Martinianus*, a much more successful pendant to Poussin's *Martyrdom of St Erasmus* in a fully Caravagesque style.

Vouet

More important than Vignon and Valentin, and, in the short run at least, more important than Poussin himself, was Simon Vouet. As Félibien remarked in 1685/8, 'it was from this time that painting in France took on a nobler and more beautiful aspect than ever before'. He went to Rome in 1613 and followed first Caravaggio, then the Bolognese.[588] In *The Birth of the Virgin* in S. Francesco a Ripa in Rome (early 1620s?) the model is Caravaggio, but Vouet never approaches that master's emotionally-charged pathos.[589] If we look forward to the monumental figures in those blond, bright paintings which he was to execute after he

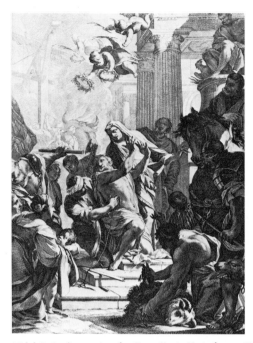

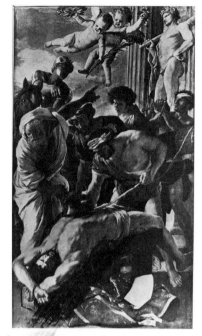

Michel Dorigny's engraving after Simon Vouet: Martyrdom of St Eustace.

Nicolas Poussin: The Martyrdom of St Erasmus, 1628–9, Rome, Vatican, Pinacoteca.

returned to Paris in 1627, it is clear that while Caravaggio's technique fascinated him, he saw that technique as but one path toward the development of essentially classical principles. He places large and simply clothed figures in noble poses, and avoids both strong emotion and the extravagances of Baroque composition. There are, in fact, many more connections between his work and that of the Bolognese School: his *Assumption of the Virgin* in Rheims (*c.* 1645) is somewhat similar to Annibale Carracci's work on the same theme in the Prado, and his *St Merri liberating prisoners* (late 1630s) in the church of St-Merri in Paris derives from Lodovico Carracci's *Bargellini Madonna* in Bologna.

When he was recalled to France in 1627 to become First Painter to Louis XIII, he was able to supply works in the modern Italian manner, yet purged of that Baroque vigour and high colour which Pietro da Cortona was currently infusing into his own works. We might say that the style he adopted in France was a version of the Baroque tempered by classicism. His *Martyrdom of St Eustace* in the church of St-Eustache in Paris (1637/8), when compared with Poussin's *Martyrdom of St Erasmus*, displays a less complicated composition and a greater clarity in both figures and setting; instead of the saint being pressed forward towards the spectator, he is centrally placed and framed by *repoussoir* figures to either side. At Vouet's workshop in the Louvre many collaborators and students were trained, including, at various times, François Perrier, Pierre Patel, Eustache Le Sueur, Pierre and Nicolas Mignard, and Charles Lebrun, the cream of the next generation of French artists. The fame of Vouet's work was extended through prints; his pupil Michel Dorigny provided a record in etchings of Vouet's important decorative work for the Chancellor Séguier, which included a chapel, gallery and library at the Hôtel Séguier. Vouet's decorative work is in a similar tradition to that of his altarpieces. The frieze of figures in the chapel of the Hôtel Séguier is

constrained behind a simple balustrade, and this is the extent of the illusionism. Simple structures such as this, taken from the decorations of Niccolò dell'Abbate and Primaticcio in the chapel of the Hôtel de Guise (c. 1555; destroyed) and from the tradition of Annibale Carracci, were to provide the model for the schemes of Lebrun and his school later in the century. Full Baroque ceiling decoration from now on found little favour in France.

Philippe de Champaigne

What Vouet did for the Italian Baroque style, Philippe de Champaigne did for the work of Rubens, whose studio, Félibien tells us, he wished to enter. He arrived in Paris from Brussels in 1621, and painted the *Portrait of Richelieu*, of which one version is in the National Gallery, London, between 1635 and 1640. This is a demonstration of how the Van Dyck idiom may be made sculptural instead of painterly, sober instead of voluptuous. In the early 1640s he developed an interest in Jansenism, and that sobriety which is never absent from his early works was now emphasized in paintings whose sparseness reflects the Christian austerity with which the subject-matter is infused.[590] Colour, setting, gestures, expression, emotion are all subdued. Such an attitude parallels that of Nicolas Poussin, who had worked with Philippe de Champaigne on decorations for the Luxembourg in about 1622. Both, in contrast with the majority of French seventeenth-century painters (and conspicuously so in the case of Vouet and Lebrun) came to regard art as something more serious than pretty decoration or propaganda Christian or political. Both saw the aim of art as the expression of and incitement to virtue. Although Philippe de Champaigne adopted an unorthodox Christian, and Poussin an essentially secular point of view, Poussin would certainly have concurred in the belief that Man is at the mercy of his passions and that, to become good, a just scale of values must be sought. For Philippe de Champaigne, this would entail a seeking for the grace of God by every individual; for Poussin, although always a Christian, an attempt to live according to the moral precepts of the Stoics. Their essential pessimism about Man, their zeal for a withdrawal from the world with its enticements and follies, presupposes an intellectualism which is far removed from the Jesuitical mainstream of French Catholicism, which confidently predicted a relatively easy salvation because of Christ's sacrifice for us. Different attitudes to such fundamental questions affected the tenor of painters' works.

Poussin

We shall look in vain in the works of Nicolas Poussin for that optimistic assertion of faith and salvation which is a cornerstone of the Italian Baroque. Nevertheless, Poussin was middle-aged before he arrived at his most austerely classical works. There is good reason to believe that his artistic journey was in a sense a pilgrimage of purification, almost of mortification, for his early period shows no such characteristics. However, his earliest work, commissioned by the Italian poet, G. B. Marino, a series of drawings illustrating Ovid's *Metamorphoses*,[596] shows a straightforward narrative gift and a sense of the dramatic quite foreign to those successors of the Second School of Fontainebleau (Lallement and Elle) under whom he probably studied in Paris from about 1612. They date from about 1623. The following year he went to Rome, no doubt hoping for further commissions from Marino, who had recently returned there from Paris. Marino soon died, but not before he had put Poussin in contact with Cardinal Francesco Barberini, who obtained for him the commission for *The Martyrdom of St Erasmus* of 1628/9, now in the Vatican Picture Gallery, but painted for an altar in St Peter's. This work and *The Virgin appearing to St James* (c. 1628, Louvre) are Poussin's only flirtations with the Baroque. The composition of the former must be studied warily, for the lineaments of the design had been fixed by Pietro da Cortona who was then transferred to a more important commission. And yet Poussin simplifies Pietro's design, strengthens its geometry, and increases its drama. In addition, he adopts a blond tone, a figure style and a type of

monumentality close to those of contemporary works by Domenichino (such as the frescoes in S. Andrea della Valle), whom we know Poussin to have much respected. The painting was not a success, perhaps because it represented a compromise between the Baroque and the classical. Valentin's pendant, *The Martyrdom of SS. Processus and Martinianus* (Vatican, 1629/30) found greater favour because of its Caravaggesque manner. Poussin's connections with Caravaggio are few, but it might be that he was inspired by Caravaggio's often startling simplicity of composition. Thus Poussin's *Massacre of the Innocents* at Chantilly (1627?) certainly derives from Guido Reni's composition on the same subject, but there is perhaps a common source in Caravaggio's *Martyrdom of St Matthew* in S. Luigi dei Francesi. All three works feature an almost schematic stylization of certain figures, helped by the parallelogram of force and emotion which makes the actions of the participants seem inevitable. In Poussin's painting, the action of the soldier balances that of the mother, and both are frozen by the geometry.

During the late 1620s and 1630s there is no consistent line of development in Poussin's work.[600] He takes up and drops styles and subject-matter almost at random, or so it appears, Titian being the most consistent source of inspiration during these years.[599] Yet his involvement with Titian's *Bacchanals* (then in the Aldobrandini Collection in Rome) is tempered by his study of Annibale Carracci and the classicizing school. *The Death of Germanicus* (c. 1627, Minneapolis) displays a Venetian feeling for colour and for paint texture, yet the composition as well as the stoic subject, both of which derive from his study of the antique,[597] provide an air of restraint. In the later 1630s, after painting a Titianesque series of *Bacchanals*[591] for Cardinal Richelieu in 1635/6, Poussin began to pay great attention to Raphael's style. Another composition for the Cardinal, *The Triumph of Neptune and Amphitrite* (c. 1637, Philadelphia) is based on the exuberance of Raphael's *Galatea* and other frescoes in the same Villa Farnesina, and has reminiscences of the Farnese Ceiling by Annibale Carracci. The *putto* in the foreground,

copied from Raphael, has its source in the antique relief of *Tritons and Sea-Nymphs* which Poussin would have seen in the collection of his patron, Prince Giustianini, and it is feasible that the general composition reflects some lost fresco or mosaic. Another patron and life-long friend, Cassiano dal Pozzo,[594] had a remarkable reference library of drawings after the antique (on all kinds of subjects) to which Poussin had access. Perhaps, indeed, Poussin

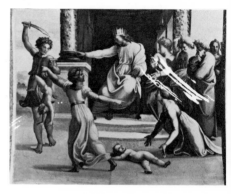

was one of the artists employed as draughtsmen in the project for this 'paper museum', of which a substantial part is now at Windsor and in the British Museum.[603–5]

As was the case with Annibale Carracci, it was to the later Raphael that Poussin looked, particularly the Raphael of the Tapestry Cartoons. He saw in that series not just a source of compositions but a demonstration of how, by gesture, expression and drapery, a noble mind in a noble body might be conjured up in paint. A presage of this attitude appears in the conspicuously un-Venetian *Adoration of the Magi* of 1633 in Dresden, which owes much to Raphael's rendering in the Vatican *logge*. The main document of Poussin's absorption of such rhetoric is *The Gathering of the Manna* of 1638 in the Louvre, of which he had written the previous year that it allowed him to show 'hunger, joy, admiration, respect. A crowd of women and children, different ages and temperaments—things which, I believe, will not displease those people who know how to read them . . .' In other words, a painting is now, for Poussin, something to be 'read'.[602] It

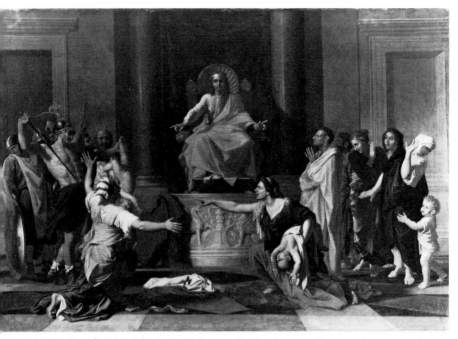

_LEFT Raphael's design, executed by Pellegrino da Modena:
The Judgement of Solomon. Rome, Vatican. A source for
Poussin's Judgement of Solomon_ ABOVE, _1649. Paris, Louvre._

is not simply an intellectual exercise, of course,
but it is far from being only a means of
delighting the eye. The subject-matter,
whether Christian or secular, is chosen for its
moral import, and the lineaments of the picture
are presented on a 'stage' so bare, so purged of
extraneous detail and of luscious colouring,
that the emotional impact made by the few
'actors' is thereby heightened.

The mention of a stage is not gratuitous.
Poussin would build a little box-theatre, with
draped wax figures which he would move
about until he had arrived at a suitably logical
composition and at lighting of a suitable direc-
tion and intensity: all this, as Sandrart tells us,
after reading carefully all the available texts,
then pondering on them, and making pre-
liminary sketches. Such a process, unusual in
the seventeenth century, is reflected in aspects
of the finished paintings. The figures are often
disposed in a frieze which is parallel to the
picture plane, because such an arrangement

clarifies the action just as it does on a real stage.
The background is often reduced to a simple
screen, whether of architecture or landscape,
which reflects our concentration back onto the
figures and conditions our mood. The sculp-
tural basis of Poussin's figures is evident, and
they gain thereby in authority and dramatic
presence. A work like _The Judgement of Sol-
omon_ of 1649 in the Louvre, which Poussin
considered his best work, makes us think of
the theatre. A preparatory drawing in the
Ecole des Beaux-Arts in Paris shows Solomon's
throne set amidst the airy sweep of a crowded
room, with massed groups disposed in depth to
either side. The painting dispenses with crowd
and with detailed architecture, and con-
centrates on the throne, flanked on either side
by a blue column, and on the action before it. A
door frame or blind window to left and right
closes this space, which is similar in type to
that in the works of Domenichino. The judge-
ment has been given, and the evil mother
demands her pound of flesh, pointing in hate
to the woman whose child is to be divided. She
in her turn makes a magnificent gesture which

halts the cruel division, gives her child to the other mother and cries to Solomon in surrender. This moment of crisis is echoed by the very composition. Here is the essential High Renaissance triangle of meaning, with other elements which heighten the tension. The bright columns both point out Solomon and separate the protagonists from the impassive, fully-frontal king and from the spectators who, chorus-like, express our emotion.

Poussin's mature paintings are about passion. We might draw a parallel between both his methods and his ends and those of Corneille and Racine, the foremost dramatists of the age in France.[592] They usually contain their plays within the classically based 'three unities' of time, place and action: there must be only one plot, and the action must be accommodated in one day and one place. They make their nobly-born characters speak in the measured, elegant alexandrine metre, which might seem at first reading to stifle the emotion so carefully dissected and analysed in their clear-sighted and conspicuously introspective speeches. In fact, such restraint intensifies and does not nullify passion; such clarity of speech, such

Poussin: Ordination from the Second Set of Sacraments 1647–8. Collection of the Duke of Sutherland.

analysis of intention, such potent and tragic inevitability help us to concentrate on the one vital theme, whether this be a stoic resignation to duty and virtue (as so often in Corneille) or a helpless decline from a sense of morality to ruin and probable death, as in Racine's *Phèdre*. The characters are usually far removed from us in time and space, as well as in social station, but it is essential to understand that this does not make their thoughts and problems irrelevant to us. On the contrary, the conventionality of setting and character allows us to focus on the struggle between reason, or virtue, and emotion, which leads to ruin—a struggle of eternal significance in human affairs.

Such considerations should prevent our seeing Poussin's paintings with antique characters and settings as mere antiquarian costume-pieces. From the late 1630s he became increasingly interested in representing details of dress, custom and architecture as accurately as possible, as can be seen by comparing the First and the Second set of *Sacraments*. He did

this because 'they will not displease those people who know how to read them', and will add more pieces to the jigsaw of Truth. The Sacraments were the institutions of the early Church; he therefore determined to represent them as accurately as his researches would allow. The settings and details served to heighten the veracity of the subject-matter, not to decorate it.[598]

Poussin paid a short visit to Paris in 1640/2, when his presence had been commanded by King Louis XIII who required him to provide decorative paintings for the Louvre. His manner of painting could not provide pretty or pompous paintings on a large scale, since he preferred to paint smaller canvases, often for a small circle of connoisseurs whom he met at this time through his patron Fréart de Chantelou. He soon made his excuses to the King and returned to Rome, although he kept in contact with his Parisian patrons. From then on he often based his paintings on subject-matter taken from Stoic authors, thereby depicting that struggle for virtue in the midst of a corrupting and fickle world which, as his letters make clear, was the main preoccupation of his own life. 'All your actions being guided by reason,' he wrote, 'you can then do nothing which will not lead to a virtuous end.' It was with this in mind that he painted *The Testament of Eudamidas* in about 1650 (now in Copenhagen State Museum of Art). The poor Corinthian, on his death-bed, leaves the care of his wife and daughter to his friends in a gesture

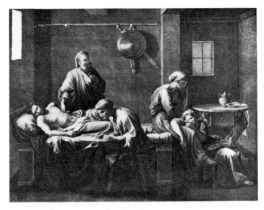

Poussin: The Testament of Eudamidas. Seventeenth-century print after the painting, now in Stockholm.

of the reciprocity of friendship. The setting is as subdued as the emotions of the participants are restrained. In Poussin's works of this period; it seems as if the very architecture conspires to uphold the same principles as the figures; precisely the same scheme operates in his paintings with landscapes, which derive largely from the example of Annibale Carracci, the inventor of the classical landscape. In the two works on the theme of Phocion, the commander wronged by his fellow townsmen, the landscape setting is imbued with a heroism which is the result of its architecture-like arrangement.[593] Its mood of reflective sobriety picks up the implications of the subject. As is often the case with the mature paintings, hard edges and straight lines predominate, in a relationship almost as mathematical as *The Madonna of the Steps* of 1648 (Washington, National Gallery of Art). Although, of course, no stoic theme, it owes its air of grandeur and heroism, its backbone, as it were, to the mathematical disposition of its setting quite as much as to the firm triangle and Raphaelesque arrangement of the figures. The elements are clear in the measured preparatory drawing in the Louvre.

Poussin's very last paintings have landscape settings,[601] for they represent at one level *The Four Seasons* (1660–4, Louvre). Although their subject-matter has one obvious interpretation, it has been shown to have much wider implications also. The painting of *Spring* shows

Poussin: preparatory drawing for The Madonna of the Steps, 1648. Paris, Louvre.

167

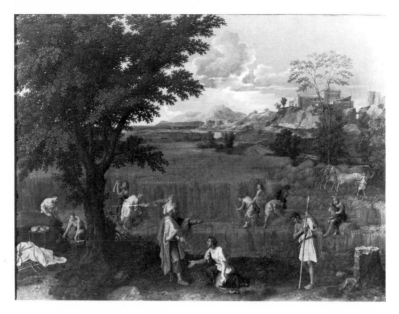

Adam and Eve, but may also refer to Apollo; *Autumn* with the gathering of the grapes refers perhaps to both Bacchus and the Eucharist. The canvases, through their biblical stories and their seasonal symbols, seem to represent a pantheistic union of pagan and Christian beliefs, as well as a more generalized meditation on human life and destiny. What higher task could there be for art than to explore the relationship between Man and the elements? Such generalization is of the essence of classicism, and gives a wider interest to some of Poussin's paintings than the specific nature of their subject would suggest. This is the case, for example, with *The Exposition of Moses* of 1654 (Ashmolean Museum, Oxford), which is used as a vehicle both for telling the story and for explaining the posture a man must adopt in the face of destiny. 'We must acquire virtue and wisdom', Poussin stated, 'in order to stand firm before the blandishments of mad, blind Fortune.' The emotions of the adult participants are expressed with an understatement made more severe by the economy of gesture and the silence which it engenders. The implications of the work, 'to those people who know how to read', are no less important than

Poussin: The Four Seasons: Summer (Ruth and Boaz), 1660–4. Paris, Louvre.

those of *Et in Arcadia Ego* of the early 1640s (Louvre). The subject here is antique, the theme of wider importance. Bellori describes it as 'happiness subjected to death', which is no less than the dilemma of all men. I am not suggesting that the apparent meaning of the subject-matter was of no importance for Poussin, but rather that he uses his mature paintings as explorations of something more than straightforward commentaries on pagan or Christian literature or history. From the happy, colourful and sometimes erotic works of his early years, he deliberately chastens the painterly qualities of his work in the 1640s and 1650s. Bernini is supposed to have remarked on his visit to France in 1665, 'Poussin is a painter who works from *here*', and to have pointed to his forehead. There is no more intellectual painter than Poussin, and it was on the example of his late period, where his *maniera magnifica* is most developed, that the standards and vitality of French academic painting were to be based for more than two hundred years.[595,606]

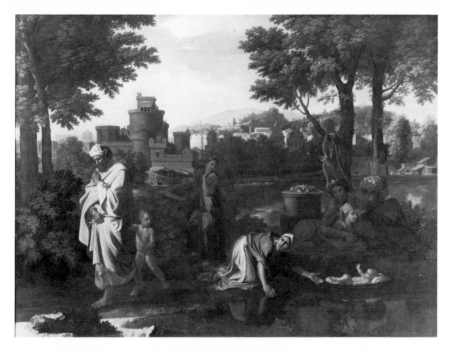

Poussin: ABOVE *The Exposition of Moses, 1654. Oxford, Ashmolean Museum, and BELOW Et in Arcadia Ego, early 1640s. Paris, Louvre.*

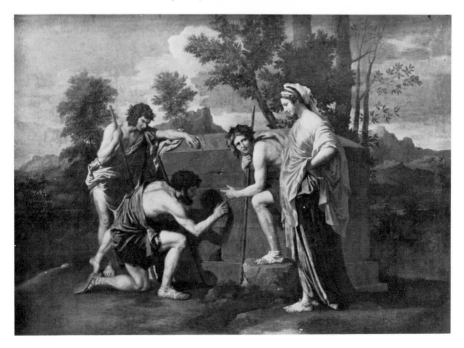

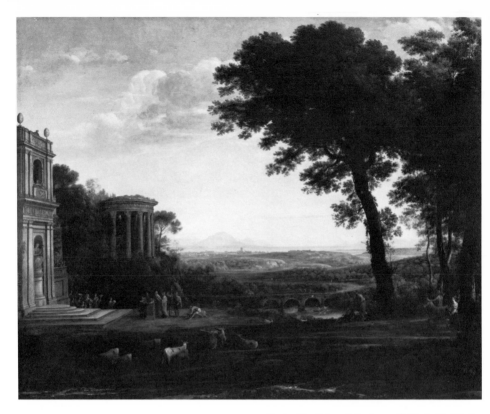

Claude: The Father of Psyche sacrificing at the Milesian Temple of Apollo, 1663. National Trust, Anglesey Abbey.

Claude

Poussin, like most of the Italian artists, was a figure painter who sometimes set his scenes in a landscape. Claude, on the other hand, was exclusively a landscape painter. Since he was a good friend of Poussin's, it is conceivable that Poussin encouraged the development of his landscape style, and equally possible that he led Claude toward his more classical style of the 1640s. Although all Claude's works contain figures, and most have definite subjects[611] prescribed by his mainly aristocratic patrons, Claude's true concern in his painting was to show the subtly changing atmosphere of the different times of day. As Sandrart writes of one of his morning pieces, 'one can truly recognize how the sun, risen for some two hours above the horizon, dissipates the nebulous air . . . showing everything perfectly in natural light and shadow, including the reflection, so that the distance of each object can be, as it were,

measured in proportion and found correct, as in life itself . . .'

Claude left his native Lorraine in about 1618 to go to Rome, and was in the large studio of the landscapist Tassi from about 1620 to about 1625. There he gained experience in the use of perspective which, allied to the emphasis on light alluded to above, provided the basis of his own ideal landscape style of the 1640s. His earlier works, indeed, take their basic vocabulary from Tassi: landscapes or coast scenes, with figures mythological, biblical or genre, and natural or man-made features.

In the 1640s, Claude began to take his subjects from classical mythology. His compositions became more serene and more firmly balanced. Because they are bigger, there tend to be more details to delight the eye. This development can be seen by comparing the recently discovered *Pastoral with a Rock Arch*

and a River (c. 1629, private collection), which shows features from the manner of both Paul Bril and Tassi, with the *Pastoral Caprice with the Arch of Constantine* (c. 1651, Grosvenor Estate), where the elements of a classical landscape are displayed: a flat foreground is marked by a tall, back-lit tree to one side, with smaller trees to the other. These lead the eye to a prominent feature in the middle ground, in this case an antique structure, beyond which the ground undulates to a hazy distance. A river, a herd of cows, and the movement of the ground connect the foreground figures with the middle ground and the horizon. Bridges, gently leaning trees and winding rivers, grazing animals, idyllic peasants, and an idealized, tranquil picture of nature are echoes of Claude's sketching trips into the Roman Campagna, which many of his canvases evoke, but do not depict exactly. The formal elements are combined with subjects classical or religious, or even simply genre, to portray a pastoral or heroic mood. As Claude grew older, this mood became increasingly poetic and elegaic, as in the renowned *Landscape with Psyche at the Palace of Cupid* (1664, T. C. Lloyd Estate).

The impetus toward antique subject-matter, especially from Virgil,[609] might have come from Poussin, whose own style was becoming more sober and heroic, and his themes much more serious, during the same period. But the inventor of the heroic landscape was Annibale Carracci, whose excursions into landscape are crucial because they were the first to demonstrate that landscape, like architecture, could be organized. The prime examples of Annibale's landscape style are lunettes painted in about 1604 for the chapel of the Aldobrandini Palace in Rome, now in the Galleria Doria-Pamphili. In *Landscape with the Entombment of Christ*, Annibale made the mood of the setting evoke and concentrate that of the small figures executing their mournful task. *The Flight into Egypt*, a less sombre subject, plays a closed and dark foreground against a lighter middle distance which is filled with incident. The placing of the figures, the cattle, the slope of the ground, river and waterfall, the angle of the light, the links between the planes of the composition are all calculated to enhance the

significance of the main figure group and to help their measured progress from right to left. A similar landscape style was continued by Annibale's heir, Domenichino, well represented in London by his frescoes of *The Story of Apollo* of 1615–17 (National Gallery).

Claude also painted works with the monumental seriousness of an Annibale Carracci or a Domenichino (see pp. 149ff., above), such as the group of eight large canvases painted between 1652 and 1675. Among these are numbered the 'Altieri' Claudes of *Landscape with the Father of Psyche sacrificing at the Milesian Temple of Apollo* (1663) and its much later pendant, the *Landscape with the Arrival of Aeneas at Pallanteum* (1675; both National Trust). Both works show a much stricter reliance on the antique texts than had earlier been Claude's custom, and a desire to accurately construct both setting and monuments.[608] But if they equal their literary sources (principally Apuleius and Virgil) in heroic style they surpass them in delicate poetry. It is this poetry, never so apparent as in these late works, which ensured Claude's continuing reputation as the greatest of all landscape painters. Admiration for his compositional techniques, and for his idealized vision of the Roman hills and fields of classical Antiquity, made his art one of the foundation stones of English landscape painting in the eighteenth century,[607] and of its three-dimensional extension, landscape gardening.[610]

Claude recorded his compositions in a volume, the *Liber Veritatis*, to guard against plagiarism and forgery. The volume was bought by the 2nd Duke of Devonshire in about 1720, and the designs were the subject of a series of engravings by Earlom, published in 1777. The popularity of Claude in England is to be judged not only by the profusion of prints after his works, by men like Arthur Pond and Charles Knapton, but also by the fabulous prices fetched by his pictures. Thus the two 'Altieri' Claudes were sold for £12,600 in 1808, much more than any work of the Dutch School. The English critics of the eighteenth century, schooled in the academic tradition, tended to place landscapes on the lower rungs of the ladder of the genres. Jonathan Richardson declared in 1719 that landscapes 'cannot

Richard Earlom after Claude: Landscape with Goats. Etching and mezzotint after a drawing in the Liber Veritatis, 1775.

Improve the Mind . . . excite no Noble Sentiments'. Towards the end of the century, however, James Barry, Professor of Painting at the Royal Academy (1782–99), praised Poussin's landscapes as 'sometimes verging to sublimity, and always engaging from their characteristic unity, graceful simplicity, or ethical associations'. Claude had been approved by Sir Joshua Reynolds himself, for in his work 'truth is founded upon the same principle as that by which the Historical Painter acquires perfect form' (*Fourth Discourse*, 1771). Thanks mainly to the Grand Tour, an institution rather strangely neglected by the French, Great Britain is rich in the works of Poussin and Claude, and their example is of the greatest importance for the patronage in Britain of Neoclassicism.

Gaspard Dughet

A lesser figure in classical landscape painting was Gaspard Dughet. He is sometimes called Gaspard Poussin, since he married Nicolas Poussin's sister and took his name, probably seeing in it a commodity of value. Baldinucci, writing in 1684, claimed that Dughet was a pupil of Claude, and implied that he learned fresco painting from him. Certainly, his early works in and around Rome are frescoes. He has never been fully studied, but he appears to have imitated both Claude and

his brother-in-law, to the confusion of scholars and collectors. He sometimes seems to have steered a middle course between Poussin and Claude, avoiding the reticence and austerity of the one and enlivening somewhat the tranquillity of the other. His fame in eighteenth-century England was great, and may be gauged by the attitude of Sir Henry Hoare, who in 1758 was searching for a Claude. None was to be had in Italy at any price, so he made do with two Dughets, both of which are still at Stourhead, whose gardens were a realization of a Claudian landscape.

The three artists discussed above, Poussin, Claude and Dughet, we tend to think of as French, but this needs qualification. Claude was from Lorraine, worked in Rome from the 1620s until his death in 1682, and received commissions almost equally from Italians, French and English. Poussin, apart from the abortive visit to Paris in 1640–2, likewise remained in Rome from 1624, but many of his mature works went to bourgeois French patrons. His work was therefore well known in the original in France—much better than Claude's, whose mature works are almost all in England, even today ('and may they always remain with us', wrote Turner in 1811). Gaspard's work followed much the same routes as that of Claude. All were frequently engraved. Claude and Gaspard made their own etchings, but their fame through engravings came mainly in the eighteenth century, in England. Nicolas Poussin, on the other hand, was copied in engravings much earlier, and his works were used to support the academic structure in France in the later seventeenth century. All three artists can justly be seen as members of the Roman school of painting, for it is in Rome that the origins of their styles are to be found, and not in their native lands. About Poussin's importance in France, more will be said later. Claude's early works had frequently been sold to French collectors, and it was therefore his early style which was imitated in France, by artists like Pierre Patel and Sébastien Bourdon. This was continued by a whole series of Claudian artists in the next

century, the most noteworthy of whom was Claude Joseph Vernet, the friend of Richard Wilson.

The rise of Paris as the artistic capital of Europe

In the early seventeenth century, Rome was the artistic capital of Europe, and her artists were wooed by foreign connoisseurs to work abroad. Charles I invited Guercino to England in 1625, then Albani, then Tacca. All refused. In France, Richelieu and Mazarin were keen collectors; at his death in 1641, Richelieu probably owned at least ten Poussins, and his *cabinet* was hung with treasures from the sack of Mantua in 1630, including Mantegna's *Parnassus* and Perugino's *Combat of Love and Chastity*. His château at the town of Richelieu was adorned with the Michelangelo *slaves* which are now in the Louvre. At first, he commissioned little from Italian artists, but eventually the success of the Barberini family as patrons must have impressed him. Mazarin, his successor, who was in power from 1642 to 1661, continued his policy of trying to attract artists from Italy. Mazarin was, of course, Italian himself, and had been secretary to members of the Bentivoglio, Sacchetti and Barberini families. He therefore had contacts in Rome but, as Poussin remarked in a letter to Jean Lemaire in 1639, only second-rate artists would go. In 1640 Mazarin sent Fréart to Rome to fetch Poussin as well as 'the best painters, sculptors, architects and other famous workers'. Clearly, he wanted Pietro da Cortona and Guercino. Only Duquesnoy agreed to go, but he died before he could do so. With the death of Urban VIII in 1644, the Barberini power came to an end, presaging the exhaustion of Roman political power in the face of the rising power of France.

Mazarin's contacts with Italy, where he had agents, were not popular in France, because he was known to favour Italian artists, architects and musicians in preference to French.* During the Fronde, in 1649, Mazarin, by then the proud owner of the Roman palace of the

*Romanelli, a Barberini artist, and Grimaldi worked on the design and decoration of the Palais Mazarin from 1646.

Bentivoglio, including the Casino with Guido Reni's *Aurora*, was forced to flee the country until 1653. In spite of his difficulties, he did manage to buy important works from Charles I's collection through the banker Jabach. His successor Colbert, who greatly increased his own art collection by buying much of Mazarin's, also sought to attract Italian artists. Bernini's visit in 1665 must have seemed a farce even at that time, for there was a strong caucus of French artistic opinion against the commission for the completion of the Louvre being awarded to a foreigner (see pp. 185–6). Bernini's insulting remarks about the state of the arts in France must have placed the final seal on a chauvinism which was to serve them for generations.

The rise of France as an artistic power was connected not only with the decline of political power in Rome but also with the decline of patronage which went with it. By the 1670s, Italian books were dedicated to Colbert (Bellori's *Vite*, 1672) and to Louis XIV (Malvasia's *Felsina Pittrice*, 1678). However, the great building projects of the reign of Louis XIV, unlike those of François I, were carried out almost exclusively by Frenchmen working within an unprecedented system of artistic control.

Lebrun and academic classicism in France

From 1661 until his death in 1683, Colbert directed the organization of the arts in France. He controlled building as Surintendant des Bâtiments (from 1664) and art as Vice-Protector (from 1661) and then Protector (from 1672) of the Académie de Peinture et de Sculpture. In any case, as he was Controller-General of Finance, all projects required his approval before funds could be made available. The 1660s might be called the decade of academies. Although the Academy of Painting and Sculpture had been founded in 1648, its final organization and the rise of its power date from 1664. The Académie des Inscriptions et Belles-Lettres dated from 1663, the Academy of Sciences from 1666, and the Academy of Architecture from 1671. The first to be formed (in

1635) was the Académie Française, which dealt with literary matters, but subjects such as dance and music were considered equally teachable, and academies governing these activities were formed in 1661 and 1669.

The Academy was an Italian idea, intended to promote painting and sculpture as liberal arts, leaving the mechanical arts to the Guilds.[618] The irony was, however, that academicians obtained freedom from the restrictive guild system only at the expense of a new enslavement to the type of art which the Academy judged suitable for the State. Inevitably, given the tenor of French culture at that time, with its strong sense of rationalism and order, that type of art was classicism. It was taught and supported in the Academy by the usual regime of drawing from masters' work, from plaster casts and antique statues, and then from the life. Lectures were given on perspective, anatomy and geometry. The pupils were therefore trained in a pre-ordained style which could fulfil Colbert's desire for uniformity whether in marble, paint, tapestry, the minor arts or architecture. The maintenance of academic priorities was assured by the assignation of two academicians to advise and correct any pupil making his presentation piece. The inevitable goal for students was to work for the Crown, which offered the largest and most lucrative commissions.

Charles Lebrun was the man who effectively controlled the arts in the reign of Louis XIV. He became a pupil of Vouet in 1634, went to Rome late in 1642 with Poussin, and studied with him there.[613] His hero in Italian art was Raphael,[615] and it was thanks to the help of Séguier (his patron from c. 1630) that scaffolding was erected so that he might study the master's frescoes. He sent back to Séguier copies of Raphael's *Madonna of Divine Love* and Guido Reni's *Aurora* in 1643.[612] In 1646 he returned to Paris, and was the main founder of the Academy of Painting and Sculpture in 1648, together with Bourdon, La Hyre and Le Sueur. He rose to a position of great power in public life, becoming First Painter to the King in 1664 and Director of the newly-founded Gobelins Factory (which made much more than tapestries) in 1662.

Lebrun's own style is a mixture of references to great Italian masters and to Poussin, whose manner was by now much esteemed.[614] 'Eclectic' is a term which fits him better than it does the Carracci, and we might say that French art under his guidance became predictably grand and classical even if it lacked the passion of Poussin's austerity. Lebrun's *Martyrdom of St John the Evangelist* of 1642 in St Nicolas, Paris, is a more painterly version of Poussin's *Martyrdom of St Erasmus*, while *The Brass Serpent* (c. 1649, Bristol), like *The Family of Darius at the Tent of Alexander* (Versailles 1660/1), might be called explications of Poussin's style.[617] The ideas of Poussin, most clearly expressed in his description of *The Gathering of the Manna* of 1638, were converted into doctrine by Lebrun, and taught at the Academy in a series of lectures, later published as *Conférences sur l'Expression des Passions* (1698). As was later the case with Sir Joshua Reynolds, there was a distinct difference in Lebrun between theory and practice, cruelly insisted upon by his enemy Mignard. Given the decorative nature of most of Lebrun's work, including painting the vast spaces of Versailles, it is not surprising that Poussin's principles, so suitable to small-scale work, had to be tempered by a certain infusion of the Baroque spirit.[619] The result, like Vouet's work earlier in the century, can be called a chastened Baroque.[616]

The consequences of French artistic hegemony and of the academic system were fundamental for the development of French art in the next two centuries and for the European academic tradition. Even the Academy of St Luke in Rome bowed to the French: Poussin and Vouet had been President, and Lebrun was elected to that post in 1675, three decades after he had returned to France from Italy! The academic system was to remain basically unchanged for two hundred years. The competitive nature of the organization, which awarded prizes and medals, encouraged a conformist attitude on the part of those who aimed for the best prize of all, the Prix de Rome. This four-year scholarship was for further training at the French Academy in Rome, founded in 1666 to provide contact for French

Rapture, early nineteenth century English stipple engraving.
The tradition of such engravings goes back to Lebrun.

artists at the very centre of antique and Renaissance art. A successful student could expect State commissions. What is more, the Academy began in 1667 (although irregularly at first) to hold exhibitions of work by Academicians. These developed into regular *Salons*, the monopolistic nature of which again assured a certain conformity to the judges' conception of good art, as well as a degree of financial success for those artists willing to obey.

The Quarrel of the Ancients and the Moderns

The organization of the Academy was not as tightly exclusive throughout its whole career as it had been under Lebrun. The period of the Rococo, which coincided with a weakening of financial aid to the academic institutions and also with a decline in the number of commissions in painting, sculpture and architecture, saw a relative neglect of the stringent classicism of the later seventeenth century. More important for the complexion of the arts at the end of the seventeenth century and during the first four decades of the eighteenth was the new scepticism of some critics and

scholars toward the relative achievements of Antiquity and modern times. Close study in several disciplines, such as architecture, poetry, sculpture and the sciences, convinced some commentators that the Ancients had long since been overtaken by the Moderns. Henceforth, they declared, there was no longer any need to refer continually to that established standard of excellence. Instead, the modern age should forge ahead with new and different criteria which better suited modern life. This, the so-called Quarrel of the Ancients and Moderns, was no short-lived squabble between narrow-minded and unimaginative men, but a debate which, after its first official airing in the Academy in 1671, continued for more than a century.

Viewed in a broader perspective, the Quarrel provided the first crack in the structure of classicism, because the proclaimed self-sufficiency of the Moderns undermined classical supremacy and sapped its foundations in academic instruction. A series of non-classical influences were introduced into French art from the Flemings to the painterly Venetians. Significantly, it was at the end of the century that Rubens's *Medici Cycle* in the Luxembourg began to be looked at with more than the indifference that it had previously engendered. Indeed, the two sides in the Quarrel over painting were called *Poussinistes* and *Rubénistes*; and in 1699 the principal *Rubéniste*, or Modern, Roger de Piles,[624,625] was elected to honorary membership of the Academy. Wider sources meant, for the Academicians, a fogging of the traditional hierarchy of the genres. Landscape, still life, domestic scenes and *fêtes galantes* became more popular.[622] History painting declined, and with it the enthusiasm for training in the classical tradition in Rome.[621]

It was this state of affairs, with *colore* triumphant over *disegno*,[620,623] that the reforms of Lenormant de Tournehem in 1745/51 were to correct. The principles which he applied represented little more than a re-application of the academic standards of the time of Lebrun and, equally, a rallying cry to the great traditions of French art as seen in the achievement of the *Grand Siècle* (pp. 204–5, below).

10

Architecture in France: Renaissance to Neoclassicism

The sixteenth century and Italy

The development of French culture in the sixteenth and seventeenth centuries was largely governed by the assimilation of Italian elements from the High Renaissance period and later. The Italian Wars (the French invaded Italy in 1494) began a vogue for things Italian and for preoccupations that the Italians held dear.[627] Academies were established in France.[632] Subjects like the French language and legal traditions were studied in an historical context.[630] Overt and complicated antiquarianism was appreciated in court art.[631] Ancient marbles were enthusiastically imported, and collected together into 'museums'.[626,628]

In architecture, the importation of a strictly High Renaissance manner was delayed, for when Milan became a French dependency, the richly decorated style of contemporary work in that city greatly appealed to the French, as many of the châteaux of the Loire Valley testify. Evidently the greater severity of Bramante's Milanese work did not attract the foreigners, preconditioned as they were by a native Gothic manner. Early French attempts to imitate Italian Renaissance style therefore show interest in the motifs of the classical style without an appreciation of its syntax. The large Porte Dorée at Fontainebleau (1528–40) by Gilles le Breton is a triumphal arch after the manner of those at the Castel Nuovo in Naples and the Palace at Urbino, but it makes many mistakes of architectural grammar: the work

Detail of a chimney of the Château de Chambord, overloaded with Renaissance forms.

has monumentality, but lacks proportion, logic and clarity.

Two buildings of the first half of the sixteenth century, both by Italians, did present a classical manner from which the French learnt. The first was the Château de Madrid, near Paris (begun 1528; now destroyed), based on the well-known symmetrical plan of Poggio a Caiano. (Poggio is also thought to have influenced the plan of Chambord (begun 1519).[629]) The second was the Château of Ancy le Franc (begun 1546; altered) by Serlio, which displays a rusticated ground storey, Doric pilasters, niches on the *piano nobile* and, in the courtyard, a system of niches which derives

LEFT *Fontainebleau: Aile de la Belle Cheminée, in an etching by Israel Silvestre.*

painter, stuccoist and architect Primaticcio returned to France, bringing with him Vignola who, however, apparently built nothing during his visit. Primaticcio did: in 1568 he designed the Aile de la Belle Cheminée at Fontainebleau, a work which in its simplicity and logic was to be a model for succeeding generations of French architects from Salomon de Brosse to François Mansart.

Philibert de l'Orme

The tradition of French architecture was not formed solely by Italians. Philibert de l'Orme probably spent the years 1533–6 in Rome in the suite of Cardinal Du Bellay, a man with Humanist interests who collected antiquities and shipped many back to his friends in France. Secretary and doctor to the Cardinal was François Rabelais; Philibert, we may assume, shared the interest in the reconstruction of Antiquity that Rabelais demonstrates in his great novel *Gargantua*, of 1534. (It has, for example, been shown that Rabelais's pre-

from Bramante. Sebastiano Serlio was summoned from Italy to France in 1540/1 by François I, to whom he had dedicated Book III of his *Architettura* of 1540. His great influence in Northern Europe was mainly due to this profusely illustrated manual, which provided a convenient crib to Italian practice for half a century. At about the same time, in 1541, the

Philibert de l'Orme's Chapel at Anet, 1549–52, photographed LEFT *and shown* RIGHT *in section, from his Architecture, 1567.*

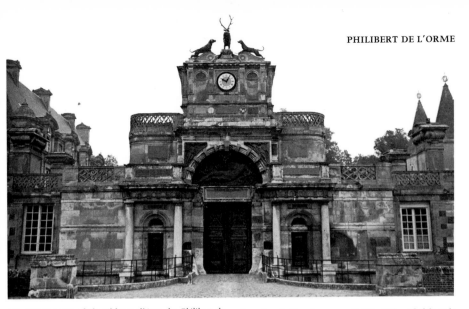

The entrance gate of the Château d'Anet, by Philibert de l'Orme.

scription for the Abbaye de Thélème is based on Serlio's reconstruction of the Roman port of Ostia.[633] Furthermore, Rabelais planned a topography of Rome.) Philibert's thorough study of Antiquity is proclaimed in his own architecture, in the structure of the Tomb of François I in the basilica of St-Denis in Paris (begun 1547), and particularly in the great Château d'Anet, of which the chapel (1549–52) and the entrance gate (c. 1552) remain.[635] The frontispiece to the house itself is in the courtyard of the Ecole des Beaux-Arts in Paris, where it was taken in 1797 as a specimen for the Musée des Monuments Français (the site being that of the secularized Couvent des Petits-Augustins).

Earlier buildings by Frenchmen had incorporated Italian elements as decorative details into a stylistic system which was largely medieval. Philibert's work, on the contrary, displays a rationality and clarity, and a comforting lack of *horror vacui*, which are distinctly Italian.[634] He also shows an individuality in assembling classical forms which is equally far removed from the work of pattern-book copyists of Italian ideas and from the luxuriant French Mannerism which flourished in the contemporary designs of Jacques Androuet du Cerceau the Elder (c. 1520–c. 1584). Compared with Pierre Lescot's Square Court of the Louvre (1546–51), Philibert's work is extremely forceful; Lescot probably did not go to Rome to study, and his work is rather flat and non-structural, as befits motifs taken from the flat pages of books rather than from the life. By contrast, we know from surviving drawings that, like Brunelleschi, Philibert occasionally uncovered parts of antique buildings in order to find out how they

Detail of a coffered vault, Temple of Venus and Rome, Rome, perhaps Philibert's source for the Anet vault OPPOSITE.

179

Symbolic representations of The Bad Architect ABOVE *and* The Good Architect RIGHT, *from Philibert de l'Orme's* Architecture, *1567.*

were built. His father was a stonemason, so it is not difficult to imagine the son developing a knowledge of structure and form. His practicality is obvious in his two books, the *Nouvelles Inventions pour bien bastir et à petit frais* (1561) and the *Architecture* (1567); illustrations to the latter show, in symbolic form, the banishment of the Gothic style in favour of a splendid antique classicism.

The architectural elements which attracted Philibert were those popular in the Italian Renaissance: arrangements of superimposed Orders (which he used for the frontispiece to Anet), the triumphal arch (used in the entrance to Anet), and the centrally planned church, which provided his most impressive creation, the chapel at Anet. It is clear that Philibert was in touch with current Roman thinking, and particularly with the profusion of ideas about how the new St Peter's should be completed (in the 1530s the site was substantially as Bramante had left it). Thus the frontispiece to Anet (ultimately based on the typical Roman

arrangement of columns and arches, as on the Colosseum) is close in manner to one of the towers of S. Biagio at Montepulciano built by Antonio da Sangallo the Elder, who was influenced in turn by the schemes for St Peter's. The chapel at Anet is small in size but massive in scale: its coffered vault (taken from the cult niches of the Temple of Venus and Rome, in

A design which is Italianate in its use of the Orders, particularly the Giant Order, and in its central courtyard, which derives from works like Mantegna's house at Mantua. From J. A. du Cerceau's Third Book of Architecture, Paris, 1582.

Rome); the four barrel vaults over the four arms (curved to fit the drum which they support); the inscription in Roman capitals around the drum; the bold floor pattern reflecting the vaulting of the dome—all these elements give to the work a grandeur which is Italian and High Renaissance. Certain of its features can be considered wilful (including the 'Romanesque' towers flanking the entrance); but nothing so controlled and so monumentally antique was, with one exception, to be built in France until the time of François Mansart.

That exception is another centrally planned building which, had it ever been finished, would have been the most Italianate structure in France. In about 1560, Primaticcio began a circular Funerary Chapel for the Valois Dynasty next to the medieval St-Denis: the mausoleum was to be of the 'Colosseum' type, but only the top of the second Order was

The vestibule of the Bourbon-Montpensier chapel, Champigny-sur-Veude. Built towards the end of the sixteenth century, this is more correctly structured than earlier French buildings in the classical style, but just as decorated.

reached, and it remained in a fragmentary state until it was pulled down in the eighteenth century. Like the chapel at Anet, its formal sources and the rationale of its iconography lie with Bramante's Tempietto and with the various projects for the new St Peter's.

Salomon de Brosse

The period following the death of Philibert de l'Orme in 1570 is confused both by the impractical size and extravagance of many of the architectural projects (compare the great display houses in contemporary England), and by the ravages wrought by the Wars of Religion. Much of the work produced has to be reconstructed from drawings and prints, but the main lines of development were clearly toward an increasing simplicity and monumentality, as exemplified in the achievements of Salomon de Brosse, whose work forms a link between Philibert de l'Orme and François Mansart. He was a grandson of Jacques I du Cerceau and must have worked on the château which his uncle Baptiste and Jacques II du Cerceau were building at Verneuil, but his own style has little to do with Mannerist extravagances. De Brosse's Palais du Luxembourg (begun 1615) and the châteaux he built at Coulommiers (began 1613) and Blérancourt (c. 1612–19) dispense with superfluous decoration and emphasize qualities which are classical: mass, balance, and clarity. De Brosse almost certainly did not visit Italy, but the patrons who commissioned him to build Blérancourt had been to Rome, and possessed drawings of contemporary wonders, particularly of the works of Vignola. Through these, Salomon completed an architectural education begun with the architectural treatises and buildings of Philibert de l'Orme, several of whose devices he adopts. The influence of Pierre Lescot is evident in the treatment of the Orders on the façades of Blérancourt, and the scheme derives from plans which Philibert made for the Château de Saint-Maur. Although he must, of course, have known of works like Maderno's S. Susanna, it was principally to Philibert's frontispiece for Anet that Salomon turned for the inspiration of his west front for St-Gervais,

181

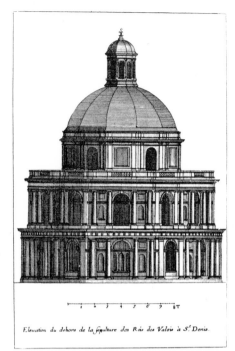

Elevation of the Valois Mausoleum at St-Denis, Paris LEFT, and plan ABOVE, designed by Primaticcio, c. 1560, but never completed. BELOW Coulommiers en Brie, Château, begun 1613, designed by Salomon de Brosse. All from Jean Marot's Recueil des Plans . . . 1654–60. Compare the centralized entrance 'tempietto' of the château with the Valois Mausoleum designs by Primaticcio ABOVE.

Eleuation du debors de la sepulture des Rois des Valois à St Denis.

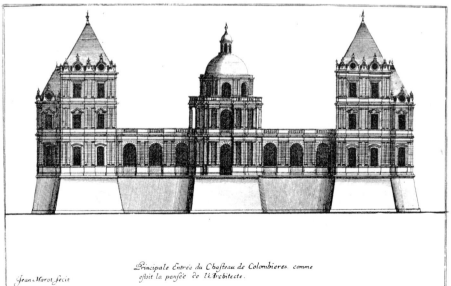

Principale Entrée du Chasteau de Colombieres. comme estoit la pensée de lArchitecte.

Jean Marot fecit

Paris (begun 1615). This façade was not the first example of the Roman church front to be built in France, but it is by far the boldest in its use of classical vocabulary.

Equally significant in Salomon's work is his attachment to the centrally planned form, as shown in his entrance pavilions to the Luxembourg, Coulommiers and Montceaux, which all rely ultimately for their design on the Valois Mausoleum, probably via the entrance and garden pavilion designs for Verneuil. The entrance pavilion at Montceaux, and that at the Luxembourg (altered internally in the early nineteenth century) survive to show the emphasis which Salomon de Brosse placed on plain stone surfaces articulated by chaste Orders and decorated only by the sharp lines formed by the angles of the masonry.

François Mansart

De Brosse's successor was François Mansart, who was fortunate in that his career began when the Wars of Religion were over, and sufficient money was available to finance such a notoriously exacting and perfectionist designer. In his infinite capacity for taking pains, and in his fertile inventiveness, Mansart was a genius. Whether he was designing the inside of a château or the outside, Mansart's manipulation of space through interestingly shaped rooms or the bold design of columns and entablatures is chastened by the reticence with which he works the plain stone and by the simple monumentality of the grand designs. Thus the Orleans Wing of the Château de Blois (1635-8, but stopped through lack of funds) is festive in its repetition of coupled pilasters and columns on the entrance side; the colonnade at ground level swings from the wings toward the triumphal arch motif of the frontispiece. Balancing such gaiety, however, are the soothing horizontals of the three entablatures, which are very boldly drawn. The inheritance of Philibert de l'Orme, Lescot and Salomon de Brosse, which will echo throughout Mansart's career, is clearly visible in the Orleans Wing at Blois. It is the French tradition of sobriety and restraint, some might say of over-intellectuality and coldness, which inoculates

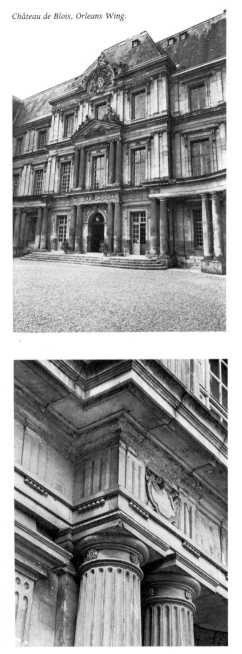

Château de Blois, Orleans Wing.

Detail of the Order and entablature of the Orleans Wing of the Château de Blois, by Mansart.

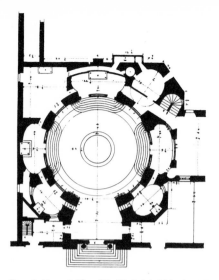

François Mansart: Plan of Ste-Marie de la Visitation, 1632–4. From Jean Marot's Recueil des plans . . ., 1654–60, and RIGHT *plan of the design for the Bourbon Funerary Chapel at St-Denis.*

Mansart against too strong a dose of the Baroque, strains of which are nevertheless in evidence in the exuberance of Blois.

Indeed, French architecture of the mid-century can be presented as part assimilation of Baroque influences, and part struggle against them. To appreciate the simplicity of the Orleans Wing, it should be compared with Louis Le Vau's Collège des Quatre Nations in Paris (begun 1661), which employs the giant Order together with wildly swinging curved façades and a boldly projecting church façade in the centre of the scheme. The Church of the Val-de-Grâce, Paris (begun 1645), of which the lower parts and the portico are due to Mansart (the rest is by Lemercier), uses the Italian church front in the Maderno manner, but simplifies and enlivens the model by introducing a much more boldly projecting portico approached by a full flight of steps. Like his predecessors, Mansart held the centrally planned church in high regard, for although only his Church of the Visitation, Paris (1632–4), survives by which we may compare his attainment with Philibert de l'Orme's in the chapel at Anet, he planned another, much grander structure. This was a Bourbon Funerary Chapel, to be attached to St-Denis and approached via the retro-choir. For this scheme there exist two drawings by Mansart of about

1664; a model is also known to have been made.

The drawings for the Bourbon Mausoleum, planned in rivalry with Primaticcio's abandoned Valois Mausoleum, show the influence of various schemes by Leonardo da Vinci, although they are much more intricate and architecturally subtle. Such a revival prompts the complex question of Leonardo's influence in France, where he spent his last years (he died in 1519).[629] He certainly prepared a grid plan for a royal palace at Romorontin near the river Cher, and its regularity might well have governed the design of Charleval (perhaps by J. A. du Cerceau the Elder) and, at a greater distance in time, the grand projects for the Tuileries and the Louvre.* Parallel illustrations for palaces occur in Serlio's 'True Sixth Book', which was probably well known in manuscript form. Such recourse to High Renaissance precedents shows where Mansart felt the origins of his style of architecture to lie.

The Bourbon Mausoleum would have been an immense building. Unfortunately, funds were available only for the completion of the

*Such an unlikely-sounding survival is far from impossible: witness the casting techniques developed by Leonardo for the Sforza Monument, possibly relayed to France in manuscript form by Benvenuto Cellini, and used at the end of the seventeenth century by Girardon. Such techniques were unknown in Italy.

Louvre, so that the King might reside in his capital city. The Louvre, more than any other project of the sixteenth and seventeenth centuries, was the repository of French faith in their own architects. It was begun on the site of the old castle by Pierre Lescot in 1546, the Square Court was quadrupled in size under Jacques Lemercier (from 1624) and Louis Le Vau (from 1650), and by 1665 only the East Front, the grand entrance, was lacking. Obviously the East Front had to be completed in a style befitting the classicism introduced since Lescot: a competition was therefore arranged in 1665. Mansart was rejected because he submitted a series of plans with too many possible variants, often incorporating a multitude of pasted flaps which further multiplied the confusion, and because he had a history of pulling things down and beginning again if anything displeased him. These Louvre projects, like Mansart's slightly earlier and equally extravagant design for an entrance porch to the Church of the Minimes (begun 1657), often include a vestibule as though they were designs for a centrally planned church. Sometimes such a plan is squeezed into the fashionable Baroque oval; were interior elevations available we might be able to compare this, the expression of Mansart's latest phase, with S. Carlo alle Quattro Fontane, by Borromini, or S. Agnese, by Bernini, both in Rome. As for the exterior elevations of his Louvre designs, these are of equally startling richness: some have superimposed Orders, others a giant Order, and all are crowned by a dome, a Roman fashion which had been growing in Paris since the church of St-Paul–St-Louis was built in 1627. Sometimes Mansart introduces columns in pairs (as at Blois) to create a strong rhythm capable of surviving such a long façade; occasionally his drawings betray his desire to rebuild other parts of the Louvre as well.

Such a desire is natural to any classically minded architect who thinks of a building as one unit constructed in one style, symmetrical in its arrangement and uniform in its detailing. Mansart had already encountered the problems of dealing with old buildings at Blois, where his Orleans Wing had to be grafted onto three sides of older work: his drawings show that he went to great trouble to make the court and the outer façades uniform in level (by introducing a basement storey on the outer façade, where the ground slopes away), and also to make both of them seem symmetrical: the result of this is that the central axis of the court façade does not bisect the building at the same point as the central axis of the outside of the same wing. Mansart would have preferred to rebuild the whole of the Château of Blois, had funds been available, just as he would later have liked to rebuild parts of the Louvre. The result at Blois might have resembled the austere magnificence of his Château de Maisons (1642–6), where he did have a free rein.

How magnificent the Louvre would have been had Mansart received the commission! However, he did not, and in 1665 the frustrated Colbert, unable to extract any satisfactory plan from a French architect, sent for a suggestion from Bernini. Back came a frothy design of swinging curves which guaranteed excitement but no extra space (which was at a premium for the Court). Bernini's design, if realized, might have resembled a giddy version of Palladio's Loggia del Capitanio: it would certainly have contrasted strongly with the rest of the Louvre, in which the Orders were used with restraint and understatement. Bernini's two later schemes were also frowned upon as impractical, and the open contempt that he showed for French art and architecture when he visited Paris in 1666 heated to boiling point the cabals which were already formed against him. The rejection of his work (and hence of his suggestion to case all earlier work at the Louvre with architecture of his own design) is symbolic not only of the French rejection of contemporary Italian Baroque style, but also of a strongly reasserted faith in the French tradition. The East Front of the Louvre was eventually built (from 1667) by a committee consisting of Le Vau, Lebrun and Claude Perrault (the French editor of Vitruvius), although the contribution of each to the design cannot be decided.[636] There are paired giant columns which might have been suggested by some of Mansart's designs, but there appears to be no obvious source for the great peristyle: it might be described as the

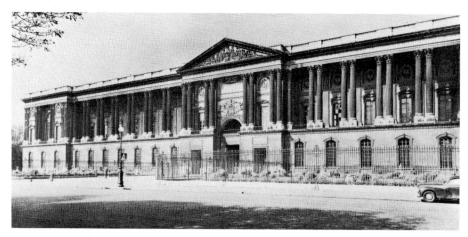

East Front of the Louvre, Paris, 1667ff.

unrolled drum of a dome. To some extent, the façade is the result of suggestions made by the committee members in their own designs, but the whole effect is Italian, of the High Renaissance period. The great columns shelter a loggia, and support a simple balustrade and an apparently flat roof (in fact it is pitched, but this is not visible from the ground); they in turn are supported by a rusticated basement storey pierced by window openings, of a type originating in Bramante's House of Raphael.[634]

The East Front of the Louvre was surely the most unusual façade erected in France during the seventeenth century; it was to have some influence in later years, for instance on Jacques-Ange Gabriel, who designed the two great palaces in the Place de la Concorde, Paris (1757–75), and the equally rational Petit Trianon at Versailles (1763–9). These structures demonstrate the continuation of the classical tradition by reference back to the practice of the *Grand Siècle*. A similar reliance on French tradition was to be a feature of French neoclassical painting as well.

The classical tradition, in architecture as in painting, was protected by its schematization into doctrine by the theorists who controlled the Académie Royale d'Architecture (founded in 1671). However, just as in painting, the demands of official architecture during the reign of Louis XIV militated against calm and simplicity, and tended to promote a pompous grandeur and over-decoration in an attempt to articulate the sheer size which the *grand goût* demanded. The progression of a modified Baroque can be followed in the elevations at

Bernini: the third design for the East Front of the Louvre, Paris. Engraving by Marot.

Versailles, which Le Vau began to remodel in 1669. The original design was moderate and restrained, but nine years later Jules Hardouin Mansart (great-nephew to François) extended the palace considerably in length, and altered all the interiors with a taste which owes much to the manner of Pietro da Cortona, the seminal Baroque architect and painter. Lebrun and his assistants decorated the new interiors in a style which also pays homage to Pietro da Cortona.

Eighteenth-century Neoclassicism

Indeed, little is seen of the essential elements of classical architecture until the time of Jacques-Ange Gabriel (1698–1782). However, there are some signs that there was occasionally some opposition to the Rococo manner of curved, graceful and pretty surfaces, intricate forms and delicate silhouettes, and the almost complete rejection of the classical Orders; an example of an architect who occasionally rejected this style, at the beginning of the eighteenth century, is Germain Boffrand (1667–1754). As befits a pupil of Jules Hardouin Mansart, much of his production is fully Rococo, but his Chapel at the Château de Lunéville (1720–3), based on his master's severe yet elegant Chapel at Versailles (begun 1678?), corrects its model by its simplicity and rationality, and, above all, by its concern with *structure*. The columns actually support their respective entablatures; they are dignified by function, not prettified by decoration. Such preoccupations had already been evinced in the Abbé de Cordemoy's *Nouveau traité de toute l'architecture* (1706) which, inspired by Claude Perrault's edition of Vitruvius (1673, 1684), looks back past the ancient Roman achievement to the work of the Greeks, whose architecture the Abbé and others saw as being similar in structural principles to Gothic. Needless to say, the Abbé held the peristyle of the Louvre in great respect. Rather less obviously, his theory of architecture bypassed the Italian High Renaissance; he claimed that the architects of St Peter's, in using piers instead of functional columns, had ignored Early Christian architecture which, in his eyes, held the key to the understanding of the great

achievements of the ancients, or *la sainte antiquité*.[638] The idea met with much opposition.

Primitivism in architecture

For us today, it seems merely curious that a scholar should try and relate Greek to Gothic.[642] The eighteenth century, however, was anxious to adopt a syncretic approach in several disciplines, particularly the study of religion, language, society and architecture, and to tabulate similarities which they felt must exist between societies widely scattered in both time and place. Above all, the eighteenth century was a period when the study of history flourished as never before; history entails the categorization of things and events within a time-scale. For architecture, the importance of the theories of Cordemoy and of the practice of Boffrand is that they look forward to the theory and practice of the mid-century. In the Abbé Laugier's *Essai sur l'architecture* (1753), function is the main theme: the principles of architecture derive from the primitive hut,[646] and only that which is essential to stability—the tree-trunk column and the tree-trunk beam, later imitated in stone—make good architecture.[640] All decorative details are forbidden because they contribute nothing. The tree-trunks from which Greek temples derive are, for the eighteenth century, no more and no less structural than the leafy forests with the tops of the

The primitive hut, from Caesariano's edition of Vitruvius, Como, 1521. Laugier's ideas are in the same tradition.

Marie-Joseph Peyre: TOP *Design for an academy, section and elevation, and* ABOVE *design for a cathedral, both from his Cours d'architecture, Paris, 1765. The obvious source for the cathedral is a purified version of St Peter's, Rome.*

trees inclining together which were the assumed origin of Gothic. Such theories do not produce buildings which look Gothic, but rather buildings which are severely classical but employ a lightness of structure inspired by the great cathedrals. The most important church of the century, Soufflot's St-Geneviève (begun 1757; now called the Panthéon), which Laugier welcomed as 'perfect', looks back to the centrally planned churches of the Italian Renaissance: beginning with a Greek cross in which nave and choir were then extended, Soufflot tried to combine classicism with a structuralism that he believed to be Gothic.[643]

In the sixteenth century, classicism in French architecture had depended on contemporary Roman example. In the 1740s, the same milieu saw the revitalization of that tradition in the form of Neoclassicism, carried back to France from Rome by returning architects.[639] Men like Jean-Laurent Legeay, who was in Rome by 1738, sought in their etchings to recreate the might and splendour of the great Roman baths. Piranesi, whose works were to be highly influential in France, later followed Legeay's ideas. Marie-Joseph Peyre, who was in Rome in 1753, built upon Legeay's ideas in the monumental yet sober designs in

his *Cours d'architecture* (1765). Here Roman baths and temples are the foundations of a style which, in its megalomania, prepares the way for the effusions of the 'Revolutionary' architecture of the end of the century; Peyre wrote that each time an architect departed from the general principles of the ancients, he created bad architecture. Another key book— important because, like Peyre's work, it taught a generation of students—was François de Neufforge's eight-volume *Recueil élémentaire d'architecture* (1757–68), which insisted on simple shapes in plan and elevation, and restated the relevance to the reformation of French architecture of the achievement of the High Renaissance and of Palladio.

The next few decades were characterized by the manner encouraged in both these books. They saw a relentless simplification and rationalization of structure to the point where plain walls became preferable even to correct articulation by the classical Orders. Theorists designed buildings which were stripped of any decoration, although, as is usually the case, very few buildings were actually constructed in such a severe manner. The type of progress made by following such fundamentalist theory is demonstrated by a comparison between Gabriel's beautiful Petit Trianon (1762–8), and Claude-Nicolas Ledoux's Pavillon de Madame du Barry at Louveciennes (1770–1). In the former, the cubic simplicity and austerity of the window embrasures are set off by the subdued richness of the fluted Corinthian columns on the garden front, and there is a considered balance of plainness and ornament in the whole composition. The Pavillon de Madame du Barry, which is based on the Petit Trianon, is clearly an attempt to correct its model: the podium and the elegant steps are gone, and there is less window area and ornamental balustrading. Ledoux, in other words, concentrates on the block-like character of the work and emphasizes this by extreme variations of light and shade. The sparing use of frieze and figures in niches emphasizes and does not mitigate the severity of the whole. Much more uncompromisingly stark structures are illustrated in his treatise of 1804 (see p. 192, below).

Why, during a period when Rome was the focus of every architect's training, when Greece was about to become fashionable again, when painters were harking back to the grand manner of Raphael, Guido Reni and Poussin, did both architects and painters begin to reject

Entrance façade of Le Petit Trianon, Versailles, by Jacques-Ange Gabriel 1763–9.

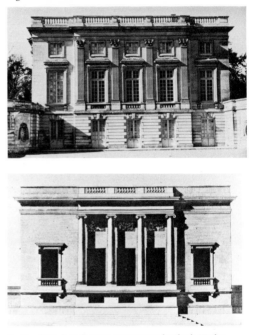

Pavillon de Madame du Barry, Louveciennes, by Claude-Nicolas Ledoux, built in 1771. Engraving from his Architecture, II, Paris, 1804.

the accumulated Renaissance tradition in favour of something much more simple, and indeed primitive? The answer is that the horizons of the eighteenth century were wider than they had been in any previous age. The men of the Age of Enlightenment travelled more extensively; they were interested in more cultures, and 'collected' a wider range of styles than their predecessors, who had been content with the Renaissance achievement. Their interest in history, and the development of techniques of study which brought that history to life, revealed to them a plethora of historical cultures which influenced fashions

189

Piranesi: The Temple of Neptune at Paestum.

and styles in the second half of the eighteenth century: from Etruscan, Pompeian, Greek or Gothic to Chinese and Indian (see pp. 231–2, below). Given such a range, the Italian Renaissance tradition took its place as one among a wide range of possible models, and the classical tradition was largely redefined.

In short, the classical tradition was extended backward in time to take in the architecture of the Greeks. Everyone knew, of course, that the Greeks had taught the Romans architecture, because Vitruvius had said so. However, the admirers of Vitruvius were at first taken aback, rather than enchanted, by the early architecture of the Greeks. Sites such as Paestum,[641] Agrigentum and others in southern Italy and Sicily were visited with increasing

frequency from the 1760s. The temples there revealed to architects a style almost brutal in its primitive simplicity and lack of civilized elegance.[644,645] Perhaps Goethe's experience was typical; in his *Italian Journey* (entry for March 1787), he describes a visit to Paestum, when the initial shock was cured by historicism:

> The first sight of them excited nothing but astonishment. I found myself in a perfectly strange world; for, as centuries pass from the severe to the pleasing, they form man's taste at the same time . . .; these crowded masses of stumpy conical pillars appear heavy, not to say frightful. But I soon recollected myself, called to mind the history of art, thought of the times when the spirit of the age was in unison with this style . . . and in less than an hour found myself reconciled to it . . .

Such historical awareness made it obvious that the history of architecture needed to be written. In his edition of Vitruvius of 1673, Claude Perrault had caused much offence in academic circles by pointing out the faults in his subject's treatment of architecture.[636] For the eighteenth century, there sprang to prominence an exciting range of styles (particularly early Greek and Etruscan) which that shrine of authority had ignored. Piranesi tried to write the Etruscans and the Greeks into a

Panaretheon from Ledoux's project for the Ideal City of Chaux, 1773–9, never built. From his Architecture, II, Paris, 1804.

A. E. Marvuglia: a design for a national monument. Boullée was not alone in his megalomania.

new history of architecture, claiming in *Magnificenza ed architettura de' Romani* (1761), and in other books, that the Etruscans and not the Greeks were the architectural teachers of the ancient world.[647] He linked 'primitive' Roman architecture with the period of the Republic (that of the Empire had served the Renaissance tradition), and thereby provided a political *rationale* for its adoption in France; at the same time French painters sought a similar morality in the same period of history. When J.-L. David set his *Oath of the Horatii* against a row of baseless Tuscan columns, with simple impost blocks and a massive wall, he intended that the architecture should speak the same political language, and hence convey the same message, as the figures. Of course, neoclassical architecture did not always have moral implications; the style was so fashionable that, as Graf Kalnein says, in the new districts of Paris 'one might have thought that one had been transported to Vicenza'[637]—for the plain fact was that the Palladian manner was more suited than the Greek to town architecture. Yet some Parisian buildings exploit the Greek taste of the period: Jacques Gondoin's Ecole de Médecine (1771–6) has a façade which is a screen of columns, like a Greek temple, and Jean-François Chalgrin's church of St-Philippe du Roule (1774–8, but designed a decade earlier)

has similar ranks of free-standing columns supporting an austere barrel vault.

There are difficulties, however, in assessing the place of the 'Revolutionary' architects* (particularly Boullée and Ledoux) in the classical tradition. Classicism demands a cool and rational style, graced by the Orders. The Revolutionary architects, by their excessive simplification of forms and surfaces, and the wide range of their sources, half-pervert the aims of classicism because they seek to evoke a strong emotional response to their work. Their style is based not on the Vitruvian manner, even less on that of the *Grand Siècle*, but rather on the historicism which is a feature of the age. That rich historical storehouse of forms (the reverse of a canon of orthodoxy) allowed their architecture, as Boullée says, to 'speak', by which he meant to evoke sensations rather than to convey an exact message. The basic geometric shapes of cube, cylinder, sphere, pyramid have grafted upon them a style now Egyptian (as in Boullée's cemetery designs), now Greek (his immensely inflated sarcophagus, a tomb the size of a temple). Styles have become malleable, to be moulded into different shapes according to the desired mood. Little wonder that the Revolutionary

*So called as much because of their new style as because of the French Revolution.

191

Approach to the cemetery, Lecce. The up-turned torches of Death, which do service for columns, are in the same spirit as Boullée's perversion of classicism.

architects are considered by the more naïve historians to be the originators of a 'modern' style of architecture. However, it is certainly true that historicism sapped the strength of classicism instead of reinforcing it. In that sense the Revolutionary architects prepared the ground for modernism—but only after the even greater licence of the nineteenth century.

If we forget for the moment the emotions evoked by the megalomania and totally impractical size of Boullée's bare and forbidding creations, it is easy enough to see in them links with classicism. Boullée's writings make it clear that, in his opinion, architecture could 'speak' about matters of state and public morality, precisely because his *architecture parlante* proclaims its function through its forms. The idea is little different in essence from Diderot's conviction that the aim of art is to inculcate virtue, and is a more strongly argued version of Alberti's attachment to certain shapes. Very few Revolutionary projects left the drawing-board, but when they did they were spectacular; an example is Claude-Nicolas Ledoux's Salines de Chaux (Arc-en-Senans, 1775–9). Ledoux was deeply moved by the monumentality of primitive architecture, and the baseless Doric Order that he uses evokes the early Greek past. Similarly, his toll-booths for the gates of Paris (1785–9) show his tendency to use the whole of architectural history (exclud-

ing Gothic) as an arsenal which can supply the toll-booths' elemental and stark shapes with excitement. His strange treatise, entitled *L'Architecture considérée sous le rapport de l'art, des moeurs et de la législation* (1804), expresses his belief that architecture can help to change society.

No one could live urban life amidst an architecture that was utopian in scale and ideals. It transpired that well-worn vocabularies were better suited to a Napoleon or to a resurrected monarchy. First Chalgrin, with his Arc de Triomphe de l'Etoile (designed 1806), provided France with a Roman classicism well suited to Napoleon's imperial image, although on a scale which would have pleased Boullée (whose pupil he was). Then two students of Peyre, Charles Percier and, from 1794 to 1814, Pierre F. L. Fontaine, created an 'Empire Style' which contrasts strongly with Revolutionary architecture; it is not only much more elegant, but also more archaeologically aware, a trend which is evident in the painting of artists like Vien and David well before the French Revolution. Thanks to the publications of Percier and Fontaine, and to the encouragement of a classical style in the arts by the public patronage of the Government and, after the Restoration, the Crown, the classical style had a much longer life in France than in England, where the Gothic Revival gained an earlier and firmer hold. In France, character-

Triumphal Arch for the marriage of Napoleon, Tuileries Gardens. From Percier and Fontaine's Description des cérémonies et des fêtes du mariage . . ., Paris, 1810. The arch was only a temporary construction, and made of wood. Such 'entries' had been popular since the Italianization of France in the sixteenth century.

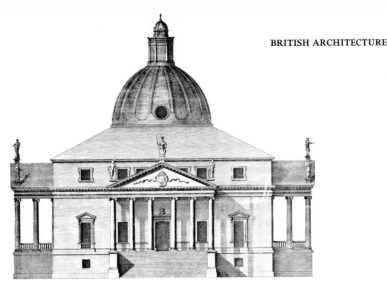

Colen Campbell's imitation of Palladio's Villa Rotonda: Mereworth Castle, Kent, From his Vitruvius Britannicus, III.

istically, the first revival style of the nineteenth century was French Renaissance; like the later Elizabethan and Jacobean revivals across the Channel, nationalist overtones were important in the choice. In a sense, all revivalism is a form of Romanticism, particularly when the solace achieved by absorption in the past depends on the sensations and not on the reason, when that solace is titillating and superficial, and is not a clearly marked road to salvation. For the Renaissance, the imitation of Rome in society, culture, law and art was the one true path to the re-creation of a noble society. The wider perspectives of the nineteenth century dissipated that article of faith by offering a series of equally attractive alternatives.

A note on British architecture

The place of British architecture in the classical tradition is ignored in this book. When older books treat 'Renaissance architecture' in Britain, they usually mean Renaissance motifs rather than a thoroughly classical style: they confuse decoration with form, Indeed, there were no sixteenth-century buildings in England to rival in precision of classical detailing and simplicity of classical form Philibert de l'Orme's château at Anet—hence no foundations laid in Elizabethan England upon which

the first palladian revival of Inigo Jones could grow.

Inigo Jones's long visit to Italy in 1613/14 instilled in him both a love of Palladio and a knowledge of Italian architecture ancient and modern. His Queen's House at Greenwich is a small villa in the tradition of Palladio; his Banqueting House in Whitehall a basilica in the Vitruvian mould. Neither these works nor his country houses (the most palladian being Stoke Bruerne, Northants) met with any imitators until the early eighteenth century. Jones's manner was, certainly, rather coldly academic, in contrast with the floridity of the still popular Elizabethan style. This, together with the uncertainties of the Civil War, spelt scant success for this first British Palladianism. The advent to power of another scholar, Christopher Wren, marked the introduction into Britain of the contemporary Italian Baroque, with an admixture of French features as well. This was easily adapted to the continuing vogue for very large country houses, and provided designs both rich and simple for the fifty-one London churches needed after the Great Fire, and for the new St Paul's. Thus, in a land hitherto used to the Gothic style (if we discount Inigo Jones's awkward Corinthian portico to old St Paul's), Wren introduced a new range of continental ideas.

It was to be the influence of Inigo Jones,

193

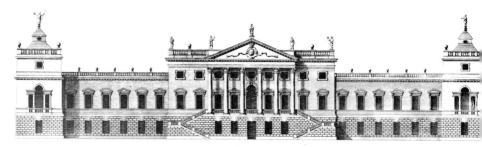

The West front of Wanstead in Essex with the four new Towers, the Seat of the Right Hon.ble the Lord Viscount Castlemain designed by Colen Campbell 1720

West façade of Wanstead, Essex, by Colen Campbell. From Vitruvius Brittanicus, III.

however, rather than the Baroque manner of Wren, which prompted the long-lasting Palladian Revival of the early eighteenth century. Richard Boyle, Earl of Burlington, William Kent, his protégé, and Colen Campbell, his adviser, all considered the Baroque style as extravagant and fanciful, particularly Vanbrugh's great piles of Blenheim and Castle Howard. Burlington, a young and wealthy aristocrat, made his Grand Tour in 1714/15 and, inspired by the publication of the first volume of Colen Campbell's *Vitruvius Britannicus* and Leoni's first translation into English of Palladio's *Quattro Libri*, which both appeared in 1715, set off again to Vicenza to study the work of his new-found hero and to collect his drawings and books. Upon his return in 1719, the Palladian group designed buildings which have much of the plain simplicity of some of Jones's creations. Mereworth Castle, by Campbell, shows how a doctrinaire palladian chastises the master's source, in this case the Villa Rotonda. Burlington's own villa at Chiswick (from the same source) is much richer and more complicated, particularly inside.

Indeed, just how like the works of Palladio is that great series of porticoed English country houses of the eighteenth century? With what work by Palladio might one compare Wanstead, or Holkham? The comparison lies only in the imitation of certain motifs, particularly the rusticated basement, the colonnaded portico, the balustrade above the cornice, the great emphasis placed on exterior staircases, and the so-called palladian window. Palladio himself produced no country houses or town palaces approaching the size of Wanstead, which has

all the features of the Elizabethan parade house clothed in a cold and regular classicizing articulation. Palladio's manner was much richer and more diverse than the sum of those few elements which Burlington decreed fit for imitation. The English could not take over Palladio wholesale, so to speak, because the social and economic traditions of the two countries were as distinct as their building histories. The British therefore contented themselves with Palladio's types of palace and villa elevation—but stretched out to often immoderate length to suit the demand for palaces in the country. The adopted formulae, published in Campbell's *Vitruvius Britannicus*, were seized upon by clients because they were easily adaptable to almost any building requirement.

The plethora of styles which are subsumed under 'Neoclassicism' will be studied in the next chapter, but it is apposite to reflect why it happened that Britain rather than continental Europe was the true home of the Gothic and Indian revivals, of Chinoiserie and Egyptomania, let alone of the late Roman Imperial and the Picturesque which were but two of Robert Adam's specialities. Burlington had envisaged but one style as the salvation of British architecture; men like Walpole, Adam and Soane embraced several. (The triumph of Gothic in the nineteenth century is one result of such latitudinarianism.) One of the answers lies in the wider horizons opened up to travellers in the eighteenth century, as a result of inclination as well as of trade and Empire. But perhaps the lack of any firm classical tradition in architecture other than that so recently created by Palladianism predisposed the Brit-

194

Ince Blundell Hall, Lancashire, from a drawing by J. P. Neale. Blundell, who started collecting in 1777, had the pantheon at the right built to hold the cream of his antiques.

ish to strike out in novel directions. It is, therefore, not surprising to find Britain rather than the Continent sheltering the greatest monuments of the Greek Revival.

Given such considerations, can we perhaps cast Britain in the role of destroyer of the classical tradition ? For her literary men, just as much as her architects, were the first to experiment with ideas which would be taken up on the Continent only toward the end of the century. We need only mention Britain's contributions to the Romantic Movement in France and Germany to realize how feeble was the hold of classicism. We might also be

forgiven for wondering how long French Neoclassicism would have survived without the sustaining ideology of Napoleon and his resuscitation of the Roman Empire. Perhaps Britain only destroyed classicism in the sense of offering to Europe a set of viable alternatives. We shall see in the next chapter how the credibility of classicism in painting and sculpture is sapped in a continuous process from about the end of the eighteenth century. In that chapter, Britain will be mentioned only as the repository for treasures gathered on the Grand Tour by the richest and most powerful nation in Europe.

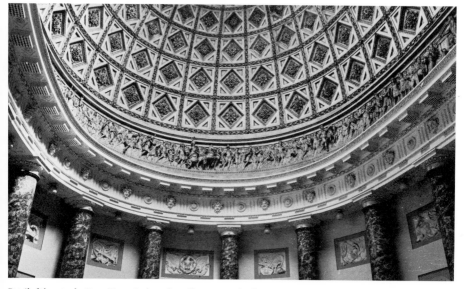

Detail of the rotunda, Stowe House. Such pantheon-like rooms occur all over England. They were often intended, like their basilican counterparts, as showcases for antiques brought back from the Grand Tour.

J. Zoffany: *Charles Towneley and his friends in the Towneley Gallery, Westminster. Collection of Burnley Corporation,* Lancashire. *The room is also lit in the antique manner, by a skylight.*

11

Neoclassicism in
Painting and Sculpture

Neoclassicism was the first artistic movement since International Gothic to become fashionable and to develop almost simultaneously in a European and not in a national context. Unlike the classicism of the High Renaissance and of the early seventeenth century, with their concentration on the city of Rome which gave to those styles an identifiable homogeneity, Neoclassicism derived from its international currency a variety of subjects, styles and attitudes which make any simple definition an impossibility.

The Grand Tour

However, Rome was again the setting for the first productions of the movement.[649,652] This was due partly to the examples of earlier classicism assembled there, and partly to the antiquities which, as E. Q. Visconti wrote proudly, made Rome 'the sole treasure-house of beauty, and the temple of good taste . . . The nations crowd around the universal Mother of solid doctrines and fine arts . . .'. During the eighteenth century, a tradition grew up in Britain that no education was complete without an extended tour of the sources of Western civilization; Rome was the main city of interest, since Greece was still under the control of the Turks and remained little visited.[648,650] Schoolmaster guides would expound the acknowledged masterpieces of antique and modern art in front of the works themselves. Those rich enough would buy and bring home antiquities and works of art, and install them in suitably antique country houses. Copies and forgeries found a ready sale, as did prints and lavishly illustrated books of the antiquities of the City. In a word, the mania for the classical

tradition was planted for the first time in England.[651] There had been precursors, such as Inigo Jones, or the Earl of Arundel who made a famous collection of antique marbles, but now antiquities were imported almost wholesale into the richest country in Europe. Curiously, the Germans and other northern states did not join in the plundering until the end of the century. France, fortified perhaps by memories of her own seventeenth-century classicism, stood aloof. Certainly, the British had much ground to make up. They founded the Royal Academy in 1768 on the model of the French Academy of Painting—but then surpassed the French in the richness of two more scholarly institutions, the Society of Antiquaries (founded 1707) and the Society of Dilettanti (1732). Both societies were responsible for the encouragement of exact scholarship which is a feature of Neoclassicism. The Dilettanti, whose rules stipulated that only men who had trodden 'Classic Ground' were to be admitted, sponsored expeditions to Asia Minor and Greece. The Antiquaries, on the other hand, were just as concerned with the Middle Ages as with classical Antiquity.

Scholarship and Neoclassicism

The Grand Tourists were well served by the greatly increased rate of archaeological excavation, and the wealth of published documentation on the life and art of the Ancients which resulted from it. The famous excavations at Pompeii[655,656] and Herculaneum,[659,661] begun in earnest in the 1730s, attracted many visitors. Many finds were stolen, in spite of jealous security measures which forbade even

197

Bartolommeo Cavaceppi: A view of his studio, from his Raccolta d'antiche statue, I, Rome, 1768. He was the greatest 'restorer' of antique statues.

sketching. During the later eighteenth century, much excavation took place in Rome and its environs, and the objects discovered were used to ornament Roman and foreign collections.[657,658] This is not the place for a disquisition on the early history of archaeology (a subject which awaits full treatment),[653] but it must be understood that archaeologists and historians of art in the eighteenth century were all concerned with uncovering and publicizing antiquities which, it was hoped, would lead toward a revival of the 'true style'—which we know as Neoclassicism. Of course, neither discipline was formulated on a scientific basis in that century, but a feature of Neoclassicism was the contemporary interest in archaeological and historical exactitude.

Indeed, the excavations of the eighteenth century, and the objects uncovered, were both cause and symptom of a more highly developed historical consciousness than had previously been seen.[654] Books of illustrations of antiquities had been available since the Re-

naissance, but now for the first time scholars began to make encyclopedic compilations of knowledge of the Ancients. The first compilations of this kind, J. G. Graevius's *Thesaurus antiquitatum romanorum* (12 vols, 1694–9) and J. Gronovius's *Thesaurus antiquitatum graecorum* (13 vols, 1697–1702), are collections of earlier works, occasionally illustrated. But the Abbé de Montfaucon's *L'Antiquité expliquée et représentée en figures* (10 vols, Paris, 1719–24) is different in that it is built around the numerous plates and, instead of being in Latin only, has parallel texts in Latin and French. An English edition later appeared (1721–5), and then a German edition. This gigantic picture-book with commentary remained an essential work of reference throughout the century, rivalled only by the catalogue of the collection of antiquities of a younger compatriot, the Comte de Caylus's *Recueil d'antiquités . . .* (7 vols, Paris, 1752–67), which is a great step forward in two respects. First, the antiquities described were those of the Greeks, the Egyptians, the Celts and the Etruscans as well as of the Romans. Second, Caylus attempted to attribute items, and to arrange them chronologically, in terms of their style and not, as all previous scholars had done, of their usage. This interest in style implies a recognition of its importance in

The museum in Sir John Soane's house in Lincoln's Inn Fields, London. Soane's collection, formed in the late eighteenth century, displays both a neoclassical concern with detail and a catholicity of interest. From The Union of Architecture, Sculpture and Painting, London 1827.

establishing a chronology of ancient art, which Winckelmann was to take one step further in his *History of Art* of 1764. Contacts between scholars like Winckelmann and Caylus and practising artists were as close in the age of Neoclassicism as they had traditionally been in earlier periods of classicism. Caylus himself holds an important place in the encouragement and development of a classical style in France; Winckelmann was involved with the art of Mengs, Gavin Hamilton with Canova, and Quatremère de Quincy with David.[660]

The net result of such excavation and publication was a widening of permissible sources which might be imitated and, thanks to the awakening of historical consciousness mentioned above, a more developed critical sense in dealing with them. The patently inferior quality of much of the work found at Herculaneum and Pompeii, especially the paintings, caused some disappointment. However, many students were convinced from their reading of the ancient authorities that the superiority of the ancients in sculpture was by no means matched in painting. The Quarrel of the Ancients and Moderns, still full of life, as the argument between Diderot and Falconet shows, proclaimed that in painting the modern world had surpassed Antiquity.[662] In sculpture, however, nothing emerged from eighteenth-century excavations to match those sculptures and bas-reliefs which had been known and admired since the Renaissance. A disturbing factor in Winckelmann's appraisal of Greek art is that most of his examples had been known for centuries (see pp. 202ff., below).

Historicism and the quest for the primitive

As early styles were brought to prominence by scholars, the focus of artistic and literary subject-matter and style began to move backwards in time. The Roman Republic gained

more attention than the Empire, and the Greece of Homer took precedence over the Rome of Virgil.[672] Philosophers dwelt on the corruptness of modern society in comparison with the simple and natural life of the primitive peoples of the world, and with Western Europe's own predecessors in that golden age of heroes described in the ancient epics.[667] A state of 'nature' was equated with virtue; the nearer to that state a society might be, so it was the more worthy of emulation on account of its virtue. Homer, the earliest known epic writer, was a focus for such primitivism, as can be seen in Robert Wood's *Essay on the original genius of Homer* (London, 1769). When he compares the age of Aristotle with that of Homer, his comparison is qualitative: 'I will venture to say that they differed as much, with regard to their reigning virtues and vices, their state of police and degree of civilization, their modes and tastes, in short, the great business and leading pleasures of life, as we do in these respects, from our Gothic ancestors in the days of Chivalry and Romance . . .' (Preface). The *earlier* state of society is to be preferred. The parallel between early Greece and the days of Chivalry is important for neoclassical art, which was to devote much attention to the heroic Middle Ages and also began to appreciate styles before Raphael.[671] Again, the scholars preceded the artists in that field as well. The eighteenth century witnessed the beginnings of serious documentary study of the Middle Ages as well as of Antiquity. Important work was done on manuscripts and on medieval history, particularly in England and Germany. It appeared quite natural to neoclassical artists that they should apply the same kind of style to their treatments of the Middle Ages as to their works on antique themes.

In part, a concern with history sprang from nationalism, which gave as much of a spur to Piranesi's championship of Italy as the home of good architecture as it did to Tuscany's new-found pride in its early past. An English scholar, Thomas Dempster, first aroused scholarly interest in the culture of the Etruscans in the seventeenth century with his *De Etruria regali*. The manuscript was not published until 1723–4, and it prompted a whole series of publications that included information on Etruria. As a weapon to fight off the burgeoning admiration for the Greeks, Piranesi found what he conceived to be the Etruscan achievement most useful. In Tuscany itself, the glorious past—the ancient, not the Renaissance past— was the reason for the foundation of the Accademia Etrusca in Cortona in 1726.[663,664]

The international nature of Neoclassicism combined with nationalism to assure the success of an outright forger. James Macpherson's poems of 1761–3, purporting to be the rediscovered and translated work of the blind Gaelic bard Ossian, provided Northern European writers and artists with a corpus of heroic deeds comparable to the best loved passages of Homer.[666,668] The poems of Ossian were early proclaimed as a forgery, but occasioned an enthusiastic response from a group of countries who began to feel a pride in the past.[665,670] They provided a fund of biblical language and simple morality. Stronger instances of nationalistic feeling can also be seen in the German interest in Teutonic legend, the English vogue for Shakespeare (who also became popular in Europe), and the numerous instances of the celebration of the national past in art. The idea of Rome had, from Carolingian times onward, been instrumental in the forging of state or dynastic identity. This impulse, in its turn, usually drew on the classical tradition for its motifs and style. But now a truly historical interest in national identity was to drive Rome and classicism slowly but surely into a position of minor importance, until the most recent revivals. Mussolini, with his logically classical revival, looked back to the grandeur of the Roman Empire. The Third Reich, on the contrary, brewed up a crazy mixture of classicism and German folk-art.

Neoclassicism and morality

Yet if subject-matter itself is no solid guide to Neoclassicism, the particular emphases in that subject-matter, and their stylistic treatment, provide a ready way of distinguishing Neoclassicism from the Rococo manner which preceded it. Neoclassicism, like all art in the

classical tradition, required work capable of a moral and rational interpretation. On both these grounds, Rococo was therefore distasteful. For a neoclassical artist, his style must eschew the prettiness and lushness of Rococo, and discover a style which would reflect the rugged morality of the subject in the sparse simplicity of setting, figures and painting technique. Some neoclassical theorists pursued an even closer connection between art and morality. Believing that art could be a positive aid toward morality, they suggested historical subjects which could underline moral criteria. The Roman historians and moralists, particularly Plutarch, were rich in episodes which would provide a stern alternative to the immoral or amoral productions of the Rococo. Such a belief in painting as an expression of the philosophy of life, an *exemplum virtutis*,[669] was not new. In France, it had been a central tenet of Poussin's art. In an age of such varied subject-matter from so many periods of history, we may perhaps consider as neoclassical that which is treated in a heroic and moralistic manner, and in a style which bears the traditional classical qualities of balance and restraint.

Gavin Hamilton: an early neoclassicist

Most of the features discussed so far in this chapter are to be found in the life and work of Gavin Hamilton, a Scotsman who lived in Rome from 1748 until his death in 1806. In the

Gavin Hamilton: Andromache Mourning the Death of Hector. Engraving by D. Cunego, 1764. The work looks back to Poussin's Death of Germanicus and antique sources.

development of Neoclassicism he is a key figure as an archaeologist, as a dealer in antiquities, as a disseminator of ideas about art and as a painter. He was, for example, friendly with those pillars of the Graeco-antiquarian style in architecture, Stuart and Revett. He visited the sites of Italy with them, especially Pompeii and Herculaneum, and may well have urged them to go to Athens. He advised Canova, who had settled in Rome in 1780, on the direction his style should take, and was perhaps instrumental in turning him away from the Baroque and toward the classical. The confines of his own taste are apparent in his *Schola Italica Picturae* (1773), where forty sixteenth- and seventeenth-century Italian paintings are reproduced, from Raphael and Michelangelo to the Carracci, Guido Reni and Caravaggio. In his first year in Rome, he was writing enthusiastically of the work of Domenichino, and his own painting is evidently based as much on seventeenth-century art as it is on classical antiquities.[673]

A fine publicist, Hamilton's work became known through engravings which, in the early 1760s, provided Europe with early illustrations of Homeric subjects treated in a stern and moral manner. For example, his *Andromache Mourning the Death of Hector* (engraved 1764) is built up of ranks of figures strictly parallel to the picture plane. The figures, eloquent in their restraint and noble in their form (in some cases derived directly from antique statues), gather round the bed in the

John Flaxman: Thetis bringing the armour to Achilles. Engraving by Piroli, The Iliad, London, 1805.

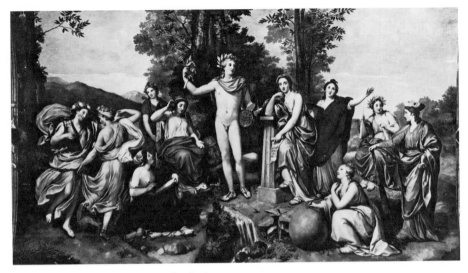

Mengs: Parnassus, 1760–1, fresco. Rome, Villa Albani.

manner of a *conclamatio* sarcophagus. The subject might be Greek, but any painter at the end of the century would have found the scene far too crowded and even ornate. Evidently, the source of its style is not Greece but the classicism of the seventeenth century, particularly the death-bed scenes by Nicolas Poussin. The same features are apparent in Hamilton's other works.[675] It is an interesting sidelight on Neoclassicism that a man who had so much opportunity for examining newly found Greek and Roman antiquities began to develop his own art as part of the existing classical tradition, and tried in no way to break away from it.[674] He can be contrasted with later artists, such as Flaxman, who, ignoring the Renaissance and seventeenth-century achievements, sought a style which really did attempt a *tabula rasa*.

Winckelmann and Mengs: the scholar and the artist

Hamilton's ideas on the imitation of past art were similar to those of Anton Raffael Mengs, except that Mengs's paintings have rather more Rococo prettiness about them.[680] His father named him after Correggio and Raphael,

and encouraged him to copy the Vatican *stanze* of his namesake. Like Reynolds, he derived his income and popularity mainly from his accomplished portraits, but his heart was with grand historical painting. His *Gedanken über die Schönheit* of 1762, quickly translated into Italian and Spanish in 1780, French in 1781 and English in 1782, proclaimed his ideal style as a mixture of Raphael, Correggio and Titian, plus a close study of Greek sculpture. In this eclectic view,[682] expression was taken from Raphael, grace and chiaroscuro from Correggio, colouring from Titian, and the ideal of beauty from Greek Antiquity—this last being the key to the formula, and the only particular in which it differed from the supposed formulae of the Carracci or the younger Poussin. An example in paint of this formula was Mengs's *Parnassus* of 1760/61, a fresco decorating the centre of the ceiling of the Salon in the Villa Albani, which was the room used by Cardinal Albani to display part of his famous collection of antique sculpture. The composition is a reworking of Raphael's *Parnassus*, with the *Apollo Belvedere*, the *Borghese Dancers*, and a pensive figure from the *Aldobrandini Wedding* prominent within the carefully balanced composition. It is not an impressive painting, for it lacks the vigour of its sources.

But it has all the hallmarks of a demonstration piece, and therein lies its importance; its success amongst the *cognoscenti* indicated the reaffirmation of classicizing ideals in Rome. Its similarities to the Farnese Gallery would not have been lost upon its admirers. The remainder of Mengs's work in the historical manner echoes his respect for Raphael and the Carracci.

Winckelmann thought Mengs the greatest of modern painters. The artist had arrived in Rome from Dresden in 1752, having already spent 1741–4 and 1747–9 in Rome. When Winckelmann himself came from Dresden in 1755 to be librarian to Cardinal Archinto, he was helped by letters of introduction to the painter, whose star was already in the ascendant. When Archinto died, Cardinal Albani made Winckelmann his librarian, thereby giving him the opportunity to study antique art and its literature in the midst of one of the best private collections in Europe. Winckelmann's post also entailed the curatorship of that collection, and he no doubt supervised if he did not programme the extensions to the Villa Albani (c. 1760) and its decoration. Dresden, with its great library, its Correggios and its Sistine Madonna, had helped to form Winckelmann's taste; in Rome he began to apply his ideas to building a formidable reputation as an antiquarian and historian.[681] He wrote essays on the *Torso Belvedere* and *Apollo Belvedere* (1759), on frescoes at Herculaneum (1762 and 1764—the first discussions), and a *History of Ancient Art* (1764), the fruit of seven years' work. The previous year he had been made Commissioner of Antiquities at the Vatican, a post similar to that held by Raphael himself. He detested the Baroque,[683] and found even the Seicento classicists insipid in comparison with Mengs, whose *Parnassus* he considered far superior to Reni's *Aurora*. Even Domenichino, who 'studied the ancients more than any other follower of the Carracci . . . did not achieve the purity of Raphael in drawing the nude . . .' For Raphael is his hero,[677] and his opinions on Greek art[679] coincide so closely with his opinion of Raphael that he clearly saw him as a Greek reincarnate; he writes in the *Gedanken*:

P. d'Hancarville: Imaginary tomb of Winckelmann. Frontispiece to Antiquities from the Cabinet of Sir W. Hamilton, Florence, 1801ff. The tomb was to honour the man who set the fashion for collectors like Towneley and Hamilton.

Noble simplicity and sedate grandeur are . . . the true characteristical marks of the best and maturest Greek writings, of the epoch and school of Socrates. Possessed of these qualities Raphael became eminently great, and he owed them to the ancients. That great soul of his, lodged in a beauteous body, was requisite for the first discovery of the true character of the ancients; he first felt all their beauties. Ye that approach his works, teach your eyes to be sensible to those beauties, refine your taste by the true antique . . .

Elsewhere he calls Raphael 'this god of artists', and states that 'we know he sent young artists to Greece, to copy there, for his use, the remains of antiquity'.

Winckelmann's belief that Greek art was the stimulus for the High Renaissance is anachronistic, and reveals much wishful thinking. It may be that he induces his specifications for good art from Raphael and applies them to his study of Greece, and *not* vice versa. What is crucial in Winckelmann's assessment of Greek art is the place he allots to it in the pattern of civilization. He explains in his *History* that

Greek art was so fine because it was influenced by the climate, the politics and the thought of the Greeks, and that their love of physical beauty, based on the male nude, was connected with their simple life-style and their love of liberty: 'it was liberty, mother of great events . . . which spread among that people the first seeds of noble sentiments . . .' Thus although his ideas on beauty and on the connections of art with philosophy and morality are by no means original, the wide view which he gives to the place of art in society is new. His location of great art among the Greeks (even if his assessment of Greek art is intuitive, and based on inferior copies)[684] points out a new direction which the classical tradition was to take at the end of the century.

Winckelmann's interest in the Greeks is part of the primitivism which runs through the art and thought of the eighteenth century. He was a librarian, and learned the need to search for a pure and unadulterated early manuscript if he wished to understand a textual tradition; on the same principle, surely Greek art (including vases[676,678]) must be more genuine and worthwhile than the later and hence corrupt Roman art. We must not over-estimate his influence on Neoclassicism, for he was probably a symptom rather than a cause of interest in things Greek. His books were very popular, but perhaps not essential to the course of Neoclassicism in England, and certainly not in France, which had its own strong aesthetic traditions and native theorists. Would Mengs's paintings have been very different without Winckelmann's theories? Indeed, did Winckelmann formulate his own theories of art, or did he have substantial help from Mengs, a writer on art himself?* Perhaps L. D. Ettlinger is right in claiming that Winckelmann's attitude to Greek art was am-

bivalent because he followed the dictates of contemporary classicism but also made of Greek art a 'religion . . . and the emotionally charged revelation of truth'.[647a] Such emotional sympathy was new, and Winckelmann's fellow Germans found it especially invigorating. Goethe, inspired by Winckelmann's vision, saw in Greek culture a rejuvenating influence on the culture of his own day. 'By reading Winckelmann,' he wrote, 'one does not learn anything but one becomes somebody.' The history of his own career, as much as that of Winckelmann, illustrates the ambivalence of Neoclassicism as interpreted by the North.

Neoclassicism in France: the revival of the Academy

France was the first country in Europe to provide official backing and a clear programme for the revival of classicism. The strength and consistency of the French programme derive from the example and influence of the *Grand Siècle*.[692]

In 1747, La Font de Saint-Yenne stated that 'only the history painter paints the soul; the rest paint only for the eyes'.[694] Seven years later he urged that painters should portray 'heroic and virtuous actions of great men— actions of humanity, generosity, courage, disdain for danger and even for one's life, of passionate zeal for honour and the safety of one's Country and, above all, for the defence of one's religion'.[695] He suggested suitable subjects, among them Socrates, Pericles, Alexander, Brutus, Scipio, Joan of Arc, the Chevalier Bayard and François I. Three years later the Comte de Caylus published his suggestions for Homeric and Virgilian subjects (see pp. 197–9), above),[686] and from time to time thereafter presented his researches into the techniques and appearance of ancient art to the Académie des Inscriptions et Belles-Lettres.

Of similar mind was Lenormant de Tournehem, who, in his position as Director General of the King's Buildings from 1745 to 1751, used his power to reform the Academy, the vehicle through which big official commissions had been made since the days of Lebrun. He re-established the post of First Painter, and ap-

*Cf. Henry Fuseli, *Lectures on Painting*, 1801, introduction:

The verdicts of Mengs and Winckelmann became the oracles of Antiquaries, Dilettanti and artists from the Pyrenees to the utmost North of Europe . . . Winckelmann was the parasite of the fragments that fell from the conversation or the tablets of Mengs . . . To him Germany owes the shackles of her artists, and the narrow limits of their aim; from him they have learnt to substitute the means for the end, and by a hopeless chase after what they call beauty, to lose what alone can make beauty interesting, expression and mind . . .

pointed to it in 1747 Charles Coypel, a fervent admirer of Raphael, the Carracci, Domenichino and Poussin. Following Caylus's advice, Tournehem had students draw from the antique, from statues and casts. Ninety-six paintings from the Royal Collections were made available for study. He re-stocked the Academy's library with works by appropriate historians and poets, for, as Reynolds was to say in his *Seventh Discourse*, 'He can never be a great artist, who is grossly illiterate.' In 1749 the Academy School opened, wherein six *élèves protégés* (paid scholars) would be taught history, literature and art to prepare them for a profitable stay at the French Academy in Rome. And what more suitable area for the students' studios than the Gallery of Apollo in the Louvre, with its decorations by Lebrun? The programmatic nature of the students' instruction was emphasized by the re-institution of lectures on artistic subjects.[693]

On Tournehem's death in 1751 his nephew, the Marquis de Marigny, succeeded him in his post.[696] His taste was formed for his new responsibilities by twenty-two months spent in Italy, under the guidance of Soufflot the architect, the Abbé Leblanc (a famous antiquarian) and Charles-Nicolas Cochin, a drawing-master, engraver and Academician who was to advise him until 1771. Once home, he set a pattern by rewarding history painters more highly than portraitists, and arranging lucrative commissions for serious-minded artists, such as the decoration of the Château of Choisy which was carried out by Carle van Loo, Halle and Vien in 1774. Marigny's successor, the Comte d'Angivillier (1774–91), increased the Exchequer grant for buying works of art, and in 1775 proclaimed the King's wish that 'four or five works in the historical genre be commissioned each year'. These were to be of subjects from Greek, Roman or French history, and all *exempla virtutis*.

Such a deliberate policy was bound to affect artistic output.[687,688] The movement toward paintings of ever greater stoicism and heroism is reflected in the entries for the annual *Salon* exhibitions where paintings of stories from Ovid, Virgil, Livy, Valerius Maximus and, most importantly, Homer and Plut-

arch, became pre-eminent as the century progressed.[685] Plutarch's *Parallel Lives*, where the life of a Greek is written in a 'pair' with the life of a Roman, accorded well with the fashion for emulation of the great virtues of the ancients. With Livy, it was the earlier books, rich in heroes such as Romulus, the Horatii, Mucius Scaevola or Cincinnatus, which attracted the artists. From the *Iliad*, scenes came to prominence which, in the first half of the century, would have been thought wild, not heroic. These included *Achilles' Wrath*, *Achilles Dragging Hector around the Walls of Troy*, and *Andromache Mourning the Dead Hector*. Artists like Brenet and Lagrenée, now largely forgotten, rose to fame by conforming to the taste formulated by official commissions.

Side by side with moral and heroic themes there existed another, more fashionable, type of 'antique' painting which is really the Rococo in different clothes. The works of Vien epitomize a continuing interest in delicate and pretty sexuality. Indeed, in his *Seller of Cupids*, imitated from a painting found at Herculaneum, he introduces an obscene gesture which is not in the equally sentimental original. Vien painted thus because sex sold well: that he could paint in the grand manner is shown by his series on *The Legend of St Martha*.[689,690] His importance in the classical tradition is his rôle as teacher, especially as Director of the French Academy in Rome from 1775 to 1781. It was Vien who first showed David the treasures of Rome, and converted him to the antique manner. He tightened up procedure at the French Academy (this had been notably slack under Natoire), and re-introduced the custom of annual *envois* by the students which were sent to Paris to show the management how they were progressing.[691]

Diderot and Greuze: the classicism of everyday life

Vien's most popular works show that a subject could be antique without being classical. Conversely, it is not necessary for the subject-matter of a painting to be antique for it to be classical in style and moralizing intent. The mature works of Jean-Baptiste Greuze show

that it was possible to adapt the popular Dutch genre scenes of ordinary family events into canvases with all the attributes of classical history painting except for the high-born characters. Greuze was encouraged in his purpose by his friendship with Denis Diderot, whom he had met in 1759, and whose accounts of the *Salons*[703] are as important for our knowledge of the age as his *Encyclopédie* is for its thought and technology. Diderot, like many of his contemporaries, believed art to have a moral aim: 'to make virtue attractive, vice odious, ridicule forceful; that is the aim of every honest man who takes up the pen, the brush or the chisel' (*Essai sur la peinture*). Art not only reflects society, but must be a force to change it, and not simply a frivolous appendage to the aristocratic Rococo.[700] His respect for the middle classes, as shown in his own plays, no doubt laid the foundations for his admiration of Greuze, but his basic ideals stem from his wide reading among the ancient authors. He especially respected the tragedians, and their exposition of deep and natural emotions: 'I will not tire of crying to our French authors: Truth! Nature! The Ancients! Sophocles, Philoctetus . . . garments and words which ring true, and a straightforward and natural plot' (*Entretiens sur le fils naturel*). He steadfastly defended antique art against the assault of the 'moderns',[697,698] although he had doubts about Winckelmann, whom he found rather bloodless.

> He who ignores the antique in favour of nature risks being petty in drawing, character, drapery and expression. He who neglects nature for the antique risks being frigid, without life—without any of those secret and hidden truths which are to be perceived in nature. I believe we must study the antique so we may learn how to see nature . . .[703]

Winckelmann, whom he calls a 'fanatic', loved only the antique.

Diderot saw the modern equivalent to ancient art in Greuze's pair of works on filial duty, *The Father's Curse* and *The Son Punished*, shown as drawings at the *Salon* of 1765, and as paintings in his studio in 1777 and 1778.

Diderot wrote: 'there are no difficult or tormented attitudes, but true actions which are suitable for the painter; . . . were they to be painted, Boucher would sell fifty of his flat and indecent puppets more quickly than Greuze would sell these two sublime works'. Both designs extended the family theme, as well as the style, of *The Village Bride* (Salon 1761, Louvre), and are in the same mode as *The Paralytic cared for by his Children* (1763, Leningrad), or *The Drunkard's Return* (1780s, Portland, Oregon). Greuze's only important work with antique subject-matter is the *Septimius Severus reproaching Caracalla* (Salon 1769, Louvre), which was his reception piece by which he gained admission to the Academy. Much to his chagrin, he was admitted as a genre painter, not a history painter. He was, in truth, ahead of his time, and it is evident with hindsight that his contributions helped to change the nineteenth-century idea of history painting. His everyday scenes are indeed as much history paintings as the reception piece. They share both sentimentality and a similar style. A few antique-inspired[701] figures are logically disposed on a shallow stage; and both the focus of the lighting and the sparseness of the setting keep the attention of the spectator on the clear gestures and composed yet contrasting expressions of the protagonists. Nothing is included which is not essential to the telling of the story, and the meaning of the works is in every case plain to see.

All these works owe their basic approach to the example of Poussin,[704,705] whom Greuze was the first eighteenth-century French artist to imitate. Poussin's *Death of Germanicus* (Minneapolis), a death-bed scene of the *conclamatio* type which was to be so popular with neoclassical artists, is the direct source of the *Severus reproaching Caracalla* and the indirect source of Greuze's other death-bed scenes. Similarly, his frieze composition derives from Poussin's grand style, well known in the eighteenth century via prints. Greuze's foray into the antique, badly received as it was, led the wounded artist to avow: 'I have studied the works of that great man and, above all, have sought the art of imbuing my figures with expression . . .' Diderot's comments must have

Greuze: The Village Bride, 1761. Paris, Louvre. In his Essay on Painting, Diderot objected to works such as these being called 'genre scenes'. They were, he asserted, as much history paintings as Poussin's Seven Sacraments.

affected Greuze's artistic allegiances, for the author's critiques of the *Salons* are full of commendation for modern painters in whose work he discerns the Carracci, Domenichino or Le Sueur. He writes of Vien's *St Denis preaching to the people of Paris*: 'his painting is as wide in scope and as wise as that of Domenichino; handsome heads, correct drawing, beautiful hands and feet, fine draperies, simple and natural expressions . . . everything is effortlessly calm . . .'[702] However, by the 1770s Greuze was not alone in his advocacy of Poussin's manner. The Abbé Laugier, who had played such an important role in establishing the theory of neoclassical architecture, declared in 1771 of Poussin: 'No *hors d'oeuvre* in his paintings, always the most advantageous point in the story, and the best circumstances to fortify the general expression; a laconicism

full of energy, which says much in a few words . . .'[699] If we lower the specification from ideal heroes to ordinary people at their moral best or worst, and from sentiment to sentimentality, the work of Greuze accords with this view of art. His paintings laid the foundations for further study of the seventeenth-century masters, and are actual prototypes for some of the compositions of J.-L. David. The converse is sometimes the case. Thus *The Drunkard's Return* of the early 1780s may well derive in figure scale, gestures and grouping from David's *Belisarius* of 1781 in Lille. But *The Oath of the Horatii* of 1758 by David takes its gestures and general approach from Greuze's earlier works. The two-way influence indicates both an attempt by the ageing Greuze to simplify and purify his style, and a similarity of aim.

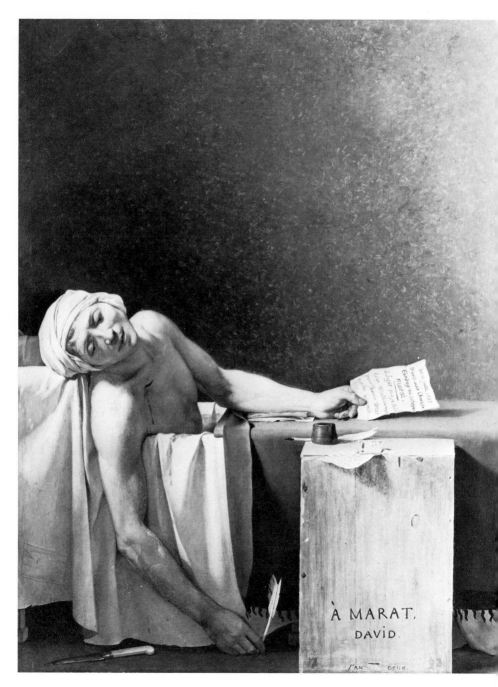

David: from Roman to Greek

When Vien returned in 1781 from a period as Director of the French School in Rome, he and his pupils represented, in the words of the *Journal de Paris* in 1783, 'the hopes of the French school of painting'. His school was to produce notable history paintings until after the Revolution. F. A. Vincent, who won the Grand Prix in 1768, was one of the first to treat French history in the grand manner; during the First Empire, he was painting contemporary scenes of historical importance, such as *The Battle of the Pyramids*. J.-B. Suvée studied under Vien in Rome, and won esteem for his religious paintings in imitation of Le Sueur as well as for ancient and modern history pieces. He was named Director of the French School in Rome in 1792. Another pupil of Vien, J. F. P. Peyron, won the Grand Prix in 1773 from under the nose of David with a *Death of Seneca*. He went to Rome to be groomed under the watchful eye of N. Halle, successor to Vien, and another history painter, only to have his fine *Death of Alceste* (Louvre) challenged at the 1785 *Salon* by David's *Oath of the Horatii*.

David was the most influential of Vien's pupils. He acknowledged his debt when, at the master's funeral in 1809, he lamented, 'Our father has ceased to live'. It was David who brought to fruition the years of planning at government level, although at first his ascendancy was by no means clear-cut.[732] At first, he was no innovator in historical subject-matter, and he gained over his contemporaries because he was a better and more flexible artist. His biographer Delécluze wrote in 1855: 'He took up and followed four theories or, rather, four manners, characterised by the *Horaces*, the *Marat*, the *Sabines* and the *Coronation of Napoleon*.' His progression from Roman historical to Greek historical scenes and then to a Rubensian Baroque can be viewed as a response to changing circumstances social and political, if we take care to avoid seeing him as a politically subversive figure. The idea

LEFT *Jacques-Louis David: Dead Marat, 1793. Brussels.*

that his work of the Revolutionary period contains contemporary and subversive messages, rather than being generally appropriate to the mood of the *Salons*, does not bear examination.[716,719] As a history painter, his interest is usually in the ideal, not in the particular. Even when he takes a contemporary event, as in the *Dead Marat*, he idealizes it, as we shall see.

David won the Prix de Rome in 1775. The work he was sending back to Paris showed that he was losing the decorative grace of the prize-work (*Antiochus and Stratonice*) in favour of the grim heroics of Homer[728] and, in Michael Levey's characterization of Neoclassicism, of the triumph of the corpse in art (*Rococo to Revolution*, London, 1966, 167). His studies in Rome led him to Caravaggio[735] and to his French equivalent, Le Valentin, one of whose works he is known to have copied.[712] He made tracings of famous paintings,[710] and built up a formidable collection of drawings. He most consistently imitated Poussin and the Carracci.[708] His *St Roch interceding with the Virgin to Cure the Plague-stricken* (1780, Marseilles) was painted in Rome, and clearly rehearses his studies of Italian art. The *Belisarius begging for Alms*, of the following year (Lille), signals the affirmation of Poussin's values for French Neoclassicism. Its restrained colouring, carefully studied antique architecture, majestically disposed figures and of moralizing *pathétique* ensured its success. The *Andromache mourning Hector*, shown at the *Salon* of 1783 (Louvre) still shows the pathos of Greuze's *The Son Punished*. Four years later, greater praise was given to another *conclamatio* scene, *Socrates taking the Hemlock* (New York, Metropolitan), which Sir Joshua Reynolds hailed as the greatest step forward since the Sistine Ceiling and the Vatican *stanze*.[736] This work replaces pathos with the stoicism of Poussin's *Testament of Eudamidas*. It is, much more than the *Andromache*, a philosophical and stoic theme which preoccupied the eighteenth century, inspired by the opening section of Plato's *Phaedo*.[731]

We may consider the *Socrates* together with *Brutus and his Dead Sons* and *The Oath of the Horatii*, for all were considered important

209

enough to be re-exhibited at the 1791 *Salon*. And in 1795, the *Socrates* was copied in an engraving by order of the Committee for Public Instruction, as an example of virtue. All three works represent a stern and stoic morality which holds the State in greater honour than family ties.[711] In all three, the seventeenth-century foundations of this latter-day Corneille have been fortified by a new and terrifying realism, a function of the dramatic stage-lighting which has its origins in Caravaggio. The setting points both the action and the moral. The three arches in the *Horatii* form the composition and yet irrevocably divide the participants from the mourning onlookers. The torso of Socrates is silhouetted against the large contemplative area of the wall. The columns in the *Brutus* divide him and the Goddess Roma from the light, and emphasize his dark resolve and calm posture in contrast to the frozen panic of his weak womenfolk, who collapse in a fluttering heap like the slain daughters of Niobe. All three scenes take place on a narrow stage, the few figures in bas-relief pressed by the setting to the front plane. In all three David makes use of unyielding geometry to symbolize unyielding virtue. The theatricality of the three paintings is not incidental. The *Brutus* was inspired by

Voltaire's popular play of the same name (1730), and Voltaire, like the figure he portrayed, was a popular hero of the Revolution. *The Oath of the Horatii* was probably engendered by a visit to a production of Corneille's play *Horace* in 1782; after seeing this David sketched the scene where the father defends his son for having killed his (the son's) sister Camilla, who had thought fit to upbraid her brother for killing a Curiace whom she was to marry.[709,718,730,737] D'Angivillier ordered a painting on this scene, for the King, which was to be shown at the *Salon* of 1783. David had second thoughts, and hit on a more heroic idea not in fact shown in Corneille's play: he imagines the sons swearing loyalty to the State on their swords, their poses repeating each other and reinforcing their mutual resolve. Their father holds up the swords, which cross at the vanishing point of the perspective. David thus invents an action which epitomizes heroism as enacted by ideal and unswerving actors. The rigour of his classical morality is not reduced by the knowledge that there is no antique source for the practice of swearing on swords, which is a feudal and Christian idea. All three paintings deal with eternally valid moral problems within a classical tradition of iconography and style. It is worth repeating

David: LEFT Socrates taking the Hemlock, 1787. New York, Metropolitan Museum of Art. RIGHT Brutus, 1789. Paris, Louvre.

David: The Oath of the Horatii, 1785. Paris, Louvre.

that David can have had no subversive intention when he painted any of them.

The important works which David executed during the Revolution also bear an antique, generalized and heroic interpretation. *The Oath of the Tennis Court*,[721] the *Dead Marat*[724] and the *Lepeletier de Saint-Fargeau Assassinated*[734] show contemporaries and record important events, but do so through references to David's earlier works and to the classical tradition itself. *The Oath of the Tennis Court* reworks *The Oath of the Horatii* on a Baroque

211

scale, and the *Lepeletier* appears to have paraphrased the *Andromache mourning Hector*. The painting of this work was probably destroyed by a Royalist descendant in 1826; it is known through a drawing by Devosge, and an engraving by Tardieu. The reminiscences in the *Marat* are more diverse. It is a pagan *pietà* reminiscent of the work of Annibale Carracci, with the instruments of the Passion transformed into writing implements, and the lance-thrust into the actual wound which Marat received. But the inscription, the equivalent of the Christian INRI, translates the packing case (to represent Marat's simple way of life—compare Diogenes and his barrel) into a votive table in the antique manner. Marat suffers as Winckelmann thought Laocoön suffered, in noble silence. He is a political martyr, and the bath in which he worked because of a skin disease becomes in effect the parade bed on which his corpse was actually displayed for public veneration. Is there any sign of the gruesomeness of death or, indeed, of that skin disease? Patched sheets, a packing case, and a corpse in a bath full of water and blood are combined in a painting which owes its heroic idealism to the abstraction of the composition and to the Caravaggesque spot-lighting. These transmute sordid objects into shapes which have their own self-sufficient beauty. Thus the

packing-case is a utilitarian object, a firm counterpoise to the corpse, and also a grave stele; it controls the shape of the composition and is the key to its strength and to its meaning. Finally, to emphasize the universality of Marat's sacrifice, the scene is set without any distracting background, in what is perhaps a Revolutionary vision of heaven. The modernity of the *Marat* is deceptive; although David certainly saw the actual corpse *in situ*, and may have used wax models in the preparation of his painting,[720] he imitated the famous antique relief of *The Bed of Policletus*, which he would have known from the replica in the Palazzo Mattei in Rome. The comparison is exact, the source common, for it had been known to Ghiberti, and probably suggested to Michelangelo the pose for the Christ in the St Peter's *Pietà*.

That incitement to virtue which is the aim of history painting, and which was one reason for the setting up of museums throughout France,[706] was emphasized by David's stage-management of festivals in the antique manner during the Revolutionary period.[713-15] These were intended to epitomize the aims and ethos of the national purpose through sanctification of its ideals. The means used were processions, *tableaux vivants*, or paintings and statues to which the public did honour. The enactment

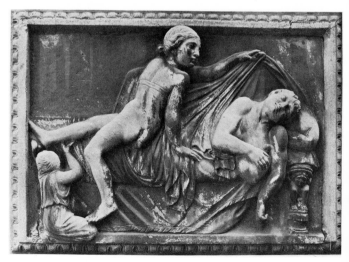

The Bed of Policletus, antique relief. Rome, Palazzo Mattei.

of Roman festival structures adapted to the glorification of a modern régime was, of course, a procedure much used since the Renaissance. But never before had prominence been given to the Roman Republic (instead of the Empire) via the images of its most famous heroes, and to their modern descendants who, by continuity and by iconography, were compared with their prototypes.[707,725] Thus Lepeletier de Saint-Fargeau, stabbed to death on 20 January 1793 by a Royalist for voting in favour of the King's execution, was exhibited in public on an antique couch, the drapes pulled back to reveal his Christ-like wound, and his clothes and the sword with which he had been killed prominently displayed. Candelabra and tripods decorated the high podium, to be mounted by the President of the Convention when he crowned the dead hero with a laurel wreath. At David's request, a bust of Lepeletier was placed next to that of Brutus in the Convention; when Marat was killed on 13 July 1793, his bust quickly joined them. On 16 October 1793, David's painting of Marat was first shown to the public (it had been ordered by the Convention) in the courtyard of the Louvre, together with that of Lepeletier. Each stood on an antique sarcophagus, and they made, quite deliberately, a matching pair. An earlier ceremony which David might have managed probably affected the form and public presentation of these two works. On 11 July 1791, thirteen years after his death, Voltaire's body was brought to Paris and conveyed to the recently finished Panthéon (originally St-Geneviève), which was decreed as a hall of French fame in the antique manner.[727] The writer-philosopher's remains were transported on an imitation antique chariot, inside a mock-marble sarcophagus flanked by genii with upturned torches. On top, on an antique bed, lay the effigy, chest exposed, and about to be crowned with a laurel wreath by a Victory. Incense smoked from candelabra at the four corners of the carriage. Participants in the procession were naturally in Roman dress, to add authenticity to the occasion. The hero's apotheosis was an antique idea which David would have known from his studies amongst the monuments of Rome and in the books of

Bartoli and Montfaucon. With such festivals in mind, we can appreciate the associations touched off by the paintings of Marat and Lepeletier. They represent not the triumph of the corpse in art, but rather the apotheosis of the hero through death into a god.

The year 1793 saw the culmination of David's ideas on the privileges and unfairness of the Academy. The body had debated, in 1790, and amidst much opposition, a democratization of organization. In 1791, the *Salon* had been opened to all comers. Following a report from David, 1793 saw the suppression of all academies, and the *Salon* that year was, strictly speaking, organized by the 'General Commune'. It contained several works of contemporary history. In October of that year, the Convention instituted a prize for painting and sculpture. In that first year, the set subject was, for painting, *Brutus killed in Combat and carried Home by his Peers*, and for sculpture, *The Schoolmaster of Falerii* (a subject painted by Poussin). The entry by Harriet, a pupil of David, provoked a remark by one juror which captured the true role of Antiquity in painting at that time:

In two years there will be born a sublimity which will surpass everything which we admire—sometimes with prejudice—in the antique. We will not be Athenians nor Romans, slaves who carry the name of free men, but Frenchmen, free by nature, philosophical by character, virtuous by disposition and artists by taste.[726]

Sentiments such as these were reinforced in 1794 by a proclamation urging artists to depict the famous scenes of the Revolution, or to design statues to be erected in honour of modern great events. In effect, David's complaint against the Academy was one of unfairness, but he did little to change its basic rôle; from its re-institution in 1816 (after a period as one section of the Institut), it flourished.

Like that of many fellow artists, David's style changed during the last years of the century from a Roman style summarized by the *Horatii* to a less realistic, almost abstract style based on line. This attempt to purify his work, perhaps spurred on by his respect for Giotto

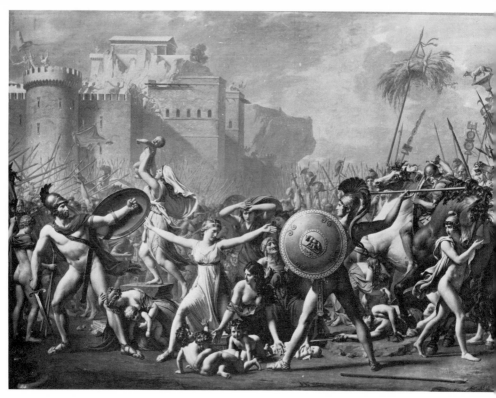

David: *The intervention of the Sabine Women, 1799.*

and certainly by the currents of primitivism already discussed, formed a Greek manner best seen in *The Intervention of the Sabine Women* of 1799 (Louvre). David turned to the newly popular study of Etruscan vases,[717] the only Greek paintings extant, and Flaxman's demonstrations of how they might be adapted to form a new linear style which would suit primitive subject-matter such as that of Homer.[733] No matter how frieze-like neoclassical multi-figure compositions had hitherto been, none had been denied that combination of light and texture which gave objects physical and moral weight and a definite position in space. But now, in search of a purity which they associated with the very earliest stages of art, artists sometimes threw overboard the accumulated technical expertise of art from the High Renaissance onwards.[729] The resultant outline style could never gain exclusive support from any artist, for its suitability for the decorative arts and for drawings and engrav-

ings was matched by a patent unsuitability for large commissions. David's *Sabines*, partly based on Flaxman's *Diomedes casting his Spear against Mars*, is, however, not wholeheartedly primitive. Its composition, expressions and attitudes owe much to the Renaissance tradition of battle and catastrophe scenes; its fresco-like tones, exactitude of draughtsmanship and archaeological detail smack of the Academy.[722] One modern critic has referred to the 'deliberate self-sterilization' of works like this, and their 'reaction against the committed "Gallic" forms of his Revolutionary works'.[723] Certainly, the works in this manner which David was to paint in the years left to him— e.g. *Sappho, Phaon and Amor* (1809, Hermitage), *Leonidas at Thermopylae* (1814, Louvre) and *Mars disarmed . . .* (1824, Brussels)—are not only deficient in moral energy, but might be said to smell of the lamp of industry rather than the light of imagination. They lack the humanity so conspicuously present in portraits in the same

style, such as the *Madame Récamier* or the *Madame de Verninac*.

David's paintings of Napoleonic subjects portray themes which replace the stoic morality of his Revolutionary works with imperial Roman grandeur. Napoleon seemed the only man capable of saving France, and David was only the most prominent of several who aided his propaganda as he became general, then First Consul, and finally Emperor. If the style David created for this 'spirit of the age on horseback' had little to do with austerity and sacrifice, it is nevertheless important for the classical tradition because it drew explicit parallels with Antiquity, and still promoted a concept of art as a glorification of the State. Yet the ambivalence of the Napoleonic style must be emphasized. That style sowed many seeds which, when they came to fruition, were to undermine the whole notion of the classical tradition. As we shall see, any student of Romanticism or Realism in France would be forced to begin with David.

one man who produced sculpture in accordance with Winckelmann's dreams, his work was an example to all. In his address to the Royal Academy on the sculptor's death, Flaxman remarked that 'prints of . . . all [his works] may be seen in the collections of the metropolis'.

Canova settled in Rome in 1780, leaving his native Possagno, near Venice, with its Venetian traditions, determined to study the antique thoroughly. His link with Winckelmann was through the productions of Bartolommeo Cavaceppi, the well-known restorer.[741–3] His reputation was established by his *Tomb of Clement XIV* of 1783–7 in SS. Apostoli, Rome. Here, Canova chastens the Baroque formula represented by works such as Bernini's *Tomb of Urban VIII* in St Peter's, replacing Bernini's lush allegories by figures in noble, body-clinging draperies (much admired by David),[739] their restraint and pose reinforcing the cubic severity of the whole composition. A source for Canova's tomb type could be sarcophagus

Neoclassical sculpture : Canova

Apart from some rather Baroque sketches, no such ambivalence between classicism and primitivism is detectable in the productions of Canova (1757–1822, roughly contemporary with David), the man who fixed the ideal style in sculpture for several generations. Because of the highly polished purity of his marble forms, and their evident and intentional connections with the masterpieces of Antiquity, Canova has received a bad press from modern critics who prefer the sketch to the finished work, and who condemn imitation as necessarily servile and as the enemy of spontaneity.* During his lifetime, however, and well after his death in 1822, his supreme excellence was not questioned. The success of his style entailed its spread throughout Europe in the form of originals, copies by his assistants, and engravings which he himself commissioned. As the

Antonio Canova: Monument to Pope Clement XIV, 1783–7. Rome, Chiesa dei SS. Apostoli.

*'This is Canova's secret, to be cold and bombastic at the same time . . . preserved in the deep-freeze, stiffened by rheumatism, fossilised like anthracite. Form, in Canova, becomes ritual . . . he does not recreate, he imitates . . .' (Mario Praz)[744]

Canova: 'Conclamatio' relief: Monument to the Countess of Haro, c. 1806, Possagno.

reliefs of *The Death of Meleager*, in which similarly disconsolate figures are placed in profile or full-face. He uses the same format and motifs for his *Monument to the Countess of Haro* (1806, Possagno), and subsequently adapts the mourning figure in profile—standing, leaning or reclining—for a series of monuments based on the form of the Greek stele. Another basic shape, the pyramid, governs the structure of his internationally acclaimed *Monument to the Archduchess Christina of Austria* (1805, Vienna, Augustines). Virtue carries the ashes of the Archduchess into the tomb in much the same way as Benjamin West's *Agrippina* carries the ashes of her husband Germanicus in the painting of 1768, now in Burghley House, Northamptonshire. The variety of Canova's monuments large and small, usually of bas-relief format, quickly made them popular. They combined the purity of white marble and the simplicity of voguish antique references and forms with a softness of execution and a sentimentality which evoke the work of Greuze or Vien.

It is his mythological and mytho-portrait pieces which approach the ideal of Winckelmann. Cicognara tells how, when the young Canova had finished the naturalistic *Daedalus and Icarus*, Volpato, Pompeo Battoni and Gavin Hamilton admired it. Hamilton urged him 'to unite with so exact and beautiful an imitation of nature, the fine taste and *beau idéal* of the ancients, of which Rome contained so many models, predicting at the same time, that by such a course he would greatly pass the limits which had been reached by the moderns'. In Canova's mature works the references are always clear, and herein lies their success. Their sensuality is often heightened, both by the working of the marble (perhaps the influence of his Venetian training) and by the sure sense of line and silhouette. Except in the case of a few works like the *Hercules and Lichas* where the Farnese Hercules moves like Laocoön, Canova's productions are of a crystalline delicacy. Nearly all the figures, except those representing moderns in antique disguise, are in heroic nudity, and display Canova's knowledge of formalized anatomy without trying to describe the human body realistically. He was *not* trying to make his figures look alive. A visitor to his studio, one of the sights of Rome, thought to praise him by remarking that the *Hebe* looked as though she might fly. Canova is said to have replied: 'I do not aim in my works at deceiving the beholder; we known that they are marble—mute and immobile . . . If my work were indeed taken for the reality, it would no longer be admired as a work of art . . . I would [i.e. wish to] excite the fancy only, not deceive the eye . . .' Certainly, part of the charm of the *Hebe* of 1795–8 (examples Chatsworth and Berlin) is precisely in an elaboration of undulating lines which abstract the forms and therefore negate realism, helped by the unnatural whiteness of the marble. Canova's movement toward abstraction, so characteristic of the age, is shown by the ease with which his works translate into outline engraving without losing all effect. (Nevertheless, his subtlety of construction allows his sculptures to give a pleasing silhouette from several different viewpoints.) Similarly, his interest in two-dimensionality is underlined by a series of projects for bas-reliefs on Homeric and Stoic themes designed between 1789 and 1794. These designs, of subjects like *The Death of Priam*, *Socrates taking the Hemlock* and *Telemachus returning to Ithaca*, are so chaste that they resemble outline engravings. Only the scene of *Socrates taking leave of his Family*

reached marble, and that remained in his studio. They were all, however, widely known through engravings.

Canova's popularity generated commissions from Napoleon and his family, in most of which he sought to portray the dynasty as successors to their imagined Roman imperial forebears.[745,747] In 1798, Rome itself was again a republic with a tribunate, a senate and five consuls. In 1809 it was annexed to the French Empire. References made by artists to the antique were therefore reasonable as well as fashionable. In 1807 Canova made a larger-than-life equestrian statue of Napoleon, in Roman dress, but the Emperor's fading fortunes ensured that he was soon, as it were, unhorsed, and the horse, in the Piazza del Plebiscito in Naples, now bears the figure of Charles III of Naples. In the colossal statue now rather appropriately at Apsley House, the Emperor is seen in heroic nudity. Letizia Bonaparte appears as *Agrippina Seated* (1805–8, Chatsworth) and, most famous of all, Pauline Bonaparte is shown as *Venus*[740] (1808, Villa Borghese, Rome). A comparison of this cool yet voluptuous work with Ingres's *La Grande Odalisque* of six years later shows the wide range of sexuality which an outline style can express. Ingres knew the *Venus*, but the origins of both works must be something like the antique *Sleeping Hermaphrodite* in the Museo delle Terme, a type which inspired Canova's *Reclining Fountain Nymph* (collection of H.M. Queen) as well.

The greatest following of Canova's style was in France, and it was often interpreted by resident foreign artists. During both Consulate and Empire, artists flocked to Paris to complete the plentiful commissions—another example of the internationalism of Neoclassicism. In one sense, Canova's own style was partly formed from French ideas, since it was his friendship with the eminent antiquarian Quatremère de Quincy, and their exchange of letters over many years, which fed him with a programme of classical aesthetics. Quatremère also made suggestions for subjects (such as the equestrian statue of Napoleon), and gave approval and encouragement. Thus, when Canova tried tinting some of his statues according to antique

Canova: Modello for the colossal statue of Napoleon, seen in the artist's museum at Possagno.

practice as suggested by Quatremère's researches, the Frenchman had to soothe him in the face of the predictable public reaction.[748] Whiteness was generally equated with purity—as with the popular misconception today about the whiteness of Greek temples

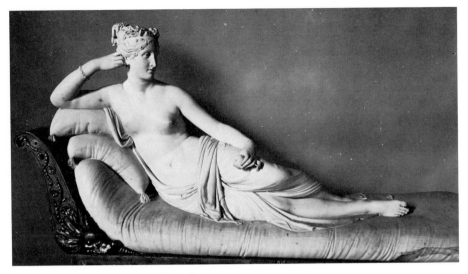

Canova: Pauline Borghese, 1808. Rome, Villa Borghese.

(which were in fact painted). The horror of the early nineteenth-century aesthetes when Quatremère pointed out that Greek temples were brightly coloured, and antique marbles sometimes treated in the same manner, might be comic to us. But the shock is characteristically that of the warm wind of an imagined ideal meeting the cold wind of reality which could not match up to the dreams.

Canova went to France three times, first in 1802, when he met David, then in 1810, and again in 1815. On the first two occasions the purpose was to execute portraits of Napoleon and his family; he even resisted an invitation to settle in France and become Director of Museums. On the last occasion he came to supplicate the Allies for the return to Italy of the works of art stolen by Napoleon, another cause dear to the heart of Quatremère. Among French sculptors, Canova was very influential: Chaudet's soft and feminine style found echoes in Canova's forms, and imitated them: he was in Rome in 1781–9. Joseph Chinard, in Rome 1784–7, worked in a similar style. Even some painters, particularly Girodet, Gérard and Guérin, took inspiration from his delicately linear representation of the nude. In more general terms Canova's achievement was to remain the ideal for academic sculptors for the whole of the nineteenth century. He worked in enough genres to provide a wide variety of imitable forms. His outline style, superficially simple, pure without austerity, graceful without over-distracting voluptuousness, antique without dryness, was repeated all over Europe and America, with an intensification of those features of hardness and dryness which were all too evident in the studio repetitions and other copies of his art.

Canova's works were also very popular with the English,[738,750] as the large number of them in English collections testifies, and as his influence on Flaxman or, at least, the similarity of their styles, suggests. Flaxman studied Greek vases as a young man, but his style only came to maturity during his stay in Italy in 1787–94, where he studied Italian art before Raphael.[751] His appreciation of Canova (who obtained at least one commission for him) is reflected in his *Fury of Athamas* of 1790–4 at Ickworth, Suffolk, a comparison of which with Canova's *Hercules and Lichas* gives some indication of comparative quality. Canova maintains the vigour of his sources in an original composition; Flaxman freezes his passionless forms into a parallelogram of ice. Canova works on the marble himself; Flaxman makes a small model which assistants then enlarge.

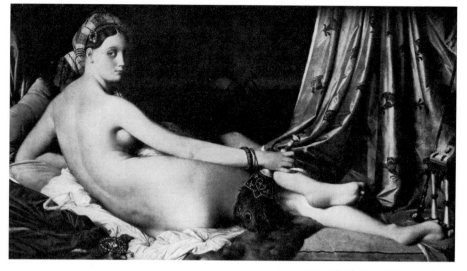

Flaxman tries hard to adapt a neoclassical style to modern dress; this, and realistic features of any kind, Canova avoids. The results of Flaxman's efforts are to be seen in his large, if not great, monuments to Nelson and other heroes of the Napoleonic Wars in St Paul's, London, England's Pantheon. Other members of the aptly named Peninsular School to get commissions there were Westmacott (a Canova pupil), the aged Thomas Banks and the young Francis Chantrey. Here, allegories in antique drapes are juxtaposed with glassy-eyed heroes in contemporary dress; fine poses are rendered ridiculous by weak composition and wooden execution.

The advent of the Elgin Marbles[746,749] in 1806 should, perhaps, have prevented St Paul's from becoming the graveyard of English sculpture, but it did not. Indeed, the evidence given to the Select Committee which was set up in 1816 to deliberate on whether the Marbles should be bought for the nation made it clear that, although they were much admired, they by no means overshadowed the other antiques which had been famous since the Renaissance. The famous occasion when Richard Payne Knight of the Society of Dilettantes shouted at Elgin that his Marbles were of the time of Hadrian emphatically does not prove him a fool, for the Elgin Marbles were outside any accepted eighteenth-century view of the ideal.[752] Would they have caused a revolution in art had they been imported fifty years earlier? B. R. Haydon's pathetic attempts to raise a British school of history painting by imitating them find no echo in sculpture itself. Westmacott's admiration for them did not radically affect his art, nor that of his successors. Canova himself came to see them in 1815 and, as he wrote to Quatremère the same year, quickly realized that most of the works on which he had based his style had been copies. He characterized the copies as affected, exaggerated, hard, conventional and geometrical in comparison with the 'real flesh, the beautiful nature' of Phidias' creations. But he had only seven years left to live, and the work he had in hand for which models had already been made, together with his advanced age, prevented any change in the direction of his work.

The relative fidelity of sculpture to the classical tradition during the nineteenth century is a reflection of the difficulties of introducing elements of modern reality into a classical form without producing bathos. The dearth of high-quality sculpture in the classical manner after Canova's death may result

partly from the legacy of Winckelmann's theories and of the antiques over which he enthused. These certainly deadened more talents than they inspired, since imitation soon became mechanical. Sculpture, the medium in which the earliest advances of the Florentine Renaissance had been made, the medium which had set the standard for the representation of the human form in paint, feeding the painter in his constant search for solid and convincing models, was about to be left behind by painting. The more adventurous the styles of painting became, the more *retardataire* classicizing sculpture looked by comparison. As painting style became less sculptural, so the sculpture became more painterly. The great sculptors of the nineteenth century, such as Géricault, Degas, Daumier and Rodin, were also painters. None is classical in any sense acceptable to Winckelmann. Their preoccupations are with modernity.

Painting in Napoleonic and Restoration France: classicism and modernity

Problems of modernity and realism occupied French artists during the Napoleonic and Restoration periods, even when their work was superficially classical. Hinted at in the work of David, these problems became explicit in Gros and Géricault, and contrast somewhat with the antiquarian aspirations and splendour of Paris as a consular and then an imperial capital second only to Rome, which was in French hands from 1809 to 1814.[755,770] Napoleon was, reportedly, no judge of art, but he saw how the arts could help his political advancement. Helped by advisers, particularly Vivant Denon,[756,765] he commissioned painters to depict his battles and noble deeds, supposedly with the example of Poussin in mind. He reputedly took an engraving of Poussin's *Testament of Eudamidas* with him on his Egyptian Campaign, remarking at one point to Denon, 'After one has seen this austere composition, one cannot forget it; Denon, *our* school of painting has grown stale; we must being it back to the ways of Poussin . . .'[773]

The planning of Paris after the Revolution,

the education of artists and the glorification of the ruler were all carried out on a grandiose scale.[754] Paris cast off its medieval air (a process suggested by the architect Pierre Patte in 1764 and partly begun in the seventeenth century) as its streets were punctuated by fine squares and triumphal arches, and churches and public buildings were erected in a classical style. Sculptors were encouraged to show parallels between Napoleon and antique rulers, and the great man's progress was monitored on medals, just as Louis XIV's had been.[768] Furthermore, a conscientious Emperor must be a connoisseur: Napoleon enriched Paris with spoils from his conquest of the whole continent. When, for example, on 27 July 1798, works of art from Rome, central Italy and Venice reached the capital, they were paraded through the streets as in an antique triumph,[756] like Sulla's trophies from the sack of Athens, or Constantine's vaunting of the treasure from Jerusalem. Most of the works of art were in packing-cases, but the bronze horses from St Mark's, Venice, were on view: a palpable reminder of Constantinople whence the Venetians had taken them. One aim of the looting was to increase the number of examples for artists to study, and that aim was pursued with native French examples as well when the Musée des Monuments Français was opened in 1795. Ecclesiastical properties had come into state ownership in 1789, and the museum received from churches and monasteries sculpture and works of art dating from the Middle Ages to the eighteenth century. Paintings from the same sources went to swell the old Royal Collections and formed the National Museum of the Louvre, which opened on 10 August 1793.[759] The Musée des Monuments Français was open on three days out of every ten for the general public, and on the other seven for artists alone.

The didactic aim of the Musée des Monuments Français, and the political tint of that didacticism, were seen on the first page of the catalogue: 'Cultivation of the arts enlarges a people's commerce and prosperity, purifies its morals, makes it more gentle and more ready to follow the laws by which it is governed . . .' The earlier ages of art were included largely as an object-lesson in what to avoid. The Direc-

Géricault: Raft of the Medusa, 1819. Paris, Louvre.

tor, Alexandre Lenoir, explained that the subdued level of fighting in the medieval section represented the level of culture when 'our school of art was sunk in the most frightful barbarity'; it was intended to convey 'that magic by which beings filled with superstitious fear were held perpetually in a state of weakness . . .'

Yet whatever the original intention of this museum, it is clear that confrontation with their medieval heritage inspired rather than revolted French artists. Among the paintings, the stylistic range of the looted works of art was similarly wide, from Raphael to Rubens, from the Italian primitives and Jan van Eyck to Tintoretto and Dutch landscape. Perhaps David's huge canvases on Napoleonic themes reflect some enthusiasm for the Baroque works on show—and an awareness that the *numen* of Napoleon could not be depicted within the strict neoclassical formula of *The Oath of the Horatii.* We might, indeed, see in Delécluze's dictum of the four manners of David (the *Horatii,* the *Marat,* the *Sabines* and the *Coro-*

nation of Napoleon) a way of clarifying the undoubted stylistic confusion of the whole Napoleonic period. The vogue for death and suffering, for strange and minutely detailed settings, for deep shadow,[735,760] for the imagination rather than the reason—all these can be traced in David, but usually restrained by the simplicity of his compositions and the light of his reason. Thus a comparison between Géricault's *Raft of the Medusa* of 1819 (Louvre) and David's *Brutus* shows many points of similarity. The divergence is in intention: between the anecdotal horror of suffering innocents cast adrift on the sea of life, and the self-willed sacrifice of family needs to the good of the State; between a group of people to whom things just happen and a man who controls his own fate. Leaving aside problems of Géricault's political awareness in the choice of that theme, and his undoubted attempt to make a serious humanitarian point, we may focus on his fascination with the macabre and perhaps judge that it perverts the monumental aspirations of that gigantic work.[764] Géricault's

Gros: Napoleon on the Battlefield of Eylau, 1808. Paris, Louvre.

works, whatever their sources and however apparently classical their compositions (for example, his riderless horse-race scenes), possess an animal power which, together with his interest in abnormal physical and psychological states, removes them from the sphere of the rational, and reflects several of the preoccupations of Romanticism, signs of which are discernible in French painting long before Delacroix.[757,772]

Ambivalence is also a characteristic of the work of Gros, a pupil of David. In spite of his avowed position as upholder of his master's classical style,[766] his depictions of Napoleonic battles and other propaganda scenes did not permit a totally idealistic rendering.[767] Or, rather, Gros sought to mix the traditions of a Lebrun (who painted many battle-scenes for Louis XIV) with real-life scenes of the horrors of war which he himself witnessed as an artist commissioned to follow the army. Unlike Leonidas at Thermopylae, Napoleon's armies did not fight in heroic nudity under a Greek sky. Gros therefore attempted to balance the ideal hero[761] of his antique bas-relief settings[769]

with a decided appetite for horror. Clearly, Gros needed the stimulus of real events[775] to fire his imagination. Unfortunately, his professorship at the Ecole des Beaux-Arts from 1816 entrenched the drier side of his classicism, as shown in his decorations for the cupola of St-Geneviève of 1814–24, with Louis XVIII quickly substituted for the intended Napoleon. These earned him a baronetcy from Charles X—an indication of official acclaim— and the telling comment of Gérard that 'c'est plus Gros que nature'. He was referring to the work's inflated rhetoric and to the significant lack of those qualities of *reportage* which had brought his otherwise highly stylized battle scenes to brilliant life. Gros's style remained stiff, and the poor reception of his *Acis and Galatea* and *Hercules and Diomedes* at the 1835 Salon probably caused him to commit suicide.

How much of the change of style during the first decades of the century was due to official pressure? We know that Napoleon, perhaps taking his cue from Denon, hated allegories. He is reported, in front of David's *Sabines*, to have said that he had never seen his own soldiers

fight like David's, and then offered to take David on campaign to see some action. Denon himself, in 1805, declared that his intention was 'to turn the arts particularly toward subjects which would tend to perpetuate the memory of what has happened these last fifteen years', and he set about achieving that aim by bureaucratic means.[765]

Even more indicative of the ambivalence of styles during this period is the career of Girodet.[753,771] He was much acclaimed by Gros, and when he died in 1824 it was the funeral discourse pronounced by Gros which predicted 'the imminent collapse of painting and sculpture, if students did not choose as models, from among the torrents of painting drowning the Salon, the works of David and Girodet'. If we bear in mind the admiration of Delacroix and Géricault for the work of Gros, Girodet's *The Funeral of Atala* or *Endymion Asleep* (1808 and 1790/1 respectively, both Louvre) seem too delicate, sensuous and sentimental to please the classicists and insufficiently robust for the romantics.[776] Girodet's work is classical in form, but romantic in atmosphere, sentiment and subject-matter; although he wrote from Italy in 1790 to his friend Gérard that he was more impressed by Rubens's Medici Gallery than by any painting in Italy, his works are almost transpositions of Canova into paint. In 1791 he asked Gérard to send him Rollin's *Histoire Romaine*, Plutarch, his print of Poussin's *Pyrrhus*, two landscapes by Poussin, 'and my Etruscan objects'.[758]

The cracks in the façade of classicism became explicit after the fall of Napoleon and the withdrawal of David to exile in Brussels (Rome was refused him). David's politics made him *persona non grata*, and his paintings were reviled by critics who saw them as stiff, academic and lifeless. A classicist was, for Delécluze in 1827, someone who 'worked mechanically from antique statues'. David himself, commenting on the Salon of 1808, had predicted the course that painting would take: 'in ten years all study of the antique will be abandoned . . . all those gods and heroes will be replaced by knights and troubadours singing underneath their lady's window at the foot

of some old castle'. Certainly, the restored monarchy had some taste for the antique, but French history and scenes of modern life came strongly into favour. The great Napoleonic history pieces were, needless to say, hidden. Paintings of subjects from the antique dropped steadily in number until 1827, and then much more sharply during the reign of Charles X (1824–30), who preferred modern subjects. Jon Whiteley, in a thesis which documents the fortunes of antique subject-matter in France at this time,[805] has pointed out that antique themes declined not because of the rise of Romanticism (cf. Delacroix's remark that David was 'the father of the modern school') but because David's own pupils, ensconced in positions of power in the Institut, had abandoned them. Official commissions, however, with their emphasis on classicism, continued to be as important as ever for an artist's livelihood. The journalist Auguste Jal reminded his readers in 1828: 'The *Salon* is as political as the elections . . . the wishes of Church and Government can be clearly seen in a dozen paintings and statues . . . ; artists are independent, but all hope for work from Government or Prefecture.'[762] Under Charles X it was the Ministry of the Interior which dealt with orders for church work, and the Direction des Musées Royaux which selected works from the *Salons* for distribution to the provinces; this was a policy of centralization which was to kill off provincial schools of art and, by the examples the Direction sent, to set the standards for public decorative commissions for the rest of the century.

Government policy towards art, and an assessment of the state of the market, was set out in an internal memo of 1816,[763] which deplored the recourse of painters to contemporary history showing people in contemporary dress: '. . . the coming generation has, indeed, become discouraged and abandoned the historical manner, the sole one worthy of the protection of the Government, and given itself almost exclusively to the anecdotal manner . . . [Contemporary dress] does not allow the painter to develop the grand principles of art . . . the study of design is neglected . . .'

The document went on to say that genre painting, which did not have the moral bias of history painting, must be discouraged by making sure that students who won the Prix de Rome should receive commissions for history paintings, and those who did not win the prize should nevertheless have the chance to do something for the Government, for, 'having no renown, [such artists] will have no pretensions, and whatever price is paid for their work will be regarded by them as fair . . .'

Ludovic Vitet saw the relationship between classicism and the government as a vicious circle and described it in an article written in 1825 entitled 'On independence in matters of taste: the intervention of the Government':

The coalition of classicism and power is in no sense a chimaera, for the one puts into practice what the other has preached in theory. The one says: Only those who follow my lessons have good taste. And the other: Only those whom I authorise have talent. From both sides, it is an apology for monopoly . . . Our statesmen are, basically, neither classic nor romantic . . . but they have such sympathy with routine and immobility that it seemed totally natural to them to organise the fine arts exactly as they were before the Revolution . . .[778]

Not that the *pensionnaires* at the French School in Rome were as pliant as the Government might have thought. During the Directorship of Guérin (a staunch classicist) between 1823 and 1828, the students gave him a difficult time. One reason for their objections must have been the severe classical line which Guérin, under the inspiration of Quatremère de Quincy, tried to adopt. Quatremère was one of the most powerful men in the artistic world. Appointed Perpetual Secretary to the Academy of Fine Arts on its reconstitution in 1816, his position assured him of power over policy,

as almost twenty-three years of correspondence demonstrate. For example, he wrote to Guérin in 1823: 'It is evident that when the King keeps students . . . it is with a view to training them to serve the government . . . ancient Rome and, above all, modern Rome, offer many examples of monuments suited to French usage.'[691] He was referring to students of architecture who were, of course, even more reliant on official favour.

Our perspective on nineteenth-century art, and our estimation of who was or was not a good artist, is radically different from that of Quatremère. Modern opinion sees artistic 'progress' at that time as in the hands of the rebels, those men who were anti-Establishment because their work was rejected, anti-museum because the museums perpetuated 'good' art, and anti-*Salon* because the *Salons* were rigged by official taste.[774] From such an ahistorical perspective, it is all too easy for the modern critic to see works like Delacroix's romantic nightmare, *The Death of Sardanapalus*,[777] as an example of a new and vigorous style in the face of an effete classicism. Yet Delacroix's position was not so clear-cut. He was wounded by the scorn cast on the *Sardanapalus*, which is a history painting in the grand manner, with numerous antique and Davidian references. (He might have been partly inspired by David's *Funeral of Patroclus*, now in Dublin.) Although we must separate his theory from his practice, as in the case of Sir Joshua Reynolds, the fact remains that he admired Raphael as the greatest of all artists (and wrote an essay on him), revered Mozart, and detested Berlioz and, later, Wagner. He saw North Africa as the nearest society corresponding to that admired by Homer—Man in a state of nobility and nature—and painted as many works on antique themes as his rival Ingres. He stands with his great contemporary as a symbol of the confusion in the French art world in the first half of the nineteenth century.

12

Ingres and the Subversion of the Classical Tradition

In a century of rapid artistic change, it was the theory, the practice and the example of Ingres which defended and maintained the classical tradition. His heroes were Raphael and Poussin, his concern was always with the ideal and never with the realistic, and his position in the art world was diametrically opposite to that of his great rival Delacroix.

Such is the orthodox view of Ingres which, whilst admitting that he is a child of his Romantic age, claims a direct connection between his art and the style of the masters of the classical tradition—as Ingres himself often did. My purpose is to demonstrate how far removed is his whole attitude to art from orthodox classicism, and to suggest that his achievement (let alone that of his contemporaries) shows that the very idea of a classical tradition had lost its meaning by the mid-century. As is the case with Delacroix, Ingres's principles of art are often very far from his actual practice; we must beware of attributing too much importance to his opinions, and prefer to rely instead on the opinions of his contemporaries and on the evidence of the paintings themselves. 'He happened to be born with very limited imaginative powers, yet with very great artistic gifts', as Agnes Mongan has put it:[794] this accounts for the dichotomy, particularly if we recall his notebooks, in which, rather than moulding his own theory of art, he laboriously copied out extracts from improving authors. The same applies to his visual sources.[795,799] Delacroix's characterization of his art (seen at the Paris Exposition Universelle of 1855) as 'the complete expression of an incomplete intelligence' is rather more than an unkind quip, for it is a judgement on the nature of Ingres's art which

we can extend by reading Baudelaire's account of the same exhibition. Admittedly the champion of Delacroix, Baudelaire's criticism of others is nevertheless both fair and acute, as we can see by reading his review of an exhibition ten years previously at the Bazar Bonne-Nouvelle. This had shown important works by David and his school, and was an act of rehabilitation, as it were, of the classical school.

Baudelaire, in his review of the Exposition Universelle, writes of an impression gained, he claims, by many people in the 'sanctuary' reserved for the works of Ingres: 'an impression, difficult to characterise, and which, in the use of strange proportions, in the feeling of unease, of *ennui*, of fear, makes one think vaguely and involuntarily of the debility caused by a lack of oxygen, by the atmosphere of a chemical laboratory, or by knowledge of some other-worldly existence . . .' He sees Ingres's figures as automata, not human beings, and believes that the undoubted power of his art has in consequence a sickly quality about it:

> . . . it would be puerile not to notice in his work a lacuna, a loss, a withering of the vitality of the spirit. The imagination which succoured those great masters [David etc.] when they strayed into their academic gymnastics—that queen of faculties has disappeared . . . I know his character well enough to believe that . . . this represents an heroic immolation on the altars of those faculties which he sincerely considers more grandiose and more important than that of the imagination . . .

Ingres's dominant characteristic Baudelaire

believes to be 'will-power or, rather, enormous abuse of will-power', and uses this idea to explain the unchanging nature of his art: 'that which he is, he has been from the beginning. Thanks to his internal fire, he will remain thus until the end. Since he has not progressed, he will not grow old.'

This brilliant characterization is relevant almost to the whole of Ingres's achievement, and can help us to place his art in that current of primitivism which we have seen gaining strength in the arts as in literature since the middle of the eighteenth century. If Delacroix found some new Greeks and a new Homeric ideal in North Africa, then Ingres took his inspiration from medieval as well as from ancient history, and developed a linear style which could scarcely be called a sublimation of the manner of Raphael. He himself believed otherwise:

Looking through Montfaucon, I became convinced that the history of France . . . would be a new vein to exploit . . . beautiful heads, bodies, attitudes and gestures are of all time . . . From which I conclude that I should take this as the best road, and content myself with exploring the Greeks, without which there is no salvation, and amalgamate them, so to speak, with this new genre. In this way, I can become an adept spiritual innovator, and give to my works that rare beauty found hitherto only in the works of Raphael.[789]

Montfaucon's book was not the *Antiquité expliquée . . .*, that repository of illustrations of antique objects, but rather the *Monuments de la monarchie française* (1729–33), a pioneering volume on the French Middle Ages matched by this time by the great detail of Lenoir's catalogue of the Musée des Monuments Français (6 vols, 1800–3). That institution, and the wide range of pictures looted by Napoleon and displayed in Paris, allowed Ingres to develop a primitivism which invaded all the genres in which he worked (compare the selective primitivism of Flaxman, or David).[779,793]

Ingres, always an awkward provincial in the sophisticated Parisian art world, won the Prix de Rome in 1801 with *The Ambassadors of*

Agamemnon at the Tent of Achilles (Paris, Ecoles des Beaux-Arts). This frieze composition with Poussinesque landscape has a very flat perspective and vigorous linear forms which imitate the outline style of Greek vase painting which his master, David, had tried with the *Sabines*. David's intentions were explained, in a booklet of 1799: 'I want to make something which is pure Greek; I feed my eyes on antique statues, and I intend to imitate some.' In his frieze Ingres did likewise, presenting the spectator with a collection of statue-like figures, some taken from the life, some from antiques, in a work of carefully researched antique detail.[783,797] That this picture was admired by Flaxman when he visited Paris in 1802 is no more surprising than the fact that Ingres used Flaxman's prints for several of his compositions.

Ingres was to receive little admiration for his work of the next five years, and public hostility made him, perhaps because of his awkwardness, adopt an over-zealous public mien which must have aggravated the factitious opposition of classic to romantic. The *Bonaparte at Liège* (1803–4, Liège), and particularly the *Napoleon on the Imperial Throne* (1806, Paris, Musée de l'Armée) were regarded by the critics as archaic. Similar horror greeted the three portraits of the Rivière Family, shown at the *Salon* of 1806. 'Gothic', 'like Dürer', 'like Van Eyck' were the commonest epithets and, indeed, they are fully justified. The landscape background to both the *Mademoiselle Rivière* and the *Bonaparte at Liège* is Early Netherlandish in style, and the enamel brightness of tone and profusion and intricacy of detail all point to sources that have little to do with Raphael and his rounded forms occupying airy space. Certainly, the *Napoleon on the Imperial Throne* is necessarily exact in detail, for it depicts the Emperor in his robes. Certainly, the arrangement of figure and throne reflects Ingres's interest in one of the most famous statues of Antiquity, the colossal chryselephantine statue of Zeus in his temple at Olympia. This work of Phidias was known only from reconstructions made from ancient literary accounts: Ingres would have sought advice from his friend Quatremère de Quincy,

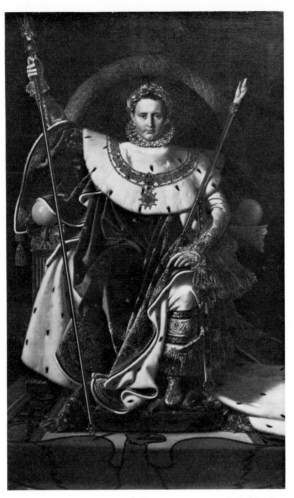

Ingres: Napoleon on the Imperial Throne, 1806. Paris, Musée de l'Armée.

whose archaeological studies are also the source for Ingres's stylistically similar *Jupiter and Thetis* of 1811 (Aix-en-Provence, Musée Granet) which does represent the lord of the gods. Yet is the *Napoleon*, with its Byzantine hieraticism and geometrically rigid frontality, a logical descendant of *The Oath of the Horatii* and hence of the tradition of Raphael and Poussin? Baudelaire, reviewing the exhibition at the Bazar Bonne-Nouvelle in 1846, remarked that the *Stratonice* (1840) would have astonished Poussin, that the *Grande Odalisque* (1814) would have tormented Raphael, and that Ingres's style of painting was as flat as a

Chinese mosaic. The works mentioned above demonstrate that such qualities were in fact evident in his art from the beginning.

Ingres increased the range of his visual and literary sources during the course of his long stay at the French Academy in Rome, from 1806 to 1824. Another important commission during this period was his immense *Romulus, Conqueror of Acron* (1812, Paris, Ecole des Beaux-Arts) which celebrates Napoleon once more. He was expected to enter Rome in triumph that year as Romulus (likewise the founder of a civilization) had done. The work, closely related in some details and in general

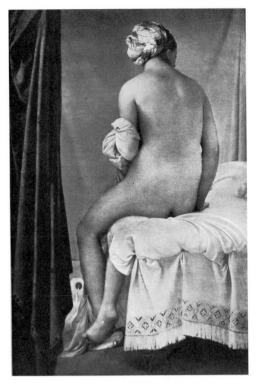

Ingres: The Bather of Valpinçon. Paris, Louvre.

form to the *Sabines* of David, dispenses with oil paint in favour of the flatter and cooler tempera, which accentuates the reduced space and the outline frieze arrangement of the massive figures. Yet the majority of the works executed in Rome (and in Florence, where he was from 1820 to 1824) are not in the least like the work of David. From Ingres's prize work, we might reasonably have expected a continuation of the austere ideal of the male nude as advocated by Winckelmann and as seen in Flaxman's outlines. Instead, he preferred to look at the work of Canova, and to combine that artist's frigid sensuality with almost photographic detailing. The realism of such details, which make us believe we can touch, for example, *The Bather of Valpinçon* (1808, Louvre), argues with the sinuous abstraction of the lines and the equivocal space construction. The source for this work is Canova's *Venus Italica* rather

than Raphael's *Graces* in the Farnesina. Its style, however, is almost anti-Renaissance: the lack of any firm ground on which the composition can build, and the rail-less curtain on the left, help to suspend the figure in silent space—or, rather, to make of it a pattern the lines of whose body and the realism of whose flesh evoke sensuality, but whose pose frustratingly conceals it. In *La Grande Odalisque* (1814, Louvre) the same characteristics are in evidence. Like the later odalisques, and like *The Turkish Bath* of 1862/3, this work evokes a romantic exoticism because of its harem overtones, but its formalism, linearity and air of detachment (the *ennui* of which Baudelaire writes) prevent that evocative participation by the spectator which is an essential feature of Romanticism. And it is the line, not the coloristic description of sheen and texture, which is the vehicle of Ingres's sensuality. To find the sources of the work, we should need to examine reclining figures from Antiquity to Giorgione, Michelangelo, Parmigianino and Bronzino. Only the Mannerists approached the complications and peculiarities of physiognomy which Ingres describes in his sweeping arabesques. If we follow any of the lines in *La Grande Odalisque*, we find others which echo them and which emphasize surface pattern at the expense of depth. The mattress is flattened by Ingres's signature into a two-dimensional signboard; the drapes hang from nowhere; the nude, not of this world, is suspended in luxury like *The Bather of Valpinçon*.

The vision which Ingres offers us in his paintings of female nudes underlines his idealism which, as we have seen, subsumes realistic details quite happily. He was violently opposed to all that works like *The Raft of the Medusa* represented: 'Is that what sane, moral painting is about? . . . Art should be concerned only with beauty . . .'[790] His hero was, naturally, Raphael, 'who laid down the eternal and incontestable limits of sublimity in art'. Ingres was captivated by the power of his drawing and the harmony and balance of his compositions. Yet his works look very different from those of Raphael, even when they are close imitations. This is partly because Ingres always drew from the living model

where possible, if necessary in the pose of the source,[800] and partly because his imitation is tinged with that admiration for Flemish detailing which he himself had admitted as early as 1806. With his standard academic belief that 'by becoming familiar with the inventions of others one learns to invent oneself' he attempts to couple the imitation of the masters of the past with a studio practice which tends towards exactitude of realistic detailing. The nature of his relationship to Raphael can be seen in a Government commission for *Christ giving the Keys to Peter* (1820, Louvre) and another for *The Vow of Louis XIII* (1824, Montauban, Cathedral). The former derives from Raphael's *Tapestry Cartoons*, the latter from a combination of *The Madonna of Foligno* and *The Sistine Madonna*. Neither is in any sense a transcription or a copy of either Raphael's drawing style or his characterization.[780] For *The Vow of Louis XIII*, Ingres has borrowed the idea of heavenly and earthly realms, but instead of suggesting a forward movement, his pyramid is in icy stasis. The holy figures avoid the world of Louis and the *putti* by deliberate distinctions of drawing style, composition and colour—high against low, soft against brittle, warm against cold—and exude 'an unforgettably arrogant and sensual majesty'. Much to Ingres's surprise, this work of historical realism was well received at the *Salon* of 1824; it attracted praise as extravagant as the odium heaped upon Delacroix's *Massacres at Chios*.[802] *Christ giving the Keys to Peter*, commissioned for the church of Trinità dei Monti in Rome, remained there until 1842, although Ingres himself wished it to be shown at the 1827 *Salon*. It is even more assertively realistic than *The Vow of Louis XIII*, and the gentle sentiments and graceful poses and draperies of Raphael are replaced by an uncompromising frontality, a forceful characterization and a monumental stiffness of poses and drapery. In the words of Jacques Foucart, the work is 'd'une fadeur terriblement saint-sulpicienne'—that is, it looks forward to the painstaking historical realism of the second half of the century which, as we shall see, Ingres had a large hand in creating.

The Apotheosis of Homer, which hung in the

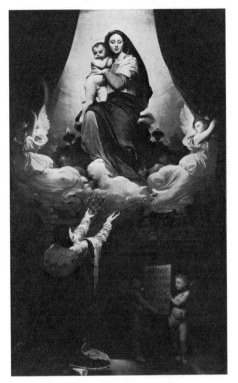

Ingres: The Vow of Louis XIII, 1824. Montauban Cathedral.

same 1827 *Salon* as Delacroix's *Death of Sardanapalus*, is the largest of Ingres's Raphaelesque paintings, but is no nearer to pastiche than any of the others. This modern version of Raphael's *Parnassus* not only proclaimed the stylistic values of the classical tradition but also tried to equal the iconography of *The School of Athens* in its reunion of great men of ancient and modern times in the realms of literature and the arts.[781,798,801] Only Raphael, his hand held by Apelles, is placed with the full-length figures of the ancients. Dante, befriended by Virgil, appears three-quarter-length, but all the other moderns are shown only half-length. Ingres expended much thought on who should figure in this programme for his contemporaries, and from about 1840 he was planning an extended version which would explain the tradition further. In the first version, he weighed Goethe and Tasso in the

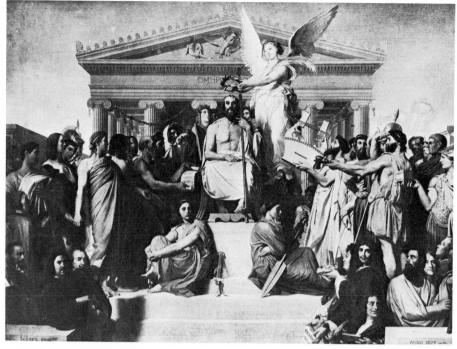

Ingres: The Apotheosis of Homer, 1827. Paris, Louvre.

balance, and found them wanting: they were replaced by Mozart and Chénier. In the second version, which got no further than a drawing, Shakespeare is excluded, but David is there, Winckelmann, and the young Ingres himself. If the iconography of *The Apotheosis of Homer* approximates to Raphael's intentions, the style is very different; it is hieratic in its stiff organization, correctly realistic in its archae- ological research. Raphael might have been unaware that Plato and Aristotle could not have known barrel vaults similar to those in *The School of Athens*; conversely, Ingres's work always makes a virtue of historical accuracy. Perhaps this aspect of his work parallels the contemporary ideology of the Romantic theatre: Stendhal's *Racine et Shakes- peare* (1823/5) protests against the rarified stylization and the conventions of the unities of time, place and action adopted by Racine and advocates the techniques of Shakespeare which, because they conjure what Stendhal calls 'perfect illusion', can bring a play to life

for a nineteenth-century audience. In paint- ing, as evinced by Stendhal's comments on the 1824 *Salon*, such an attitude implied oppo- sition to the classicism championed by De- lécluze, which he characterized as stiff, heavy and lacking in imagination: 'What are antique bas-reliefs to me? Let's make some good modern painting.' By 1828 even Delécluze was forced to admit that the momentum of Dav- idian classicism had been dissipated, and that 'for several years now, in France, the word "classic" has been applied to every painter without imagination who makes it his task to imitate mechanically antique sculpture or the works of the sixteenth-century masters.'

The problem lay in finding a manner suit- able for history painting now that the types seen in the works of David were discredited. It has been affirmed that 'apart from Delacroix, the French Romantic movement failed to pro- duce a single painter of stature because it never managed to evolve a distinctive historical style'.[804] It was, in fact, to be Ingres to whom

some critics looked in the late 1820s and the 1830s because they believed that his art, being neither classic nor romantic, could provide just such a distinctive historical style. His manner was patently different from that of Delacroix, and it may be that he felt a certain estrangement from David who, in 1806, had described his work as German and Gothic, and not like that of Raphael; certainly, he left his master out of the first version of *The Apotheosis of Homer*. David's remark, and his prediction already quoted that 'in ten years . . . all those gods and heroes will be replaced by knights and troubadours' was fulfilled in a series of paintings which Ingres executed between 1815 and 1825. These included subjects such as *Francis I at the Deathbed of Leonardo da Vinci* (1818, Paris, Petit Palais) and *Paolo and Francesca* (1819, Angers), and formed part of a *style troubadour*[785] which had previously aroused interest in the later eighteenth century in both literature and art. Ingres joined medievalism of style to medievalism of subject-matter to produce works which might reasonably be called genre pieces, since they lack the high purpose and moralistic tradition of the classical history piece.

Ingres also turned his interest in historical realism in the direction of antique subject-matter. The most influential painting in this mode is the *Stratonice* (1840, Chantilly), commissioned as a pendant to Delaroche's *Assassination of the Duc de Guise*, and painted during Ingres's Directorate at the French Academy in Rome. It is minutely detailed, as archaeologically correct as he could make it, and sharply linear; Ingres called it 'my big miniature'. When it was exhibited in Paris in 1840 some critics hailed it as a successful attempt at blending archaeological accuracy with historical subject-matter. One commentator welcomed Ingres as the man who had rejuvenated art, and, rather ominously, noted that 'in the past a painter read the poets: now he must translate the antique learned commentaries'.[805]

Such a remark emphasizes the impact made by the *Stratonice*, and the gulf which separated it from works like *The Testament of Eudamidas* or *The School of Athens*. From the grand generalization of the classical tradition to the intricate realism of the *Stratonice*, from the morality of the former to the picturesque *troubadour à la grecque* ('Greek medievalism') of the latter is a distance too great to be explained away by positing a slight change of direction in classicism itself, particularly since the work tells such a touching tale of finally requited love. That distance is a function of the vogue for a different kind of history painting and of the development, the increased pace and the public popularity of archaeological scholarship in the earlier nineteenth century.[787,788] I have already outlined the interest of painters in modern history, the Middle Ages and the primitive past that was prevalent from the time of Napoleon onwards. Does not the realism of the *Stratonice* merely transport a genre subject into the distant past to produce a work of what might be called archaeological genre? The contemporary attraction of this picture, which would have delighted Quatremère de Quincy even if it would have shocked Poussin, is to be seen in the popularity of the archaeological style among Ingres's pupils and other academically-minded artists in England as well as in France. How, in a century which glorified in the achievements of its historical scholarship, could artists who wished to paint the antique possibly make do with the traditional classical manner?

The first half of the nineteenth century is a period of great confusion in the arts. That confusion is by no means clarified by dividing artists and literary men into classic and romantic camps, for few are so considerately unsubtle as to belong wholly to either side. Just as Delacroix has elements of classicism in his style and opinions, so Ingres is in a similarly equivocal position. The main reason for the confusion of the period is perhaps the widening of permissible sources of inspiration, whether geographical, historical or spiritual, some of which we have traced to the middle of the eighteenth century. That sense of difference and interest in history which had been such a powerful stimulus in the production of a classical style in the art and literature of the Renaissance was, from the eighteenth century, to exert a pressure toward modernism. The Quarrel of the Ancients and Moderns had

shown that the ancients were by no means the only source of knowledge or, indeed, of aesthetic achievement. Anthropologists travelled over the face of the globe and saw very different civilizations from which the eighteenth century, in love with the idea of the primitive, was willing to learn; evidence brought back showed that the Eastern civilizations were at least as sophisticated as those of Greece and Rome. Montesquieu, in his *Lettres Persanes* of 1721, had two Persians examine French society as if France were, herself, an ethnographic *objet trouvé*. In his *L'Esprit des lois* (1748) he expounded a similar theory of relativity. Indeed, Descartes and Pascal had preceded him in this by a hundred years. In the field of art, Greece and Rome held their attraction until the beginning of the nineteenth century, as a telling anecdote about Ingres makes clear. One day Jules Laurens, a musician, was talking to Ingres about Persian music as he had heard it at Isfahan:

> . . . I explained as best I could the irregularities and mistakes which, to our Western ears, its rhythms and tonality possessed. I explained that Persian music had its own method, its own aesthetic, its own virtuosity and its own classicism—its own emotion and charm . . . Such words made Ingres stiffen into recalcitrance, then become troubled and piteously uneasy. Almost in tears he exclaimed, 'Then where does that leave our sensations and our scale of values? Where are we in relation to Bach, Gluck, Mozart and Beethoven? Are they deceiving themselves and us, or are we all deceiving ourselves?' . . . And he remained dispirited . . .[803]

Ingres apparently felt his whole view of life and of the nature of art to be under attack. At the very least, his remarks show the narrowness of his mind and the naïveté of his dependence upon the classical tradition which he believed he was defending in practice as well as in theory. Préault's characterization of him as 'a Chinaman astray amongst the ruins of Athens' strengthens the irony of Ingres's alarm at the possibility of other, equally valid aesthetic

systems. By a possibly subconscious recourse to styles of art before Raphael, and to aspects of mannerism so evident in his portraits, Ingres subverted the classical tradition by seemingly misunderstanding its nature and aims—as a Chinaman might have done. Classicism displays a healthy mind in a healthy body within an imagined mathematically constructed space. Ingres knows nothing of aerial perspective, writes Baudelaire in his review of the exhibition at the Bazar Bonne-Nouvelle, and he continually emphasizes the aura of debility which surrounds his figures. Classicism (and, in his theory, Ingres himself) vaunts drawing as the probity of art; but Ingres's paintings are, writes Baudelaire, as flat as Chinese mosaics, and his love of colour 'like that of a couturier'. In a classical painting, line describes and delimits form; in Ingres's works, the line has its own vigorous vitality independent of the form, the strength of which it saps.

In his *Salon de 1846*, written a year after the exhibition at the Bazar Bonne-Nouvelle, Baudelaire surveys with frustration and distaste the chaos of contemporary art, which he attributes to a 'debilitating and sterile liberty', to self-doubt, and to a lack of divine naïveté.[792] Only strong artists like Delacroix and Ingres are capable of keeping their heads above water; the rest, like monkeys,

> are the republicans of art, and the present state of painting is the result of anarchical liberty which glorifies the individual, no matter how feeble he may be, at the expense of the group, that is to say the schools of art . . . Individuality, that jewel of small price, has devoured collective originality . . . The painter himself was killed painting . . .

From our twentieth-century perspective, we read Baudelaire's words with the knowledge of the present emergence of Courbet and Realism—a development nearly as distasteful to Baudelaire as it was to Ingres. Courbet was the first artist to paint what had hitherto been considered genre subjects on a scale large enough to endow them with the monumentality and significance usually reserved for history paintings. The trend toward the accep-

tance of any subject-matter as worthy of the artist's brush had begun even before the Romantics, but it was Courbet's example which pointed the way toward an art which was popular, relevant and modern. With the complex demands of the art market, and the gradually changing tastes of patrons, how could classicism maintain its position? Embalmed in the aspic of the academies, and preserved by official commissions, classical history painting continued, but became more and more out of touch with modern trends.[784] History painting tended to descend to the level of high anecdote and picturesque detail to ease its acceptance in the market place. The success of Gérôme, Delaroche or Bougereau proclaims their unerring touch, but their works are not classical in any traditional sense. Classical elements, of course, are to be found in the work of many nineteenth- and indeed twentieth-century artists, who continued to find inspiration in the themes and motifs of Greece and Rome.[786,796] Artists like Puvis de Chavannes, Seurat, Degas, Cézanne and Picasso, however, no longer partook of an unbroken classical tradition which formed the model and the *raison d'être* of their work. Today we are no longer willing to accord a hierarchy of excellence to artistic objects: an African mask would seem to deserve sympathy and reverence equal to that devoted to a madonna by Raphael. As a refuge from self-doubt, we reject nothing. The origins of such an attitude are to be found in that broadening of intellectual horizons which is a feature of eighteenth-century rationalism.[782,791]

The classical tradition cannot assimilate such free thought, because it is firmly wedded to Renaissance forms of art. Did the Renaissance in Italy ever make an effort to understand and assimilate those very different forms of art in the rest of Europe, let alone in the East or the Americas? Even Dürer seems to have considered the treasure of Montezuma as a collection of curiosities, but not as art. Self-confidence such as that evinced by Vasari in his *Lives* is an essential element in the security and vigour of any tradition, as Baudelaire recognized. In the case of the classical tradition, it was sustained by a belief in the values of Graeco-Roman civilization which survived the translation from Renaissance Italy to France in the seventeenth century and was indeed strengthened by an authoritarian ardour. A last glorious revival on a European scale preceded collapse in the nineteenth century under the pressure of more eclectic intellectual, emotional and aesthetic values.

Bibliography

The asterisks and numbers prefixed to certain items in the Bibliography are explained in the Foreword, p. 8. The following abbreviations have been used:

AAF	Archives de l'art français
AB	Art Bulletin
Acts	Acts of the XX International Congress of the History of Art, 3 vols, Princeton, 1963
Akten 1964	Akten des 21 internationalen Kongresses für Kunstgeschichte in Bonn 1964, 3 vols, Berlin, 1967
AQ	Art Quarterly
BM	Burlington Magazine
BSHAF	Bulletin de la Société de l'Histoire de l'Art français
GBA	La Gazette des Beaux-Arts
IHA	L'Information d'Histoire de l'Art
IMU	Italia Medioevale e Umanistica
JHI	Journal of the History of Ideas
JKHS	Jahrbuch der kunsthistorischen Sammlungen, Wien
JSAH	Journal of the Society of Architectural Historians
JWCI	Journal of the Warburg and Courtauld Institutes
Karl der Grosse	Karl der Grosse, Lebenswerk und Nachleben, 5 vols, ed. W. Braunfels, Dusseldorf, 1965–8
Mitt. DAI	Mitteilungen des deutschen archäologischen Instituts, römische Abteilung
Mitt. KHIF	Mitteilungen des kunsthistorischen Instituts in Florenz
Münchner Jahrbuch	Münchner Jahrbuch der bildenden Kunst
RA	La Revue de l'Art
RAAM	La Revue de l'Art ancien et moderne
Zf.KG	Zeitschrift für Kunstgeschichte

Introduction: What is Classicism?

Battisti, E., 'Classicism', in The McGraw-Hill Encyclopaedia of World Art, New York and London, 1957–68. (Survey with bibliography)

Battisti, E., et al., 'Antique revival', in The McGraw-Hill Encyclopaedia of World Art, New York and London, 1957–68. (Survey with bibliography)

Blunt, A., Artistic Theory in Italy, 1450–1600, Oxford, 1940.

Boas, G. (ed.), The Greek Tradition (Symposium, Baltimore Museum of Art, 1939), Baltimore, 1939. (With papers on archaeology and the idea of classical antiquity, classicism in medieval art, the ancients as authority in seventeenth-century France, etc.)

Bolgar, R. R., The Classical Heritage and its Beneficiaries, Cambridge, 1954. (Learned and detailed; concentrates on literature from fall of Rome to c. 1600)

Bolgar, R. R. (ed.), Classical Influences on European Culture, A.D. 500–1500 (International conference, King's College, Cambridge, 1969), Cambridge, 1971. (Sections on manuscripts, teaching, classical ideas in literature, thought and art)

Bolgar, R. R. (ed.), Classical Influences on European Culture, A.D. 1500–1700, Cambridge, 1976. (Proceedings of 1974 Conference, which tried 'to draw attention to certain obvious gaps in our present-day knowledge ... and to indicate certain topics ... for future research'.)

Fehl, P., The Classical Monument: Reflections on the connection between morality and art in Greek and Roman sculpture, New York, 1972. (Apology for classicism)

Ferguson, W. K., The Renaissance in Historical Thought: Five centuries of interpretation, Boston, 1948.

Gombrich, E. H., Aby Warburg: an intellectual biography, London, 1970. (His concern with 'the after-life of antiquity'. Cf. review by C. Gilbert in Journal of Modern History, XLIV (1972), 381–91, who believes the book gives insufficient attention to the background)

Heckscher, W. S., Imago: a pictorial calendar for 1963: Ancient art and its echoes in post-classical times (The Netherlands Classical Association). (Selective bibliography, and refs for each item. Most useful; parallels Vermeule below)

Highet, G., The Classical Tradition: Greek and Roman influences on Western literature, Oxford, 1949. (Rich in references; thorough index)

Hunger, H., Lexikon der griechischen und römischen Mythologie mit Hinweisen auf das Fortwirken antiker Stoffe und Motive in der bildenden Kunst des Abendlandes bis zur Gegenwart, Vienna, 1953

Kenney, E. J., *The Classical Text. Aspects of editing in the age of the printed book*, Berkeley, Los Angeles and London, 1974. (Partly a history of classical scholarship)

Kermode, F., *The Classic*, London, 1975. (Influence of Virgil and of the idea of Rome)

Ladendorf, H., *Antikenstudium und Antikenkopie: Vorarbeiten zu einer Darstellung ihrer Bedeutung in der mittelalterlichen und neueren Zeit*, 2nd edn, Berlin, 1958. (Very large bibliography divided by subject, and indexed; useful illustrations)

Levin, H., 'Contexts of the classical', in his *Contexts of Criticism*, Cambridge, Mass., 1957, 38–54.

London: Warburg Institute, *Catalog of the Warburg Institute Library*, 12 vols, rev. edn, Boston, Mass., 1967. (Very useful; Vols 9–11 for post-antique art)

* Luck, G., 'Scriptor classicus', *Comparative Literature*, X (1958), 150–8. (Definition via a history of the term 'classic')

Nash, E., *A Pictorial Dictionary of Ancient Rome*, English translation of rev. edn, 2 vols, London, 1968. (Bibliographies per item; Renaissance material cited where useful)

Pfeiffer, R., *A History of Classical Scholarship from 1300 to 1850*, Oxford, 1976.

Reynolds, L. D. and Wilson, N. G., *Scribes and scholars. A guide to the transmission of Greek and Latin literature*, 2nd edn (enlarged), Oxford, 1974.

Rowland, B., *The Classical Tradition in European Art.* (Useful for its illustrations)

Sandys, J. E., *A History of Classical Scholarship*, 2nd edn, 3 vols, Cambridge, 1906ff.

*Secretan, D., *Classicism*, London, 1973. (Useful primer, mainly concerned with literature)

Summerson, J., *The Classical Language of Architecture*, London, 1964.

Tatarkiewicz, W., *History of Aesthetics.* III: *Modern Aesthetics*. The Hague and Paris, 1974. (Commentaries on selected key texts)

Venturi, L., *Storia della critica d'arte*, 2nd edn, Turin, 1964. (With larger bibliography than the English translation)

*Vermeule, C. C., *European Art and the Classical Past*, Cambridge, Mass., 1964. (Indispensable survey of forms and motifs from point of view of a classical archaeologist; review by E. H. Gombrich in *Journal of Roman Studies*, LVI (1966), 259–60)

*Weiss, R., *The Renaissance Discovery of Classical Antiquity*, Oxford, 1969. (Fundamental: a history of Renaissance antiquarianism)

Wellek, R., 'The term and concept of classicism in literary history', in E. R. Wasserman (ed.), *Aspects of the 18th Century*, Baltimore and London, 1965, 105–28. (Well referenced)

Wilamovitz-Moellendorff, U. von, *Storia della filologia classica*, Italian translation from the German, Turin, 1967.

Wittkower, R., 'Imitation, eclecticism, genius', in E. R. Wasserman (ed.), *Aspects of the 18th Century*, Baltimore and London, 1965, 143–61.

Wölfflin, H., *Classic Art*, English translation, London, 1952.

1 Bialostocki, J., 'The Renaissance concept of nature and antiquity', in *Acts*, II, 19–30. (Imitation of nature through imitation of the antique)

2 Gombrich, E. H., 'The style *all'antica*: imitation and assimilation', in *Acts*, II, 31–41. ('Illusion of movement and life' attracted the Renaissance to the antique)

3 Janson, H. W., *Apes and ape-lore in the Middle Ages and the Renaissance*, London, 1952. (287–325: 'Ars simia naturae')

4 *Lee, R. W., *Ut Pictura Poesis. The humanistic theory of painting*, New York, 1967.

5 McKeon, R., 'The transformation of the liberal arts in the Renaissance', in B. S. Levy (ed.), *Developments in the Early Renaissance*, Albany, 1972, 158–206. (Good bibliography)

6 *Panofsky, E., *Idea: A concept in art theory*, English translation, New York, 1968. (Fundamental; reprints essential texts)

7 Trinkaus, C., *In Our Image and Likeness: Humanity and divinity in Italian humanist thought*, 2 vols, London, 1970. (On attempts to define 'the nature, condition and destiny of man within the inherited framework of the Christian faith')

8 Weise, G., *L'ideale eroico del Rinascimento e le sue premesse umanistiche*, Naples, 1961. (Quotation I 126–7)

9 Weise, G., *L'ideale eroico del Rinascimento: Diffusione europea e tramontana*, Naples, 1965. (Sequel to the above; both cite a wealth of examples, fifteenth to eighteenth centuries)

1 Classicism from the Fall of Rome to Nicola Pisano: Survival and Revival

Pagan into Christian

Beckwith, J., *Early Christian and Byzantine Art*, Harmondsworth, 1970.

Beyen, H. G., 'Rome's Bijdrage tot de Ontwikkeling der Bieldende Kunst in het Westen', *Mededelingen van het Nederlands Instituut te Rome*, X (1940), 25–57. (French summary)

Bialostocki, J., 'Encompassing types and archetypal images', *Arte Lombarda* (Studi in onore di G. N. Fasola), 1964, 275–284.

*Gough, M., *The Origins of Christian Art*, London, 1973.

* Grabar, A., *Christian Iconography: A study of its origins*, London, 1969. (Good bibliography)

Kitzinger, E., 'The Hellenistic heritage of Byzantine art', *Dumbarton Oaks Papers*, XVII (1963), 97–115.

Krautheimer, R., *Early Christian and Byzantine Architecture*, Harmondsworth, 1965.

Morey, C. R., *Early Christian Art. An outline of the evolution of style and iconography in sculpture and painting from Antiquity to the 8th century*, Princeton, 1941.

* Oakeshott, W., *Classical Inspiration in Mediaeval Art*, London, 1959. (Richly illustrated)

Springer, A., *Das Nachleben der Antike im Mittelalter. Bilder aus den neueren Kunstgeschichte*, Bonn, 1886.

Swift, E. H., *Roman Sources of Christian Art*, New York, 1951. (Includes architecture)

10 Amelung, W., 'Di statue antiche trasformate in figure di santi', *Mitt.DAI*, XII (1897), 71–4.

11 Buddensieg, T., 'Gregory the Great, the destroyer of pagan idols. The history of a mediaeval legend concerning the decline of ancient art and literature', *JWCI*, XXVIII (1965), 44–65.

12 Dotzauer, W., 'Die Ankunft des Herrschers. Der fürstliche "Einzug" in die Stadt (bis zum Ende des Alten Reichs)', *Archiv für Kulturgeschichte*, LV (1973), 245–88.

13 Fohlen, C., 'Connaissance et utilisation des tombes antiques pendant le haut moyen age', *Mélanges de la Société toulonnaise des études classiques*, II (1948), 179–93.

14 Grabar, A., *The Beginnings of Christian Art, 200–395*, English translation, London, 1967.

15 Haufmann, G. M. A., *The Season Sarcophagus in Dumbarton Oaks*, 2 vols, Cambridge, Mass., 1951.

16 Kantorowicz, E. H., 'The king's advent', *AB*, XXVI (1944), 207–31.

17 Lawrence, M., 'A gothic reworking of an Early Christian sarcophagus', *Art Studies*, VII (1929), 89–153.

18 L'Orange, H. P., *Apotheosis in Ancient Portraiture*, Oslo, 1947.

19 L'Orange, H. P., *Studies in the Iconography of Cosmic Kingship in the Ancient World*, Oslo, 1953. (139–70: 'The gesture of power.')

20 Mâle, E., 'L'art symbolique à la fin du moyen age: les triomphes', *RAAM*, XIX (1906), 111–26.

21 Saxl, F., 'Pagan and Jewish elements in Early Christian sculpture', in his *Lectures*, 45–57, 2 vols, London, 1957.

22 Saxl, F., 'Pagan Sacrifice in the Italian Renaissance', *JWCI*, II (1938/9), 346–67.

23 Schmidt, J. H., 'Nachrömische Triumphtore', *Das Werk des Kunstlers*, I (1939), 362–99.

24 Schnitzler, H., *Mittelalter und Antike. Über die Wiedergeburt der Antike in der Kunst des Mittelalters*, Munich, 1949. (Short illustrated survey, Carolingian to Nicola Pisano)

25 Schweitzer, B., *Die spätantiken Grundlagen der mittelalterlichen Kunst*, Leipzig, 1949.

Survival and revival

Bonicatti, M., 'Traccia per uno studio sull'arte tardo antica nell'ambiente urbano occidentale', *Studi Miscellanei*, I (1961), 11–27. (Good bibliography; centres on the MS. of the Vatican Virgil)

Chiri, G., 'La cultura classica nella coscienza medioevale', *Studi Romani*, II (1954), 395–410.

Curtius, E. R., *European Literature and the Latin Middle Ages*, English translation, London, 1953.

Demus, O., *Byzantine Art and the West*, London, 1970.

Gargner, E., 'Zur spätantiken Renaissance', *JKHS*, VIII (1934), 1–28.

Hubert, J., Porcher, J., and Volbach, W. F., *Europe in the Dark Ages*, English translation, London, 1969.

Marrou, H.-I., *Saint Augustin et la fin de la culture antique*, Paris, 1938. (Problem of a balance between old and new)

Panofsky, E., and Saxl, F., 'Classical mythology in mediaeval art', *Metropolitan Museum Studies*, IV (2) (1933), 228–80.

*Seznec, J., *The Survival of the Pagan Gods*, English translation, New York, 1953.

Weitzmann, K., 'The survival of mythological representations in Early Christian and Byzantine art and their impact on Christian iconography', *Dumbarton Oaks Papers*, XIV (1960), 45–68.

*Wolff, P., *The Awakening of Europe*, Harmondsworth, 1968. (In series 'Pelican History of European Thought'; from Fall of Rome to Abelard).

26 Beckwith, J., *Early Mediaeval Art*, London, 1964. (30ff. for obsession with the 'authentic')

27 Beckwith, J., 'The Werden Casket Reconsidered', *AB*, XL (1958), 1–11.

28 Colin, J., 'La plastique "gréco-romaine" dans l'Empire carolingien', *Cahiers archéologiques*, II (1947), 87–114. (Explains return to Byzantine examples because of melting down of western material)

29 Cumont, F., 'L'Adoration des Mages et l'art triomphal de Rome', *Memorie della Pontifica Accademia Romana di Archeologia*, III (1932), 81–105.

30 Duval, N., 'Les origines de la basilique chrétienne. Etat de la question', *IHA*, VII (1962), 1–19.

31 Grabar, A., *Martyrium: Recherches sur le culte des reliques et l'art chrétien antique*, 2 vols, Paris, 1943–6.

32 Ragusa, I., 'The Re-use of Roman Sarcophagi during the Middle Ages and the Renaissance', M.A. thesis (unpublished), New York Institute of Fine Arts, 1951. (I have not seen this item)

33 Simone, F., 'La coscienza della Rinascita negli umanisti', *La Rinascita*, II (1939), 838–71; and III (1940), 163–86.

34 Walter, C., 'Papal political imagery in the mediaeval Lateran Palace', *Cahiers archéologiques*, XX (1970), 155–76; and XXI (1971), 109–36.

35 Wes, W. A., 'La fin de Rome dans l'historiographie de l'humanisme italien', *Mededelingen van het Nederlands Instituut te Rom*, XXXVI (1974), 113–22.

36 Williams, P. L., 'Two Roman reliefs in Renaissance disguise', *JWCI*, IV (1941), 47–66.

The Carolingian Renaissance

Braunfels, W. (ed.), *Karl der Grosse, Lebenswerk und Nachleben*, 5 vols, Dusseldorf, 1965–8. (Especially Vols III and IV)

*Bullough, D., *The Age of Charlemagne*, 2nd edn, London, 1973.

Bullough, D., '*Europae pater*: Charlemagne and his achievement in the light of recent scholarship', *English Historical Review*, LXXV (1970), 59–105.

*Conant, K. J., *Carolingian and Romanesque Architecture, 800–1200*, Harmondsworth, 1966.

Council of Europe, *Charlemagne: oeuvre, rayonnement et survivances*, Exhibition catalogue, Aix-la-Chapelle, 1965.

Davis-Weyer, C., *Early Mediaeval Art 300–1150: Sources and documents*, New Jersey, 1971.

Krautheimer, R., *Studies in Early Christian, Mediaeval and Renaissance Art*, New York, 1969. (Reprints, with additions, important articles such as 'The Carolingian revival of Early Christian architecture', ex. *AB*)

Laistner, M. L. W., *Thought and Letters in Western Europe, 500–900*, 2nd edn, London, 1957.

37 Bandmann, G., 'Die Vorbilder der Aachener Pfalzkapelle', in *Karl der Grosse*, II, 424–62.

38 Beckwith, J., 'Byzantine influence at the court of Charlemagne', in *Karl der Grosse*, III, 288–300.

39 Belting, H., 'Der Einhardsbogen', *Zf.KG*, XXXVI (1973), 93–121.

40 Benson, G. R., 'New light on the origin of the Utrecht Psalter', *AB*, XIII (1931), 13–79.

41 Bloch, H., 'Monte Cassino, Byzantium and the West in the earlier middle ages', *Dumbarton Oaks Papers*, III (1946), 166–224.

42 Boselli, G., *Sommario delle vite de gl'imperatori romani*, Bologna, n.d. (late seventeenth century). (On medals of the emperors, short commentary)

43 Cecchelli, C., 'Ispirazione classica e biblica nell'iconografia carolingia', *Studi Romani*, V (1956), 523–38.

44 Crozet, R., 'Les survivances de la pensée et de l'art antiques dans la peinture carolingienne', in *Mélanges d'histoire du moyen age dédiés à la mémoire de Louis Halphen*, Paris, 1951, 165–8.

45 Falkenstein, L., *Der 'Lateran' der karolingischen Pfalz zu Aachen*, Cologne and Graz, 1966. (Aachen as a second Rome)

46 Folz, R., *The Coronation of Charlemagne*, English translation, London, 1974.

47 Gaehde, J. E., 'Carolingian interpretations of an Early Christian picture cycle to the Octateuch in the Bible of San Paolo fuori le Mura in Rome', *Frühmittelalterliche Studien*, VIII (1974), 351–84.

48 Golzius, H., *Icones Imperatorum Romanorum*, Antwerp, 1645.

49 Heckscher, W. S., 'Relics of pagan antiquity in mediaeval settings', *JWCI*, I (1937/8), 204–20.

50 Heer, F., *The Holy Roman Empire*, English translation, London, 1968.

51 Hoffmann, H., 'Die Aachener Theoderichstatue' in V. R. Elbern (ed.), *Das Erste Jahrtausend. Kultur und Kunst im werdenden Abendland an Rhein und Ruhr*, 3 vols, Düsseldorf, 1962, 318–35.

52 Hubert, J., Volbach, W. F., and Porcher, J., *Carolingian Art*, English translation, London, 1970. (Quotation 35)

53 Kleinbauer, W. E., 'Charlemagne's palace chapel at Aachen and its copies', *Gesta*, IV (1965), 2–11.

54 Knowles, M. D., 'The preservation of the classics', in F. and C. E. Wright (ed.), *The English Library before 1700*, London, 1958, 136–47.

55 *Lasko, P., *Ars Sacra*, Harmondsworth, 1972. (Quotation 53)

56 Lavin, I., 'The house of the Lord: Aspects of the role of palace triclinia in the architecture of late Antiquity and the early Middle Ages', *AB*, XLIV (1962), 1–27.

57 Leroux, H., 'Figures équestres et personnages du nom de Constantin aux XIe et XIIe siècles', *Bulletin de la Société des Antiquaires de l'Ouest*, XII (1974), 379–84.

58 Matthiae, G., 'La cultura artistica in Roma nel secolo IX', *Rivista dell'Istituto Nazionale di Archeologia e Storia dell'Arte*, III (1954), 257–74.

59 Montesquiou-Fezensac, B. de, 'L'Arc d'Einhard', *Cahiers archéologiques*, VIII (1956), 147–74.

60 Morey, C. R., 'The covers of the Lorsch Gospels' *Speculum*, III (1928), 64–74; and IV (1929), 411–29.

61 Mütherich, F., 'Die Buchmalerei am Hofe Karles des Grossen', in *Karl der Grosse*, III, 9–53.

62 Pächt, O., 'Notes and observations on the origin of humanistic book-decoration', in D. J. Gordon (ed.), *Fritz Saxl: A volume of memorial essays*, London, 1957, 184–94.

63 Riché, P., *Education et culture dans l'Occident barbare, VIe–VIIIe siècles*, Paris, 1962.

64 Rosenbaum, E., 'The evangelist portraits of the Ada School and their models', *AB*, XXXVIII (1956), 81–90. (Dependence on Mediterranean MSS., sixth to eighth centuries)

65 Rosenthal, E., 'Classical elements in Carolingian illustration', *La Bibliofilia*, LV (1953), 85–106.

66 Schober, A., 'Das Rombild der Ludwigsbulle', *Anzeiger der Osterreichen Akademie der Wissenschaft*, LXXXVI (1949), 410–23.

67 Schwartz, J., 'Quelques sources antiques d'ivoires carolingiens', *Cahiers archéologiques*, XI (1960), 145–62.

68 Snijder, G. A. S., 'Antique and mediaeval gems on bookcovers at Utrecht', *AB*, XIV (1932), 5–52.

69 Snijder, G. A. S., 'Frühmittelalterliche Imitationen antiker Kameen', *Germania*, XVII (1933), 118–24.

70 Swarzenski, H., 'The Xanten Purple Leaf and the Carolingian Renaissance', *AB*, XXII (1940), 7–24.

71 Tolnay, C. de, 'The visionary evangelists of the Reichenau School', *BM*, LXIX (1936), 257–63. (Ottonian figures as 'Atlas')

72 Ullmann, B. L., *The Origin and Development of Humanistic Script*, Rome, 1960.

73 Verbaek, A., 'Die architektonische Nachfolge der Aachener Pfalzkapelle', in *Karl der Grosse*, IV, 113–56.

74 Volbach, W. F., *Elfenbeinskulpturen der Spätantike und des frühen Mittelalters*, 2nd edn, Mainz, 1952.

75 Weisbach, W., 'Les images des évangélistes dans l'Evangiliaire d'Othon III et leurs rapports avec l'antiquité', *GBA*, XXI (1939), 131–52.

76 Weitzmann, K., 'The Herakles plaques of St Peter's Cathedra', *AB*, LV (1973), 1–35. (Problems of dating 'revival' material)

77 Wesenberg, R., *Bernwardische Plastik*, Berlin, 1955.

78 Wormald, F., *The Utrecht Psalter*, Utrecht, 1953.

The Renaissance of the Twelfth Century

*Brooke, C., *The Twelfth-Century Renaissance*, London 1969.

Durand-Lefebvre, M., *Art gallo-romain et sculpture romane*, Paris, 1937.

Giocarinis, K., 'Bernard of Cluny and the antique' *Classica et Medievalia*, XXVI (1965), 310–48. (311, note 2, for bibliographical suggestions)

Goldschmidt, A., 'Das Nachleben der antiken Formen im Mittelalter', *Vorträge der Bibliothek Warburg 1921–22*, Leipzig and Berlin, 1923, 40–9.

Hamann-Maclean, R. H. L., 'Antikenstudium in der Kunst des Mittelalters', *Marburger Jahrbuch für Kunstwissenschaft*, XV (1949 and 1950), 157–250.

Liebeschütz, H., 'Das 12. Jahrhundert und die Antike', *Archiv für Kulturgeschichte*, XXXV (1953), 247–71.

Pächt, O., 'The pre-carolingian roots of early romanesque art', in *Acts*, I, 67–75.

Sanford, E. M., 'The twelfth century—renaissance or proto-renaissance?', *Speculum* XXVI (1951), 635–42.

Sauerländer, W., 'Art antique et sculpture autour 1200', *Art de France*, I (1961), 47–56. (Fountain bowl of the Sens School with strong antique connections)

Shearer, C., *The Renaissance of Architecture in Southern Italy*, Cambridge, 1935.

Southern, R. W., *Mediaeval Humanism and Other Studies*, Oxford, 1970.

79 Adhemar, J., *Influences antiques dans l'art du moyen age français; recherches sur les sources et les thèmes d'inspiration*, London, 1939. (Survey from Merovingian times to the Duc de Berry; 208ff. for cult of Charlemagne)

80 Benoit, F., 'La légende d'Hercule à Saint-Trophîme d'Arles', *Latomus*, IX (1950), 67–71.

81 Bloch, M., *Land and Work in Mediaeval Europe*, English translation, London, 1967. (1–43: 'The Empire and the idea of Empire under the Hohenstaufen')

82 Boutemy, A., and Vercouteren, F., 'Foulcoie de Beauvais et l'intérêt pour l'archéologie antique au XIe et XIIe siècle', *Latomus*, I (3) (1937), 173–86.

83 Demus, O., 'A Renascence of Early Christian art in the 13th century in Venice', K. Weitzmann (ed.), *Late classical and mediaeval studies in honour of A. M. Friend Jnr.*, Princeton, N.J., 1955, 348–61.

84 Deschamps, P., 'Etude sur la renaissance de la sculpture à l'époque romane', *Bulletin Monumental* (1925), 5–98.

85 Durliat, M., 'L'art roman en France', *Journal des Savants* (1972), 114–38. (*Etat de la question*; large number of references)

86 Glass, D., 'Romanesque sculpture in Campania and Sicily: a problem of method', *AB*, LVI (1974), 315–24. (Use of antique sources; well referenced)

87 Horn, W., *Die Fassade von St-Gilles; eine Untersuchung zur Frage des Antikeneinflusses in der südfranzösischen Kunst des 12. Jahrhunderts*, dissertation, Hamburg, 1937.

88 Jullian, R., 'Les survivances antiques dans la sculpture lombarde', *Etudes Italiennes*, I (1931), 131–40, 217–28.

89 Lassalle, V., *L'Influence antique dans l'art roman provençal*, Paris, 1970.

90 Nochles, K., 'Die Fassade von S. Pietro in Tuscania. Ein Beitrag zur Frage der Antikenrezeption im 12. und 13. Jahrhundert in Mittelitalien', *Römisches Jahrbuch für Kunstgeschichte*, IX–X (1961/2), 15–72.

91 Paatz, W., 'Italien und die künstlerischen Bewegungen der Gotik und Renaissance', *Römisches Jahrbuch für Kunstgeschichte*, V (1941), 165–222.

92 Panofsky, E., *Renaissance and Renascences in Western Art*, Copenhagen, 1960. (Quotation 113)

93 Pope-Hennessy, J., *Italian Gothic Sculpture*, London, 1955. (Quotation 5)

94 Rey, R., 'Quelques survivances antiques dans la sculpture méridionale', *GBA* (1928), 173–91.

95 Wentzel, H., 'Portraits "à l'antique" on French mediaeval gems and seals', *JWCI*, XVI (1953), 342–50.

2 Antique Art and the Renaissance: a Gallery of Types

Meyer-Weinschel, A., *Renaissance und Antike. Beobachtungen über das Aufkommen der antikisierenden Gewandgebung in der Kunst der italienischen Renaissance*, Reutlingen, 1933. (Wide-ranging; concentrates on drapery; 244 illus.)

Panofsky, E., *Tomb Sculpture: Four lectures on its changing aspect from ancient Egypt to Bernini*, ed. H. W. Janson, New York, 1964.

Rowland, B., 'Montecavallo revisited', *AQ*, XXX (1967), 143–52. (Fame of the Horse-tamers in the Renaissance)

Rubinstein, R. O., 'A Bacchic sarcophagus in the Renaissance', in *The Classical Tradition* (British Museum Yearbook No. 1), London, 1976, 103–56. (The sarcophagus is now in the British Museum, London)

Saxl, F., 'Rinascimento dell'antichità. Studien zu den Arbeiten A. Warburgs', *Repertorium für Kunstwissenschaft*, XLIII (1922), 220–72.

Schmitt, A., 'Gentile da Fabriano und der Beginn der Antikennachzeichnung', *Münchner Jahrbuch*, XI (1960), 91–146. (With catalogue)

96 Ansaldi, G. R., 'Il Laocoonte del rinascimento e il Laocoonte dell'antichità', *Emporium*, CI (1945), 54–61. (Copies and reconstructions)

97 Antal, F., 'Some examples of the role of the maenad in Florentine art of the later 15th and early 16th centuries', *JWCI*, I (1937/8), 71–3.

98 Bieber, M., *Laocoön: the influence of the group since its rediscovery*, New York, 1942.

99 Bober, P. P., 'An antique sea-thiasos in the Renaissance', in L. F. Sandler (ed.), *Essays in memory of Karl Lehmann*, New York, 1964, 43–48. (Similar in intention to Loeffler's article, below)

100 Bober, P. P., 'The census of antique works of art known to Renaissance artists', in *Acts*, II, 82–9. (Files at Warburg Institute, London)

101 Chastel, A., *Art et humanisme à Florence au temps de Laurent le Magnifique*, Paris, 1961. (631–71: 'Le Musée Etrusque et l'*Etruscan Revival*')

102 Dacos, N., 'A propos d'un fragment de sarcophage de Grottaferrata et de son influence à la Renaissance', *Bulletin de l'Institut Historique Belge de Rome*, XXXIII (1961), 143–50.

103 Dacos, N., *La Découverte de la domus aurea et la formation des grotesques à la Renaissance*, London, 1969.

104 Dacos, N., 'Ghirlandaio et l'antique', *Bulletin de l'Institut Historique Belge de Rome*, XXXIV (1962), 419–55. (Example of a sketch-book and list)

105 Essen, C. van, 'Elementi etruschi nel rinascimento toscano', *Studi Etruschi*, XIII (1939), 497–9. (Cites many comparisons)

106 Essen, C. van, 'Les frises dans le Cortile du Palazzo Spada a Rome', *Bulletin van de Vereeniging tot Bevordering der Kennis van de Antieke Beschaving*, XXIV and XXVI (1949/51), 91–5.

107 Ettlinger, L., '*Exemplum doloris*: reflections on the Laocoön group', in M. Meiss (ed.), *De Artibus Opuscula XL. Essays in honour of Erwin Panofsky*, New York, 1961, 121–6.

108 Friederichs, C., and Wolters, P., *Die Gispabgüsse antiker Bildwerk*, Berlin, 1885. (Heckscher calls this 'the nearest thing to a census of antiques')

109 Herbig, R., 'Etrusca aeterna', in *Studies presented to David M. Robinson*, St. Louis, Missouri, 1951, I, 730–5.

110 Keller, H., *Das Nachleben des antiken Bildnisses von der Karolingerzeit bis zur Gegenwart*, Freiburg im Breslau, 1970.

110a Lanciani, R., *Storia degli Scavi di Roma*, 4 vols, 1902–12. (Re-use of sarcophagi, I, 29–36)

111 Lawrence, M., 'City Gate sarcophagi', *AB*, X (1927), 1–45.

112 Lawrence, M., 'Columnar sarcophagi in the Latin West', *AB*, XVI (1932), 103–85.

113 Loeffler, E. P., 'A famous antique: a Roman sarcophagus at the Los Angeles Museum', *AB*, XXXIX (1957), 1–7. (Influence of one sarcophagus over centuries)

114 Oleson, J. P., 'A reproduction of an Etruscan tomb in the Parco dei Mostri at Bomarzo', *AB*, LVII (1975), 410–17. (Note 50 for further references)

115 Prandi, A., 'La fortuna del Laocoonte della sua scoperta nelle Terme di Tito', *Rivista dell'Istituto Nazionale d'Archeologia e Storia dell'Arte*, III (1954), 78–107.

116 *Salis, A. von, *Antike und Renaissance: über Nachleben und Weiterwirken der alten in der neueren Kunst*, Erlenbach and Zurich, 1947. ('Monographs' on antique types: 35–60: Domus aurea; 136–53: *Laocoön*; 165–89: *Belvedere torso*; etc.)

117 Schwinn, C., *Die Bedeutung des* Torso von Belvedere *für Theorie und Praxis der bildendend Kunst von 16. Jahrhundert bis Winckelmann*, Berne and Frankfurt-am-Main, 1973.

118 Trachtenberg, M., 'An antique model for Donatello's marble *David*', *AB*, L (1969), 286–9. (Etruscan bronze goddess, Museo Archeologico, Florence)

119 Vermeule, C. C., 'The Dal Pozzo–Albani drawings of classical antiquities in the British Museum', *Transactions of the American Philosophical Society*, L (part 5), Philadelphia, 1960. (Short introduction; well-illustrated catalogue; see also items 603–5 below)

120 Winner, M., 'Zum Apoll vom Belvedere', *Jahrbuch der Berliner Museen*, X (1968), 181–99.

121 Winner, M., 'Zum Nachleben des Laokoon in der Renaissance', *Jahrbuch der Berliner Museen*, XVI (1974), 83–121.

3 Roma Quanta Fuit Ipsa Ruina Docet

The idea of Rome in the Middle Ages

Besso, M., *Roma e il Papa nei proverbi e nei modi di dire*, rev. ed, Rome and Florence, 1971. (31–82: 'Roma Caput Mundi')

Brentano, R., *Rome Before Avignon*, London, 1974. (Ch. I: 'The Physical City'; ch. II: 'The Ideal City')

Dupre Theseider, E., *L'idea imperiale di Roma nella tradizione del medio evo*, Milan, 1942.

Mazzolani, L. S., *The Idea of the City in Roman Thought*, English translation, London, 1970. (*Civitas/urbs*, usually focused on Rome)

Mommsen, T. E., 'Petrarch's conception of the dark ages', *Speculum*, XVII (1942), 226–42. (As *very* dark)

Schneider, F., *Rom und Romgedanke im Mittelalter: Die geistigen Grundlagen der Renaissance*, Munich, 1926. (General survey)

122 Bayley, C. C., 'Petrarch, Charles IV and the *renovatio imperii*', *Speculum*, XVII (1942), 323–41. (Petrarch's desire to restore Rome, Italy and the Empire)

123 Bracco, V., 'Il ricordo dei monumenti di Roma e del mondo romano nella *Divina Commedia*', *Studi Romani*, XIII (1965), 281–95.

124 Brezzi, P., *Roma e l'impero medioevale, 774–1252*, Bologna, 1947.

125 Buschhausen, H., 'Das Alterbildnis Kaiser Friedrichs II', *JKHS*, LXX (1974), 7–38.

126 Davis, C. T., *Dante and the Idea of Rome*, Oxford, 1957. (Large bibliography)

127 Demus, O., 'A renascence of Early Christian art in 13th century Venice', in K. Weitzmann (ed.), *Classical and mediaeval studies in honour of A. M. Friend*, Princeton, 1955, 348–61.

128 Graf, A., *Roma nella memoria e nelle immaginazioni del medio evo*, Turin, 1915.

129 Gregorovius, F., *The History of the City of Rome in the Middle Ages*, English translation, London, 1900ff. (I, 296ff. for barbarian destruction and renovation)

130 *Hammer, W., 'The concept of the New or Second Rome in the middle ages', *Speculum*, XIX (1944), 50–62.

131 Kantorowicz, E., *Frederick the Second, 1194–1250*, English translation, London, 1931. (Especially 441–516)

132 Kaschnitz-Weinberg, G., 'Bildnisse Friedrichs II von Hohenstaufen. I: Der Kolossalkopf aus Lanuvium', *Mitt.DAI*, LX/LXI (1953/4), 1–21.

133 Lavagnino, E., 'Il Campidoglio al tempo di Petrarca', *Capitolium*, XV (1941), 103–14. (With survey of later developments)

134 Lenkeith, N., *Dante and the Legend of Rome*, London, 1952. (Mediaeval and Renaissance Studies, Supplement 2)

135 Llewellyn, P., *Rome in the Dark Ages*, London, 1970.

136 Mattei, R. de, 'Petrarca e Roma', *Studi Romani*, XXII (1974), 155–71.

137 Pratt, K. J., 'Rome as eternal', *JHI*, XXXVI (1965), 25–44.

138 Rubinstein, N., 'The beginnings of political thought in Florence. A study in mediaeval historiography', *JWCI*, V (1942), 198–227. (Florentine 'nationalism' and links with antique Roman example)

139 Rubinstein, N., 'Vasari's painting of The Foundation of Florence in the Palazzo Vecchio', in D. Fraser, H. Hibbard, and M. J. Lewine (eds.), *Essays in the History of Architecture presented to Rudolf Wittkower*, London, 1967, 64–73.

140 Schramm, P. E., *Kaiser Rom und Renovatio*, 2nd edn, Darmstadt, 1957.

141 Tellenbach, G., 'La città di Roma dal IX al XI secolo vista dai contemporanei d'oltre frontiera', *Studi storici in onore di Ottorino Bertolini*, Pisa, 1972, II, 679–734.

142 *Van Cleve, T. C., *The Emperor Frederick II of Hohenstaufen, Immutator Mundi*, Oxford, 1972. (Especially 333–46)

143 Weiss, R., 'Petrarch the antiquarian', in C. Henderson Jnr. (ed.), *Classical and mediaeval studies in honour of B. L. Ullmann*, Rome, 1964, II, 199–209.

144 Weiss, R., *The Renaissance Discovery of Classical Antiquity*, Oxford, 1969. (Numerous footnotes, but no bibliography; quotation, 191)

145 Wentzel, H., 'Der Augustalis Friedrichs II und die abendländische Glyptik des 13. Jahrhunderts', *Zf.KG*, XV (1952), 183–7.

146 Witt, R., 'Coluccio Salutati and the origins of Florence', *Il pensiero politico*, II (1969), 161–72.

Attitudes to the Monuments during the Middle Ages

Hülsen, C., *Le chiese di Roma nel medio evo*, Florence, 1927.

Ross, J. B., 'A study of twelfth-century interest in the antiquities of Rome', in J. L. Cate and E. N. Anderson (eds.), *Mediaeval and historical essays in honour of J. W. Thompson*, Chicago, 1938, 302–21. (Refers to Bishop of Winchester's purchases, of which nothing remains)

147 Ackerman, J. S., 'Marcus Aurelius on the Capitoline Hill', *Renaissance News*, X (1957), 69–75.

148 Ashby, T., and Dougill, W., 'The Capitol, Rome, its history and development', *Town planning review*, XII (1927), 159–80.

149 Boüard, A. de, 'Gli antichi marmi di Roma nel medio evo', *Archivio della società romana di storia patria*, XXXIV (1911), 239–45.

150 Comparetti, D., *Virgilio nel medio evo*, 2nd edn (by G. Pasquali), Florence, 1937.

151 Coulter, C., 'Boccaccio's archaeological knowledge', *American Journal of Archaeology*, XLI (1937), 397–405.

152 Déer, J., 'The dynastic porphyry tombs of the Norman period in Sicily' (Dumbarton Oaks Studies, V), Cambridge, Mass., 1959. (150–4 for political implications)

153 Fedele, P., 'Sul commercio delle antichità in Roma nel XII secolo', *Archivio della società romana di storia patria*, XXXIII (1909), 465–70.

154 Glass, D., 'Papal patronage in the early 12th century: notes on the iconography of cosmatesque pavements', *JWCI*, XXXIII (1969), 386–90.

155 Glass, D., 'Studies in Cosmatesque Pavements', Unpublished Ph.D thesis, Johns Hopkins University, Baltimore, 1968. (122*ff*. for ritual use of porphyry, and mingling of sacred and profane)

156 Heckscher, W. S., *Die Romruinen. Die geistigen Voraussetzungen ihrer Wertung im Mittelalter und in der Renaissance*, dissertation, Hamburg, 1936. (Review by W. Hammer in *Classical Philology*, XXXIII (1938), 433–5)

157 Hülsen, C., *Bilder aus der Geschichte des Kapitols*, Rome, 1889.

158 Lanciani, R., *The Destruction of Ancient Rome*, London and New York, 1899.

159 Mann, J. G., 'Instances of antiquarian feeling in mediaeval and renaissance art', *Archaeological Jnl*, LXXXIX (1932), 254–74.

160 Mitchell, C., 'The Lateran fresco of Boniface VIII', *JWCI*, XIV (1951), 1–6. (Papal adoption of the imperial idea)

161 Mommsen, T. E., 'Petrarch and the decoration of the *Sala Virorum Illustrium* in Padua', *AB*, XXXIV (1952), 95–116.

162 Müntz, E., 'Etudes iconographiques. La légende du sorcier Virgile dans l'art du XIVe, XVe et XVIe siècles', *Monatsberichte für Kunst und Kunstwissenschaft*, II (1902), 85–91.

163 Müntz, E., 'La tradition antique chez les artistes du moyen age', *Journal des savants* (1887), 629–42; (1888), 40–50, 162–177. (Nominally a review of Springer's *Das Nachleben der Antike im Mittelalter*)

164 Nochles, K., 'Die Kunst des Cosmaten und die Idee der Renovatio Romae', in *Festschrift Werner Hager zum 65. Geburtstag*, Recklinghausen, 1966, 17–37.

165 Pietrangeli, C., 'I palazzi capitolini nel medioevo', *Capitolium*, XXXIX (1964), 191–4. (Very well illustrated)

166 Quinones, R. J., *The Renaissance Discovery of Time*, Cambridge, Mass., 1972. (Literary rather than philosophical)

167 Rodocanachi, E., *Le Capitole romain, antique et moderne*, Paris, 1904. (Contrasting attitudes, medieval and later)

168 Rushforth, G. McN., 'Magister Gregorius *De Mirabilius Urbis Romae*', *Journal of Roman Studies*, IX (1919), 14–58.

169 Schmitt, A., 'Zur Wiederbelebung der Antike im Trecento. Petrarcas Rom-Idee in ihrer Wirkung auf die Paduaner Malerei. Die methodische Einbeziehung des römischen Münzbildnisses in die Ikonographie "Berühmter Männer",' *Mitt.KHIF*, XVIII (1974), 167–218.

170 Schudt, L., *Le guide di Roma: Materialen zu einer Geschichte der römischen Topographie*, Vienna and Augsburg, 1930. (Divided by language of guide-book and then by type: topographical, antiquarian, architectural, etc.)

171 Siebenhüber, H., *Das Kapitol in Rom. Idee und Gestalt*, Munich, 1954. (Cf. Ackerman's review in *AB*, XXXVIII (1956), 55–7, with further references)

172 Spargo, J. W., *Virgil the Necromancer*, Cambridge, Mass., 1934.

173 Turner, A. R., *The Vision of Landscape in Renaissance Italy*, Princeton, 1966. (Ch. VIII: 'In ruinous perfection')

174 Valentini, R., and Zucchetti, G., *Codice topografico della Città di Roma*, Rome, 1940–53. (IV, 65–73, for Dondi's account; cf. Panofsky's *Renaissance and renascences . . .*, 208–9, for Dondi's account as quoted in text)

175 Weiss, R., 'Lineamenti per una storia degli studi antiquarii in Italia dal dodicesimo secolo al sacco di Roma del 1527', *Rinascimento*, IX (1958), 141–201. (Large bibliography)

Rome after the return of the Popes from Avignon

Ettlinger, L., *The Sistine Chapel before Michelangelo*, Oxford, 1965.

Hermanin, F., *Die Stadt Rom im 15. und 16. Jahrhundert*, Leipzig, 1911. (The appearance of the City)

Mariani, V., *Incontri con Roma nel Rinascimento: L. B. Alberti, Donatello, A. Mantegna, Raffaello*, Rome, 1960.

Müntz, E., *L'art à la cour des papes. Innocent VIII, Alexandre VI, Pie III (1484–1503). Recueil de documents inédits ou peu connus*, Paris, 1898.

Pastor, L., *The history of the popes from the close of the middle ages*, English translation, London, 1891*ff*. (40 vols)

Roeder, H., 'The borders of Filarete's bronze doors to St. Peter's', *JWCI*, X (1947), 150–3. (Mixture of classical literature and medieval style)

176 Battisti, E., 'L'antichità in Nicolo V e l'iconografia della Cappella Sistina', in *Il mondo antico nel Rinascimento* (Atti del V Convegno di studi sul Rinascimento), Florence, 1958, 207–16.

177 Ciaccio, L., 'La scultura romana del Rinascimento. Primo periodo (sino al Pontificato di Pio II)', *L'Arte*, IX (1906), 165–84, 345–56, 433–41. (Conscious antiquarianism)

178 Esch, A., 'Florentiner in Rom um 1400', *Quellen und Forschungen*, LII (1972), 476–525.

179 Fontana, V., *Artisti e commitenti nella Roma del Quattrocento. Leon Battista Alberti e la sua opera mediatrice*, Rome, 1973. (Good sketch concerning 1417–83)

180 *Gabel, L. C., 'The first revival of Rome, 1420–1484', in *The Renaissance reconsidered. A symposium* (Smith College studies in history, XLIV), 1964, 13–25.

181 Giordani, P., 'Scultura romana del Quattrocento. I bassorilievi del Tabernacolo di Sisto IV', *L'Arte*, X (1907), 263–75.

182 Greco, A., 'Momenti e figure dell'umanesimo romano', in *Aspetti dell'umanesimo a Roma* (Lectures at the Istituto di Studi Romani, 1967/8), Rome, 1969, 31–72.

183 Horne, H., 'An account of Rome in 1450', *Revue archéologique*, X (1907), 82–97. (The *Zibaldone* di Giovanni Rucellai)

184 Kennedy, R. W., 'The contribution of Martin V to the rebuilding of Rome, 1420–31', in *The Renaissance reconsidered. A symposium* (Smith College studies in history, XLIV), 1964, 27–52.

185 Pietrangeli, C., 'I palazzi capitolini nel Rinascimento', *Capitolium*, XXXIX (1964), 195–8. (Includes a model of the Senatorio before Michelangelo's alterations)

186 *Saxl, F., 'The Capitol during the Renaissance—a symbol of the imperial idea', in his *Lectures*, 2 vols, London, 1957, 200–14.

187 Ullmann, B. L., *The humanism of Coluccio Salutati*, Padua, 1963.

Scholarly study of the antiquities of Rome

Billanovich, G., *I primi umanisti e le tradizioni dei classici latini*, Freiburg, 1953.

Dudley, D. R., *Urbs Roma. A source book of classical texts on the city and its monuments*, London, 1967.

Francastel, P., 'La fête mythologique au Quattrocento. Expression littéraire et visualisation plastique', *Revue d'Esthétique*, V (1952), 376–410.

Marchant, H. J., 'Papal inscriptions in Rome, 1417–1527', unpublished M.Phil. dissertation, London University, 1973. (With much on epigraphic styles)

Morison, S., *Politics and script. Aspects of authority and freedom in the development of Graeco-Latin script . . .* (Lyell Lectures 1957, ed. N. Barker), Oxford, 1972. (264*ff*: 'From Martin V to Sixtus V')

Stark, C. B., *Systematik und Geschichte der Archäologie der Kunst*, Leipzig, 1880. (I, 80–161, for history of Renaissance antiquarianism)

188 Allen, D. C., *Mysteriously meant. The rediscovery of pagan symbolism and allegorical interpretation in the Renaissance*, Baltimore and London, 1970. (Ch. IX, 'The symbolical interpretations of Renaissance antiquarians'—but no more than disconnected notes)

189 * Burke, P., *The Renaissance sense of the past*, London, 1969. (Extracts with commentaries; résumé in *Journal of World History*, II (1969), 615–32)

190 Castagnoli, F., 'Raffaello e le antichità di Roma', in *Raffaello—L'opera, le fonti, la fortuna*, ed. M. Salmi, Novara, 1968, II, 571–86.

191 Goldschmidt, E. P., *The printed book of the Renaissance*, Cambridge, 1950. (74*ff*.)

192 Hill, G. F., 'Classical influence on the Italian medal', *BM*, XVIII (1911), 259–69.

193 Küthmann, H., Overbeck, B., Steinhilber, D., and Weber, I., *Bauten Roms auf Münzen und Medaillen* (Exhibition, Staatlichen Münzsammlung Munich, 1973), Munich, 1973. (Buildings of Rome in antique, medieval and modern times; well illustrated)

194 Lanciani, R., 'La pianta di Roma antica e i disegni archeologici di Raffaello Sanzio', *Rendiconti dell'Accademia dei Lincei*, 1895, 791–804.

195 Meiss, M., 'Toward a more comprehensive Renaissance palaeography', *AB*, XLII (1960), 97–112. (Revival of the Imperial Roman majuscule)

196 *Momigliano, A., 'Ancient history and the antiquarian', *JWCI*, XIII (1950), 285–315. (Fundamental article on distinction between history and antiquarianism)

197 Robathan, D. M., 'Flavio Biondo's *Roma instaurata*', *Medievalia et humanistica*, I (1970), 203–16.

198 Rosati, F. P., 'Ispirazione classica nella medaglia italiana del Rinascimento', in *La medaglia d'arte* (Atti del primo convegno internazionale di studi, Udine, 1970), Udine, 1973, 95–105. (Basic bibliography)

199 *Scherer, M., *The marvels of ancient Rome*, New York, 1955. (Pictorial commentary)

200 Spring, P., 'The topographical and archaeological study of the antiquities of the City of Rome, 1420–1447', unpublished Ph.D. thesis, Edinburgh University, 1972.

201 Wardrop, J., *The script of humanism. Some aspects of humanistic script, 1460–1560*, Oxford, 1963. (1–18: 'The rise of humanistic cursive: antiquarian and scholarly influences', with useful references)

202 Weiss, R., 'Andrea Fulvio antiquario romano', *Annali della scuola normale superiore di Pisa: lettere, storia e filosofia*, Pisa (1959), 1–44.

203 Weiss, R. (ed.), Andrea Fulvio: *Illustrium Imagines*, Rome, 1967. (Includes account of numismatic studies in the Renaissance)

204 Weiss, R., 'Biondo Flavio archeologico', *Studi Romagnoli*, XIV (1963), 335–41.

205 Weiss, R., 'Traccia per una biografia di Annio da Viterbo', *IMU*, V (1962), 425–41. (Scholar notorious as a literary forger)

206 Weiss, R., 'The study of ancient numismatics during the Renaissance', *Numismatic chronicle*, VIII (1968), 177–87.

The collecting of Antiquities

Clain-Stefanelli, E. E., *Numismatics: an ancient science. A survey of its history*, Washington, 1940.

Degenhardt, B., 'Michele di Giovanni di Bartolo: disegni dall'antico e il Camino "Della Iole"', *Bollettino d'Arte*, XXXV (1950), 208–15.

Holst, N. von, *Creators, collectors and connoisseurs. The anatomy of artistic taste from antiquity to the present day*, English translation, London, 1967.

Müntz, E., *Les antiquitéz de la ville de Rome au XIVe, XVe et XVIe siècles. Topographie, monuments, collections*, Paris, 1886.

*Taylor, F. H., *The taste of angels. A history of art collecting from Rameses to Napoleon*, Boston, 1948.

Van der Meulen, M., 'Cardinal Cesi's antique sculpture garden: notes on a painting by Hendrick van Cleef III', *BM*, CXVI (1974), 14–24. (Painting dated 1550)

207 Brummer, H. H., *The Statue Court of the Vatican Belvedere*, Stockholm, 1970.

208 Carettoni, G., 'La riscoperta dei monumenti romani', in *Aspetti dell'umanesimo a Roma* (lectures at the Istituto di studi romani, 1967/8), Rome, 1969, 75–84.

209 Chastel, A., *Art et humanisme à Florence au temps de Laurent le Magnifique*, Paris, 1961. (31–82 on collecting)

210 Dannenfeldt, K. H., 'Egypt and Egyptian antiquities in the Renaissance', *Studies in the Renaissance*, VI (1959), 7–27.

211 Fanelli, V., 'Aspetti della Roma cinquecentesca. Le case e le raccolte archeologiche del Colcci', *Studi Romani*, X (1962), 391–402.

212 Goodhart, P. (ed.), *Two Renaissance book hunters. The letters of Poggius Bracciolini to Nicolaus de Niccolis*, New York and London, 1974.

213 Heckscher, W. S., *Aeneas Insignes Statuas Romano Popolo Restituendas Censuit*, The Hague, n.d.

214 Hübner, P. G., *Le statue di Roma. Grundlagen für eine Geschichte der antiken Monumente in der Renaissance* (Römische Forschungen, Biblioteca Hertziana, II), Leipzig, 1912. (Uncompleted; cf. important review by C. Hülsen in *Göttingischen gelehrten Anzeiger*, V (1914), 257–311)

215 Hülsen, C., *Römische Antikengarten des XVI Jahrhunderts*, Heidelberg, 1917. (Illustrated catalogue of the collections of Cardinals Cesi and Carpi, and of the Cardinal of Ferrara)

216 Hülsen, C., 'Scavi e scavatori nel Rinascimento', *Marzocco*, 30 March 1913 (from a lecture).

217 Magnaguti, A., 'La più illustre collezionista del Rinascimento', *Rivista italiana di numismatica*, XXVI (1913), 389–94. (Some of Isabella d'Este's coins came from Delos)

218 Michaelis, A., 'Storia della collezione capitolina di antichità fino all'inaugurazione del Museum', *Mitt. kaiserlich DAI*, VI (1891), 3–66. (12–15 for gift of Sixtus IV)

219 Müntz, E., 'Le Musée du Capitole et les autres collections romaines à la fin du 15e siècle et au commencement du 16e siècle', *Revue archéologique*, XLIII (1882), 24–36.

220 Müntz, E., *Les collections des Médicis au XVe siècle*, Paris and London, 1888.

221 Robert-Delondre, L., 'Les sujets antiques dans la tapisserie', *Revue archéologique*, V (1917), 296–309; VII (1918), 131–50; IX (1919), 48–63; X (1919), 294–333. (14th–16th centuries)

222 Sabbadini, R., *Le scoperte dei codici latini e greci ne' secoli XIV e XV*, Florence, 1905.

223 Scheicher, E., 'Die "Trionfi". Eine Tapisserienfolge des Kunsthistorischesmuseum in Wien', *JKHS*, LXVII (1971), 7–46.

224 Venturi, A., 'Les *Triomphes* de Pétrarque dans l'art représentatif', *RAAM* (1906), 81–209. (The antique in court life)

225 Weiss, R., *Un umanista veneziano: Papa Paolo II*, Venice and Rome, 1958.

226 Zappert, G., 'Uber Antiquitäten Funde im Mittelalter', *Sitzungsberichte der kaiserlichen Akademie der Wissenschaften. Philosophische-historische Klasse*, II, iv (1850), 752–98. (Well documented)

The use of antiquities by artists

Bartoli, A., *I monumenti antichi di Roma dei disegni degli Uffizi*, 5 vols, Rome, 1914–22.

Berlin-Dahlem: Kupferstichkabinett, *Zeichner sehen die Antike. Europäische Handzeichnungen 1450–1800* (Exhibition), Berlin-Dahlem, 1967. (Discursive; many references)

Warburg, A., *La rinascita del paganismo antico. Contributi alla storia della cultura*, Italian translation, Florence, 1966.

Waetzoldt, W., *Das klassische Land. Wandlungen der Italien-Sehnsucht*, Leipzig, 1927. (Survey of North European interest in Italy)

Weise, G., *Renaissance und Antike*, Tübingen, 1953. (Well referenced, well illustrated)

227 Ashby, T., 'Antiquae statuae urbis Romae', *Papers of the British School at Rome*, IX (1920), 107–58. (Cavalieri's enormous success, from c. 1561)

228 Berlin: Staatliche Museen, *Katalog der Ornamentstichsammlung der staatlichen Kunstbibliothek Berlin*, 2 vols, Berlin, 1939. (Invaluable reference tool of over 5,000 entries)

229 Bober, P., 'The census of antique works of art known to Renaissance artists', in *Acts*, II, 82–9.

230 Brigode, S., 'Les recueils de monuments d'Italie', *Bulletin de l'Institut historique Belge de Rome*, XIV (1934), 242–56. (Lists the main books)

231 Calarco, A. S., 'Commemorative monuments in 16th century Italy', unpublished Ph.D. thesis, Case Western Reserve University, 1973.

232 Dacos, N., 'Ghirlandaio et l'antique', *Bulletin de l'Institut historique Belge de Rome*, XXXIV (1962), 419–55.

233 Egger, H., *Codex Escurialensis. Ein Skizzenbuch aus der Werkstatt Domenico Ghirlandaios*, Vienna, 1906.

234 Fienga, D. D., 'The *Antiquarie Prospettiche Romane* composte per Prospectivo Melanese Depictore': a document for the study of the relationship between Bramante and Leonardo da Vinci', unpublished Ph.D. thesis, University of California, 1971.

235 Giglioli, G. A., 'La Calumnia d'Apelle', *Rassegna d'arte antica e moderna*, VII (1920), 173–82.

236 Gilbert, C., 'Antique frameworks for Renaissance art theory: Alberti and Pino', *Marsyas*, III (1945), 87–98.

237 Ivins, W., *Prints and visual communication*, Cambridge, Mass., 1969.

238 Lloyd, C. H., *Art and its images*: exhibition, Bodleian Library, Oxford, 1975. (5–23 for problems of accuracy)

239 Smith, W., 'Definitions of *statua*', *AB* (1968), 263–7.

240 Thode, H., *Die Antiken in den Stichen Marcanton's, Agostino Veneziano's und Marco Dente's*, Leipzig, 1881.

241 Zerner, H., 'A propos de faux Marcantoine. Notes sur les amateurs d'estampes à la Renaissance', *Bibliothèque d'humanisme et de renaissance*, XXIII (1961), 477–81.

What is a forgery?

Ashmole, B., *Forgeries of ancient sculpture: creation and detection* (J. L. Myres Memorial Lecture), Oxford, 1961. (Examples *c*. 1800, *c*. 1850 and *c*. 1920)

Bianchi Bandinelli, R., 'An "antique" reworking of an antique head', *JWCI*, IX (1946), 1–9. (Exercise after the antique by Nanni di Banco?)

Bruand, Y., 'La restauration des sculptures antiques du Cardinal Ludovisi', *Mélanges d'archéologie et d'histoire*, LXVIII (1956), 397–418. (Differing attitudes to tampering with originals)

Cagiano de Azevedo, M., *Il gusto del restauro delle opere d'arte antiche*, Rome, 1948.

Hayward, J. F., 'Spurious antique vase designs of the 16th century', *BM*, CXIV (1972), 378–86.

Oechslin, W., 'Il Laocoonte—o dei restauri delle statue antichi', *Paragone arte*, CCLXXXVII (1974), 3–29.

Paul, J., 'Antikenergänzung und Ent-Restaurierung', *Kunstchronik*, XXV (1972), 85–112. (Account of 1972 symposium)

Pope-Hennessy, J., 'Michelangelo's *Cupid*: the end of a chapter', *BM*, XCVIII (1956), 403–11. (Roman with sixteenth-century head)

Revue de l'Art 'Copies, repliques, faux', *RA*, XXI (1973), 5–31. (Survey from Antiquity onwards)

Shapiro, M., 'Renaissance or Neo-Classic? A forgery after the antique reconsidered', *AB*, XLIV (1962), 131–5.

Tietze, H., 'The psychology and aesthetics of forgery in art', *Metropolitan Museum Studies*, V (1934), 1–19.

Wolters, W., 'Eine Antikenergänzung aus dem Kreis des Donatello', *Pantheon*, XXXIII (1974), 130–3. (An antique statue transformed into a saint)

242 Buitron, D. M., 'The *Alexander Nelidow*: A Renaissance bronze?', *AB*, LV (1973), 393–400.

243 Courajod, L., *L'imitation et la contrefaçon des objets d'art antiques au XIVe et XVe siècles*, Paris, 1889. (The best survey)

244 Gorini, G., 'Appunti su Giovanni di Cavino', in *La Medaglia d'Arte* (Atti del primo convegno internazionale di studi, Udine, 1970), Udine, 1973, 110–20. (The most notorious coin forger)

245 Greenhalgh, M., 'A Paduan medal of Queen Artemesia of Caria', *Numismatic Chronicle*, XII (1972), 295–303.

246 Kühlenthal, M., 'The Alberini sarcophagus: Renaissance copy or antique?', *AB*, LVI (1974), 414–21. (Antique from Eastern Empire; much comparative material)

247 Williams, P. L., 'Two Roman reliefs in Renaissance disguise', *JWCI*, VI (1940/1), 47–66.

The use of antiquities by builders

248 Gloton, J., 'Transformation et réemploi des monuments du passé dans la Rome du XVIe siècle: les monuments antiques', *Mélanges d'archéologie et d'histoire*, LXXIV (1962), 705–58.

249 Jestaz, B., 'L'exportation des marbres de Rome de 1535 à 1571', *Mélanges d'archéologie et d'histoire*, LXXV (1963), 415–66. (Thorough)

250 Mahon, D., 'Nicolas Poussin and Venetian painting', *BM*, LXXXVIII (1946), 19, note 39.

251 Müntz, E., 'Les monuments antiques de Rome à l'époque de la Renaissance', *Revue archéologique*, III (1884), 296–313.

252 Pedretti, C., *A chronology of Leonardo da Vinci's architectural studies after 1500*, Geneva, 1962. (162–71 for Letter to Leo X)

253 Rodocanachi, E., 'Les anciens monuments de Rome, 15e–18e siècle. Attitude du Saint-Siège à leur égard', *Revue archéologique*, IV (1913), 171–83.

The use of antiquities by landowners

Coarelli, F., 'L'Ara di Domizio Enobarbo e la cultura artistica in Roma nel II secolo a.C.', *Dialoghi di Archeologia*, II (1968), 302–68. (See 318–25 for use of altar reliefs as decoration for Palazzo Santacroce, Piazza di Branca, Rome, during seventeenth and eighteenth centuries)

McKay, A. G., *Houses, villas and palaces in the Roman world*, London, 1975.

254 Bianchini, F., *Il Palazzo dei Cesari*, Verona, 1738.

255 Boni, G., 'L'Arcadia sul Palatino', *Bollettino d'Arte*, VIII (1914), 369–80.

256 Carettoni, G., 'Il Foro Romano nel medio evo e nel Rinascimento', *Studi Romani*, XI (1963), 406–16.

257 Carettoni, G., 'Il Palatino nel medio evo', *Studi Romani*, IX (1961), 508–18.

258 Carini, I., *L'Arcadia dal 1690 al 1890*, Rome, 1891.

259 Eaton, C. A., *Rome in the 19th century*, ed. cit., London, 1892. (II, 276, for quotation)

260 Giess, H., 'Studien zur Farnese-Villa am Palatin', *Römisches Jahrbuch für Kunstgeschichte*, XIII (1971), 179–230.

261 Hülsen, C., 'Septizonium', *Zeitschrift für Geschichte der Architektur*, V (1912), 1–24.

262 Lanciani, R., 'Il "Palazzo Maggiore" nei secoli XVI–XVIII', *Mitt.DAI*, IX (1894), 3–36.

263 Levin, H., *The myth of the golden age during the Renaissance*, Bloomington and London, 1969.

264 Lugli, G., *Roma antica. Il centro monumentale*, Rome, 1946. (414*ff*; Horti Farnesiani)

265 Romanelli, P., 'Horti Palatini Farnesiorum', *Studi Romani*, VIII (1960), 661–72.

The use of antiquities by architects: the Renaissance villa

*Dickinson, G., *Du Bellay in Rome*, Leiden, 1960. (Best-referenced description in English of sixteenth-century Rome, with very good bibliography, especially of source books)

Frommel, C., *Die Farnesina und Peruzzis architektonisches Frühwerk*, Berlin, 1961.

Giamatti, A. B., *The earthly paradise and the Renaissance epic*, Princeton, 1966. (Survey with commented bibliographies)

Heydenreich, L. H., 'Entstehung der Villa und ländlichen Residenz im 15. Jahrhundert', *Acta historiae*

artium academiae scientiarum Hungaricae, XIII (1967), 9–12. (Typology)

Rupprecht, B., 'Villa. Zur Geschichte eines Ideals', in *Probleme der Kunstwissenschaft, II: Wandlungen des paradiesischen und utopischen. Studium zum Bild eines Ideals*, Berlin, 1966, 210–50.

Smith, G., 'The stucco decoration of the Casino of Pius IV', *Zf.KG*, 1974, 116–56. (Totally pagan)

266 Ackerman, J., 'The Belvedere as a classical villa', *JWCI*, XIV (1951), 70–91.

267 Ackerman, J., *The Cortile del Belvedere*, Vatican City, 1954.

268 *Ackerman, J., 'Sources of the Renaissance villa', in *Acts*, II, 6–18. (Emphasizes un-antique appearance of early villas)

269 Ashby, T., 'The Villa d'Este at Tivoli and the collection of classical sculptures which it contained', *Archeologia*, LXI (1908), 219–56.

270 Beck, I., 'Il capitello composito a volute invertite. Saggio su una forma antica nella struttura borrominiana', *Analecta Romana Instituti Danici*, V (1969), 225–33.

271 Beck, I., 'Ut ars natura—ut natura ars. Le ville di Plinio e il concetto del giardino nel Rinascimento', *Analecta Romana Instituti Danici*, VII (1971), 109–56.

272 Bentmann, R., and Müller, M., 'Materialen zur italienischen Villa der Renaissance', *Architectura*, II (1972), 167–91. (Thematic extracts from antique and Renaissance authors, with index)

273 Billig, R., 'Die Kirchenpläne al modo antico von Sebastiano Serlio', *Opuscula Romana*, I (1954), 21–38.

274 Blunt, A., Introduction to The Renaissance and Mannerism Acts, III, 3–11. (Quotation, 11)

275 Bonelli, R. (ed.), *Bramante tra umanesimo e manierismo*, exhibition catalogue, Rome, 1970. (Reconstructions in model form of the Belvedere: plates XIX–XXVII)

276 Bruschi, A., 'Orientamenti di gusto e indicazioni di teoria in alcuni disegni architettonici del Quattrocento', *Quaderni dell'Istituto di storia dell'architettura*, XIV (1967), 41–52. (Problems of Renaissance reconstructions)

277 Carunchio, T., *Origini della villa rinascimentale*, Rome, 1974.

278 Coffin, D. R., 'Pirro Ligorio on the nobility of the arts', *JWCI*, XXVII (1964), 191–210.

279 Coffin, D. R., *The Villa d'Este at Tivoli*, Princeton, 1960.

280 Contini, F., *Pianta della Villa Tiburtina di Adriano Cesare già da Pirro Ligorio*, Rome, 1751. (With additions to Pirro's plan)

281 Dacos, N., *La decouverte de la domus aurea et la formation des grotesques à la Renaissance*, London, 1969.

282 Ehrle, P., *Roma al tempo di Giulio III. La pianta di Roma di L. Bufalini del 1551*, Rome, 1911. (Summarizes previous plans, 7–13)

283 Fancelli, P., *Palladio e Praeneste. Archeologia, modelli, projettazione*, Rome, 1974.

284 Forster, K. W., 'Back to the farm. Vernacular architecture and the development of the Renaissance villa', *Architectura*, IV (1974), 1–12.

285 Franciscis, A. de, and Pane, R., *Mausolei Romani in Campania*, Naples, 1957. (On rich variety available to the Renaissance)

286 Frommel, C. L., 'La Villa Madama e la tipologia della villa romana nel Rinascimento', *Palladio*, XI (1969), 47–64. (Survey of antique influences; N.B. this issue of the periodical devoted to the subject of the villa, with survey articles and detailed studies)

287 Gombrich, E. H., 'Hypnerotomachiana', *JWCI*, XIV (1951), 119–25. (Bramante's classical garden in the Vatican)

288 Gould, C., 'Sebastiano Serlio and Venetian painting', *JWCI*, XXV (1962), 56–64. (Painted 'reconstructions' of the antique)

289 Heydenreich, L. H., 'Der Palazzo Baronale der Colonna in Palestrina', in G. Kauffmann and W, Sauerländer (eds.), *Walter Friedländer zum 90. Geburtstag*, Berlin, 1965, 85–91.

290 Hülsen, C., 'Bramante und Palestrina', in *Festschrift für Hermann Egger*, Graz, 1933, 57ff.

291 Hunt, J. D., 'Gardening, and poetry and Pope', *AQ*, XXXVII (1974), 1–30. (19–23 for Castelli's reconstructions)

292 Kähler, H., *Hadrian und seine Villa bei Tivoli*, Berlin, 1950. (Plates 15 and 16 for the reconstruction of the Piazza d'Oro)

293 Kretzulesco Quaranta, E., 'L'itinerario archeologico di Polifilo: L. B. Alberti come teorico della *Magna Porta*', *Atti dell'accademia nazionale dei Lincei. Rendiconti, classi di scienze morali, storiche e filologiche*, XXV (1970), 175–201. (Especially 186ff.)

294 Lehmann, K., 'The ship fountain from *The Victory of Samothrace* to the *Galeria*', in P. W. and K. Lehmann, *Samothracian reflections. Aspects of the revival of the antique*, Princeton, 1973, 180–259.

295 Lightbown, R. W., 'Nicholas Audebert and the Villa d'Este', *JWCI*, XXVII (1964), 164–90. (Quotation, 175)

296 Lugli, G., *La Villa d'Orazio*, Rome, 1930. (7ff. for early interest in antique villas)

297 *Mandowsky, E., and Mitchell, C., *Pirro Ligorio's Roman antiquities*, London, 1963. (7–20 for summary of archaeology to the mid-century)

298 Michailova, M., 'Mausolei romani nei disegni di un architetto italiano del Rinascimento all'Ermitage di Leningrado', *Palladio*, XIX (1969), 3–13. (Fra Giocondo)

299 Neuerberg, N., *L'architettura delle fontane e dei ninfei nell'Italia antica*, Naples, 1965.

300 Neuerberg, N., 'Raphael at Tivoli and the Villa Madama', in L. F. Sandler (ed.), *Essays in honour of Karl Lehmann*, New York, 1964, 227–41.

301 Redig de Campos, D., *I palazzi vaticani*, Bologna, 1967. (Belvedere on 124ff., 134ff., 147ff., and 167ff.)

302 Saccomani, E., 'Le "grottesche" venete del '500', *Atti dell'istituto veneto di scienze, lettere ed arti*, CXXIX (1970–1), 293–343.

303 Schülz, J., 'Pinturicchio and the revival of antiquity', *JWCI*, XXV (1962), 35–55.

304 Tanzer, H. H., *The villas of Pliny the Younger*, New York, 1924. (List of reconstructions: 45–135)

305 Zander, G., 'Le invenzioni architettoniche di G. B. Montano Milanese', *Quaderni dell'istituto di storia dell'architettura*, XXX (1958), 1–21; XLIX (1962), 1–32.

306 Zorzi, G., *I disegni delle antichità di Andrea Palladio*, Venice, 1959. (Cat. 23 for Temple of Fortuna)

245

307 Zorzi, G., 'Progetti giovanili di Andrea Palladio per villini e case di campagna', *Palladio*, IV (1954), 59–76. (Circular staircase idea)

308 Zorzi, G., 'Il Tempio della Fortuna Primigenia di Palestrina nei disegni di Andrea Palladio', *Palladio*, I (1951), 145–52.

309 Zorzi, G., 'La "Villa di Mecenate" e il Tempio di Ercole Vincitore a Tivoli nei disegni di Andrea Palladio', *Palladio*, VII (1957), 149–71.

4 Nicola Pisano and Giotto, Founders of Renaissance Classicism

Nicola Pisano

Coletti, L., 'Il problema di Nicola Pisano', *Belle arti*, I (1946), 9–18, 65–75.

Crichton, G. H., and E. R., *Nicola Pisano and the revival of sculpture in Italy*, Cambridge, 1938.

Jullian, R., *L'éveil de la sculpture italienne. La sculpture romane dans l'Italie du nord*, Paris, 1949.

*Pope-Hennessy, J., *Italian gothic sculpture*, London, 1955.

Swarzenski, G., *Nicola Pisano*, Frankfurt-am-Main, 1926. (Nicola and the Antique Master at Rheims)

Valentiner, W. R., 'Studies on Nicola Pisano', *AQ*, XV (1952), 9–36.

310 Bottari, S., 'Commentari capuani per Nicola Pisano', *Cronache di archeologia e storia dell'arte*, 1963, 84–122.

311 Bottari, S., 'Nicola Pisano e la cultura meridionale', in his *Saggi su Nicola Pisano*, Bologna, 1969, 1–13. (Comparative plates)

312 Paatz, W., 'Italien und die künstlerichen Bewegungen der Gotik und Renaissance', *Römisches Jahrbuch für Kunstgeschichte*, V (1941), 165–222. (173ff. for Nicola Pisano)

313 Papini, R., 'Pro-memoria sulla classicità di Giovanni Pisano', in *Miscellanea di storia dell'arte in onore di Igino Benvenuto Supino*, Florence, 1933, 113–23. (Giovanni and a Roman battle sarcophagus in the Termi)

314 Pistoia: Conference, *Il gotico a Pistoia nei suoi rapporti con l'arte gotica italiana* (Atti del 2 convegno internazionale di studi, Pistoia, 1966), Rome, 1972. (With text of a lecture on the Pistoia Pulpit, 165–79)

315 Sanpaolesi, P., 'Ispirazioni da un modello di scultura classica in Pisa nel XII e XIII secolo', *Mitt.KHIF*, VII (1953/6), 280–2. (Sarcophagus from the portal of S. Paolo a Ripa d'Arno)

316 Seidel, M., 'Studien zur Antikenrezeption Nicola Pisanos', *Mitt.KHIF*, XIX (1975), 307–92. (98 illustrations and many exact comparisons)

317 Weinberger, M., 'Nicola Pisano and the tradition of the Tuscan pulpits', *GBA*, LV (1960), 129–46.

318 Weise, G., *L'Italia e il mondo gotico*, Florence, 1956. (Gothic strain, thirteenth to fifteenth centuries)

Giotto

Baxandall, M., *Giotto and the orators: humanist observers of painting in Italy and the discovery of pictorial composition, 1340–1450*, London and New York, 1971. ('. . . the grammar and rhetoric of a language may substantially affect our manner of describing and, then, of attending to pictures . . .')

319 Alpatoff, M., 'The parallelism of Giotto's Paduan frescoes', *AB*, XXIX (1947), 149–54. (Reprinted in Stubblebine (no. 326 below)

320 Cole, B., 'Old in new in the early Trecento', *Mitt.KHIF*, XVII (1973), 229–48. ('Passionate nostalgia' for earlier styles)

321 Denny, D., 'Some symbols in the Arena Chapel frescoes', *AB*, LV (1973), 205–12.

322 Offner, R., 'Giotto, non-Giotto', *BM*, LXXIV (1939), 259–68. (Reprinted in Stubblebine, no. 326 below)

323 Paeseler, W., 'Giottos *Navicella* und ihr Spätantikes Vorbild', *Römisches Jahrbuch für Kunstgeschichte*, V (1941), 50–162.

324 Smart, A., *The Assisi problem and the art of Giotto*, Oxford, 1971. (83–106 for summary of borrowings from Antiquity)

325 Stubblebine, J. H., 'Byzantine influence on 13th century Italian panel painting', *Dumbarton Oaks Papers*, XX (1966), 87–101.

326 *Stubblebine, J. H., *Giotto: the Arena Chapel frescoes*, London, 1969. (Includes various reprinted articles)

327 Telpaz, A. M., 'Some antique motifs in Trecento art', *AB*, XLVI (1964), 372–6.

328 White, J., *Art and architecture in Italy, 1250–1400*, Harmondsworth, 1966. (94–107 for Cavallini)

329 White, J., 'Cavallini and the lost frescoes of S. Paolo', *JWCI*, XIX (1956), 84–95.

330 White, J., 'Giotto's use of architecture in *The Expulsion of Joachim* and *The Entry into Jerusalem* at Padua', *BM*, CXV (1973), 439–47. (On Giotto's 'sense of history')

5 The Early Renaissance

Sculpture and civic pride

Becker, M. B., *Florence in transition*, 2 vols, Baltimore, 1968, (II, 25–98: 'Florentine polis and culture at the advent of civic humanism')

Chastel, A., *Art et humanisme au temps de Laurent le Magnifique*, Paris, 1961. (Best introduction to Early and High Renaissance)

Meyer-Weinschel, A., *Renaissance und Antike. Beobachtungen über das Aufkommen der antikisierenden Gewandgebung in der Kunst der italienischen Renaissance*, Reutlingen, 1933. (244 illustrations)

331 Baron, H., 'Cicero and the Roman civic spirit in the middle ages and the early Renaissance', *Bulletin of the John Rylands Library*, XXII (1937), 72–97.

332 Baron, H., *The Crisis of the Early Italian Renaissance. Civic Humanism and Republican Liberty in an Age of Classicism and Tyranny*, rev. edn, Princeton, 1966.

333 Fiocco, G., 'I Lamberti a Venezia—II: Pietro di Niccolo Lamberti', *Dedalo*, VIII (1927/8), 343–76.

334 Gordon, D. J., 'Giannotti, Michelangelo and the cult of Brutus' in D. J. Gordon (ed.), *Fritz Saxl . . . A volume of memorial essays . . .*, London, 1957, 281–96. (For a later example of politics and art)

335 Hartt, F., 'Art and freedom in Quattrocento Florence', in L. F. Sandler (ed.), *Essays in memory of Karl Lehmann*, New York, 1964, 114–31. (Quotation, 117)

336 *Janson, H. W., 'The revival of antiquity in early Renaissance sculpture', in *Mediaeval and Renaissance Studies* (Proceedings of the Southeastern Institute of Mediaeval and Renaissance Studies, summer 1969), Chapel Hill (1971), 80–102.

337 Martines, L., *The social world of the Florentine humanists, 1390–1460*, London, 1963. (271–86: 'The genesis of civic humanism')

338 Seymour, C., 'The younger masters of the first campaign of the Porta della Mandorla', *AB*, XLI (1959), 1–17.

Ghiberti

339 *Krautheimer, R., *Lorenzo Ghiberti*, Princeton, 1956. (56: Hercules Master; Ch. XIX: Coluccio Salutati and artists)

340 Valentiner, W. R., 'Donatello and Ghiberti', in his *Studies in Italian Renaissance sculpture*, London, 1950, 44–69.

Donatello

Francovich, G. de, 'Appunti su Donatello e Jacopo della Quercia', *Bollettino d'Arte*, IX (1929), 145–71. (Donatello and Roman portraiture)

*Janson, H. W., *The sculpture of Donatello*, 2nd edn, Princeton, 1963.

Picard, C., 'Donatello et l'antique', *Revue archéologique*, XXVIII (1947), 77–8. (Classical Greek art)

Valentiner, W. R., 'Donatello and the mediaeval front plane relief', in his *Studies in Italian Renaissance Sculpture*, London, 1951, 1–21. (Donatello and the Middle Ages)

341 Barasch, M., 'Character and physiognomy: Bocchi on Donatello's *St George*. A Renaissance text on expression in art', *JHI*, XXXVI (1975), 413–30. (Text published 1584, written 1571)

342 Bovini, G., 'Le vicende del *Regisole*', *Felix Ravenna*, XXVI (1963), 138–54. (Literature and influence)

343 Burger, F., 'Donatello und die Antike', *Repertorium für Kunstwissenschaft*, XXX (1907), 1–13. (Trajan's Column and the Paduan reliefs)

344 Erffa, H. M. von, 'Judith-Virtus Virtutum-Maria', *Mitt.KHIF*, XIV (1970), 460–5. (Medieval and Marian connections of the *Judith and Holofernes*)

345 Forsyth, J. H., 'Magi and majesty: a study of Romanesque sculpture and liturgical drama', *AB*, L (1968), 215–22.

346 Friis, H., *Rytterstatuens Historie i Europa fra Oldtiden indtil Thorvaldsen*, Copenhagen, 1933. (283 illustrations)

347 Heydenreich, L. H., 'Marc Aurel und Regisole' in W. Gramberg, *et al.* (eds.), *Festschrift für Erich Meyer zum Sechzigsten Geburtstag. Studien zu Werken in den Sammlungen des Museums für Kunst und Gewerbe Hamburg*, Hamburg, 1959, 146–59.

348 *Janson, H. W., 'Donatello and the antique', in *Donatello e il suo tempo* (Atti del VIII convegno internazionale di studi sul rinascimento), Florence, 1968, 77–96.

349 Janson, H. W., 'The equestrian monument from Cangrande della Scala to Peter the Great', in A. R. Lewis (ed.), *Aspects of the Renaissance*, Austin and London, 1967, 73–85.

350 Janson, H. W., 'Giovanni Chellini's *libro* and Donatello', in *Studien zur toskanischen Kunst. Festschriften für Ludwig Heydenreich*, Munich, 1964, 131–8. (Terracotta *Joshua* and its fame)

351 Lavin, I., 'The sources of Donatello's pulpits in San Lorenzo', *AB*, XLI (1959), 19–38.

352 Lehmann, P. W., 'Theodosius or Justinian? A Renaissance drawing of a Byzantine rider', *AB*, XLI (1959), 39–57. (Donatello would have known of the *Justinian* in Constantinople)

353 Mariani, V., 'Donatello', in his *Incontri con Roma nel Rinascimento*, Rome, 1960, 25–36.

354 Martinelli, V., 'Donatello e Michelozzo a Roma', *Commentari*, VIII (1957), 167–94; IX (1958), 3–24.

355 Mormone, R., 'Donatello, Michelozzo e il Monumento Brancacci', *Cronache di archeologia e di storia dell'arte* (1966), 121–33.

356 Nicco, G., 'Jacopo della Quercia e il problema del classicismo', *L'arte*, XXXII (1929), 126–37.

357 Pope-Hennessy, J., *Donatello's relief of The Ascension with Christ giving the keys to St. Peter*, London, 1949.

358 Pope-Hennessy, J., 'The forgery of Italian Renaissance sculpture', *Apollo*, XCIX (1974), 242–67. (Lasting vogue for the 'sweet style')

359 Pope-Hennessy, J., *The Virgin with the laughing Child*, London, 1957.

360 Roques de Maumont, H. von, *Antike Reiterstandbilder*, Berlin, 1958.

361 Seymour, C., *Sculpture in Italy, 1400–1500*, Harmondsworth, 1966. (90, table 3 for comparative proportions)

362 Siren, O., 'The importance of the antique to Donatello', *American Journal of Archeology*, XVIII (1914), 438–61.

363 White, J., 'Donatello's High Altar in the Santo at Padua', *AB*, LI (1969), 1–14, 119–41.

Masaccio

Beck, J. H., 'Masaccio's early career as a sculptor', *AB*, LIII (1971), 177–95.

Sandström, S., *Levels of unreality. Studies in structure and construction in Italian mural painting during the Renaissance*, Uppsala, 1963.

364 Dempsey, C., 'Masaccio's *Trinity*: altarpiece or tomb?', *AB*, LIV (1972), 279–81. (Conversion from tomb to altar)

365 Meiss, M., 'Masaccio and the early Renaissance: the circular plan', in *Acts*, II, 123–45.

366 *Mesnil, J., 'Masaccio and the antique', *BM*, XLVIII (1926), 91–8.

367 Polzer, J., 'Masaccio and the late antique', *AB*, LIII (1971), 36–40. (Origin of *The Tribute Money* in a lost fresco in S. Paolo, Rome)

Piero della Francesca

Battisti, E., *Piero della Francesca*, 2 vols, Milan, 1971.

*Clark, K., *Piero della Francesca*, 2nd edn, London, 1969.

Clough, C. H., 'Piero della Francesca: some problems of his art and chronology', *Apollo*, XCI (1970), 278–89.

Gilbert, C., *Change in Piero della Francesca*, New York, 1969.

White, J., *The birth and rebirth of pictorial space*, London, 1957.

368 Clark, K., 'Leon Battista Alberti on painting', *Proceedings of the British Academy*, XXX (1944), 283–302.

369 Salmi, M., *Piero della Francesca e il Palazzo Ducale di Urbino*, Florence, 1945. (Piero's architectural knowledge)

370 Westfall, C. W., 'Painting and the liberal arts: Alberti's view', *JHI*, XXX (1969), 487–506.

371 Wittkower, R., and Carter, B. A. R., 'The perspective of Piero della Francesca's *Flagellation*', *JWCI*, XVI (1953), 292–303.

Mantegna

*Kristeller, P., *Andrea Mantegna*, London, 1901. (Fundamental)

Low, P., 'The knowledge and influence of classical sculpture in Venice and Padua *c.* 1460–1530', unpublished M.A. Report, University of London, Courtauld Institute, 1973. (I have not seen this item)

Paccagnini, G., and Mezzetti, A. (eds.), *Andrea Mantegna*, Exhibition catalogue, Venice, 1961.

Paccagnini, G., 'Il Mantegna e la plastica dell'Italia settentrionale', *Bollettino d'arte*, XLVI (1961), 65–100.

Romanini, A. M., 'L'itinerario pittorico del Mantegna e il 'primo' rinascimento padano-veneto', in *Arte in Europa. Scritti di storia dell'arte in onore di Edoardo Arslan*, Milan, 1966, 437–64.

Sparrow, J., *Visible words. A study of inscriptions in and as books and works of art*, Cambridge, 1969. (See Ch. II for the Renaissance)

372 Archangeli, F., 'Un nodo problematico nei rapporti fra Leon Battista Alberti e il Mantegna', in *Il Sant' Andrea di Mantova e Leon Battista Alberti* (Conference, Mantua, 1972), Mantua, 1974, 189–203.

373 Battisti, E., 'Il Mantegna e la letteratura classica', in *Arte, pensiero e cultura a Mantova nel primo rinascimento* (VI convegno internazionale di studi sul rinascimento, 1961), Florence, 1965, 23–56.

374 Chirol, E., 'L'influence de Mantegna sur la Renaissance en Normandie', in *Actes du XIXe congrès international d'histoire de l'art*, Paris, 1959, 240–7.

375 Fasolo, V., 'L'ispirazione romana negli sfondi architettonici del Mantegna', *Palladio*, XIII (1963), 79–84.

376 Fiocco, G., 'Il museo imaginario di Francesco Squarcione', *Atti e memorie dell'Accademia patavina di scienze, lettere ed arti*, LXXI (1958/9), 59–72.

377 Hartt, F., 'The earliest works of Andrea del Castagno', *AB*, XLI (1959), 159–81, 225–36.

378 Knabenshue, P. D., 'Ancient and mediaeval elements in Mantegna's *Trial of St. James*', *AB*, XLI (1959), 59–73.

379 Lehmann, P. W., 'An antique ornament set in a Renaissance tower: Cyriacus of Ancona's Samothracian nymphs and muses', *Revue archéologique* (1968), 197–214.

380 Lehmann, P. W., 'The sources and meaning of Mantegna's *Parnassus*' in P. and K. Lehmann, *Samothracian reflections. Aspects of the revival of the antique*, Princeton, 1973. 58–178. (Mantegna's knowledge of Ciriaco's drawings)

381 Levenson, J. A., Oberhüber, K., and Sheenan, J. L., *Early Italian engravings from the National Gallery of Art*, Washington, 1973. (165*ff*. for survey of Mantegna's influence)

382 Levi, A., 'Rilievi di sarcophagi del Palazzo Ducale di Mantova', *Dedalo*, VII (1926/7), 205–30.

383 Luzio, A., *La galleria dei Gonzaga . . . documenti degli archivi di Mantova e Londra*, Milan, 1913.

384 Mariani, V., 'Andrea Mantegna', in his *Incontri con Roma nel Rinascimento*, Rome, 1961, 39–49.

385 Meiss, M., *Andrea Mantegna as illuminator*, New York, 1947. (68–77 for Feliciano)

386 Meiss, M., 'Toward a more comprehensive Renaissance palaeography', *AB* XLII (1960), 97–112. (Mantegna as reviver of Imperial Roman majuscule)

387 Moschetti, A., 'Le iscrizioni lapidarie romane negli affreschi del Mantegna agli Eremitani', *Atti del reale istituto veneto di scienze, lettere ed arti*, LXXXIX (1929/30), 227–39.

388 Muraro, M., 'Mantegna e Alberti', in *Arte, pensiero e cultura a Mantova nel primo Rinascimento* (Atti del VI congresso internazionale di studi sul rinascimento, 1961) Florence, 1965, 103–32.

389 Pogány-Balás, E., 'On the problems of an antique archetype of Mantegna's and Dürer's', *Acta historiae artium*, XVII (1971), 77–89. (Influence of Mantegna's prints)

390 Pogány-Balás, E., 'Problems of Mantegna's destroyed fresco in Rome, representing *The Baptism of Christ*', *Acta historiae artium*, XVIII (1972), 107–24. (Fame, connections with the antique)

391 Salmi, M., 'Andrea Mantegna e l'umanesimo', *Rinascimento*, I (1961), 95–103.

392 *Saxl, F., 'Jacopo Bellini and Mantegna as antiquarians', in his *Lectures*, 2 vols, London, 1957, 150–60.

393 Schmitt, A., 'Francesco Squarcione als Zeichner und Stecher', *Münchner Jahrbuch*, XXV (1974), 205–13.

394 Scott-Elliot, A. H., 'The statues from Mantua in the collection of King Charles I', *BM*, CI (1959), 218–27.

395 Tamassia, A. M., 'Visioni di antichità nell'opera del Mantegna', *Atti della pontifica accademia romana di archeologia: rendiconti*, XXVIII (1954/5), 213–49. (Squarcione as teacher of Mantegna)

396 Vermeule, C., 'A Greek theme and its survivals: the ruler's shield (tondo image) in tomb and temple', *Proceedings of the American philosophical society*, CIX (1965), 361–97.

6 The High Renaissance

Leonardo da Vinci

Allison, A. H., 'Antique sources of Leonardo's *Leda*', *AB*, LVI (1974), 375–84.

* Freedberg, S. J., *Painting in Italy, 1500–1600*, Harmondsworth, 1971.

Freedberg, S. J., *Painting of the High Renaissance in Rome and Florence*, 2 vols, Cambridge, Mass., 1961. (Sensitive; good corpus of plates)

397 Chastel, A., 'Les capitaines affrontés dans l'art du 15e siècle', *Mémoires de la société nationale des antiquaires de France*, IX (1954), 279–89.

398 Clark, K., *Leonardo da Vinci*, London, 1939. (Quotation, 41, from Penguin edn, 1959)

399 *Clark, K., 'Leonardo and the antique', in C. D. O'Malley (ed.), *Leonardo's Legacy*, Berkeley and Los Angeles, 1969, 1–34.

400 Gould, C., 'Leonardo's great battle-piece: a conjectural reconstruction', *AB*, XXXVI (1954), 117–29.

401 Isermeyer, C. A., 'Die Arbeiten Leonardos und Michelangelos für den grossen Ratsaal in Florenz', in *Studien zur toskanischen Kunst. Festschrift für Ludwig Heydenreich*, Munich, 1964, 83–130. (With bibliography)

402 Pogány-Balás, E., 'Remarques sur les têtes de guerriers de Léonard de Vinci et le portrait colossal en bronze de Constantin', *Bulletin du musée hongrois des beaux-arts*, XLII (1974), 41–54.

403 Posner, K. W. G., *Leonardo and Central Italian art: 1515–1550*, New York, 1974. (17ff: 'Leonardo's dark manner and the challenge of antique painting')

404 Richter, I. A. (ed.), *Selections from the notebooks of Leonardo da Vinci*, London, 1952. (Quotations 176, 195, 225)

405 Shearman, J., 'Leonardo's colour and chiaroscuro', *Zf.KG*, XXV (1962), 13–47.

406 Soos, G., 'Antichi modelli delle statue equestri di Leonardo da Vinci', *Acta historiae artium*, IV (1956), 129–34.

407 Spencer, J. R., 'Sources of Leonardo da Vinci's *Sforza Monument*', in *Actes du XXIIe congrès international d'histoire de l'art, Budapest, 1969*, Budapest, 1972, II, 735–42.

408 Steinberg, L., 'Leonardo's *Last Supper*', *AQ*, XXXVI (1973), 297–410. (Full account with bibliography)

409 Steinitz, K. T., 'Leonardo da Vinci's concept of the antique', in *Proceedings of the fourth international congress of aesthetics*, Athens, 1960, 114–18.

410 Zoubov, V. P., 'Leon-Battista Alberti et Léonard da Vinci', *Raccola Vinciana*, XVIII (1962), 1–14.

Raphael

Dussler, L., *Raphael. A critical catalogue of his pictures, wall-paintings and tapestries*, English translation, London, 1971.

Hartt, F., 'Raphael and Giulio Romano, with notes on the Raphael school', *AB*, XXVI (1944), 67–94.

Huemer, F., 'Raphael and the Villa Madama', in *Essays in honour of Walter Friedländer*, New York, 1965, 92–9. (A supplementary volume to *Marsyas*)

*Pope-Hennessy, J., *Raphael*, London, 1970.

411 Alpatow, M., 'La Madonna di S. Sisto', *L'Arte*, LVI (1957), 25–50. (Originality and fame)

412 Arasse, D., 'Extases et visions béatifiques à l'apogée de la Renaissance: quatre images de Raphäel', *Mélanges d'archéologie et d'histoire*, LXXXIV (1972), 403–92. (Development of gesture and expression)

413 Badt, K., 'Raphael's *Incendio del Borgo*', *JWCI*, XXII (1959), 35–59.

414 Berström, I., *The revival of antique illusionistic wall-painting in Renaissance art*, Stockholm, 1957. (45–53 for Farnesina)

415 Blunt, A., 'The legend of Raphael in Italy and France', *Italian studies*, XIII (1958), 2–20.

416 Bottari, S., 'Raffaello alla Farnesina e la prima 'maniera' italiana', *Studi urbinati*, XXXVI (1962), 167–86.

417 Couprie, L. D., 'Rafael's Sposalizio. Een mathematische Analyse van de Compositie', *Simiolus*, II (1967–8), 134–44. (English summary)

418 Dacos, N., *La découverte de la 'domus aurea' et la formation des grotesques à la Renaissance*, London, 1969.

419 Dollmayr, H., 'Lo stanzino da bagno del Cardinal Bibbiena', *Archivio storico dell'arte*, III (1890), 272–80.

420 Euboeus, T. (pseudonym of Baron de Lepel), *Catalogue des estampes gravés d'après Rafael*, Frankfurt-am-Main, 1819.

421 Goldberg, V. L., 'The School of Athens and Donatello', *AQ*, XXXIV (1971), 229–36.

422 Golzio, V., *Raffaello nei documenti e nelle testimonianze dei contemporanei e nella letteratura del suo secolo*, Vatican City, 1936.

423 Gombrich, E. H., 'Raphael's *Segnatura* and the nature of its symbolism', in his *Symbolic images*, London, 1972, 85–101. (Refutes intricate and extravagant explanations)

424 Habig, I., 'Die Kirchenlehrer und die Eucharistie. Ein Beitrag zur *Disputa* Raffaels und zu einem Bildthema in ihrer Nachfolge', *Römische Quartalschrift für christliche Altertumskunde und Kirchengeschichte*, LXVIII (1973), 35–49.

425 Hoogewerff, G. J., 'Leonardo e Raffaello', *Commentari*, III (1952), 173–83. (Trivulzio projects and the *Heliodorus*)

426 Hoogewerff, G. J., 'Raphael en Leonardo da Vinci', *Mededelingen van het Nederlands Historisch Instituut te Rome*, IV (1947), 27–40.

427 Hoogewerff, G. J., 'Raffaello nella Villa Farnesina: affreschi ed arazzi', *Mededelingen van het Nederlands Historisch Instituut te Rome*, XXXI (1963), 5–19.

428 Hübner, P. G., 'Studien über die Benutzung der Antike in der Renaissance', *Monatshefte für Kunstwissenschaft*, II (1909), 273–80.

429 Hülsen, C., 'Die Halle in Raffaels *Schule von Athen*', *Mitt.KHIF*, IV (1911), 229–36.

430 Jenkins, M., *The state portrait: its origin and evolution*, New York, 1947.

431 Levey, M., 'Raphael revisited', *Apollo*, LXXVI (1962), 678–83. (Raphael as the 'most notorious victim of art history's embalming')

432 Loewy, E., 'Di alcune composizione di Raffaello ispirate a monumenti antichi', *Archivio storico dell'arte*, II (1896), 241–51. (In particular *The Judgement of Paris* and the *Ezechiel*)

433 Lotz, W., 'Raffaels *Sixtinische Madonna* im Urteil der Kunstgeschichte', *Jahrbuch der Max Planck Gesellschaft der Wissenschaften*, 1963. (I have not seen this item)

434 Mariani, V., 'Raffaello e il mondo classico'. *Studi romani*, VII (1959), 162–72.

435 Mazzini, F., 'Fortuna storica di Raffaello nel Cinquecento', *Rinascimento*, IV (1953), 67–78.

436 Müntz, E., *Les historiens et les critiques de Raphael, 1483–1883*, Paris, 1883.

437 Oberhuber, K., 'Die Fresken der Stanza dell'Incendio im Werk Raffaells', *JKHS*, LVIII (1962), 23–72.

438 Oberhuber, K., 'Vorzeichnungen zu Raffaels *Transfiguration*', *Jahrbuch der Berliner Museen*, IV (1962), 116–49.

BIBLIOGRAPHY

439 Piel, F., *Die Ornamente-Grotteske in der italienischen Renaissance zu ihrer kategorialen Struktur und Entstehung*, Berlin, 1962.

440 Posner, K., 'Raphael's *Transfiguration* and the legacy of Leonardo', *AQ*, XXXV (1972), 343–72.

441 Putscher, M., *Raphaels Sixtinische Madonna. Das Werk und seine Wirkung*, Tübingen, 1955.

442 Richter, I., 'The drawings for Raphael's *Entombment*: a contribution to the understanding of Raphael's art', *GBA*, XXVIII (1945), 335–56. (Contemporary Florentine milieu)

443 Salis, A. von, *Antike und Renaissance . . .* Erlenbach and Zurich, 1947. (190–223: antique precedents for the Farnesina)

444 Saxl, F., 'The Villa Farnesina', in his *Lectures*, 2 vols, London, 1957, 189–99.

445 Scheicher, E., 'Die Groteskenmonate eine Tapisserienserie des Kunsthistorisches Museum in Wien', *JKHS*, LXIX (1973), 55–84.

446 Shearman, J., 'Die Loggia der Psyche in der Villa Farnesina und die Probleme der letzen Phase von Raffaels graphischen Stil', *JKHS*, LX (1964), 59–100.

447 Shearman, J., *Raphael's Cartoons . . . and the tapestries for the Sistine Chapel*, London, 1972.

448 Sommer, C., 'A new interpretation of Raphael's *Disputa*', *GBA*, XXVIII (1945), 289–96. (As a glorification of the rebuilding of St Peter's)

449 Standen, E. A., 'Some sixteenth century Flemish tapestries related to Raphael's workshop', *Metropolitan Museum Journal*, IV (1971), 109–21.

450 *Stridbeck, C. G., *Raphael and tradition*, Stockholm, 1963. (Mainly concerning Early Christian influence on Raphael)

451 Traeger, J., 'Raffaels Stanza d'Eliodoro und ihr Bildprogram', *Römisches Jahrbuch für Kunstgeschichte*, XIII (1971), 30–99. (On the meaning of the frescoes)

452 Venturi, A., 'Il gruppo del *Laocoonte* e Raffaello', *Archivio storico dell'arte*, II (1889), 97–112.

453 Vito Battaglia, S. de, 'La stufetta del Cardinal Bibbiena', *L'arte*, XXIX (1926), 203–12.

454 Vöge, W., *Raffael und Donatello*, Strasburg, 1896.

455 Weizsacker, H., 'Raphaels *Galatea* im Lichte der antiken Uberlieferung', *Die Antike*, XIV (1938), 231–42. (Suggests the Aphrodite of Capua as a model)

456 White, J., and Shearman, J., 'Raphael's tapestries and their cartoons', *AB*, XL (1958), 193–221, 299–323.

Michelangelo

Gilbert, C., 'Texts and contexts of the Medici Chapel', *AQ*, XXXIV (1971), 391–408. (Survey of interpretations, with bibliography)

*Hibbard, H., *Michelangelo*, London, 1975.

Tolnay, C. de, *Michelangelo*, 5 vols, Princeton, 1943–60.

*Tolnay, C. de, *Michelangelo*, New Jersey, 1975. (Reduction of the above)

Wilde, J., 'The decoration of the Sistine Chapel', *Proceedings of the British Academy*, XLIV (1958), 61–81.

457 Barocchi, P., 'Schizzo di una storia della critica cinquecentesca sulla Sistina', *Atti e memorie dell'accademia toscana di scienze e lettere*, XX–XXI (1956), 175–212.

458 *Battisti, E., 'The meaning of classical models in the sculpture of Michelangelo', in *Akten*, II, 73–8. (Survey)

459 Battisti, E., 'Storia della critica su Michelangelo', in G. Gronchi (ed.), *Atti del convegno di studi michelangioleschi*, Rome, 1966, 177–200.

460 Bottari, S., 'Michelangelo anticlassico', *Il Verri*, XVII (1964), 16–31.

461 Brugnoli, M. V., 'Note sul rapporto Leonardo-Michelangelo', *Bollettino d'arte*, XL (1955), 124–40.

462 Chastel, A., 'Michel-Ange en France', in G. Gronchi (ed.), *Atti del convegno di studi michelangioleschi*, Rome, 1966, 261–78.

463 Chatelet Lange, L., 'Michelangelos *Herkules* im Fontainebleau', *Pantheon*, XXX (1972), 455–68.

464 Eisler, C., 'The Madonna of the Steps: problems of date and style', in *Akten 1964*, Berlin (1967), II, 115–21 (Seen as a Donatellesque pastiche)

465 Ettlinger, L., 'Hercules Florentinus', *Mitt.KHIF*, XVI (1972), 119–42.

466 Frazer, A., 'A numismatic source for Michelangelo's First Design for the Tomb of Julius II', *AB*, LVII (1975), 53–7.

467 Gombrich, E. H., 'A classical quotation in Michelangelo's *Sacrifice of Noah*', *JWCI*, I (1937/8), 69. (Meleager sarcophagus)

468 Hartt, F., '*Lignum vitae in medio paradisi*: The *Stanza della Segnatura* and The Sistine Ceiling', *AB*, XXXII (1950), 115–45, 181–218. (Ceiling as Tree of Jesse of the Pope; High Renaissance as result of Pope's personality and programme)

469 Heye, E., *Michelangelo im Urteil französischer Kunst des XVII und XVIII Jahrhunderts*, Strasburg, 1932.

470 Keutner, H., 'Über die Entstehung und die Formen des Standbildes im Cinquecento', *Münchner Jahrbuch*, VII (1956), 138–68.

471 Kleiner, G., *Die Begegnungen Michelangelos mit der Antike*, Berlin, 1949.

472 Kriegbaum, F., 'Michelangelo und die Antike', *Münchner Jahrbuch*, II/IV (1952/3), 10–36. (Concentrates on the Medici Chapel)

473 Levine, S., 'The location of Michelangelo's David and the meeting of January 25th 1504', *AB*, LVI (1974), 31–49. (Cf. answer by N. R. Parks in *AB*, LVII (1975), 560–70)

474 Lisner, M., 'Das Quattrocento und Michelangelo', *Akten, 1964*, II, 78–89.

475 Melchiori, G., *Michelangelo nel Settecento Inglese. Un capitolo del gusto in Inghilterra*, Rome, 1950.

476 Norton, P. F., ' The lost *Sleeping Cupid* of Michelangelo', *AB*, XXXIX (1957), 251–7. (History prior to disappearance)

477 Panofsky, E., 'The Neoplatonic movement and Michelangelo', in *Studies in Iconology*, New York, 1962, 171–230.

478 Parronchi, A., 'The language of Humanism and the language of sculpture: Bertoldo as illustrator of the *Apologi* of Bartolommeo Scala', *JWCI*, XXVII (1964), 108–36.

479 Parronchi, A., 'Sul probabile tipo del *Cupido dormiente* di Michelangelo', *Arte antica e moderna*, XXVII (1964), 281–94. (Prototype seen as sleeping hermaphrodite)

480 Seymour, C., '*Homo magnus et albus*. The Quattrocento

background for Michelangelo's *David* of 1501–4', *Akten 1964*, II, 96–105.

481 *Seymour, C., *Michelangelo's David. A search for identity*, Pittsburgh, 1967. (Antecedents, 21–66)

482 Tolnay, C. de, 'Donatello e Michelangelo', *Donatello e il suo tempo*, Florence, 1968, 259–75. (49 plates of comparisons)

483 Tolnay, C. de, 'Le madonne di Michelangelo. A proposito di due disegni della Vergine col Bambino al Louvre', *Mitt. KHIF*, XIII (1968), 343–66. (Antique elements)

484 Walton, F. R., 'Adam's ancestor', *Archaeology*, XIII (1960), 253–8.

485 Weizsäcker, H., 'Der David des Michelangelo in seinen Beziehungen zur Antike', *Jahrbuch der Preussischen Kunstsammlungen*, LXI (1940), 163–72.

486 Wilde, J., 'Michelangelo and Leonardo', *BM*, XCV (1953), 65–77.

487 Wilde, J., 'Eine Studie Michelangelos nach der Antike', *Mitt.KHIF*, IV (1932/4), 41–64. (Antiquity and Florentine forebears)

Titian and Roman classicism

* Kennedy, R. W., *Novelty and tradition in Titian's art*, Northampton, Mass., 1963.

Kennedy, R. W., 'Tiziano in Roma', in *Il mondo antico nel rinascimento* (Atti del V convegno internazionale di studi sul rinascimento, Florence, 1956), Florence, 1958, 237–43.

Rosand, D., 'Titian in the Frari', *AB*, LIII (1971), 196–213. (Paintings in their setting)

Roskill, M. W., *Dolce's Aretino and Venetian art theory of the Cinquecento*, New York, 1968. (75–82 on relations between Venice and Central Italy, 1500–57)

488 Brendel, O. J., 'Borrowings from ancient art in Titian', *AB*, XXXVII (1955), 113–25.

489 Caldwell, M. P., 'The public display of sculpture in Venice, 1200–1600', unpublished Ph.D. thesis, London University, 1975. (Chapters on 'Legend and history' and on the Grimani Collection)

490 Candida, B., *I calchi rinascimentali della collezione Mantova Benavides nel Museo del Liviano a Padova*, Padua, 1967. (Cf. review by N. Dacos in *Archeologia classica*, XXI (1969), 101–4)

491 Fletcher, J., 'Marcantonio Michiel's collection', *JWCI*, XXXVI (1973), 382–5.

492 Fubini, G., and Held, J. S., 'Padre Resta's Rubens drawings after antique sculpture', *Master drawings*, II (1964), 123–41. (Unusual viewpoints)

493 Gould, C., 'Correggio and Rome', *Apollo*, LXXXIII (1966), 328–37.

494 Meiss, M., 'Sleep in Venice. Ancient myths and renaissance proclivities', *Proceedings of the American Philosophical Society*, CX (1966), 348–82. (*Locus classicus* of sleeping figure, 'as Florence was of the figure that struggles and aspires . . . expressive of their concepts of love, of life, and of the power of natural generation')

495 Perry, M., 'A Greek bronze in renaissance Venice', *BM*, CXVII (1975), 204–11.

496 Rosand, D., 'Titian and the *Bed of Polycletes*', *BM*, CXVII (1975), 242–5.

497 Smart, A., 'Titian and the *Toro Farnese*', *Apollo*, LXXXV (1967), 420–31.

Classicism and mannerism: the growth of academies

Clark, K., *A failure of nerve*, H. R. Bickley Memorial Lecture, Oxford, 1967.

Dumont, C., 'Le maniérisme. Etat de la question', *Bibliothèque d'humanisme et de renaissance*, XXVIII (1966), 439–57.

Friedländer, W., *Mannerism and anti-mannerism in Italian painting*, New York, 1957.

Gombrich, E. H., 'Introduction: the historiographic background', *Acts*, II, 163–73. (Survey with texts)

Ivanoff, N., 'Stile e maniera', *Saggi e memorie*, I (1957), 109–63. (Use of terms from 16th century)

Shearman, J., '*Maniera* as an aesthetic ideal', in *Acts*, II, 200–21.

*Shearman, J., *Mannerism*, Harmondsworth, 1967.

498 Barocchi, P., 'Michelangelo e il manierismo', *Arte antica e moderna*, XXVII (1964), 260–80.

499 Curtius, E. R., *European literature and the latin middle ages*, English translation, London, 1953, 273*ff*.

500 Freedberg, S. J., 'Observations on the painting of the *maniera*', *AB*, XLVII (1965), 187–97. (Good straightforward account)

501 Goldstein, C., 'Towards a definition of academic art', *AB*, LVI (1974), 102–9.

502 Goldstein, C., 'Vasari and the Florentine *Accademia del disegno*', *Zf.KG*, XXXVIII (1975), 145–72.

503 Labrot, M. G., 'Conservatisme plastique et expression rhétorique. Réflexions sur le développement de l'académisme en Italie centrale', *Melanges d'archéologie et d'histoire*, LXXVI (1964), 555–624.

504 Pevsner, N., *Academies of art, past and present*, Cambridge, 1940.

505 Pevsner, N., 'The Counter-Reformation and mannerism', in his *Studies in art, architecture and design*, I, London, 1968, 11–33.

506 Summers, D., 'Maniera and movement: the *figura serpentinata*', *AQ*, XXXV (1972), 269–301. (Development of classicizing *contrapposto*)

507 Weise, G., *Il manierismo, Bilancio critico del problema stilistico e culturale*, Florence, 1971. (Full survey of the problem; useful plates)

508 *Wölfflin, H., *Classic art*, English translation, London, 1952.

7 Classicism in Italian Architecture

Brunelleschi

*Heydenreich, L. H., and Lotz, W., *Architecture in Italy, 1400–1600*, Harmondsworth, 1974.

Murray, P., 'The Italian Renaissance architect', *Journal of the Royal Society of Arts* (1966), 589–607. (Approach to, and use of, antiquity)

Pellati, F., 'Vitruvio e il Brunelleschi', *La Rinascita*, II (1939), 343–65. (I have not seen this item)

BIBLIOGRAPHY

509 Argan, G. C., 'The architecture of Brunelleschi and the origins of perspective theory in the 15th century', *JWCI*, IX (1946), 96–121.

510 Bruschi, A., 'Considerazioni sulla "maniera matura" del Brunelleschi, con un'appendice sulla Rotonda degli Angeli', *Palladio*, XXII (1972), 89–126.

511 *Burns, H., 'Quattrocento architecture and the antique: some problems', in R. R. Bolgar (ed.), *Classical influences on European culture, A.D. 500–1500*, Cambridge, 1971, 269–87.

512 Cadei, A., 'Coscienza storica e architettura in Brunelleschi', *Rivista dell'istituto nazionale d'archeologia e storia dell'arte*, XVII (1971), 181–240.

513 Fontana, P., 'Il Brunelleschi e l'architettura classica', *Archivio storico dell'arte*, VI (1893), 256–67.

514 Hofmann, V., 'Brunelleschis Architektursystem', *Architectura*, I (1971), 54–71. (Plus sources and influence)

515 Klotz, H., *Die Frühwerk Brunelleschis und die mittelalterliche Tradition*, Berlin, 1970.

516 Prager, F. D., and Scaglia, G., *Brunelleschi: studies of his technology*, Cambridge, Mass., 1970. (On his interest in Roman masonry, cf. Prager in *Osiris* IX, 1950)

517 Saalman, H., 'Filippo Brunelleschi: capital studies', *AB*, XL (1958), 113–37.

518 Saalman, H. (ed.), *The life of Brunelleschi by Antonio di Tuccio Manetti*, University Park, Pennsylvania and London, 1970. (Quotation, 50–2)

519 Waddy, P., 'Brunelleschi's design for S. Maria degli Angeli in Florence', *Marsyas*, XV (1970/2) 36–45.

The centrally planned church: a Renaissance ideal

Licht, K. de F., *The Rotunda in Rome. A study of Hadrian's Pantheon*, Copenhagen, 1968. (203–26, 249–51, for influence)

MacDonald, W. L., *The Pantheon. Design, meaning, progeny*, London, 1976. (94*ff.* for progeny)

520 Hautecoeur, L., *Mystique et architecture: symbolisme du cercle et de la coupule*, Paris, 1954.

521 Lötz, W., 'Notizien zum kirchlichen Zentralbau der Renaissance', in W. Lötz and L. L. Moller (eds.), *Studien zur toskanischen Kunst. Festschrift für L. H. Heydenreich*, Munich, 1964, 157–65. (Especially 158–61).

522 * Meeks, C. V., 'Pantheon paradigm', *JSAH*, XIX (1960), 135–44.

523 Sinding-Larsen, S., 'Some functional and iconographical aspects of the centralised church in the Italian Renaissance', *Acta ad archeologiam et artium historiam pertinentia*, II (1965), 203–52. (204*ff.* for liturgical problems)

524 Stettler, M., 'Von römischen zum christlichen Rundbau. Eine raumgeschichtliche Skizze', *Museum Helveticum*, VIII (1951), 260–70.

525 Van Regteren Altena, I. Q., 'Hidden records of the Holy Sepulchre', in D. Fraser, *et al.* (eds.), *Essays in the history of architecture presented to R. Wittkower*, London, 1967, 17–21.

Alberti, architect and scholar

(Alberti) 'Omaggio ad Alberti', *Studi e documenti di architettura*, I (December 1972). (By various contributors; critical bibliography at 15–56)

Argan, G. C., 'Alberti' in *Dizionario biografico degli Italiani*, I, 1960.

Johnson, E. J., *S. Andrea in Mantua: the building history*, University Park and London, 1975. (With much on sources)

Juřen, V., 'Le projet de Giuliano da Sangallo pour le palais du roi de Naples', *RA*, XXV (1974), 66–70. (Alberti and antiquity; summary of research)

Mantua: Conference, *Il Sant'Andrea di Mantova e Leon Battista Alberti* (Conference on quincentenary of his death, Mantua, 1972), Mantua, 1974.

*Wittkower, R., *Architectural principles in the age of humanism*, 3rd edn, London, 1962. (3–13: 'Alberti's programme of the ideal church')

Zoubov, V. P., L.-B. Alberti et Léonard de Vinci', *Raccolta Vinciana*, XVIII (1961), 1–14. (Survey of influence)

526 Borsi, F., 'I cinque ordini architettonici e L. B. Alberti', in 'Omaggio ad Alberti' (cited above), 59–130.

527 Bulman, L. M., 'Artistic patronage at SS. Annunziata, 1440–c. 1520', unpublished Ph.D. thesis, London University, 1971. (Section III for the tribune; III, 27–36 for Alberti's hand in the design)

528 Ciapponi, L. A., 'Il *De Architectura* di Vitruvio nel primo Rinascimento', *IMU*, III (1960), 59–99.

529 Fallico, R. S., 'L'Alberti e l'antico nel *De re aedificatoria*', in *Il Sant'Andrea di Mantova e L. B. Alberti* (Conference, Mantua, 1972), Mantua, 1974, 157–70.

530 Gilbert, C., 'Antique frameworks for Renaissance art theory: Alberti and Pino', *Marsyas*, III (1945), 87–98. (Alberti's treatise on painting)

531 Grayson, C., 'The composition of L. B. Alberti's *De re aedificatoria*', *Münchner Jahrbuch*, XI (1960), 152–61. (Quotation, 158)

532 Hamberg, P. G., 'Vitruvius, Fra Giocondo and the city plan of Naples. A commentary on some principles of ancient urbanism and their rediscovery in the Renaissance', *Acta archaeologia*, XXXVI (1965), 105–25.

533 Horster, M., 'Brunelleschi und Alberti in ihrer Stellung zur römischen Antike', *Mitt.KHIF*, XVII (1973), 29–64. (Including the temple as mausoleum)

534 Hubala, E., 'L. B. Albertis Langhaus von S. Andrea', in *Festschrift für Kurt Badt*, Berlin, 1961, 83–120.

535 *Krautheimer, R., 'Alberti and Vitruvius', in *Acts*, II, 42–52. (50–1 for comparison of their books on architecture)

536 Krautheimer, R., 'Alberti's *templum etruscum*', *Münchner Jahrbuch*, XII (1961), 65–72.

537 Mardersteig, G., 'Leon Battista Alberti e la rinascita del carattere lapidario romano nel Quattrocento', *IMU*, II (1959), 285–307.

538 Mariani, V., 'Roma in L. B. Alberti', *Studi romani*, VII (1959), 635–46. (Reprinted in his *Incontri con Roma nel rinascimento*, Rome, 1960, 11–22)

539 Mitchell, C., 'The imagery of the Tempio Malatestiano', *Studi romagnoli*, II (1952), 77–90. (Quotation, 82)

540 Onians, J. B., 'Style and decorum in 16th century Italian architecture', unpublished Ph.D. thesis, London University, 1968. (Useful sections on: The Temple and Palace of Solomon and the Vatican, 205*ff.*; Alberti and Cicero, 289*ff.*; The Hypnerotomachia and influence of Alberti, 405*ff.*; and 'The Orders in Practice, Alberti to Serlio', 486*ff.*)

252

541 Ricci, C., *Il Tempio Malatestiano*, Milan and Rome, 1924. (210*ff*. and 280*ff*. for Alberti and Early Christian architecture)

542 Rimini (Palazzo dell'Arengo), *Sigismondo Pandolfo Malatesta e il suo tempo* (Exhibition, Rimini, 1970), Vicenza, 1970. (125–75 for Tempio Malatestiano)

543 Saxl, F., 'The classical inscription in Renaissance art and politics', *JWCI*, IV (1941), 19–46. (Greek influence on sculpture of the Tempio: 32–7)

544 Scaglia, G., 'The Renaissance drawings of church façades', *AB*, XLVII (1965), 173–85.

545 Simoncini, G., *Città e società nel Rinascimento*, 2 vols, Turin, 1974. (With good bibliography; profusely illustrated)

546 Westfall, C. W., *In this most perfect paradise. Alberti, Nicholas V and the invention of conscious urban planning in Rome, 1447–1455*, University Park, Pennsylvania and London, 1974. (Does not fulfill the promise of its title)

Leonardo and Bramante: the High Renaissance in architecture

Bramante: Conference, *Studi Bramanteschi* (Atti del congresso internazionale, Milan, Urbino and Rome, 1970), Rome, 1974. (Includes papers on Bramante and Leonardo in Milan, Bramante's reputation and his knowledge of Antiquity)

Bruschi, A., *Bramante architetto*, Bari, 1969.

Geymüller, H. von, *Les projets primitifs pour Saint-Pierre*, Paris, 1875–80.

547 Fienga, D. D., 'The *Antiquarie prospetiche romane composte per Prospectivo Melanese Depictore*. A document for the study of the relationship between Bramante and Leonardo da Vinci', unpublished Ph.D. thesis, University of California, 1970. (114*ff*. for Alberti and Leonardo, résumé in *Studi Bramanteschi* (cited above), 417*ff*.)

548 Heydenreich, L. H., 'Leonardo and Bramante: genius in architecture', in C. D. O'Malley (ed.), *Leonardo's legacy*, Berkeley and Los Angeles, 1969, 125–48.

549 Lang, S., 'Leonardo's architectural designs and the Sforza Mausoleum', *JWCI*, XXXI (1968), 218–33.

550 *Murray, P., *Bramante's Tempietto*, Newcastle upon Tyne, 1972.

551 Murray, P., 'Leonardo and Bramante', *Architectural review*, CXXXIV (1963), 346–51. (Bramante as transmitter of Brunelleschi's ideas)

552 Murray, P., 'Observations on Bramante's St. Peter's' in D. Fraser *et al.* (eds.), *Essays in the history of architecture presented to R. Wittkower*, London, 1967, 53–9.

553 Pedretti, C., *A chronology of Leonardo da Vinci's architectural drawings after 1500*, Geneva, 1962.

554 Pedretti, C., 'Newly discovered evidence of Leonardo's association with Bramante', *JSAH*, XXXII (1973), 223–7.

555 Pedretti, C., 'The original project for S. Maria delle Grazie', *JSAH*, XXXII (1973), 30–42.

556 Rosenthal, E., 'The antecedents of Bramante's tempietto', *JSAH*, XXIII (1964), 55–74.

Mannerism

Ackerman, J. S., *The architecture of Michelangelo*, Harmondsworth, 1970, with catalogue by J. Newman.

Hartt, F., *Giulio Romano*, 2 vols, New Haven, 1958.

Paccagnini, G., *Il Palazzo Te*, Milan, 1957.

Palladio

*Ackerman, J. S., *Palladio*, Harmondsworth, 1966. (Best short account; good bibliography)

Puppi, L., *Andrea Palladio*, English translation, London, 1975. (The fullest and latest summary and bibliography of this most studied of all architects)

557 Argan, G. C., 'Andrea Palladio e la critica neoclassica', *L'Arte*, I (1930), 327–46.

558 Sinding-Larsen, S., 'Palladio's *Redentore*, a compromise in composition', *AB*, XLVII (1965), 419–37. (For the suggestion that Palladio intended a central plan)

559 Wittkower, R., 'Palladio and Bernini', in his *Palladio and English Palladianism*, London, 1974, 25–38.

560 Zorzi, G., *I disegni delle antichità di Andrea Palladio*, Venice, 1959.

8 The Classical Revival in Seventeenth-Century Italy

The Carracci

Posner, D., *Annibale Carracci*, 2 vols, London, 1971.

*Waterhouse, E., *Italian baroque painting*, London, 1962. (Best survey of all seventeenth-century work)

561 Bodmer, H., 'Le note marginali di Agostino Carracci nell'edizione del Vasari del 1568', *Il Vasari*, X (1939), 89–127. (Transcription)

562 Dempsey, C., '*Et nos cedamus amori*: observations on the Farnese Gallery', *AB*, L (1968), 363–74.

563 Fokker, T. H., 'The origin of Baroque painting', *AB*, XV (1933), 299–308. (Farnese Gallery)

564 Jaffe, M., 'The interest of Rubens in Annibale and Agostino Carracci: further notes', *BM*, XCIX (1957), 375–9.

565 Martin, J. R., *The Farnese Gallery*, Princeton, 1965.

566 Martin, J. R., '*Immagini della virtù*: the paintings of the Camerino Farnese', *AB*, XXXVIII (1956), 91–112.

567 Mazzini, F., 'Fortuna storica di Raffaello nel sei e settecento', *Rinascimento*, VI (1955), 145–62.

568 Pepper, D. S., 'Augustin Carrache, maître et dessinateur', *RA*, XIV (1971), 39–44.

569 Puyvelde, L. van, 'Les sources du style de Rubens. I: le contacte avec l'art antique et l'art italien', *Revue belge d'archéologie et d'histoire de l'art*, XXI (1952), 23–44.

570 Sulzberger, S., 'Rubens et la peinture antique', *Revue belge d'archéologie et d'histoire de l'art*, XI (1941), 59–65.

571 Vaes, M., 'Le séjour de Van Dyck en Italie (mi-novembre 1621–automne 1622)', *Bulletin de l'institut historique belge de Rome*, IV (1924), 163–234.

572 Vita, A. del, 'L'animosità di Agostino Carracci contro il Vasari', *Il Vasari*, XVI (1958), 64–78.

BIBLIOGRAPHY

Classicism and Baroque

Borea, E., *Domenichino*, Florence, 1965.

Bottari, S. (ed.), *Il mito del classicismo nel Seicento*, Florence, 1964.

Briganti, G., *Pietro da Cortona o della pittura barocca*, Florence, 1962.

Marabottini, A. (ed.), *Pietro da Cortona* (catalogue of exhibition), Rome, 1950.

573 Giongo, G., 'La critica su Guido Reni e la fortuna della sua fama', *Rivista dell'istituto nazionale d'archeologia e storia dell'arte*, II (1953), 353–72.

574 Jacob, S., 'Pietro da Cortona et la décoration de la Galérie d'Alexandre VII au Quirinal', *RA*, XI (1971), 42–54. (Modified *quadratura* painting)

575 Pepper, D. S., 'Caravaggio and Guido Reni: contrasts in attitudes', *AQ*, XXXIV (1971), 325–44. (Reni's Caravaggesque phase)

576 Pepper, D. S., 'Guido Reni's early drawing style', *Master Drawings*, VI (1968), 364–82. (Influence of teaching of Agostino Carracci)

577 Posner, D., 'Domenichino and Lanfranco: the early development of Baroque painting in Rome', in W. Cahn *et al.* (eds.), *Essays in honour of Walter Friedländer*, New York, 1965, 135–46.

Eclecticism

Labrot, G., 'Conservatisme plastique et expression rhétorique. Réflexions sur le développement de l'académisme en Italie Centrale (Rome et Florence), 1550 env.–1620 env.', *Mélanges d'archéologie et d'histoire*, LXXVI (1964), 555–624. (Jaundiced view of the classical *renovatio*)

*Lee, R. W., *Ut pictura poesis: the humanistic theory of painting*, New York, 1967.

Pevsner, N., *Academies of art past and present*, Cambridge, 1940.

578 Lee, R. W., Review of Mahon's *Studies in seicento art and theory*, *AB*, XXXIII (1951), 204–12. (Affirmation of eclecticism of Carracci)

579 Mahon, D., 'Art theory and artistic practice in the early seicento: some clarifications', *AB*, XXXV (1953), 226–32. (Reply to Lee's review above; Mahon refutes eclecticism theory)

580 Mahon, D., 'The construction of a legend: the origin of the classic and eclectic misinterpretations of the Carracci', in his *Studies in seicento art and theory*, London, 1947, 195–229.

581 *Mahon, D., 'Eclecticism and the Carracci: further reflections on the validity of a label', *JWCI*, XVI (1953), 303–41.

582 Panofsky, E., *Idea, a concept in art theory*, English translation, New York, 1968. (See Section 6: 'Classicism'; quotation, 107)

Caravaggio

*Friedländer, W., *Caravaggio studies*, Princeton, 1955.

Moir, A., *The Italian followers of Caravaggio*, Harvard, 1967.

Nicolson, B., 'Caravaggio and the caravaggesques: some recent research', *BM*, CXVI (1974), 586–93.

583 Argan, G. C., 'Caravaggio e Raffaello', in *Caravaggio e i Caravaggeschi* (Quaderno 205 of the Accademia nazionale dei lincei), Rome, 1974, 19–28.

584 Graeve, M. A., 'The stone of unction in Caravaggio's painting for the Chiesa Nuova', *AB*, XL (1958), 223–38. (Includes prototypes)

585 Lavin, I., 'Divine inspiration in Caravaggio's two *St. Matthews*', *AB*, LVI (1974), 59–81.

586 Röttgen, H., 'Caravaggio-Probleme', *Münchner Jahrbuch*, XX (1969), 143–70. (155*ff.* for Caravaggio and the High Renaissance)

587 *Wittkower, R., *Art and architecture in Italy 1600–1750*, 2nd edn, Harmondsworth, 1965. (Quotation, 21)

Carlo Maratta

Mezzetti, A., 'Contributi a Carlo Maratti', *Rivista dell'istituto d'archeologia e storia dell'arte*, Rome, IV (1955), 253–354.

9 Art in Seventeenth-Century France

*Blunt, A., *Art and architecture in France, 1500–1700*, Rev. edn, Harmondsworth, 1973.

Brody, J. (ed.), *French classicism. A critical miscellany*, Englewood Cliffs, New Jersey, 1966. (Extracts on seventeenth to twentieth centuries, with commentaries)

Hautecoeur, L., *Littérature et peinture en France du XVIIe au XXe siècle*, 2nd edn, Paris, 1963.

Peyre, H., *Le classicisme français*, New York, 1942.

Peyre, H., *Qu'est-ce que le classicisme?* rev. edn, Paris, 1965. (Chapter on the visual arts in seventeenth century, and a large bibliography)

Rocheblave, S., *L'age classique de l'art français*, Paris, 1932. (Survey of period from Henry IV to Napoleon)

Vouet

Crelly, W. R., *The painting of Simon Vouet*, New Haven and London, 1962.

588 Dargent, G., and Thuillier, J., 'Vouet en Italie', *Saggi e memorie*, IV (1965), 27–63.

589 Goldstein, C., 'Forms and formulas: attitudes towards Caravaggio in seventeenth-century France', *AQ*, XXXIV (1971), 345–55.

Philippe de Champaigne

590 Dorival, B., *Philippe de Champaigne et Port-Royal* (catalogue of exhibition at the Musée National des Granges de Port-Royal), Paris, 1957.

Poussin

Blunt, A., *Nicolas Poussin*, 3 vols, London, 1966/7. (Exhaustive bibliography)

Bray, R., *La formation de la doctrine classique en France*, Paris, 1961.

Fontaine, A., *Les doctrines d'art en France. Peintres, amateurs, critiques de Poussin à Diderot*, Paris, 1909.

*Friedländer, W., *Nicolas Poussin: a new approach*, London, 1966.

Poussin, N., *Correspondance*, ed. C. Jouanny, in *Archives de l'art français*, V, 1911.

Schnapper, A., 'La question Poussin', *IHA*, VI (1961), 82–90. (Etat de la question)

Thuillier, J., 'L'année Poussin', *Art de France*, I (1961), 336–48. (I.e. the year of the Paris Exhibition of his work)

591 Adelson, C., 'Nicolas Poussin et les tableaux du Studiolo d'Isabelle d'Este', *Revue du Louvre et des musées de France*, XXV (1975), 237–41. (For his work for Richelieu)

592 Barnwell, H. T., 'Some notes on Poussin, Corneille and Racine', *Australian Journal of French Studies*, IV (1967), 149–61.

593 Blunt, A., 'The heroic and the ideal landscape in the work of Poussin', *JWCI*, VII (1944), 154–68.

594 Brejon de Lavergnée, A., 'Tableaux de Poussin et d'autres artistes français dans la collection Dal Pozzo: deux inventaires inédits', *RA*, XIX (1973), 79–96.

595 Chastel, A. (ed.), *Actes du colloque Poussin*, 2 vols, Paris, 1960. (Some important work, including a section, 265*ff*., on Poussin's fame)

596 Costello, J., 'Poussin's drawings for Marino and the new classicism', *JWCI*, XVIII (1955), 296–317.

597 Dempsey, C., 'The classical perception of nature in Poussin's earlier works', *JWCI*, XXIX (1966), 219–49. (1626–38)

598 Dempsey, C., 'Poussin and Egypt', *AB*, XLV (1963), 109–19. (Poussin's scholarship)

599 Mahon, D., 'Poussin and Venetian painting', *BM*, LXXXVIII (1946), 15–20, 37–42.

600 Mahon, D., *Poussiniana: afterthoughts arising from the exhibition*, special number of *GBA*, also published separately, Paris, 1962.

601 Mahon, D., 'Réflexions sur les paysages de Poussin', *Art de France*, I (1961), 119–32.

602 Marin, L., 'La lecture du tableau d'après Poussin', *Cahiers de l'association internationale des études françaises*, XXIV (1972), 251–66.

603 Vermeule, C., 'Aspects of scientific archaeology in the 17th century. Marble reliefs, Greek vases, manuscripts and minor objects in the Dal Pozzo-Albani drawings of classical antiquity', *Proceedings of the American philosophical society*, CII (1958), 193–214.

604 Vermeule, C., 'The Dal Pozzo-Albani drawings of classical antiquities in the British Museum', Philadelphia, 1960 (*Transactions of the American Philosophical Society*, N.S. 50, 5).

605 Vermeule, C., 'The Dal Pozzo-Albani drawings of classical antiquities in the Royal Library at Windsor Castle', Philadelphia, 1966 (*Transactions of the American Philosophical Society*, N.S. 56). (Cf. severe review by N. Dacos in *Revue belge de philologie et d'histoire*, XLVII (1969), 502–9)

606 Wildenstein, G., 'Les graveurs de Poussin au XVIIe siècle', *GBA*, XLVI (1955), 75–371 (also separately published, Paris, 1958). (Corrections by M. Davies and A. Blunt in *GBA*, LX (1962), 205–22)

Claude

Bologna: Palazzo dell'Archiginnasio, *L'ideale classico del Seicento in Italia e la pittura di paesaggio*, 2nd edn, Bologna, 1962. (With essays by various authors)

Clark, K., *Landscape into art*, London, 1949.

*Kitson, M., *The art of Claude Lorrain* (exhibition, Hayward Gallery, London), London, 1969.

Knab, E., 'Die Anfänge des Claude Lorrain', *JKHS*, LVI (1960), 63–164.

Röthlisberger, M., *Claude Lorrain: the paintings*, 2 vols, Newhaven, 1961.

607 Howard, D., 'Some 18th century English followers of Claude', *BM*, CXI (1969), 726–33.

608 Kennedy, I. G., 'Claude and architecture', *JWCI*, XXXV (1972), 260–83.

609 Kitson, M., 'The Altieri Claudes and Virgil', *BM*, CII (1960), 312–18.

610 Manwaring, E. H., *Italian landscape in 18th century England*, New York, 1925.

611 Röthlisberger, M., 'The subjects of Claude's paintings', *GBA*, LV (1960), 209–24. (Subjects 'the only key to the full understanding of his landscapes')

Gaspard Dughet

Sutton, D., 'Gaspard Dughet: some aspects of his art', *GBA*, LX (1962), 269–312.

Waddingham, M., 'The Dughet problem', *Paragone*, XIV (1963), 37–54.

Waterhouse, E., *Baroque painting in Rome. The seventeenth century*, London, 1937. (61–3 for Dughet)

The rise of Paris as the artistic capital of Europe

Haskell, F., *Patrons and painters. A study of the relations between Italian art and society in the age of the Baroque*, London, 1963. (146*ff*. on decline of Rome)

Lebrun and academic classicism in France

Fontaine, A., *Académiciens d'autrefois*, Paris, 1914.

Fontaine, A., *Les collections de l'Académie Royale de Peinture et de Sculpture*, Paris, 1910.

*Goldstein, C., 'Studies in 17th century French art theory and ceiling painting', *AB*, XLVII (1965), 231–56. (Italian origins of French theory)

Keller, U., *Reitermonumente absolutischer Fürsten. Staatstheoretische Voraussetzungen und politische Funktionen*, Munich and Zurich, 1971. (47*ff*. for Girardon's *Louis XIV*)

Lille: Palais des Beaux-Arts, *Au temps du Roi Soleil. Les peintres de Louis XIV (1660–1715)* (exhibition), Lille, 1968.

Picard, R., 'Le Brun-Corneille et Mignard-Racine', *Revue des sciences humaines*, CVI (1962), 175–82.

Picard, R., 'Racine and Chauveau', *JWCI*, XIV (1951), 259–74. (Problems of classicism in France, and its extent)

Turner, N., 'An attack on the Accademia di S. Luca: Ludovico David's *L'Amore dell'Arte*', in *The Classical Tradition* (British Museum Yearbook, No. 1), London, 1976, 157–86. (David, in 'one of the earliest critical investigations of the institutionalisation of art education', blames the classical tradition for the state of contemporary art)

Versailles: Château, *Charles Le Brun, 1619–1690. Peintre et dessinateur* (exhibition), Paris, 1963.

Wildenstein, D., 'Les oeuvres de Le Brun d'après les gravures de son temps', *GBA*, LXVI (1965), 1–58. (With 303 illustrations)

612 Auzas, P.-M., 'L'influence du Guide sur la peinture française au XVIIe siècle', *Actes du XIXe congrès international d'histoire de l'art*, Paris, 1959, 356–67.

613 *Blunt, A., 'The early work of Le Brun', *BM*, LXXXV (1944), 165–73, 186–94.

614 Blunt, A., 'Jacques Stella, the de Masso family and falsifications of Poussin', *BM*, CXVI (1974), 745–51.

615 Montagu, J., 'Charles Le Brun's use of a figure from Raphael', *GBA*, LI (1958), 91–6.

616 Montagu, J., 'The early ceiling decorations of Charles Le Brun', *BM*, CV (1963), 395–408.

617 Posner, D., 'Charles Le Brun's *Triumphs of Alexander*', *AB*, XLI (1959), 237–48. (As a 'didactic example of the Academic style')

618 Thuillier, J., 'Académisme et classicisme en France: les débuts de l'Académie Royale de Peinture et de Sculpture', in S. Bottari (ed.), *Il mito del classicismo nel seicento*, Florence, 1964, 181–209.

619 Thuillier, J., 'Le Brun et Rubens', *Bulletin des musées royaux des beaux-arts de Belgique*, XVI (1967), 247–68.

The Quarrel of the Ancients and the Moderns

Baron, H., 'The quarrel of the ancients and moderns as a problem in Renaissance scholarship', *JHI*, XX (1959), 3–22.

620 Becq, A., 'Rhétorique et littérature d'art en France à la fin du XVIIe siècle: le concept de couleur', *Cahiers de l'association internationale des études françaises*, XXIV (1972), 215–32. (Colour is to painting what rhetoric is to speech)

621 Goldstein, C., 'Observations on the role of Rome in the formation of the French Rococo', *AQ*, XXXIII (1970), 227–45. (With remarks on Rome's decline; useful references)

622 Schnapper, A., *Tableaux pour le Trianon de Marbre 1688–1714*, Paris and The Hague, 1967. (Stylistic changes in the course of 160 orders for paintings)

623 Seznec, J. (presiding), Section on 'La littérature et les arts au XVIIe siècle', in *Cahiers de l'association internationale des études françaises*, XXIV (1972), 187*ff*. (Including 'colour' in literature and art at the end of the seventeenth century)

624 Teyssèdre, B., *L'histoire de l'art vue du Grand Siècle: recherches sur L'Abregé de la vie des peintres par Roger de Piles (1699) et ses sources*, Paris, 1964.

625 Teyssèdre, R., *Roger de Piles et les débats sur le coloris au siècle de Louis XIV*, Paris, 1965.

10 Architecture in France: Renaissance to Neoclassicism

The sixteenth century and Italy

*Blunt, A., *Art and architecture in France, 1500–1700*, 2nd edn, Harmondsworth, 1970.

Hautecoeur, L., *Histoire de l'architecture classique en France*, 8 vols, Paris, 1943–7. (Fundamental)

Polidori, M. L., *Monumenti e mecenati francesi in Roma (1492–1527)*, Viterbo, 1969.

626 Châtelet-Lange, L., 'Le "Museo de Vanves" (1560). Collections de sculptures et musées au XVIe siècle en France', *Zf.KG*, XXXVIII (1975), 266–85.

627 Comito, T., 'Renaissance gardens and the discovery of paradise', *JHI*, XXXII (1971), 483–506. (With section on Charles VIII's reactions to Italy)

628 Favier, S., 'Les collections de marbres antiques sous François Ier', *Revue du Louvre et des musées de France*, XXIV (1974), 153–6.

629 Guillaume, J., 'Léonard de Vinci et l'architecture française. 1. Le problème de Chambord. 2. La villa de Charles d'Amboise et le Château de Romorontin. Réflexions sur un livre de Carlo Pedretti', *RA*, XXV (1974), 81–4, 85–91. (Pedretti's book is entitled *Leonardo da Vinci: The royal palace at Romorontin*, Cambridge, Mass., 1972)

630 Kelley, D. R., *Foundations of modern historical scholarship. Language, law and history in the French Renaissance*, New York and London, 1970.

631 Monnier, G., and McAllister-Johnson, W., 'Caron antiquaire. A propos de quelques dessins du Louvre', *RA*, XIV (1971), 23–30.

632 Yates, F. A., *The French academies of the sixteenth century*, London, 1947.

Philibert de l'Orme

633 *Blunt, A., *Philibert de l'Orme*, London, 1958. (11–13 for Ostia)

634 Châtelet-Lange, L., 'Philibert de l'Orme à Montceaux-en-Brie: le Pavillon de la Grotte', *Architectura*, III (1973), 153–70. (Currency in France of Bramante's *House of Raphael* type; and of the Giant Order, as at Montceaux)

635 Hoffmann, V., 'Philibert de l'Orme und das Schloss Anet', *Architectura*, III (1973), 131–52. (Sources in Antiquity and High Renaissance)

Salomon de Brosse

Coope, R., *Salomon de Brosse and the development of the classical style in French architecture from 1565 to 1630*, London, 1972. (With valuable survey and references)

François Mansart

Blunt, A., *François Mansart and the origins of French classical architecture*, London, 1947.

Braham, A., and Smith, P., *François Mansart*, 2 vols, London, 1973. (Introduction plus superbly illustrated catalogue raisonné)

*Braham, A., and Smith, P., *François Mansart 1598–1666*, an exhibition of drawings and photographs, Hayward Gallery, London, 1971. (In effect a résumé of the above)

Hautecoeur, L., *L'histoire du Louvre*, Paris, 1928.

636 Herrmann, W., *The theory of Claude Perrault*, London, 1973. (115*ff*. for the Louvre peristyle; 70*ff*. for Vitruvius)

Eighteenth-century Neoclassicism

Kaufmann, E., *Architecture in the age of reason. Baroque and post-baroque in England, Italy and France*, Cambridge, Mass., 1955.

637 *Kalnein, Graf W., and Levey, M., *Art and architecture of the 18th century in France*, Harmondsworth, 1972. (Quotation, 335–6)

638 Nyberg, D., *'La sainte antiquité*. Focus on an 18th century architectural debate', in D. Fraser et al. (eds.), *Essays in the history of architecture presented to R. Wittkower*, London, 1967, 159–69.

Primitivism in architecture

Kaufmann, E., 'Three revolutionary architects: Boullée, Ledoux and Lequeu', *Transactions of the American Philosophical Society*, 42, Philadelphia, 1952.

McCarthy, M., 'Documents on the Greek Revival in architecture', *BM*, CXIV (1972), 760–9.

Pérouse de Montclos, J., *Etienne-Louis Boullée*, Paris, 1969.

Rome, Villa Medici, *Piranèse et les Français 1740–90*, exhibition May–November 1976, also shown at Dijon and Paris. (Large bibliography)

Rosenau, H., 'The engravings of the *Grands Prix* of the French Academy of Architecture', *Architectural History*, III (1960).

Wiebenson, D., *Sources of Greek Revival architecture*, London, 1969.

639 Harris, J., 'Le Geay, Piranesi and international neoclassicism in Rome, 1740–50', in D. Fraser et al. (eds.), *Essays in the history of architecture presented to R. Wittkower*, London, 1967, 189–96.

640 Herrmann, W., *Laugier and 18th century French theory*, London, 1962.

641 Lang, S., 'The early publication of the temples at Paestum', *JWCI*, XIII (1950), 48–64.

642 Middleton, R. D., 'The Abbé de Cordemoy and the graeco-gothic ideal: a prelude to romantic classicism', *JWCI*, XXV (1962), 278–320; XXVI (1963), 90–123.

643 Petzet, M., *Soufflots Sainte-Geneviève und der französische Kirchenbau des 18. Jahrhunderts*, Berlin, 1961.

644 Pevsner, N., and Lang, S., 'Apollo or Baboon?', *Architectural review*, CIV (1948), 271–9.

645 *Pevsner, N., and Lang, S., 'The Doric revival', in Pevsner's *Studies in art, architecture and design*, London, 1968, I, 197–211.

646 Rykwert, J., *On Adam's house in paradise. The idea of the primitive hut in architectural theory*, New York, 1972.

647 Wittkower, R., 'Piranesi's *Parere su l'architettura*', *JWCI*, I (1938/9), 147–58.

11 Neoclassicism in Painting and Sculpture

Dobai, J., *Die Kunstliteratur des Klassizismus und der Romantik in England*, 2 vols, Bern, 1974 and 1975. (Encyclopaedic; Vol. 3 will take the work to 1850)

Gerlach, P., *Antikenstudium im Zeichnungen klassizistischer Bildhauer*, Munich, 1973.

* Honour, H., *Neoclassicism*, Harmondsworth, 1968.

Pariset, F. G., *L'art néoclassique*, Paris, 1974. (Covers Central Europe, Russia and U.S.A.; short bibliography by country)

Zeitler, R., *Klassizismus und Utopia*, Uppsala, 1954. (Chapters on individual artists)

647a London: Royal Academy, etc., *The age of neoclassicism*, 14th exhibition of the Council of Europe, London, 1972. (A mine of information. Quotation, xxxiv)

The Grand Tour

Hautecoeur, L., *Rome et la renaissance de l'antiquité à la fin du XVIIIe siècle*, Paris, 1912.

Lewis, L. *Connoisseurs and secret agents in 18th century Rome*, London, 1961. (With much on Albani)

Michaelis, A., *Ancient marbles in Great Britain*, Cambridge, 1882. (Still the best account of collecting)

Rome: Museo di Roma, *Il settecento a Roma*, exhibition, Rome, 1959.

Schudt, L., *Italienreisen im 17. und 18. Jahrhundert*, Vienna and Munich, 1959.

648 Bainbridge, T., 'English ideas about Greek and Roman art and their place in contemporary critical theory, 1740–1790', unpublished Ph.D. thesis, Cambridge University, 1973. (With chapter on travelling in Italy and Greece)

649 Broeder, F. den (cataloguer), *The academy of Europe: Rome in the 18th century*, exhibition at the William Benton Museum of Art, University of Connecticut, 1973.

650 Crook, J. M., *The Greek Revival*, London, 1972. (Part I: 'The rediscovery of Greece')

651 Saxl, F., and Wittkower, R., *British art and the Mediterranean*, London, 1948. (Picture book to be supplemented by J. Marle's large Arts Council pamphlet, *Neo-classical England*, London, 1972)

652 Waterhouse, E. K., 'Painting in Rome in the 18th century', *Museum Studies*, VI (1971), 6–21. ('the seminal center of artistic ideas in Italy in the 18th century … remained Rome')

Scholarship and Neoclassicism

653 Hausmann, V. (ed.), *Allgemeine Grundlagen der Archäologie*, Munich, 1969. (11–22 for the period to Winckelmann)

654 Howard, S., 'An antiquarian handlist and the beginnings of the Pio Clementino', *Eighteenth century studies*, VII (1973), 40–61. (Well-referenced account of antiquarianism)

655 Leppmann, W., *Pompeii in fact and fiction*, English translation, London, 1968.

656 Michels, A. K. (cataloguer), *Pompeiana. Exhibition of Pompeian art and its influence in the 18th and early 19th centuries …*, Smith College Museum, Northampton, Mass., 1948.

657 Pietrangeli, C., 'Archaeological excavations in Italy, 1750–1850', in *The age of neoclassicism* (cited above no. 647a), xlvi–lii.

658 Pietrangeli, C., *Scavi e scoperte di antichità sotto il pontificato di Pio VI*, 2nd edn, Rome, 1958.

659 Praz, M., 'Herculaneum and European taste', *Magazine of art*, XXXII (1939), 684–93, 727.

660 Schneider, R., *Quatremère de Quincy et son intervention dans les arts*, Paris, 1910. (370ff. for Greek polychromy)

661 Seznec, J., 'Herculaneum and Pompeii in French litera-
ture of the 18th century', *Archaeology*, II (1949), 150–8.

662 Seznec, J., 'L'ombre de Tirésias', in his *Essais sur
Diderot et l'antiquité*, Oxford, 1957, 43–57. (Quarrel of
the Ancients and Moderns)

Historicism and the quest for the primitive

Gay, P., *The Enlightenment: an interpretation. The rise
of modern paganism*, London, 1967. (With long biblio-
graphical essay; see especially 505–34)

Lovejoy, A. O., *Essays in the history of ideas*, Baltimore,
1948. (Particularly 'The parallel of deism and
classicism', 78–98)

Manuel, F. E., *The 18th century confronts the gods*,
Cambridge, Mass., 1959.

663 Bloch, R., 'Le dix-huitième siècle et l'Etrurie', *Latomus*,
XVI (1957), 128–39.

664 Cochrane, E. W., *Tradition and enlightenment in the
Tuscan academies, 1690–1800*, Rome, 1961. (157–205 for
antiquities, archaeology and history)

665 Cristea, S. N., 'Ossian v. Homer: an 18th century
controversy. Melchior Cesarotti and the struggle for
literary freedom', *Italian studies*, XXIV (1969), 93–111.

666 Hamburg: Kunsthalle, *Ossian und die Kunst um 1800*,
exhibition, Hamburg, 1974. (or, similarly, the Paris
1975 version of the same exhibition)

667 Hatfield, H., *Aesthetic paganism in German literature
from Winckelmann to the death of Goethe*, Cambridge,
Mass., 1964. (Wide-ranging)

668 *Okun, H., 'Ossian in painting', *JWCI*, XXX (1967),
327–56.

669 Rosenblum, R., *Transformations in late 18th century art*,
Princeton, 1967. (50–106 for the *exemplum virtutis*)

670 Tieghem, P. van, *Ossian en France*, 2 vols, Paris, 1907.
(In literature)

671 Venturi, L., *Il Gusto dei Primitivi*, Turin, 1972.

672 Wiebenson, D., 'Subjects from Homer's *Iliad* in neo-
classical art', *AB*, XLVI (1964), 23–37.

Gavin Hamilton: an early neoclassicist

* Irwin, D., *English neoclassical art. Studies in inspiration
and taste*, London, 1966.

*Irwin, D., 'Gavin Hamilton: archaeologist, painter and
dealer', *AB*, XLIV (1962), 87–102.

Locquin, L., 'Le retour à l'antique dans l'école anglaise
et dans l'école française avant David', *La revue de l'art
français et des industries de luxe*, VIII (1922), 473–81.
(Statement of Hamilton's importance)

Previtali, G., *La fortuna dei primitivi dal Vasari ai
neoclassici*, Turin, 1964. (218–48 for 18th century)

* Waterhouse, E., 'The British contribution to the neo-
classical style in painting', *Proceedings of the British
Academy*, XL (1954), 57–74.

*Wind, E., 'The revolution of history painting', *JWCI*, II
(1938/9), 116–27. (Antique to modern dress)

673 Forster-Hahn, F., 'After Guercino or after the Greeks?
Gavin Hamilton's *Hebe*: tradition and change in the
1760s', *BM*, CXVII (1975), 365–71.

674 Forster-Hahn, F., 'The sources of true taste: Benjamin
West's Instructions to a Young Painter for his Studies in

Italy', *JWCI*, XXX (1967), 367–82. (Interest in
seventeenth-century classicism)

675 Rosenblum, R., 'Gavin Hamilton's *Brutus* and its after-
math', *BM*, CIII (1961), 8–16.

Winckelmann and Mengs: the scholar and the artist

Althaus, H., *Laokoon. Stoff und Form*, Bern, 1968.

Gerstenberg, K., *J. J. Winckelmann und A. R. Mengs*,
Berlin, 1929.

Justi, C., *Winckelmann und seine Zeitgenossen*, 4th edn,
introduction by L. Curtius, Leipzig, 1943. (A biography
of the whole period)

Klenze, C. von, *The interpretation of Italy during the past
two centuries: a contribution to the study of Goethe's
Italienische Reise*, Chicago, 1907.

Leppmann, W., *Winckelmann*, London, 1971. (Only
biography in English)

Trevelyan, H., *Goethe and the Greeks*, Cambridge, 1941.
(Influence of Winckelmann)

Trevelyan, H., *The popular background to Goethe's
hellenism*, London, 1934.

676 Cook, R. M., *Greek painted pottery*, London, 1960.
(288–330: 'The history of the study of vase-painting')

677 Ebhardt, M., *Die Deutung der Werke Raffaels in der
deutschen Kunstliteratur von Klassizismus und Romantik*,
Baden-Baden, 1972.

678 Griefenhagen, A., *Griechische Vasen auf Bildnissen der
Zeit Winckelmanns und des Klassizismus*, Göttingen,
1939.

679 *Hatfield, H., *Winckelmann and his German critics*, New
York, 1943. (6–20 for his ideas on Greek art)

680 Hornisch, D., *Anton Rafael Mengs und die Bildform des
Frühklassizismus*, Recklinghausen, 1965.

681 Irwin, D. (ed.), *Winckelmann: writings on art*, London,
1972. (53–7 for Winckelmann as the 'father of art
history')

682 Lee, R. W., Review of Mahon's *Studies in Seicento art and
theory*, *AB*, XXXIII (1951), 204–12. (208ff. for
Winckelmann's views on Seicento eclecticism)

683 Nivelle, A., 'Winckelmann et le baroque', *Revue belge de
philologie et d'histoire*, XXXVI (1958), 854–60.

684 Pelzel, T., 'Winckelmann, Mengs and Casanova: a
reappraisal of a famous 18th century forgery', *AB*, LII
(1972), 301–31.

Neoclassicism in France: the revival of the Academy

Badolle, M., *L'abbé Barthélémy (1716–1795) et
l'héllénisme en France dans la deuxième moitié du 18e
siècle*, Paris, 1926.

685 Bardon, H., 'Les peintures à sujets antiques au XVIIIe
siècle d'après les livrets des Salons', *GBA*, LXI (1963),
217–50.

686 Caylus, Comte A.-M. de, *Tableaux tirés de l'Iliade, de
l'Odyssée d'Homère et de l'Eneide de Virgile . . .*, Paris,
1757.

687 Engerand, F., *Inventaire des tableaux commandés et
achetés pour la Direction des Bâtiments du Roi
(1709–1792)*, Paris, 1900.

688 Furcy-Raynaud, M., 'Inventaire des sculptures exéc-
utées au 18e siècle pour la Direction des Bâtiments du
Roi', *Archives de l'art français*, XIV (1927), *passim*.

689 Gaehtgens, T. W., 'Diderot und Vien. Ein Beitrag zu Diderot's klassizistischer Ästhetik', *Zf.KG*, XXXVI (1973), 51–82.

690 Gaehtgens, T. W., 'J. M. Vien et les peintures de la légende de sainte Marthe', *RA*, XXIII (1974), 64–9. (Hailed as 'une oeuvre maîtresse')

691 Lapauze, H., *Histoire de l'Académie de France à Rome*, 2 vols, Paris, 1924. (I, 348–81, for Vien's directorship; quotation, II, 156–7)

692 Locquin, J., *La peinture d'histoire en France de 1747 à 1785*, Paris, 1912. (144, note I, for instances of interest in the *grand siècle*)

693 Müntz, E., 'L'art français du XVIIIe siècle et l'enseignement académique', *RAAM* (1897), 31–48.

694 Saint Yenne, La F. de, *Réflexions sur quelques causes de l'état présent de la peinture en France*, The Hague, 1747. (Quotation, 8)

695 Saint Yenne, La F. de, *Sentiments sur quelques ouvrages de peinture, sculpture et gravure écrits à un particulier en Province*, Paris, 1754. (Quotation, 51)

696 Scott, B., Ten articles on 18th century French patrons and collectors, including Marigny and Angivillier, *Apollo*, XCVII (1973), 11–91.

Diderot and Greuze: the classicism of everyday life

Bertrand, L., *La fin du classicisme et le retour à l'antique*, Paris, 1896. (Ch. III for Diderot and antique literature)

*Brookner, A., *Greuze. The rise and fall of an 18th century phenomenon*, London, 1972.

Munhall, E., 'Greuze and the Protestant spirit', *AQ*, XXVII (1964), 2–23. (Morality in Greuze and Diderot)

Seznec, J., 'Diderot et l'affaire Greuze', *GBA*, LXVII (1966), 339–56.

Seznec, J., 'Le "musée" de Diderot', *GBA*, LV (1960), 343–56. (On his artistic education)

Weinshenker, A. B., *Falconet: his writings and his friend Diderot*, Geneva, 1966.

697 Dilckmann, H., and Seznec, J., 'The horse of Marcus Aurelius. A controversy between Diderot and Falconet', *JWCI*, XV (1952), 198–228.

698 Dowley, F. H., 'Falconet's attitude towards antiquity and his theory of reliefs', *AQ*, XXXI (1968), 185–204. (With review of opinions from Perrault onward)

699 Laugier, L'Abbé, *Manière de bien juger des ouvrages de peinture*, Paris, 1771. (Quotation, 84)

700 Leith, J. A., *The idea of art as propaganda in France, 1750–1799*, Toronto, 1965.

701 Sauerländer, W., 'Pathosfiguren im Oeuvre des J-B Greuze', in G. Kauffmann and W. Sauerländer (eds.), *Walter Friedländer zum 90 Geburtstag*, Berlin, 1965, 146–50.

702 Seznec, J., 'Diderot and historical painting', in E. R. Wassermann (ed.), *Aspects of the 18th century*, Baltimore and London, 1965, 129–42. (Quotation, 140)

703 Seznec, J., and Adhémar, J., *Diderot: Salons*, 4 vols, Oxford, 1957–67. (Quotation, II, 206–7)

704 Verdi, R., 'Poussin's *Eudamidas*: 18th century criticism and copies', *BM*, CXIII (1971), 513–24.

705 Wildenstein, G., 'Catalogue des graveurs de Poussin, par Andreson', abridged, with reproductions, in *GBA*, LX (1962), 139–202.

David: from Roman to Greek

Cantinelli, R., *J.-L. David 1748–1825*, Paris and Brussels, 1930. (Good plates)

Caso, J. de, 'David and the style *all'antica*', *BM*, CXIV (1972), 686–90.

Coche de la Ferté, E., and Guey, J., Analyse archéologique et psychologique d'un tableau de David: *Les amours de Paris et d'Hélène*, *Revue archéologique*, XL (1952), 129–61.

David, J.-L.-J., *Le peintre J.-L. David, 1748–1825, souvenirs et documents inédits*, Paris, 1880.

Delécluze, E. J., *Louis David, son école et son temps*, Paris, 1855.

Hautecoeur, L., *Louis David*, Paris, 1954. (Best modern account)

Levey, M., 'Reason and passion in J.-L. David', *Apollo*, LXXX (1964), 206–11.

Pollak, B., 'De invloed can enige Monumenten der Oudheid op het Classicisme van David, Ingres en Delacroix', *Nederlands Kunsthistorisch Jaarboek*, II (1948/9), 287–315.

Sloane, J. C., 'David, Robespierre and the *Death of Bara*', *GBA*, LXXIV (1969), 143–60.

Verbraeken, R., *J.-L. David jugé par ses contemporains et par la postérité*, Paris, 1973. (Interesting but unreliable)

Wildenstein, D., and G., *Documents complémentaires au catalogue de l'oeuvre de Louis David*, Paris, 1973. (Chronological, as is exhaustive bibliography)

706 Boyer, F., 'Le Directoire et la création des musées des Départements', *BSHAF* (1972), 325–30.

707 Boyer, F., 'Six statues de législateurs antiques pour le palais Bourbon sous le Directoire', *BSHAF* (1958), 91–4.

708 Brookner, A., 'J.-L. David, a sentimental classicist', *Akten 1964*, I, 184–90. (Stresses Seicento sources)

709 Calvert, A., 'Unpublished drawings for The Oath of the Horatii by David', *Master drawings*, VI (1968), 37–42.

710 Coggins, C., 'Tracings in the work of J.-L. David', *GBA*, LXXII (1968), 259–64.

711 Crocker, L. G., 'The discussion of suicide in the 18th century', *JHI*, XIII (1952), 47–72.

712 David, J.-L.-J., *Notice sur le Marat*, Paris, 1867, 36.

713 Dowd, D. L., 'Art and theatre during the French Revolution', *AQ*, XXIII (1960), 3–22.

714 Dowd, D. L., '"Jacobinism" and the fine arts: the revolutionary careers of Bouqier, Sergent and David', *AQ*, XVI (1953), 195–214.

715 Dowd, D. L., *Pageant-master of the Republic: J.-L. David and the French Revolution*, Lincoln, Nebraska, 1948.

716 *Ettlinger, L., 'J.-L. David and Roman virtue', *Journal of the Royal Society of Arts*, CXV (1967), 105–23. (Clears up basic misunderstandings about politics and art in David)

717 Griefenhagen, A., 'Nachlänge griechischer Vasenfunde im Klassizismus (1790–1840)', *Jahrbuch Berliner Museen*, V (1963), 84–105.

718 Hazlehurst, F. H., 'The artistic evolution of David's Oath', *AB*, XLII (1960), 59–63.

719 Herbert, R. L., *David, Voltaire, Brutus and the French Revolution: an essay in art and politics*, London, 1972. (Critique by C. Sells in *BM*, CXVII (1975), 811–13)

259

720　Hinman, H. E., 'David and Madame Tussaud', *GBA*, XLVI (1965), 231–8.

721　Kagan, A. A., 'A classical source for David's *Oath of the Tennis Court*', *BM*, CXVI (1974), 395–6. (*Exemplum virtutis* from Plutarch)

722　Kemp. M., 'J.-L. David and the prelude to a moral victory for Sparta', *AB*, LI (1969), 178–83. (*Leonidas* and David's 'Greek' style)

723　Kemp, M., 'Some reflections on watery metaphors in Winckelmann, David and Ingres', *BM*, CX (1968), 266–70. (Quotation, 269)

724　Lankheit, K., *J.-L. David: Marat*, Stuttgart, 1962.

725　Parker, H. T., *The cult of antiquity and the French Revolution*, Chicago, 1937.

726　Renouvier, J., *Histoire de l'art pendant la Révolution considérée principalement dans les estampes*, 2 vols, Paris, 1863. (Quotation, 18; I, 1–44, for institutions of the period)

727　Rockwood, R. O., 'The legend of Voltaire and the cult of the Revolution, 1791', in Herr (ed.), *Ideas in history. Essays presented to Louis Gottschalk*, Durham, N. Carolina, 1965, 110–34.

728　Rosenblum, R., 'David's *Funeral of Patroclus*', *BM*, CXV (1973), 567–76.

729　Rosenblum, R., 'The origin of painting: a problem in the iconography of romantic classicism', *AB*, XXXIX (1957), 279–90.

730　Rosenblum, R., 'A source for David's *Horatii*', *BM*, CXII (1970), 269–73.

731　Salmon, A., 'Le *Socrate* de David et le *Phédon* de Platon', *Revue belge de philologie et d'histoire*, XL (1962), 90–111.

732　Schnapper, A., 'Les académies peintes et le *Christ en croix* de David', *Revue du Louvre et des musées de France*, XXIV (1974), 381–92. (On his early work)

733　Symmons, S., 'French copies after Flaxman's *Outlines*', *BM*, CXV (1973), 591–9.

734　Vallery-Radot, J., 'Autour du portrait de Lepeletier de Saint-Fargeau sur son lit de mort, par David', *AAF*, XXII (1950–7), 354–61.

735　Whiteley, J. J. L., 'Light and shade in French neoclassicism', *BM*, CXVII (1975), 768–73. (On Chiaroscuro)

736　Wind, E., 'A lost article on David by Reynolds', *JWCI*, VI (1943), 223–4.

737　Wind, E., 'The sources of David's *Horaces*', *JWCI*, IV (1940/1), 124–38.

Neoclassical sculpture: Canova

Hubert, G., *La sculpture dans l'Italie napoléonienne*, Paris, 1964.

Hubert, G., 'La sculpture néoclassique et l'Italie napoléonienne', *IHA*, X (1965), 108–19. (Condensation of the above)

Hubert, G., *Les sculpteurs italiens en France sous la Révolution, l'Empire et la Restauration, 1790–1830*, Paris, 1964.

738　Honour, H., 'Antonio Canova and the Anglo Romans: I: The first visit to Rome. II: The first years in Rome', *The Connoisseur*, CXLIII (1959), 241–5; CXLIV (1960), 225–31.

739　*Honour, H., 'Canova and David', *Apollo*, XCVI (1972), 312–17.

740　*Honour, H., 'Canova's statues of Venus', *BM*, CXIV (1972), 658–70.

741　Howard, S., 'Bartolommeo Cavaceppi and the origins of neoclassic sculpture', *AQ*, XXXIII (1970), 120–33.

742　Howard, S., 'Boy on a dolphin: Nollekins and Cavaceppi', *AB*, XLVI (1964), 177–89.

743　Howard, S., 'Sculptures of Bartolommeo Cavaceppi and origins of neoclassicism: a Ceres series and sundries', in *Actes du XXIIe congrès international d'histoire de l'art, Budapest 1969*, II, Budapest, 1972, 227–32.

744　Praz, M., *On neoclassicism*, English translation, London, 1969. (With section on Canova; quotation 142–3)

745　Rouchès, G., 'Les rapports de Canova avec la France', *BSHAF* (1922), 63–74.

746　St. Clair, W., *Lord Elgin and the marbles*, London, 1967.

747　Schneider, R., 'L'art de Canova et la France impériale', *Revue des études napoléoniennes* (1912), 36–57.

748　Schneider, R., *L'esthétique classique chez Quatremère de Quincy*, Paris, 1910.

749　Smith, A. H., 'Lord Elgin and his collection', *Journal of Hellenic studies*, XXXVI (1916), 163–372. (Basic account)

750　Watson, F. J. B., 'Canova and the English', *Architectural review*, CXXII (1960), 403–6.

751　Whinney, M., 'Flaxman and the 18th century', *JWCI*, XIX (1956), 269–82. (Classical sources; studies)

752　Will, F., 'Two critics of the Elgin Marbles: Hazlitt and Quatremère de Quincy', *Journal of aesthetics and art criticism*, XIV (1956), 462–74.

Painting in Napoleonic and Restoration France: classicism and modernity

Caubisens-Lasfargues, C., 'Peinture et préromantisme pendant la Révolution française', *GBA*, LVIII (1961), 367–76.

Caubisens-Lasfargues, C., 'Le salon de peinture pendant la Révolution', *Annales historiques de la Révolution française*, XXXIII (1961), 191–214.

Eitner, L., 'Géricault's *Dying Paris* and the meaning of his romantic classicism', *Master drawings*, I (1963), 21–34.

Pelles, G., *Art, artists and society. Origins of a modern dilemma. Painting in England and France 1750–1850*, New Jersey, 1963. (A 'social psychology of art')

Webb, T. *et al.*, 'Romantic Classicism', the summer 1976 issue of *Studies in Romanticism* (with articles on Mengs's English critics, Baudelaire and classical allusion).

753　Adhémar, J., 'L'enseignement académique en 1820. Girodet et son atelier', *BSHAF* (1933), 270–83.

754　Biver, M.-L., *Le Paris de Napoléon*, Paris, 1963.

755　Boyer, F., *Le monde des beaux-arts en Italie et la France de la Révolution et de l'Empire*, Turin, 1970.

756　Chatelain, J., *D. V. Denon et le Louvre de Napoléon*, Paris, 1973. (With his speech on the spoils from abroad)

757　*Friedländer, W., *David to Delacroix*, Cambridge, Mass., 1952.

758　Gérard, H., *Correspondance de François Gérard*, Paris, 1867. (Quotation, 59)

759　Gould, C., *Trophy of conquest. The Musée Napoléon and the creation of the Louvre*, London, 1965.

760 Guercio, A. del, 'Géricault e Caravaggio', *Paragone*, CXCI (1966), 70–6.

761 Herbert, R., 'Baron Gros' *Napoléon* and Voltaire's *Henri IV*', in F. Haskell *et al.* (eds.), *The artist and the writer in France. Essays in honour of J.* Seznec, Oxford, 1974, 52–71. (Gros's emphasis on the heroic forebear)

762 Jal, A., *Esquisses, croquis ou tout ce qu'on voudra sur le Salon de 1827*, Paris, 1828.

763 Lacambre, G., and J., 'La politique d'acquisition sous la Restauration: les tableaux d'histoire', *BSHAF* (1972), 331–44.

764 Lebel, R., 'Géricault, ses ambitions monumentales et l'inspiration italienne', *L'Arte*, LIX (1960), 327–42.

765 Lelièvre, P., *Vivant Denon. Directeur des beaux-arts de Napoléon*, Paris, 1942. (IV: 'Mécanisme des commandes impériales')

766 Lelièvre, P., 'Gros, peintre d'histoire', *GBA*, IX (1936), 289–304.

767 Lelièvre, P., '*Napoléon sur le champ de bataille d'Eylau* par A-J Gros. Précisions sur les conditions de la commande', *BSHAF* (1955), 51–5. (Realism demanded)

768 * Levey, M., 'A hero to his painters', in his *Painting at court*, London, 1971, 153–80. (Napoleon)

769 McCoubrey, J., 'Gros' *Battle of Eylau* and Roman imperial art', *AB*, XLIII (1961), 135–9.

770 Madelin, L., *La Rome de Napoléon*, Paris, 1906. (Especially 148*ff.*; 'tour' of the City, 527–51)

771 Montargis: Museum, *Girodet 1767–1824*, exhibition, Montargis, 1967.

772 Paris: Grand palais, *De David à Delacroix. La peinture française de 1774 à 1830*, exhibition, Paris, 1974/5. (Introductory essays, bibliographies for each painting and general one at end; now the prime reading for the Neoclassical period)

773 Rocheblave, S., *L'age classique de l'art français*, Paris, 1932. (Quotation, 195)

774 Rubin, J. H., 'Oedipus, Antigone and exiles in post-Revolutionary French painting', *AQ*, XXXVI (1973), 141–71. (28 paintings on the theme, 1780–1817)

775 Schlenoff, N., 'Baron Gros and Napoleon's Egyptian campaign', in W. Cahn *et al.* (eds.), *Essays in honour of W. Friedländer*, New York, 1965, 152–64. (For direction of Gros's art by Denon)

776 Schneider, R., 'L'art anacréontique et alexandrin sous l'Empire', *Revue des études napoléoniennes*, IX (1916), 257–71. (Vogue for prettiness)

777 Spector, J., *Delacroix: The Death of Sardanapalus*, London, 1974.

778 Trahard, P., *Le romantisme défini par Le Globe*, Paris, 1924. (Quotation, 46)

12 Ingres and the Subversion of the Classical Tradition

Alazard, J., *Ingres et l'Ingrisme*, Paris, 1950. (School and influence)

Amaury-Duval, E.-E., *L'atelier d'Ingres*, Paris, 1924.

Berger, K., 'Poussin's style and the 19th century', *GBA*, XLV (1955), 161–70.

Bertrand, L., *La fin du classicisme et le retour à l'antique . . . en France*, Paris, 1896. (Literature and art, late eighteenth and early nineteenth centuries)

Courthion, P., *Ingres raconté par lui-même et par ses amis*, 2 vols, Geneva, 1947.

Haskell, F., 'The manufacture of the past in 19th century painting', *Past and present*, LIII (1971), 109–20.

Haskell, F., 'The old masters in 19th century French painting', *AQ*, XXXIV (1971), 55–85.

Haskell, F., *Rediscoveries in art. Some aspects of taste, fashion and collecting in England and France*, London, 1976. (Rich and subtle survey from eighteenth century to *c.* 1880)

Hazard, P., *European thought in the 18th century*, English translation, London, 1954.

Lapauze, H., *Ingres, Sa vie et son oeuvre 1780–1867 d'après des documents inédits*, Paris, 1911.

Montauban: Museum, *Ingres et ses maîtres de Rocques à David*, exhibition, Toulouse and Montauban, 1955.

Montauban: Museum, *Ingres et son temps*, exhibition, 1967.

Paris: Petit palais, *Ingres*, exhibition, 1967/8.

*Rosenblum, R., *Ingres*, London, 1967.

Ternois, D., 'Baudelaire et l'Ingrisme', in U. Finke (ed.), *French 19th century painting and literature* (symposium), Manchester, 1972, 17–38.

Ternois, D., 'Ingres et l'Ingrisme. Etat des travaux et bibliographie', *IHA*, XII (1967), 206–18.

779 Alazard, J., 'Ce que J. A. D. Ingres doit aux primitifs italiens', *GBA*, IX (1936), 167–75.

780 Auzas, P.-M., 'Observations iconographiques sur *Le Voeu de Louis XIII*', in the *Colloque Ingres*, Montauban, 1969, 1–11.

781 Auzas, P.-M., 'Les peintures de Girodet au Palais de Compiègne', *BSHAF* (1969), 93–106. (Decorations of 1811, similar to Ingres's *Apotheosis of Homer*)

782 Barzun, J., *Classic, romantic and modern*, rev. edn., London, 1962. (Originally called *Romanticism and the modern ego*; useful survey of attitudes)

783 Blum, I. 'Ingres classicist and antiquarian', *Art in America*, XXIV (1936), 3–11.

784 *Boime, A., *The academy and French painting in the 19th century*, London, 1971. (1–21: 'The crystallisation of French official art'; large bibliography)

785 Bourg-en-Bresse: exhibition, *Le style troubadour*, exhibition at the Musée de l'Ain, 1971.

786 Brendel, O. J., 'The classical style in modern art', in W. J. Oates (ed.), *From Sophocles to Picasso: the present-day vitality of the classical tradition*, Bloomington, 1962, 71–118. (Survey)

787 Canat, R., *L'Héllenisme des romantiques*, 3 vols, Paris, 1951–5.

788 Canat, R., *La renaissance de la Grèce antique, 1820–50*, Paris, 1911. (This and 787 are superb)

789 Cassou, J., 'Ingres et ses contradictions', *GBA*, VI (1934), 146–64. (Quotation, 149)

790 Cogniet, R. (ed.), *Ingres: écrits sur l'art*, Paris, 1947. (Quotation, 54)

791 Georgel, P., 'Les transformations de la peinture vers 1848, 1855, 1863', *RA*, XXVII (1975), 62–77. (Summary, with profuse references, of opinions on the origins of 'modern' art)

792 Kelley, D., '*Modernité* in Baudelaire's art criticism', in F. Haskell *et al*. (eds.), *The artist and the writer in France. Essays in honour of J. Seznec*, Oxford, 1974, 138–52.

793 Lamy, M., 'La découverte des primitifs italiens au XIXe siècle: Seroux d'Agincourt et son influence . . .', *RAAM*, XXXIX (1921), 169–81; XL (1921), 182–90.

794 Mongan, A., 'Ingres and the antique', *JWCI*, X (1947), 1–13.

795 Naef, H., 'Ingres et ses muses', *L'Oeil*, XXV (1957), 48–51.

796 Pach, W., *The classical tradition in modern art*, London, 1959.

797 Schlenoff, N., 'Ingres and the classical world', *Archaeology*, XII (1959), 16–25.

798 Schlenoff, N., *Ingres: ses sources littéraires*, Paris, 1956. (148–177 and 178–200; studies *The Apotheosis of Homer* as a classical and as a romantic document)

799 Ternois, D., 'Les collections d'Ingres', *Art de France*, II (1962), 207–21. (Catholicity of taste)

800 Ternois, D., 'Ingres et sa méthode', *La Revue du Louvre*, XVII (1967), 195–208.

801 Ternois, D., 'Les sources iconographiques de *L'Apothéose d'Homère*', *Bulletin de la société archéologique de Tarn-et-Garonne*, LXXXIV (1954–5), 26–45.

802 Ternois, M.-J., 'Ingres et *Le Voeu de Louis XIII*', *Bulletin de la société archéologique de Tarn-et-Garonne*, LXXXVI (1958), 23–38. (Commissioning and critical reception)

803 Toussaint, H., *Le Bain Turc d'Ingres*, exhibition, Louvre, Paris, 1971. (Sources, reception, fame; quotation, 19)

804 * Wakefield, D., 'Stendhal and Delécluze at the Salon of 1824', in F. Haskell *et al*. (eds.), *The artist and the writer in France. Essays in honour of J. Seznec*, Oxford, 1974, 76–85.

805 Whiteley, J. J. L., 'The revival in painting of themes inspired by Antiquity in mid-nineteenth century France', unpublished D.Phil. thesis, Oxford University, 1972. (With much on Ingres; quotation, 104)

Index

The main references to important subjects are in bold type. References to illustrations appear in italics. Works of art are indexed under the artist; architecture appears under both architect and place. All references to antiquities appear under the heading 'Antiquities as sources'.

Picture Credits

Permission to reproduce copyright material on the pages listed is gratefully acknowledged below. All other illustrations are either out of copyright, or by the author.

Ashmolean Museum, Oxford: 169 (top)

Biblioteca Nazionale Centrale, Florence: 133 (left)

Biblioteca Reale, Turin: 133 (right)

Duke of Sutherland Collection (on loan to the National Gallery of Scotland): 95, 119, 166

Gabinetto Fotografico Nazionale, Rome: 37 (bottom left), 59 (left), 68, 70 (both), 73, 74, 77 (left), 81 (right), 82, 84, 86, 87, 90, 93, 94, 95, 99, 105, 106, 108, 109, 111, 114, 115 (both), 124, 125, 134, 148, 150 (left), 151, 152–3, 155 (both), 156, 157 (both), 158 (left), 159, 165, 167 (bottom), 168, 196, 199, 211 (both), 214, 216, 217, 218, 228

Kunsthistorisches Museum, Vienna: 59 (right)

Metropolitan Museum, New York: 210

Musées Royaux des Beaux-Arts, Brussels: 208

National Gallery, London: 96

National Trust, Anglesey Abbey: 170

Photographie Giraudon: Cover photograph of Ingres: La Grande Odalisque

Victoria and Albert Museum, London: 26, 101

Warburg Institute, London: 43, 63 (bottom)